MW00587068

THE BODY INCANTATORY

THE SHENG YEN SERIES IN CHINESE BUDDHIST STUDIES

THE SHENG YEN SERIES IN CHINESE BUDDHIST STUDIES

CHÜN-FANG YÜ, SERIES EDITOR

Following the endowment of the Sheng Yen Professorship in Chinese Buddhist Studies, the Sheng Yen Education Foundation and the Chung Hua Institute of Buddhist Studies in Taiwan jointly endowed a publication series, the Sheng Yen Series in Chinese Studies, at Columbia University Press. Its purpose is to publish monographs containing new scholarship and English translations of classical texts in Chinese Buddhism.

Scholars of Chinese Buddhism have traditionally approached the subject through philology, philosophy, and history. In recent decades, however, they have increasingly adopted an interdisciplinary approach, drawing on anthropology, archaeology, art history, religious studies, and gender studies, among other disciplines. This series aims to provide a home for such pioneering studies in the field of Chinese Buddhism.

Michael J. Walsh, *Sacred Economies: Buddhist Business and Religiosity in Medieval China*
Koichi Shinohara, *Spells, Images, and Mandalas: Tracing the Evolution*
 of Esoteric Buddhist Rituals
Beverley Foulks McGuire, *Living Karma: The Religious Practices of Ouyi Zhixu (1599–1655)*

THE BODY INCANTATORY: SPELLS AND THE RITUAL IMAGINATION IN MEDIEVAL CHINESE BUDDHISM

PAUL COPP

COLUMBIA UNIVERSITY PRESS NEW YORK

COLUMBIA UNIVERSITY PRESS
PUBLISHERS SINCE 1893
NEW YORK CHICHESTER, WEST SUSSEX
cup.columbia.edu

Copyright © 2014 Columbia University Press
Paperback edition, 2018
All rights reserved

Library of Congress Cataloging-in-Publication Data

Copp, Paul F., 1965- author.
 The Body incantatory : spells and the ritual imagination in medieval
Chinese Buddhism / Paul Copp.
 pages cm. — (The Sheng Yen series in Chinese Buddhist studies)
 Includes bibliographical references and index.
 ISBN 978-0-231-16270-8 (cloth)—ISBN 978-0-231-16271-5 (pbk.)—
 ISBN 978-0-231-53778-0 (e-book)
 1. Buddhist incantations—History. 2. Buddhism—China—Rituals—History.
I. Title.

 BQ5535.C67 2014
 294.3'438—dc23

 2013036862

♾

Cover image: Madame Wei Mahāpratisarā amulet. Eighth century? Yale University
Art Gallery ("Tantric Buddhist Charm," 1955.7.1a). Hobart and Edward Small Moore
Memorial Collection, bequest of Mrs. William H. Moore. Ink and colors on silk.
21.5 cm × 21.5 cm.

For Anna

If one holds it to be self-evident that man is gratified by his fantasy, then one must consider that his fantasy is not like a painted picture, or a plastic model, but a complicated construction of heterogeneous components: words and images. Then one would not place operations with written and spoken signs in opposition to operations with "mental images" of events.

We must plow through the complete language.

—LUDWIG WITTGENSTEIN, "Remarks on Frazer's *Golden Bough*"

I SING the Body electric;
The armies of those I love engirth me, and I engirth them;
They will not let me off till I go with them, respond to them,
And discorrupt them, and charge them full with the charge of the Soul.
Was it doubted that those who corrupt their own bodies conceal themselves;
And if those who defile the living are as bad as they who defile the dead?
And if the body does not do as much as the Soul?
And if the body were not the Soul, what is the Soul?
. . . the body itself balks account.

—WALT WHITMAN, *Leaves of Grass* [1881 ed.]

CONTENTS

ILLUSTRATIONS

PREFACE: THE BODY INCANTATORY

Perhaps a bronze pot may have shaped early modes of thought as much as the other way around?
—MARTIN J. POWERS, Pattern and Person: Ornament, Society, and Self in Classical China

When Chinese of the late medieval period (ca. 600–1000 CE) turned to Buddhist practices for healing, for relief from the hardships of this life and the next, or for the utter transformations of body and spirit promised in them, one resource was the religion's great store of incantations. Spells, in fact, were among Buddhism's most popular elements. As chanted tones, they were central features of the ritual practices of all traditions, whether in grand communal ceremonies, in the quieter daily liturgies of individual monks and laypeople, or in the therapeutic techniques of traveling priests and ritualists. Incantations were equally popular as written texts, in forms such as amulets printed on paper and worn hidden on the body, or as inscribed stone pillars set high on hills, in monastic courtyards, or within tombs—forms attested in archeological finds across the length and breadth of the Tang Empire (618–907) and through the tenth century. This book covers all forms of Buddhist incantation techniques practiced in this age, but it is mainly about Chinese images and uses of the members of one genre of spell, dhāraṇī (Ch. tuoluoni, zongchi, et al.), particularly the ways they were imagined and used in written forms. Like other Buddhist spells in China, dhāraṇīs were Indic incantations transliterated into Chinese syllables (though sometimes translated) whose powers were said to range from the cure of toothache and armpit odor to the guarantee of future awakening as a buddha. Nearly ubiquitous in Mahāyāna Buddhist literature, spells were prominent features of Buddhist practice in medieval China and from there across East Asia. Dhāraṇīs were included in early Mahāyāna scriptures such as the Lotus Sūtra to bless and protect those who propounded these radically new and controversial texts. Incantations were given similar roles in the liturgies evidenced in the breviary-like booklets discovered among the manuscripts and xylographs at Dunhuang, the great caravanserai and Buddhist center that served as a doorway in and out of

medieval China. In these collections, incantations usually begin or end chant-ing programs consisting also of prayers (or "vows," *yuanwen*) as well as short passages from long scriptures and/or short scriptures, such as the *Heart Sūtra*, in their entireties.

Perhaps most famously, dhāraṇīs were central elements of the ceremonies of Esoteric, or Tantric, Buddhism, by which for the purposes of this book I mean in particular the systems of ritual-philosophical practice that in mid and late Tang China centered on the *Mahāvairocana*, *Susiddhikara*, and *Vajraśekhara* (a.k.a. *Sarvatathāgatatattvasaṃgraha*) scriptures as explicated and elaborated by the priests Śubhakarasiṃha, Vajrabodhi, Amoghavajra, and their disciples, lineages that in the Tang flourished most importantly in the Qianfu, Daxing-shan, and Qinglong monasteries of the capital Chang'an and the Jin'ge mon-astery of Mt. Wutai.[1] In later centuries, these Chinese ritual dispensations took root (and grew) most successfully in Japan, while later Indic forms of Eso-teric Buddhism established themselves most importantly in Tibetan cultural spheres. In both cases, the traditions are often considered to form a separate "vehicle" of Buddhist practice: the *Vajrayāna*. In such contexts, dhāraṇīs were often the main event of a rite; indeed, certain examples, such as the *Zunsheng zhou*, the *Incantation of Glory* (the Chinese version of the *Uṣṇīṣavijaya*)—one of the spells whose Tang history of practice this book takes as a focus—became the centers of Esoteric subtraditions of their own, particularly in Tibetan reli-gious spheres. As this book will explore, however, older dhāraṇī traditions—perhaps especially in medieval China, in the centuries before the distinctive dhāraṇī-deity cults become widespread around the turn of the second mil-lennium CE—constituted a vibrant heritage of their own, with its own logics and histories quite apart from those of the high Esoteric traditions. Indeed, a principal goal of this book is to explore relatively neglected elements in the history of Buddhist incantation practice in China, practices that have been considered poor relations of those of the more glamorous lineages of high Esoteric Buddhism preeminent in the imperial capitals of the middle and late period of the Tang Dynasty.

My interest in this topic, and in my particular approach to it, grew out of the observation that in a wide range of Buddhist writings the transforma-tive speech of the Buddha—including dhāraṇīs—was at times said itself to undergo uncanny transformations, to become something entirely unlike speech that yet retained its potency as an agent of ultimate spiritual transfor-mation. In the case of dhāraṇīs it could, to take an example that will require all of chapter 3 to fully explore, become dust, shadow, or stone imbued with

the same saving power as a sūtra or spell. This discovery proved to be but the first hint that the usual definitions of dhāraṇīs and other similar incantations, which claim they are potent only as accurately reproduced Sanskrit sounds, were too thin to account for the richness of the ways these incantations were imagined and used in medieval Chinese Buddhism. Dhāraṇīs in this period, in short, were not what we have been told they were. What follows in this book is an attempt to begin to give a better account of the plastic and contingent nature of spells as Chinese of the latter centuries of the first millennium CE understood them—that is, as they wrote about them, put them into practice, and constructed them in material forms. The study is organized around the broad question of what kinds of things dhāraṇīs were seen to be, and made into, by the people of this age. This question, as I hope the above example suggests, is neither as trivial nor its answers as self-evident as they might at first seem. Answering the question, in fact, reveals aspects of Buddhist practice that have remained obscure in part *because* these spells have seemed relatively trivial (or worse) when compared with the philosophical systems and literary monuments of the religion, and because their natures and forms have seemed self-evident and thus unworthy of sustained investigation. This book argues, very much to the contrary, that Chinese traditions of dhāraṇī practice richly reward sustained attention. Understood within their various contexts, dhāraṇīs are much more than simply the strings of Sanskrit syllables rendered awkwardly into Chinese that are their most basic, and widely known, forms. For Chinese Buddhists of the late centuries of the first millennium CE, spells entailed ways of imagining—writing, building, and acting—that are far more complex, and surprising, than their usual scholarly conceptions reveal.

One of the basic assumptions of this book is that these wider sets of practices and images are not meaningfully separate from the incantations themselves. Just as when one considers an object of practical use one is not simply thinking about an object of a certain shape and heft but, at least implicitly, the range of practices of which it is part, so spells must not be seen merely as strings of awkward syllables but also as the ways they were imagined, received, reproduced, and interpreted. Borrowing the phrasings of two scholars of mysticism, spells were both a "topic and its interpretation; the interpretation is part of the topography."[2] My attempt to broaden our conception of these Buddhist incantations to include their interpretations, structuring contexts, and the modes of their enactments and depictions is also a tactic intended to make clear the degree to which dhāraṇīs have a synecdochic relationship (a trope itself central to classical understandings of dhāraṇīs) with

larger Buddhist and Chinese traditions. The relationship between Buddhist spells and Buddhism, for example, is not at all that between "magic" and "religion" as this dyad has commonly been understood in Western scholarly discourse—that is, as practices based in mutually exclusive logics. The magic of Buddhist spells (the dazzling and mysterious potencies attributed to them) is simply that of Buddhism itself. Attention to the details of Chinese Buddhist spell craft, in fact, reveals veins in the Buddhist tradition—as well as commonalities among traditions—that are otherwise difficult to see. Despite their near invisibility in modern scholarship on Chinese Buddhism, Chinese Buddhists of the period treated in this book used (chanted, read, touched) dhāraṇīs and mantras nearly every day. Taking this fact seriously allows us to cut across conceptual terrain shaped in part by the tradition of seeing Chinese Buddhism principally in terms of doctrines, schools, festivals, deity cults, sacred locales, and the other guiding frames of contemporary scholarship.[3] Spell practices offer their own maps.

This is especially true of the practices and forms of two dhāraṇīs, the incantations known as the Dasuiqiu tuoluoni, the Incantation of Wish Fulfillment (Chinese versions of the Mahāpratisarā dhāraṇī) and the Foding zunsheng tuoluoni, the Incantation of the Glorious Buddha's Crown (Chinese versions of the Uṣṇīṣavijayā dhāraṇī, often called by its abbreviated name, the Incantation of Glory). The material practices that featured these two dhāraṇīs, which achieved great popularity in China in the eighth, ninth, and tenth centuries, lie at the heart of this book. Though both were, importantly, incantations— that is, texts chanted aloud in elaborate monastic ceremonies and in smaller personal rites—they were most famous in this period as what in this book I will call "material incantations": spells active in physical form as inscriptions. But the full range of their reproductions is important to keep close in mind; each of their modes will be featured at various points in this book. In the late medieval period these (and other) Buddhist incantations were written, stamped, and printed on amulets worn on the body; they were carved on pillars, written on funerary jars and coffins, and embedded in literary texts. They were analyzed in extensive and densely philosophical commentaries and praised in miracle tales and poems. Stories about them (or images from those stories) were painted on cave-shrine walls, and the spells themselves were personified and then painted, sculpted, visualized, and contemplated. This startling range of reception and production eases our passage across the boundaries of the conceptual terrain mentioned before. Attention to the full range of Buddhist spell practice allows a more complete grasp of the

practices of Tang Buddhism than is possible through the study of most other single components of the religion.

This brings us to one of the book's main methodological points. A full accounting of dhāraṇīs shows that some of the most striking philosophical claims of medieval Chinese Buddhism had material life in the community, not simply in the minds and commentaries of the monastic literati. In something like a mutually enriching causal loop, in fact, doctrinal conceptions were at times partly shaped by material practice, from which many of their metaphors for what was potent and true were drawn; in turn, material practice was in part shaped by doctrine (and on and on). We can see this in the case of seals in medieval Chinese Buddhism, ritual objects with close connections to material incantation practice. It is clear in the interplay of seal metaphors and material practices, in what the art historian Eugene Wang has noted as the "oscillation" the term "Buddha seal" displays "between an abstraction and a material object."[4] A Chinese description of the nature of the practice engaged in by a Buddhist monk at Nālanda, the great Indian monastic university, states that the monk "held in his palm the secret key to meditation and wore at his sash the mystic seal of the Thus-Come One."[5] At the most basic level, in its context this means simply that he was skilled at meditation and at the ritual practices of Esoteric Buddhism (we encounter this statement within the biography of Śubhakarasiṃha, one of the three chief Esoteric masters of early eighth century China). In the immediate context of the account one need not linger over the metaphors or read them too closely; the images themselves are clear and potent. In a study that takes seriously the imaginative and bodily character of ritual practice, however, immediate rhetorical contexts are only one piece in a much larger cultural realm in which the particular characters of certain bodily practices, here including styles of dress and adornment that were very much current in Tang China, provided metaphors for Buddhist virtues and practices.

As a host of philosophers and social theorists have noted, this is, in general terms, simply a standard feature of human social life. In the words of Jonathan Lear, "as we put ourselves forward in one way or another [or, here, as we put another forward], we tend to do so in terms of established social understandings and practices."[6] In the case of the Chinese account of the monk at Nālanda, socially potent styles of dress provided figures of the (officially) inconceivable nature of the Buddha's cosmic wisdom and skill and the monk's mastery of it. What is the ungraspable interfusion of mind and world, the inconceivable unity that is irreconcilable difference, the mystic quiddity

of no-thing? It is, here, the wearing of a seal (of the Buddha figured as king), a common sight and action with its own bodily particularities: robes of authority, a cord weighted with a seal hanging down. The "mystic seal" of the Awakened One—the truth of Buddhism—was understandable and in some sense enactable as a particular bodily form and disposition. The metaphor was also a material reality. This was the case, as here, even when a practice-derived metaphor had had a long history in Chinese religious discourse and grown common there, as seal metaphors had by the time the account appeared. Yet seals continued to be worn in religious practice and, more to the point here, during the age with which this book is concerned, and in which the passage quoted appeared, seal uses and forms were undergoing important transformations and were very much a living part of Tang Buddhist culture. The material reality was also a metaphor. Attention to ritual practice in history can reveal vitalities in linguistic usage and conception that are otherwise difficult to see. The reverse is also true: once an image derived from practice took on power in the tradition, the practice itself, if still a live option, was in turn enriched and intensified by the life of that image in language and thought. The domains of thought and bodily practice were interwoven. The mind was in the body, in ornaments and clothing, and those ornaments were in the mind.[7]

Ideas such as these inform some of the most interesting recent work on material culture and constitute part of a scholarly conversation to which I hope this book can contribute. In terms of work in this vein on premodern Chinese material (and visual) culture, Martin J. Powers's *Pattern and Person: Ornament, Society, and Self in Classical China* stands out for me as especially insightful, particularly in its exploration of "graphic paradigms . . . [that framed] social and political thought."[8] Powers examines the ways that the classical Chinese "physical understanding of fluid behavior" may have shaped early understandings of the nature of the Dao such as those found in the *Huainanzi*, and that, as the epigraph to this preface quotes him, bronze pots may have shaped modes of thought as much as the other way around.[9] He credits David Keightley's work on "archaeology and mentality" as inspiration, particularly his discussions of the "relationship between the technology of a culture and its conception of the world and man himself."[10] This book will not attempt to advance any theories of material culture and cognition, but takes from works such as those of Martin Powers, Richard Sennett, and Webb Keane a basic methodological orientation toward its subject. To study Buddhist doctrine, for example, shorn of the particular bodily practices of particular historical moments is to denature it, to erase the specific character of the images that

in part make it up. This book, alongside the body of work that has inspired it, highlights the profound interrelationship of conceptual thought and bodily practice characteristic of Buddhism (and perhaps all other human activities).

The material culture of Buddhism in medieval China was central to the practice of the religion, not at all the secondary aspect that too many modern studies have made it out to be (when they treat it at all). Buddhism was a thing of architectural structures and images and words on stone, silk, and the walls of caves perhaps even more than it was of words inked on paper to be read, chanted aloud, or analyzed in commentaries. Among the chief ways, after all, that most Buddhists of this period would have engaged the religion most often were in forms such as spell pillars, sūtra paintings on silk and on temple walls, and the monumental presences of cliff-carved images and temples. These forms of engagement shaped the understandings of Buddhism for medieval Chinese. The towering majesty of the cliff-sculpted Longmen Mahāvairocana Buddha imposing upon those standing beneath it their inescapable insignificance within the awful grandeur of the Buddhist cosmos (and, in its original context, the Chinese imperium); an armlet on one's upper right arm, in visual and bodily mimesis of the bodhisattvas portrayed on temple walls, bearing potent phrases promising release from the prison created by eons of deluded or evil acts—bodily practices such as these did not merely illustrate doctrines, they made them part of human bodily mortal life. More than this, centered on material objects whose particular bundles of forms, materials, and physical surrounds inevitably encouraged understandings and modes of engagement that escaped those narrowly prescribed in religious doctrine, material practice (and culture) has its own ungovernable social power, to which the writers of normative scripture must at times react.[11] At least to the extent that they were part of actual practice, the material and the intellectual were fully intertwined in medieval Chinese Buddhism.

Yet, though objects inscribed with Buddhist incantations lie at its heart, this is neither a work of art history nor (at least primarily) a study of Buddhist material culture; it focuses instead on practices—discursive, ritual, and conceptual—and in the main it does so through analyses of texts. (Chapter 2, a study of amulets of the Incantation of Wish-Fulfillment, is an exception). The book has two principal goals. In terms of the history of Buddhist incantation practice in China, it shows that contrary to the prevailing model of the singular and all-encompassing evolution of Esoteric Buddhism, an evolution usually said to have subsumed and erased the older traditions of incantation practice that had in part given rise to it, dhāraṇī practices in late medieval China were instead

part of a far more open and wide-ranging technical culture—one connecting medieval China with the cultures to its west and south—that carried forward, among other things, an ancient heritage of protective magic. Dhāraṇīs and dhāraṇī practices were important parts of Buddhism in China for at least five hundred years before proponents of the "Esoteric synthesis" began to establish their lineages there in the early eighth century; during that half-millennium this history shaped religious practice in China in ways that have only recently begun to be appreciated.[12] This history, the book argues, in no way came to an end after the Esoteric lineages were established in the Tang capitals. After an introduction and first chapter that lay out some of the background (historical and theoretical) necessary to an exploration of these Chinese histories of practice, the two central chapters of the book—chapters 2 and 3—explore two histories of material incantation in the late medieval period, those centering on the incantations of Wish Fulfillment and Glory. Chapter 4, "Mystic Store and Wizards' Basket," then steps back from a focus on individual practical traditions and considers the broader history of Chinese Buddhist incantation practice of which the two incantatory traditions, as well as that of the Esoteric lineages, were part.

Centering an exploration of incantation practices in evidence such as that contained in Chinese tombs of the eighth, ninth, and tenth centuries, as I do in this book, rather than in the texts of the high ceremonial traditions of the great monasteries of the capitals, makes clear that the older and simpler practices remained a vital option for Chinese of the late Tang, Five Dynasties, and early Song periods, quite apart from their syntheses within the burgeoning tradition of Buddhist Tantra.[13] That is, even as eminent monks such as Yuanzhao (d. 778) and Kūkai (774–835) were training in the imperial monasteries of Chang'an, immersing themselves in the doctrines and learned dispositions of high Esoteric ritual practice and spreading its texts and lineages across East Asia, new forms of ancient dhāraṇī practices were spreading among the people, inculcating their own ideas and bodily ways—spreading, in fact, among a diverse swathe of medieval Chinese, from little-known monks and local Buddhist organizations and traveling merchants to emperors such as Tang Suzong (711–762; r. 756–762) and high-ranking ministers such as the poet Bai Juyi (772–846). The book is thus not a study of Esoteric Buddhism in the strict sense (though it will at times touch on the subject) but of other traditions of Buddhist practice within the wider heritage of which the high Esoteric tradition was but one exemplar. It is intended in part to begin a study of this wider heritage in China and to begin the elucidation of a better model for its place in the history of Chinese Buddhism.

The second goal of this book is, once again, more simply to explore the ritual logics of material incantations and the understandings of their nature implied within those logics. As noted earlier, dhāraṇīs—and especially those dhāraṇīs said to be active in inscribed forms and often discovered in those forms in contexts of talismanic use—were not what most canonical accounts (both traditional and modern) have made them out to be. Discovering what they *were* requires attention not only to the pronouncements of scholastic commentaries and other explicitly normative writings but also and especially to small and ordinary details found in a range of writings and in a range of ritual practices and their excavated *instrumenta*. In giving close attention to descriptions of material incantations and their proper enactments, and to what those descriptions entailed about how the natures of both were imagined, this book will seek to elucidate what we might think of as some of the structuring images in medieval Chinese Buddhism: metaphors and concepts that, along with others, conditioned the ways one could write, pray, or move.

The book centers the two metaphors that, it argues, were at the heart of material dhāraṇī practice in late medieval China—that were in fact in large part what made certain inscribed spells *spells*, and not relics or merely parts of scriptures. These were the tropes of adornment and anointment, which chapter 1 shows were derived from ancient Indic techniques for enchanting bodies with spoken incantations, whether to heal or otherwise empower them. Though they were originally simply small ritual modes, two among a great many, each came to be the primary governing logic of an individual dhāraṇī tradition. The ritual/conceptual figure of adornment, as chapter 2 shows, underlay the practices of the *Mahāpratisarā dhāraṇī*, the *Incantation of Wish Fulfillment*; while that of anointment structured the most basic understandings of the *Uṣṇīṣavijayā dhāraṇī*, the *Incantation of Glory*—and was, indeed, encoded within the very words of the spell, as chapter 3 shows. Indic figures of the imagination were not the only ones in play in the traditions, however. Chapter 1 explores how material Buddhist incantations in China absorbed, particularly in their textual descriptions, tropes derived from ancient Sinitic amulet practices, especially those of seals and talismans (*fu*); it also examines the extent to which medieval Chinese seal and talisman practitioners, in turn, absorbed some of the conventions of Buddhist spell practice into their own techniques. Finally, the introduction and chapter 4 both discuss ways in which Buddhist philosophical doctrines were enacted in dhāraṇī practices over a period stretching nearly a thousand years.

I hope that this book can advance our understanding of what John Kie-schnick has discussed in terms of the material culture of "sacred power" in Chinese Buddhism.[14] As a general point, that numinous things were important in Buddhism and in Chinese religion is well known—relics and images, espe-cially, have in the last decade or so received a great deal of attention, partly as an antidote for what some have seen as earlier Buddhology's overemphasis on the purely philosophical aspects of the religion. My own focus here is on spell-inscribed objects, but it is important to keep in mind the fact that they are, in one regard, simply a subset of the much larger category of magical objects. We must be careful, however, not to overstate this relation, given that such a frame tends to flatten out important distinctions among objects like relics, images, and inscribed bells, and among structuring ideas of efficacy such as adornment and anointment, which as I try to show in this book run deep within Buddhism. The failure to make these distinctions seems to me a weakness of Kieschnick's otherwise impeccable and profound study of sacred objects, in that he too often discusses all such things as if they were imbued with a homogenous "sacred power" that differs only in the forms of its manifestations.[15] In his defense, it should be noted that the tendency of Chinese texts to describe the natures and workings of these objects in terms of the same vocabulary—particularly of ling and ganying —makes his recourse to a unifying idiom of "sacred power" understandable. It is difficult indeed to avoid at least an implicit distinction between "the words" and "the power"—understood as that between container and content—and to write as if the latter were cleanly detachable from the for-mer. Once the idea of "power" arises, the distinction between it and its carrier seems unavoidable, but this way of speaking must not be allowed to slip into a rigid ontological distinction that can lead one to posit unhelpful equivalences between very different sorts of objects and the practices that featured them. The sometimes small differences in the ways numinous objects are described and used reveal subtle complexities that are best preserved in our own accounts. This position, in regards to the present subject, is clarified by John Strong's work on relics of the Buddha, in which he calls attention to the fact that scholars' ten-dencies to group relics and images together as if they were basically the same is not reflected in traditional accounts, which treat them as separate classes of things, with different logics.[16] Material incantations, too, have their own logics; I treat them in this book with only bare reference to things like relics and images of the Buddha as a tactic to avoid this flattening of the complex terrain.

The imaginative power of medieval dhāraṇī practice is perhaps clearest in the ways its logics construed the human body. Though chanted spells were

often directed at the physical person, material incantations, especially, were targeted at bodies that they might transform them—from painful into easeful, and more fundamentally from gross mortal stuff into the pure luminous substance of the truly real. For this reason—and also for the simple fact that material incantations were material objects—they were engaged bodily: touched, rubbed into skin, worn, approached, lived near, and sited close to bodies of the dead. These practices were elements in a vision of perfectible human being that, inspired by Walt Whitman's "body electric," I call in this book the "body incantatory": the body adorned or infused with the stuff of a spell and transformed into it.[17] The "uncanny transformations" noted earlier, the ways the speech of the Buddha could become purifying dust or shadow, were said in the tradition to have included comparable transformations of human bodies. One version of the marvelous bodies produced by dhāraṇī practice is strikingly evoked in a passage that I will consider at length in chapter 3, but which can here at the outset suggest something of what is to come. It describes the incantatory body resulting not from a material spell but from a chanted one.

If any man or god chants this dhāraṇī and then bathes other beings within a river or within the great sea, the water that is used to bathe these persons will infuse them and condense on their bodies, where it will dissipate all the heavy sins of their evil deeds. These people will be reborn in pure lands. They will be born as emanations on lotus flowers and will not receive birth through wombs, moisture, or eggs. How much greater is the power manifested *while* one is chanting [the spell]! If one walks down a road while chanting it and a great wind comes and blows the body hair, hair, and clothes [of the chanter], the wind that continues on, passing any of the classes of beings, blowing them and sticking to their bodies, will dissipate utterly all the heavy sins of their evil actions. These beings will not receive evil rebirths and will ever be born before buddhas.[18]

Though they are especially vivid, these claims are in many ways typical examples of the bodily transmutations featured in exhortations to Buddhist spell craft. Other accounts, as we will see, stress the new buddha-like luminosity and "diamond" (jin'gang; vajra) substance of spell-transformed bodies, as well as their healing properties—all, famously, properties of buddhas and bodhisattvas, as well as of the incantations that stood in for them. In fact,

depictions of buddhas and bodhisattvas in late medieval paintings, for example, those in the Mogao caves near Dunhuang (a site of key importance in this study), present spectacular views of the bodies also promised in incantation scriptures. These figures radiate physical and spiritual ease. They are, nearly always, *literally* radiant: they shine, and in the case of buddhas in incantation scriptures, the luminosity they emit is at times said to be the very spells they speak.[19] The author of the only surviving commentary on the *Incantation of Glory* devotes a great deal of time to the identity of incantation and light and on the power that inheres in this incantatory light; as well, other dhāraṇī scriptures report that the light spreading out from the body of the Buddha proclaims itself to be the very spell he is about to speak.[20] Buddhist scriptures and commentaries, in fact, dwell on the purifying power of this radiance; more, the tradition is in part structured around claims about the transformative flesh of the bodies of these divine beings—both their actual corporeal meat and bone, potent as relic or charm or even meal, and those special objects that are so closely associated with such beings that they are considered parts of their divine bodies: scriptures, images, objects, and spells. These too were said to be luminous, perfecting those who see or hear them, who think on them, who touch them, who wear them. Material incantations were in this way exemplars of a much wider set of objects construed as powerful within a continuum understood to link body and person. It is crucial when reading these accounts to keep in mind that what was true for the body was true for the *person*, for if in some styles of Buddhism the body is said really to be mind, in dhāraṇī practice the mind is, at least in part, really body: the bodily person—extending across lifetimes and worlds—alterable in its essence from something sinful, hell bound, and suffering into the very luminous purity of the buddhas.

THANKS

The Body Incantatory has grown and changed over the many years I have worked on it. Its earliest versions were written under the guidance of Stephen F. Teiser, who remains a cherished conversation partner and mentor. From those early years, too, I remain very grateful to Jacqueline I. Stone, Jeffrey Stout, Robert H. Sharf, Lu Yang, Susan Naquin, Kuo Li-ying, Roderick Whitfield, Al Dien, and Mimi Yiengpruksawan for conversations that helped me to clarify my work on this book and for the examples they set. I owe special thanks to Mimi also for inviting me to join Yale traveling faculty seminars to Buddhist sites in China that have proved formative for my work. Speaking of teachers, though I studied with them before I began this project, I would like to take this opportunity to thank Alvin P. Cohen and Peter N. Gregory, who long ago helped me begin to find my way on the roads of Sinology and Buddhist Studies.

This book first began to take on its present form when I started the research that led to what is now chapter two in Heidelberg, Germany, in 2006-7, where I worked as a researcher at the Heidelberger Akademie der Wissenschaften. I am grateful to Lothar Ledderose for taking me on as a member of his team that year and the following summer, and to the Balzan Foundation for funding my research. It was a very precious time in which I began a complete overhaul and rethinking of my research and, indeed, of my methods as a scholar. Work, and conversations, that first year with Professor Ledderose, Li Chongfeng, Zhang Zong, Claudia Wenzel, Tsai Sueyling, Petra Roesch, Zhang Shaohua, Waiming Ho, and Angelika Borchert immersed me in the disciplines of art history and material culture fieldwork in ways that directly shaped this book. The following summer in Heidelberg I had, as well, the great good fortune of being neighbor and junior researcher to Funayama Toru, from whom I learned much about reading Buddhist texts and about the discipline of scholarship.

My colleagues in the study of East Asia at the University of Chicago make up a demanding and nourishing intellectual community. Donald Harper, especially, has been a generous mentor and critic, and helped me to improve this work both by his interventions into the text and simply by the example he sets. I am truly grateful to all my colleagues at Chicago, but in the narrower terms of my work on this book let me here recall with special gratitude conversations with James Ketelaar, Katherine Tsiang, Michael Bourdaghs, Ping Foong, Tamara Chin, Wu Hung, Judith Zeitlin, and Edward Shaughnessy. Equally, Chicago's faculty in Buddhist Studies—including, aside from Jim and Kathy, Dan Arnold, Steven Collins, Matthew Kapstein, Christian Wedemeyer, and Brook Ziporyn—provide another cherished intellectual community. Finally, let me thank Wendy Doniger and Bruce Lincoln for welcoming my participation in the History of Religions program in the Divinity School.

More generally, let me thank other friends and colleagues without whom work on this book would not have been the pleasure it has almost always been. At Western Michigan University, in Kalamazoo, while I was first trying to learn the craft of professoring, David Ede and Steve Covell (and his wife Ying and their children Xiaoyi, and Yixiang) were true friends and colleagues and I am very grateful to them. Here in Chicago, Eric Nyozan Shutt has not only been a good friend and a helpful critic of my writing, he has reminded me how much I still have to learn about the true practice of the way of the buddhas. Finally, it would hardly be right not mention at least a few of my best boon companions on the scholar roads over these past fifteen years or so: Juhn Ahn, Ian Chapman, Chen Huaiyu, Jessey Choo, Bryan Cuevas, Amanda Goodman, Ryan Bongseok Joo, Lin Hsueh-yi and Mark Meulenbeld, Kevin Osterloh, Mark Rowe, Asuka Sango, Chuck Wooldridge, and Stuart Young.

I have been very fortunate to receive critiques of the work that led to this book from many fine scholars. In addition to those mentioned above in this regard, scholars who have read and responded to all or parts of this book include Wendi Adamek, James Benn, Michael Bourdaghs, Jacob Dalton, Lothar Von Falkenhausen, Judith Farquhar, Luca Gabbiani, Gergely Hidas, Nobumi Iyanaga, Charles Orzech, Ryan Overbey, Rob Linrothe, Rick McBride, Richard Payne, Peter Skilling, Henrik Sørensen, Dorothy Wong, and Chuck Wooldridge. In addition, I presented material from this project on many occasions over about eight years and received much helpful feedback—and cordial hospitality—from many scholars. I am grateful to all who organized and attended these events, and especially to those who made formal responses to material now in this book, including Robert Gimello (who responded on

two occasions, at meetings at Hsi-lai Temple and at Yale), Cristina Scherrer-Schaub (at a meeting of the IABS in Bangkok), Ryūichi Abé (as part of an AAR panel in San Antonio), James Benn (at a meeting at Harvard), Amanda Goodman (at a meeting at McMaster) and Eugene Wang (as part of an AAS panel in Chicago). Let me offer special thanks to James Robson, who carefully read and commented on two quite different drafts of this book, and to the two other, anonymous, readers of the manuscript for the press.

I am very grateful to Chün-fang Yü, the editor of the Sheng Yen Series in Chinese Buddhist Studies in which this book appears, for accepting the volume within the series and for her support of the manuscript throughout its many and long travails. Thanks are also owed Wendy Lochner and Christine Dunbar at Columbia University Press for their support of the book, and to the copyeditors for their hard work on a knotty text. I am grateful to Sun-ah Choi, Seunghye Lee, Wang Huimin, and Katherine Tsiang for providing photos for this project, to Christina Yu for help and advice on image issues, and to Anna Cui for crucial help in securing image rights from Chinese museums. Joy Brennan prepared the glossary and was, overall, a great help in preparing the manuscript for publication. Needless to say, I bear sole responsibility for the book's flaws and shortcomings.

Let me take this opportunity to express my profound gratefulness to the International Balzan Foundation, the Columbia University Seminars, and (at the University of Chicago) the China Committee of the Center for East Asian Studies, the College, and the Franke Institute for the Humanities, for their financial support of my research for, writing of, and final preparations of this book. An earlier version of part of the introduction appeared in the *Bulletin of the School of Oriental and African Studies* 71.3 (2008); an earlier version of part of chapter two appeared in *Cahiers d'Extrême-Asie* 17 (2008). I thank their publishers for allowing that material to be reworked and published here.

I am deeply grateful for the love and support of my father, my mother and Bob, and my sister during the long and often difficult years of my studies and early career.

The final years of my work on this book have been enriched in every way by the appearance of Anna Cui in my life. That such love and delight—and now, true marriage—could grow in such uncertain times has both restored my faith and revealed depths I didn't know were there. Gratefulness cannot begin to tell it. This book is for her.

ABBREVIATIONS

B Beijing Collection of Dunhuang Manuscripts (National Library, Beijing). In DHBZ.

BQ *Baqiongshi jinshi buzheng* 八瓊室金石補正. Lu Zengxiang 陸增祥, ed. In *Shike shiliao congshu* 石刻史料叢書, jiabian 甲編: 9. Yan Gengwang 嚴耕望, ed. Taipei: Yinwen yinshuguan, 1967.

BSKS *Busshō kaisetsu daijiten* 佛書解說大辭典. Tokyo: Daitō Shuppansha, 1964–1988.

Ch. Chinese

DHBZ *Dunhuang baozang* 敦煌寶藏. Huang Yongwu 黃永武, et al., eds. Taipei: Xinwenfeng.

H *Hōbōgirin: Répertoire du Canon Bouddhique Sino-Japonais, Éditions de Taishō (Taishō Shinshū Daizōkyō)*, 2nd ed. Paul Demiéville, Hubert Durt, and Anna Seidel, eds. Paris: Libraire D'Amérique et D'Orient, 1978.

JSCB *Jinshi cuibian* 金石萃編. Ed. Wang Chang 王昶. In *Shike shiliao congshu* 石刻史料叢書, jiabian 甲編: 6. Yan Gengwang 嚴耕望, ed. Taipei: Yinwen yinshuguan, 1967.

P Pelliot collection of Dunhuang manuscripts (Bibliothèque Nationale, Paris). International Dunhuang Project online database (idp.bl.uk).

S Stein collection of Dunhuang manuscripts (British Library, London). International Dunhuang Project online database (idp.bl.uk).

ShM Shanghai Museum collection of Dunhuang and Turfan manuscripts. *Shanghai bowuguan cang Dunhuang Tulufan wenxian* 上海博物館藏敦煌吐魯番文獻. Shanghai: Shanghai guji, 1993.

Skt. Sanskrit

SP Stein collection of Dunhuang paintings (British Museum, London). International Dunhuang Project online database (idp.bl.uk).

T *Taishō shinshū daizōkyō* 大正新修大藏經, 100 vols., eds. Takakusu
 Junjirō 高楠順次郎, Watanabe Kaigyoku 渡邊海旭, et al., Tokyo:
 Taishō issaikyō kankōkai, 1924–1932.

XB *Quan Tang wen xinbian* 全唐文新編. Changchun, China: Jilin wenshi,
 2000.

XZ *Xu zangjing* 續藏經. Rpt., Shanghai: Shangwu, 1923.

THE BODY INCANTATORY

INTRODUCTION: *DHĀRAṆĪS* AND THE STUDY OF BUDDHIST SPELLS

Dhāraṇī incantations and related mystic phrases like *mantra*, *hṛdaya*, *paritta*, and *vidyā* have been integral parts of nearly all Buddhist traditions since at least the early centuries CE.[1] That they remain so today is obvious to any traveler in contemporary Buddhist countries, where spells commonly adorn the bumpers of cars or dangle within pouches from rearview mirrors and cell phones.[2] Modern scholarship, however, was relatively slow to take them seriously; indeed, from early on in the modern study of Buddhism there was a marked aversion to their study that has only recently abated.[3] For a stark example of this aversion we need look no farther than the work of F. Max Müller, the first Western scholar to turn his attention to one of the incantations central to this book, the *Uṣṇīṣavijayā-dhāraṇī*, who in his 1884 introduction to "the Ushnîsha-Vigaya-Dhâraṇî as an inscription" had the following to say about this "miserable" genre of Buddhist writing:

> Most of these Dhâraṇîs are prayers so utterly devoid of sense and grammar that they hardly admit and still less are deserving of a translation, however important they may be palæographically, and, in one sense, historically also, as marking the lowest degradation of one of the most perfect religions, at least as conceived originally in the mind of its founder. Here we have in mere gibberish a prayer for a long life addressed to Buddha, who taught that deliverance from life was the greatest of all blessings. While the beautiful utterances of Buddha were forgotten, these miserable Dhâraṇîs spread all over the world, and are still to be found, not only in Northern but in Southern Buddhism also Here, as elsewhere, the truth of the Eastern proverb is confirmed, that the scum floats along the surface, and the pearls lie on the ground.[4]

While, as later chapters will make clear, Müller's characterization of dhāraṇīs as prayers was ahead of his time, his denigration of them was unfortunately to be a recurring motif in the formative age of Western scholarship. D.T. Suzuki, an immensely influential figure in both the rise of popular interest in Buddhism in America and as well in its early academic study there, in 1932 was similarly dismissive.

> Dhāraṇī is a study by itself. In India where all kinds of what may be termed abnormalities in religious symbology are profusely thriving, Dhāraṇī has also attained a high degree of development as in the case of Mudrā (holding the fingers), Āsana (sitting), and Kalpa (mystic rite). When a religious symbolism takes a start in a certain direction, it pursues its own course regardless of its original meaning, and the symbolism itself begins to gain a new signification that has never been thought of before in connection with the original idea. The mystery of an articulate sound that definitely fascinated the imagination of the primitive man has come to create a string of meaningless sounds in the form of a dhāraṇī. Its recitation is now considered by its followers to produce mysterious effects in various ways in life.[5]

Few scholars of Buddhism would endorse such views today. Indeed, this book contributes to a field that has in large part fully embraced a view of Buddhism (and not only the Buddhism of premodern China but the many Buddhisms across the Asias of all epochs) as in deep and often structuring ways characterized by elements that Müller and Suzuki would have found dismayingly irrational and even un-Buddhist. The study of the history of Buddhism, in this way, is simply one branch of the wider study of human history, and its practitioners have tended to follow trends in that broader endeavor. Recent scholarship on East Asian Buddhism has in many cases reflected a turn among some practitioners of the humanities away "from the primacy of discourse to the priority of the object" and the embodied human practices that feature them.[6] In this vein, recent works have explored the centrality to Buddhist practice of visual images, materiality and bodily life, manuscript culture, ritual action, and even non-Buddhist elements (from traditions such as Daoism or Bön), in important cases demonstrating the normalness to Buddhism, and to Buddhist notions of virtue and purity, of such seemingly sensational examples of the irrational (to modern Western sensibilities, at least) as self-immolation, or "auto-cremation."[7] As James Benn has made clear in

his recent study of this practice in premodern China, such elements of the religion are not at all "artificial or arbitrary" fetishes of a modern voyeuristic scholarship "[focusing] on the sensational or grotesque," but in fact basic features of the Buddhist tradition.[8] In fact, it is now clear that not to take serious account of such practices is to be in danger of creating a fetishized Buddhist tradition, one characterized by modern fantasies and self-images.[9]

Dhāraṇīs and other incantations were central parts of Buddhist practice in medieval China—they are commonly found in the small breviary-like codices found at Dunhuang, for example, alongside sūtra passages and prayers, a fact that speaks to their place in monks' quotidian rounds of recitation and prayer. In addition, Chinese Buddhist tales and biographies from the period contain numerous examples of monks chanting dhāraṇīs, as well as "incantatory prayers" (zhouyuan), as a part of their regular duties. Though the legendary exploits of wizard-monks such as Fotudeng (232–348) and Śubhakarasiṃha (Shanwuwei, 637–735) did indeed earn special mention and praise in the canonical literature, incantations were not in themselves special, or only the extreme recourse of dire situations; all monks seem to have regularly chanted them.[10] Indeed, not only monks chanted them—the material record contains many examples of lay people chanting spells, wearing them as amulets, or having them engraved on their memorial stelae for the various sorts of aid their practice promised.[11] Dhāraṇī pillars, to take the most prominent example, spread as much through the efforts of lay societies as through those of monasteries. And in terms of those spells that were mostly chanted, not carved in stone, materials that speak of the spread of the "augmented" version of the Incantation of Glory, for example, suggest that it gained acceptance most widely among lay Buddhists.[12]

The nature of dhāraṇīs, and of Buddhist spells in general, is the subject of every page of this book, but a brief introduction to their forms and structure will be helpful here at the outset. As is well known, the word dhāraṇī (like the word dharma) is derived from the Sanskrit root √dhr, "to support," "maintain," "hold." The derived term seems to have originally referred to the capacity to maintain one's "hold" of things such as scriptures (in strengthening one's memory), of beneficial power (in improving one's fate, or karmic roots), or of one's own self-composure, as well as the ability to increase one's "grasp of" (in the sense of "understanding of" or "knack for") things ranging from Buddhist doctrines, to contemplative textual objects, to incantations. Some of the earliest extant uses of the term do not refer to mnemonics, spells, or syllables at all, but simply to a quality of the bodhisattva, the spiritually advanced

being. Yet it is clear that very early on the word *dhāraṇī* came also (and most commonly) to denote strings of words and syllables—by far their most widely understood referent today and since at least the Tang period in China. The term's basic sense of "grasp"—*dhāraṇī* is commonly translated in Chinese as "encompassing hold/grasp" (*zongchi*)—indicates, in part, that they were "taken as summarizing or holding the teachings of the Buddha," a fact that seems to have contributed to understandings of their status as "utterances of magical power."[13] Explanations of the efficacy of these spells proliferated in medieval Buddhism, both in China and elsewhere.

In its most common form, a dhāraṇī incantation is a string of often ungrammatical Indic[14] words at times interspersed with syllables lacking any discursive content at all in any language, whose spoken tones were said (in works of exegeses) to epitomize doctrines or states of being. Their most emblematic form of enactment was ritual chanting—sometimes as the culmination of a rite and sometimes as ancillary components of rites dedicated to the manifestation of other forms of Buddhist power, such as images or scriptures. They often occur in sūtras as well, typically (in texts such as the *Lotus Sūtra* and the *Laṅkavatāra Sūtra*) as spells included toward the end of the scriptures to protect the texts and its proponents. Later, by the third century CE, sūtras featuring dhāraṇīs at their cores appeared. In these texts spells are the centerpiece of the text and the subject of its narrative, not an ancillary component.[15] Though in India dhāraṇīs would have been half or even wholly intelligible, in China their discursive meanings were in large part lost because, with the notable exception of a few translated examples, dhāraṇīs were always transliterated. They were thus nonsensical in purely textual terms to all but a relatively few adepts who had access to interpretive glosses on the spells or to oral teachings.

Strange on the page and in the ear, dhāraṇīs were perhaps the most mysterious feature of medieval Chinese Buddhist practice—literally "incomprehensible," *bukesiyi*, as the common Buddhist expression has it. Related to this, one element nearly universal in theoretical understandings of Buddhist spells is the notion that they are irreducibly sonic in nature. As the philologist-monk Huilin (d. 820) noted in his classic work *Sound and Sense of the Scriptures* (*Yiqie jing yinyi*), when considering the words (*zi*) used in dhāraṇī, one should only pay attention to their sounds and "not seek for the meaning of the words."[16] More specifically, according to such accounts, the original Indic sounds must be reproduced in transliteration as accurately as possible and then never lost. Writings on dhāraṇīs are filled with assertions that the only way to invoke the powers of a spell is to properly pronounce it. Toward that end, pronunciation

guides were often inserted as interlinear notes into written versions of the spell; more than this, the direct transmission of the correct pronunciation was often said to be indispensable.

THE FORMS OF DHĀRAṆĪS IN CHINA

Strict adherence to such canonical pictures of the nature of dhāraṇīs, however, can blind one to the rich culture of Chinese Buddhist spell practices. In fact, strict interpretation of the account given above would imply that Chinese got dhāraṇīs wrong more often than they got them right, for on this view the magic of the Indic spells must necessarily have been lost in their Chinese permutations. If the power of dhāraṇīs inheres wholly in their original Sanskrit sounds and is lost in any other medium or form, then the apparent disregard of most Chinese for the strictly accurate reproduction of those sounds—that is, by learning Sanskrit instead of relying on "clumsy" transliterations into the script of their native tongues or simply upholding the written representations of those sounds[17]—can only have entailed the loss of this power. Representations of dhāraṇīs, on this view, like mere paintings of cakes as discussed in certain Buddhist teachings, can have no sustaining power.

And yet Chinese Buddhists, medieval and modern, have found their dhāraṇīs powerful in the many forms in which they have produced them. Though nods have often been given to the traditional view, in most cases Chinese versions of Sanskrit spells have been frozen for more than a thousand years. In modern temples in China, for example, it is nearly always the medieval transcription of the *Heart Sūtra*'s famous spell that is chanted—not one in romanized Sanskrit and not one in Chinese characters chosen to make contemporary Mandarin or local dialect pronunciations more closely match the supposedly timeless syllables of the original. The Chinese characters chosen by the legendary translators of the medieval period, through ages of practical tradition, have become "real" forms of the spell. Those transcriptions—that is, those *written* forms—themselves became timeless and essential, at least in most practical contexts. But it was not just the characters per se that were seen as true instantiations of the spells. As was so often the case with spells in China, *specific physical examples* of the writing of dhāraṇīs, including the material employed, were themselves dhāraṇīs, not merely the incidental details of their encoding for future speech. In China, dhāraṇīs were fluid in form and substance, and none more so, at least in terms of explicit description, than spells such as the *Mahāpratisarā* and *Uṣṇīṣavijayā* dhāraṇīs.

To miss this fact is to miss a great deal of importance in the long history of Chinese Buddhism. Canonical Indic forms of dhāraṇis (or of sūtras and stūpas) can obscure our vision of non-Indic Buddhist traditions as much as they enable it. Indeed, I think it is fair to wonder what is actually being described in scholarly works that picture a unitary dhāraṇī tradition, spanning cultures and languages, that take original—or putatively original—Sanskrit sounds as that tradition's unwavering core. It is unquestionable that there is an important place for the study of translation and transliteration in the creation of new "Buddhisms" in cultures other than India, but the objectifying practices inherent in such studies should not be allowed to mask what is vital in the religious lives of the people within those other contexts. The danger of what Pierre Bourdieu (following Valentin Voloshinov) called "philologism" seems to me especially acute here: taking the objectifying nature of philological practices of decipherment as having been the nature of the practices in which the texts studied were actually produced and understood.[18]

Partly as an attempt to avoid this danger, my interest in this book is mainly in the contexts, formats, uses, and ancillary practices associated with dhāraṇis, rather than in the specific syllables employed in each spell or each version of each spell. Those syllables are, clearly, deeply important to any understanding of these potent phrases, and I will not ignore them. But, for my purposes, the forms and surrounds of the spells are where the most interesting features of dhāraṇis are to be found, particularly since my guiding question concerns the particular ways Buddhist spells were imagined and put into practice. As noted before, many of the forms of dhāraṇis were material and visual. One goal of this study is to give a picture of dhāraṇis in China that shows the naturalness of dhāraṇī pillars and amulets, the most common forms of the incantations featured in this book within medieval Chinese religious culture—objects that do not seem natural at all within a scholarly frame that privileges an idealized (and often lost, or even fictive) Sanskrit orality.

I said that I will not ignore the specific transliterated phrases of the spell. Neither, however, will I spend much time on them. This will surely seem odd in a study of dhāraṇis, since many studies of the incantations feature scholarly redactions at their core. I will not provide such texts for two reasons. The first is that I think they give misleading impressions of the incantations that are my subject in this book, both of which came in many different syllabic forms. Sometimes these differences were the result of attempts to get the Indic sounds right: different dialects, accents, and ears led to different linguistic choices. Quite often they were due to mistakes.[19] But whatever the

reasons for this variety of forms, it was a fact; I do not want to mask it by offering a redacted version of either the Chinese transliterations or (still less) of a putatively original Sanskrit form.

My main reason for slighting the actual syllables of the spells in my analysis, however, is that I do not want to give the impression—unhelpful, as I see it—that certain arrangements of syllables were the basic stuff of the spells. This is not to deny that particular sequences of syllables were closely associated with the dhāraṇīs I study in this book, or that they were very often spoken incantations. Clearly in both cases they were. But instead of being a specific and unwavering run of syllables—isolatable, recognizable, and reproducible through scholarly analysis—the Zunsheng zhou (for example) was in practice anything that was called the "Zunsheng zhou." More than this, a central presupposition of this book is that these particular sequences of syllables, contrary to canonical definitions of dhāraṇīs, were incidental to what I would like to posit as the "stuff of spells"—the components of their imaginative depiction, interpretation, situatedness, and practice. Centering a single text of a particular spell focuses attention away from what I want to talk about.

The question "What were dhāraṇīs in late medieval China?" is best seen as complex and difficult to answer if it is to be of real interest and not simply a reproduction of canonical definitions or scholarly habits. I am not the first writer to see the study of Asian spells in this way. Andre Padoux wondered, "Should one try to define mantras at all?" Instead of attempting to do so, he thought it better to "remain content with . . . noting the uses and forms of mantras, the varieties of mantric practices and utterances (or some of them), as well as some of the Indian theories on their subject."[20] In this spirit, rather than develop a new normative definition of Chinese dhāraṇīs, in this book I explore the contours of their imagination through case studies of what I call in this book "material incantations," two important exemplars of which are the Incantation of Wish-Fulfillment and the Incantation of Glory, spells whose practices, instrumenta, and ritual logics I explore in the two central chapters of this book.

Spells in General and Chinese Buddhist Spells

As with any topos isolated within the archive, there are numerous methodological and theoretical issues involved in the study of dhāraṇīs in medieval China. Opportunities to understand the ways the incantations of Glory and Wish-Fulfillment clarify such perennially vexed issues as the nature of ritual language, the status of the hoary Weberian divide between the ethical and the magical,

BRIDWELL LIBRARY
SOUTHERN METHODIST UNIVERSITY
DALLAS, TEXAS 75275

the nature of intercultural translation, even the nature of Buddhism itself as it is seen to exist across cultures, will recur throughout this book. Full consideration of these issues, however, must await some future vantage. Otherwise, I fear one of Walter Benjamin's tasks of the translator—the job of making sure the language one is translating reshapes one's native language (or categories of thought) at least as much as one's own language restructures the foreign one—will remain undone.[21] Without first knowing what medieval Chinese Buddhist spells were, in something approaching their full extent, the attempt to place them within larger academic debates (a task that seems to me an important job of the historian) can hardly do more than simply recapitulate the terms of those debates. Most general pictures of "magical speech" are based in research on particular sorts of ritual action described in particular ways, whether that of Trobriand Islanders, as in Malinowski's seminal work and Tambiah's rethinking of it,[22] the literary presentations of Frazer's *Golden Bough* as read by Wittgenstein,[23] or Indian mantras as understood by Fritz Staal.[24] Such theories work for the ways language is used in the contexts that shaped them, but they often work much less well for other sorts of ritual language. Few theories of how spells or other examples of magical speech "work" offer much help in understanding the two dhāraṇīs featured in this book when they are kept squarely in their practical and literary contexts. None are adequate to them as a whole. This is largely because a full-scale treatment of dhāraṇī practices in medieval China (which, let me emphasize, this work only begins) shows dhāraṇīs to have been much more than simply "spells," where that word is taken to mean potent effective utterances. Dhāraṇīs, and especially the two featured here, were much more than that. They were "spells" in two senses: they were, at times, spoken for the potent effects such speakings were said to cause, and they were called *zhou*, a term that is often well translated by the English word *spell*. But as noted, people also wrote them, touched them, wore them, interpreted them, worshipped them, and buried their dead near them, behaviors that do not jibe well with either the English word *spell* or most theories of ritual language. Thus, while the intellectual history of modern thinking about the nature of spells and ritual language looms over any new study of utterances and writings named "spells," the ways this history might unhelpfully condition approaches to this subject need to be carefully considered.

The study of incantations and spells has benefited a great deal from its inclusion in studies of language considered more generally under the rubric of "ritual speech"; I do not mean to imply otherwise. But the use of this frame has exacted a cost. One of the general points I would like to make in this book

is that it has been misleading to foreground the *spoken* nature of dhāraṇīs in China. This emphasis has encouraged a one-dimensional picture of the nature of ritual language in general. More to the point, for my purposes it has contributed to a picture of spells in Chinese religion that obscures the important place in that culture of the *writing* of spells. Limiting myself to the case of incantations in East Asian religious traditions—and especially those that originated in Indian religions—there seem to me at least two reasons why the orality of incantations has been stressed. First, as noted, traditional theories of the nature of those spells insist on their essential (and untranslatable) sonic character. The power of mantras and dhāraṇīs, in China as in India, is normally said by traditional philosophers to reside entirely in their correctly reproduced sounds.[25] Scholars have more often than not taken such prescriptions at their word, and in many cases they have been right to do so. The second reason, I suspect, is the general interest in ritual itself, and the ways in which religious ritual has been depicted in academic writing. Taking the first of these, I think scholarship has tended to privilege oral versions of spells because rituals tend to feature the *speaking* of spells (rather than the writing of spells or the manipulation of already written ones). More basically than this, it is also possible that, at least as they are used in normal speech, the very words *spell* and *incantation* (or *mantra* for that matter) seem to foreground their own orality, drawing our attention rather naturally to their spoken forms.

On another level, the intellectual history of the study of ritual has conditioned us to look first to the act of speaking. Studies of ritual language have ranged from those featuring analytic categories such as language games, speech acts, language ideology, framing indexes, entextualization, and Pierce's notion of iconic signs, to investigations that play down the linguistic aspects of spells altogether, drawing instead on observations about the "pre-sleep monologues of babies"[26] and the songs of birds. Though most of these are perfectly applicable to investigations of writing, they have typically been theorized in relation to *spoken* language and its contexts. The most famous example of Austinian speech act (and the term itself might be a giveaway) "I now pronounce you man and wife" is taken from a rite that features ritual *speaking*-as-doing (though the performance of a written contract is not unimportant).[27] In addition, to all too briefly take another example, examination of moments of ritual speech has provided most of the material for the development of the notion of framing indexes in ritual, those linguistic properties, such as intonation or esoteric vocabulary, that indicate the nature of the speech act being performed.[28]

In the cases of mantras and dhāraṇīs, at least, this general orientation to the subject gets us into trouble when we turn our attention to the ways these spells were conceived and used in Chinese religious practice. The wide use of written spells in these traditions is an important and understudied phenomenon, and one whose proper study takes us into surprising materials. By written spells, to clarify, I do not mean talismans or other sorts of charms whose inscribed and physical nature is always said to be primary, but rather written versions of incantations that were otherwise oral in nature, or at least in use. Spells that were written, and found powerful in their written forms, were also spoken. In this book I explore the ways dhāraṇīs were reproduced and understood as, among other things, ritually recited incantations, as objects of philosophical contemplation and linguistic interpretation, as components of certain scriptural genres, and as the products of various practices of spell writing. Though it would be against my purposes here to generalize, I hope that the chapters that follow offer insights not only into often neglected areas of medieval Chinese religion but as well into the nature of practices that make language use seem somehow "magical" or "religious."[29]

"DHĀRAṆĪ" IN BUDDHIST WRITINGS

Western theories of the nature of potent ritual speech are not the only relevant pictures for a study of Buddhist incantations. The Buddhist tradition itself, including its medieval Chinese versions, contains many influential accounts of the character of dhāraṇīs, as well as the multiple senses of the term *dhāraṇī*, which as we will see meant a great deal more than "spell." A brief survey of these accounts adds a crucial piece to the picture this book constructs of the nature of material dhāraṇī practice, of its place within the complex history of thought and practice centering on the syllables known as dhāraṇīs, and the meanings of the word *dhāraṇī* and its Chinese cognates.

In dhāraṇī sutras such as the scriptures of the incantations of *Glory* and *Wish Fulfillment*, and in the bodily practices they in part gave rise to, the natures of dhāraṇīs and their potencies are figured in images, in narrative structures, and in material, visual, and behavioral forms; elsewhere in this book I suggest that analyses of the spells in these texts and in those that draw on them require a broadly literary and visual/material-cultural approach. In order in part to set the stage for that work, here at the outset I will briefly examine exegetical discussions of spells, which by their very nature give more explicit pictures of their subjects embedded within larger and often elaborately

systematic theoretical frameworks. I will give an overview of key elements in this vast body of scholastic literature by focusing on disparate senses of the term dhāraṇī and its Chinese cognates presented in some of the most influential scholastic treatments of dhāraṇīs known in China, as well as others that, though the nature of their influence is harder to gauge, were composed by some of the most prominent monks of the medieval period.[30]

Dhāraṇī, the Sanskrit word that stands behind the relevant Chinese technical terms—including "spell" (zhou), "tuoluoni", "grasp/hold" (chi), "encompassing grasp/hold" (zongchi), "sublime grasp/hold" (weimichi), as well as, often, "real word" (zhenyan) and "mystic word" (miyan)—has a confusing (and often confused) set of referents.[31] Because the Uṣṇīṣavijayā and Mahāpratisarā dhāraṇīs were only incantations (or incantation relics) in Tang times, this book mainly treats dhāraṇī as a term for incantations. It is important to emphasize, however, that the term did not only, or in some historical periods even usually, refer to incantations. Even in later periods when the term mainly indicated incantations, older philosophical senses remained in play.[32] From its earliest uses in works extant in Chinese, dhāraṇī also indicates mnemonic devices and textual objects used in contemplative practices, qualities (or "adornments," zhuangyan) of bodhisattvas, and even deities in their own rights, as well as important philosophical concepts. Failure to make careful distinctions among the various senses of the term (which are only in part differentiated by its various cognates) has sown confusion, as has the assumption that dhāraṇī always or most basically means "spell."

Let us start with a basic and perhaps rather obvious premise: questions about the natures of dhāraṇīs, whether they concern the category as a whole or the particular sense of any one example of the term dhāraṇī or its cognates, must be sensitive to the specific rhetorical and practical contexts in which these terms appear. Elements of those contexts can include the genre of text the terms are parts of, the explicit and implicit arguments they participate in, as well as the doctrinal and practical frameworks that condition them. As noted, one of the concerns of this book is to show the extent to which scholarly conceptions of dhāraṇīs, particularly of dhāraṇīs in Chinese Buddhism, have suffered from overgeneralization, one result of which is that the deep complexities of the term have been glossed over, as have the traditions of doctrinal thought and spell craft of which they were emblematic.[33] We must be clear about what is at issue within the various discussions of the nature of dhāraṇīs, as well as the ways that the modern scholarly habit of privileging certain canonical accounts of them have conditioned our views of what dhāraṇīs are or could be.

The most influential of these pictures include the notions that the earliest referents of dhāraṇī were mnemonic devices and that the term itself fundamentally means "memory." The most important classical treatments of dhāraṇī as a theoretical concept, however, in texts translated into Chinese from Indic languages and intellectual milieus as well as those composed in Chinese to meet native Chinese concerns, show each of these understandings to overly privilege a rather narrow band of the term's usage. Instead, the many senses of dhāraṇī in these works are helpfully approximated by the English word *grasp*, which maps onto the primary usages of the word, not to mention its literal meaning, rather closely: basically, to hold (whether in one's hand, mind, or nature) and to understand (including in the sense of "to have the knack for"). Keeping the basic literal meaning of the term in mind rather than privileging extended senses like memory or incantation allows the reader of Buddhist texts to appreciate the full complexity of the term and its associated doctrinal and practical traditions. This is not to say, however, that memory (or mnemonics as a larger category) and various understandings of "spell" were not important themes in early Buddhist writings on dhāraṇīs but simply that they were but two elements in that discourse and that neither should be given an overly privileged place in our understandings of dhāraṇī as the name for a family of concepts.[34] Such a reading practice, moreover, makes clear that medieval Chinese not only maintained traditional Buddhist conceptions, they employed them subtly and profoundly in both doctrinal and historical writings through at least the tenth century, the period covered in this book.

Reading dhāraṇī in this way also reveals deeper continuities within Chinese Buddhist traditions, and perhaps within those of Asia as a whole, than are otherwise clearly in view. Some of these continuities are visible in the ways the philosophical understandings I explore in this section were echoed in the wide range of practices that dhāraṇīs—including especially the runs of syllables known by this name—were parts of. Understanding that the basic practical sense of dhāraṇī was "grasp" or "hold," not memory or spells, helps to illuminate the connections that obtain among the doctrinal treatments discussed here and the many injunctions encountered in texts of various kinds to "hold"[35] dhāraṇī incantations in the mind and, indeed, on the body. This book demonstrates that the logic of dhāraṇī as the emblem of a family of concepts and practices was maintained in Chinese Buddhism across a wide range of religious behavior, from learned scholastic writing to popular methods of preparing the corpse for burial.

Dhāraṇī, in fact, turns out to be a term overloaded with referents and complexly constructed by its uses within various traditions. The apparent unity of the word is simply an illusion. Things could hardly have been otherwise for a signifier whose history was shaped in part by the transformations attendant upon the spread of Buddhism across Asia, a region "crisscrossed with the intersecting boundary lines of cultures and languages, [and] anything but a naïve monoglotic world."[36] Our knowledge that the Sanskrit word dhāraṇī and its cognates stand behind the range of terms used to render its various senses (incantation, grasp, tuoluoni) casts something of a unifying spell over our understanding. There is a sense, in fact, in which dhāraṇī is not a single term at all. What follows is an outline genealogy of the term's illusory, or at least densely complex, unity as it is encountered within texts important in Chinese Buddhism into the Tang period.

"DHĀRAṆĪ" IN THE STAGES OF THE BODHISATTVA PATH

The close association of the term dhāraṇī with memory has sometimes been thought to follow naturally from the putative original nature of dhāraṇīs as mnemonic devices.[37] Jens Braarvig, in what has become a standard article on the subject, notes the "obvious connotations of memory" that attach to the term.[38] Another scholar, going somewhat further, asserts that the Chinese translation of dhāraṇī as "comprehensive retention" (zongchi; "encompassing grasp" as I render it here) "[alludes] to the memory function";[39] another, making it clearer still, claims that "the literal significance of the term 'dhāraṇī'" is "memory."[40] Braarvig's main concern in his article is to explore the concept's connections with "eloquence" (Skt. pratibhāna) and the way the two form the basis of the bodhisattva's abilities as a preacher of the Dharma.[41] The bodhisattva remembers the teachings (or has a command or grasp of them) and is eloquent in their exposition, matching his words to the capacities of his audience. Braarvig quotes the Lalitavistara sūtra:

> Attaining dhāraṇī is an entrance into the light of Dharma, as it functions so as to retain all that the buddhas spoke; attaining pratibhāna is an entrance into the light of Dharma, as it functions so as to please all living beings with good sayings.[42]

But as Braarvig and others also make clear, dhāraṇī in this sense does not simply mean the rote memorization of the teachings. The Bodhisattvabhūmi,[43]

or *Stages of the Bodhisattva Path*, in one of the most often-cited canonical discussions of dhāraṇī, famously divides dhāraṇīs into four kinds.[44] The first is called in Sanskrit, *dharmadhāraṇī*, or, in my rendering, "grasp of the teachings." The second is called *arthadhāraṇī*, "grasp of the meaning." Respectively, these two terms indicate the capacity to grasp and keep in mind the letter and the meaning of the teachings. The third form is called *mantradhāraṇī*, or "grasp of mantra/spells." The precise meaning of this dhāraṇī is the least agreed upon; its basic sense is a grasp of—that is, knack for employing—certain runs of syllables in various ways. The final sort of dhāraṇī is called *kṣantidhāraṇī*, or "the grasp by which one attains the patient acceptance of a bodhisattva."

Taking the first two kinds of dhāraṇī as a pair, it is important to note that these uses of the word *dhāraṇī* do not simply refer to memory. Grasping the meaning of the teachings, for example, is not precisely the same as remembering their full extent; in fact it would seem to obviate the need for actual memorization of the letter of the teachings. It is possible that these four are to be taken as stages of accomplishment, moving in the direction of a progressively more refined "grasp" of Buddhist teachings, beginning with simply remembering their letter and then finally, in the fourth "stage" of dhāraṇī, attaining the patient acceptance of the fact that the phenomenal world is empty of any stable abiding essences, a state of being understood in the Buddhist tradition to result from a very high level of spiritual maturity. This notion of the scheme might not seem at first to square well with the third sort of dhāraṇī, *mantradhāraṇī*, which is often taken to simply name dhāraṇī as spells (*mantra*) but instead indicates a "grasp" of spells, or spell-like runs of syllables, whether in the mind, the understanding, or in some form of practical mastery. Braarvig, as well, notes that a close reading of these texts makes it appear unlikely that the term *mantradhāraṇī*, or "spell dhāraṇī" if we translate from the Chinese, should simply be taken to indicate "magical formula."[45] Taking the term as constructed according to the pattern of the previous two, it is clear that the meaning must be along the lines of "grasping" the phrases of the magical formula (Ch.: *zhoushu*). The *Stages'* explication confirms this. "What is spell-dhāraṇī? When the bodhisattva attains this samādhi power, he rids beings of afflictions by means of the phrases of spells."[46] Here again, dhāraṇī refers to a state of spiritual attainment, or a mental state—a samādhi centering on spells rather than a specific kind of spell (or run of syllables). This understanding of the term is further supported in an exegesis of the *Bodhisattvabhūmi* included among the manuscripts discovered at Dunhuang. The text, which is found untitled on the manuscript known as Pelliot Chinois

2141, was given the title *Record of the Meaning of the Bodhisattvabhūmi* (*Dichi yiji*) by the editors of the *Taishō Collection of Scriptures*. It explains the term *spell-dhāraṇī* as follows: The text "says 'spell' (*zhoushu*), [because] one [must] cultivate wisdom to use them. [Because] one has attained dhyāna-concentration (*chanding*) and cultivated wisdom and mastery (*hui zizai*), one is able to employ spells. Because [in this state] one is not deluded in regards to spells, it is thus named 'spell-dhāraṇī.'"[47]

We should note that the fact that spells are the proper focus of the bodhisattva's samādhi here is clearly not arbitrary, given that the last sort of dhāraṇī also involves the syllables of spells. This last form, the "dhāraṇī in which one attains the patient acceptance of a bodhisattva" (*de pusa ren tuoluoni*), "consists," as Braarvig explains, "in pondering a mantra until one understands its meaning, namely that it is without meaning, and accordingly understands all dharmas as being beyond expression." Attaining this understanding, the bodhisattva is able to abide without fear amid the "unarisen" phenomenal world. This is one of the loftiest states of spiritual attainment in Buddhism.[48] There is a specific incantation associated with this practice, which the *Bodhisattvabhūmi* calls, in the Chinese translation, the "spell to attain the patient acceptance of a bodhisattva" (*de pusa ren zhoushu*).[49] The spell goes: *iṭi miṭi kiṭi bhi kṣānti svāhā.*

It is, in miniature, a typical early dhāraṇī incantation, in that it is partly made up of syllables that would have made sense to Buddhists of the period, at least in terms of their practical and doctrinal associations (*kṣānti*, which we have already seen as "patient acceptance," and *svāhā*, a term that, though it lacks clear discursive meaning, was a classical ending of spells and would have been "understood" in terms of its function), and partly of those that wouldn't (*iṭi miṭi kiṭi*). But here the latter group's lack of discursive sense has utility: it offers a clarifying synecdoche of the rest of phenomenal reality. The practitioner, contemplating its lack of sense is awakened to the fact that this brief string of syllables is not unique in its "meaninglessness," for indeed this is the nature of all things. The spell is thus said to be "excellent at liberating" (*shanjie*). Contemplating it, one "realizes that the meaning of all words and speech, as well as the inherent nature of all dharmas, is unattainable" (*bukede*).[50] There is a fascinating paradox here: a proper grasp (*chi*) of reality shows it to be ungraspable. This is surely part of the point of the progression of dhāraṇī implied in this scheme, and it is one familiar to readers of Buddhist texts. The true grasp is of that which cannot be grasped; the true meaning is that there is no meaning. The Dunhuang commentary cited above confirms

that this understanding was indeed current in medieval Chinese scholastic circles. In its comment on this passage, the text explains that one

> first contemplates the spell and then understands it to be like all dharmas. The Thus-Come One's discourse upon the "spell for attaining patient acceptance" is a succinct explanation of the cultivation of patient acceptance. The syllables of spells spoken by the Thus-Come One all reveal the principle [of emptiness]. When the bodhisattva investigates them he completely awakens to the real nature of things—thus [the spell] is named "patient acceptance."[51]

The text then summarizes the fruits of this contemplation: "Because one understands [the nature of] the spell one is perfectly aware of the emptiness of all dharmas without exception."[52]

Syllable contemplation practices that were in key ways similar to that of the *Bodhisattvabhūmi* were also featured in sūtra texts and seem to have been in fairly wide circulation by the time the *Bodhisattvabhūmi's* account was composed. Zhi Qian's (fl. 223–253) early third-century translation of the *Anantamukha-dhāraṇī-sūtra*, the *Scripture of the Sublime Grasp of the Immeasurable Portal (Foshuo wuliangmen weimichi jing)*, contains the earliest surviving version of this practice—one whose textual traces predate Dharmakṣema's translation of the *Bodhisattvabhūmi* by nearly two centuries. In this text, dhāraṇīs are enacted through a meditative and ethical practice centering on the contemplation of the *meanings* of dhāraṇī syllables (not their meaninglessness), to be performed in secluded locales such as mountains and marshlands. The eight syllables of the dhāraṇī are to be activated, among other ways, through chanting them—the standard method to enact dhāraṇīs in later Buddhist practice. Interestingly, however, this is not the first method described. The principal way to practice the syllables is to write them out and contemplate (*guan*) them, and thereby "enter" their meanings. The text states, "There are four methods by which one may quickly achieve this dhāraṇī, [*chi*, again, clearly conceived in the text as a spiritual attainment parallel with samādhi]. What are the four? The first is to enter the meanings of the eight syllables (*ru bazi yi*). The meanings of the eight syllables are: 'trace' (*ji*), 'intelligence' (*min*), 'reflection' (*wei*), 'relinquishment' (*qi*), 'compassion' (*bei*), 'harmony' (*tiao*), 'extinction' (*mie*), and 'patient acceptance' (*ren*). Constant writing of this dhāraṇī [is the means]."[53] The first thing we can notice here—and it is one of the things for which the text is most famous—is the fact that Zhi Qian has translated the dhāraṇī. It is one of the very few scriptures to do this. The reason he did so is

not difficult to determine: one can hardly "enter the meaning" of the syllables, which here seems to denote "come to a profound understanding of their full discursive and spiritual import," without knowing what that import is. The meanings of these syllables are crucial to the practice that features them, just as the meaninglessness of the syllables that compose the "dhāraṇī in which one attains the patient acceptance of the bodhisattva" is indispensable to the logic of its attendant practices.

Issues of the meaninglessness, or hyper-meaningfulness, of dhāraṇīs would come to loom large in the traditions of Buddhist incantation practice, in part as a result of the mystic potency said in later practices to inhere within the syllables.[54] Though in the early period, as we have seen—in texts such as the *Bodhisattvabhūmi* and Zhi Qian's *Anantamukha*—the virtue was clearly said to reside in the *practices of contemplation* brought to bear on the syllables, rather than in the texts contemplated; in later centuries this potency had shifted to the syllables themselves. The identity of dhāraṇī syllables with reality in its truest form, furthermore, had by the late medieval period in China come to be understood as the nature of *all* textual dhāraṇīs, regardless of form or context—though by the late centuries of the first millennium, in China at least, there was mainly only one form of textual dhāraṇī, the incantation.

We see this fundamental identity clearly in the following representative and concise statement of the late tenth- and early eleventh-century monk Zhiyuan (976–1022), in his comment on an incantation associated with the Bodhisattva Guanyin: "The Great Text [*dapin*; that is, the long version of the *Mahā-Prajñāpāramitā-sūtra*] states, 'the unarisen nature of dharmas is itself the Buddha.' The meaning of the dhāraṇī is the same as this."[55] A note written on the back of a Dunhuang manuscript containing (on its front) a range of dhāraṇīs and ritual texts makes a related claim about the connection between dhāraṇīs and reality itself. It reads, "Dhāraṇīs (*tuoluoni*) are in the language of the Western nations. Here we translate them as 'complete grasp.' Because they express the attribute of reality, they are called the 'great eloquence of the complete grasp'" (*da shixiang gu yanwei zongchi dabian*).[56] The identity of incantations with the true nature reality—as in fact its verbal expression (echoing, in part, ancient pre-Buddhist Indic ideas)—became especially prominent in commentaries from the Esoteric tradition. The most famous such assertion, at least in China, is surely Yixing's (likely at least in part a report of his teacher Śubhakarasiṃha's lectures) that mantras were "the speech of reality, the speech of suchness" (*zhenyu ruyu*), a construal of the incantations featured in their most common Chinese translation, "real words."[57] Paradoxically, perhaps, on these readings it would be hard to imagine a *more* meaningful

Buddhist text than a dhāraṇī or mantra: their syllables express the very nature of buddhas, and, it follows, are only understandable by them. This last feature of the mystery of dhāraṇī incantations had been central to their explication in Chinese Buddhism since at least the sixth century, when we find it in Narendrayaśas's (Nalientiyeshe; 517–582) translation of the *Sūryagarbha-vaipulya-sūtra*, where it is asserted that the incantations are so profound that only a buddha can understand them. "As for the meaning of dhāraṇīs, no gods or men are able to understand them, even bodhisattvas of the tenth stage are not able to understand them; only buddhas [are able to understand them]."[58]

Returning to the early texts, it is clear that *dhāraṇī*, particularly translated as *chi*, "grasp/hold," and *zongchi*, "encompassing grasp/hold," refers in these texts both to a quality or capacity of the Buddhist practitioner and to the particular kinds of texts employed in the attainment of that capacity: in other words, to the capacity itself, to the employment of that capacity, and to the texts used in its attainment or enactment. Before I turn to canonical discussions that focus on the nature of the spiritual capacity, however, let me make one last exploration of the tools prescribed to attain it, a set of passages that will also allow us another opportunity to reconsider the association of dhāraṇī with memory.

Dharmakṣa's (Zhu Fahu d. 316) late third-century translation of the *Bhadrakalpikasūtra*, the *Scripture of the Excellent Eon* (*Xianjie jing*) contains a section on dhāraṇī practice that is closely in line with the *Bodhisattvabhūmi* and the *Anantamukha*. Here, again, the distinction—but close relation—between dhāraṇī as a quality of the practitioner (the bodhisattva) and as a name for a particular genre of text is crucial. The *Scripture of the Excellent Eon* features a practice similar to that of the *Scripture of the Sublime Grasp of the Immeasurable Portal*, but with interesting variations. The practice is presented, in a way that should now be familiar, as leading to the practitioner's awakening to the fact that "all the dharmas of this age"—that is, all the phenomena of the "Excellent Eon" in which we live—are "utterly without anything to attach to." This understanding, the text relates, saves and nourishes sentient beings "like sweet dew." The text then claims that by "entering the dhāraṇī (*zongchi*) portal of the sixteen syllables" one can attain this understanding, which it names, reflecting the *Anantamukha*, the "immeasurable dhāraṇī portal" (*wuliang zongchi men*). Displaying a close affiliation with the *Anantamukha*'s emphasis on the "meanings" of the syllables, the *Excellent Eon* clarifies that it is the "teachings" (*jiao*) of the sixteen syllables—which include cryptic glosses such as "without/non" (*wu*), "cross/measure" (*du*), "grasp/hold" (*chi*), among others—that is their operative essence.[59]

This emphasis on the meanings of the syllables in the *Anantamukha* and *Bhadrakalpika*, including the deeper understanding of the nature of reality their

contemplations are said to unlock, helps clarify what is at issue when scholars claim that early dhāraṇīs were mnemonic aids or "codes."[60] In these passages, the syllables do initially appear to function as aids to remembering specific concepts, whether as mnemonic triggers or as codes. Taken as parts of the contemplative programs in which they are presented, however, it is clear that the code-like character of the syllables is only their first layer. Taken as wholes, the reflective practices described in these texts present the syllables as objects that enable understanding in subtler—or at least less straightforward—ways. A famous sequence of dhāraṇī syllables given and described in the *Great Perfection of Wisdom Scripture* and its Chinese explication in the *Treatise on the Great Perfection of Wisdom*[61] present not simply a code but a self-contained contemplative program. Each syllable is first tied to a doctrinal concept according to a code-like "a is for apple" mnemonic logic. As the *Treatise* explains it: "a" stands for "*anutpāda (anoubotuo)*, which in Chinese is 'unborn' [or, more technically in Buddhist thought, 'unarisen']." In a similar vein, the text continues, "if one hears the syllable *luo* [usually transliterating the Sanskrit *ra* or *rā*], then based on its meaning one understands that all dharmas are apart from defilements. *Luoshe* (*rāga*, 'craving') is in Chinese 'defilement' (*gou*)."[62] And so on. If the canonical accounts ended here then it would make sense to understand dhāraṇī (*tuoluoni*) in this passage as simply referring to mnemonics aids: "a" is for unarisen, "ra" is for defilement," etc. But this identification is foreclosed by the *Treatise's* comment on the *Scripture's* assertion that the syllables that make up the "dhāraṇī portal" are characterized by "syllable equivalence" and "word equivalence" (*zideng yudeng*).[63] The *Treatise* makes clear that this refers to the undifferentiation (*pingdeng*), or emptiness, of all syllables and words, the lack of any basis in them for "attraction or revulsion" (*aizeng*). The text then claims that the cognitive discrimination that characterizes our usual approach to words—and by extension to all phenomena—is the result of the fact that we "abide in notions of me and mine" and in our usual "scattered and chaotic" (*sanluan*) forms of mental functioning, which prevent us from seeing things as they really are (*bu jian shishi*). Using an image common in Buddhist philosophy, the text then likens this predicament to "water disturbed by wind such that nothing [within it] can be seen." The "equivalence" to be contemplated in the syllables of the dhāraṇī gate, the passage continues, is the "same as ultimate emptiness and nirvana. By means of this dhāraṇī the bodhisattva understands that all dharmas are unobstructed [that is, interdependent and in themselves empty]: this is what is called 'the equivalence within syllables and words'."[64] The *Perfection of Wisdom* passage comes to a conclusion here, with the Buddha

saying, "This, Subhūti, is what is named the 'dhārani portal': the syllable 'a' that has been explained. If the bodhisattva-mahāsattva can hear, receive, chant, recite, and grasp this seal of the gate of syllables, this seal of the syllable 'a,' if he can discourse on it for others and in this way understand it, he will then attain the twenty meritorious virtues." These virtues include a steadfast mind, wisdom, lack of doubt and regret, among other qualities.[65] Though memorization and something analogous to the unlocking of codes is clearly an element of this practice, they are not its full extent—profounder contemplations and attainments beyond memorization and intellectual unraveling are closer to its essence.

Returning to the fourfold definition of dhāraṇīs with which I began this discussion, it is clear that we cannot simply take the four "kinds" of dhāraṇīs listed in the Bodhisattvabhūmi as being universally applicable or valid—as being definitions of "what dhāraṇīs are," simpliciter. As a set they have very specific referents that were limited to particular contexts. This is especially true of the last member of the set, "kṣānti-dhāraṇī"—once the early syllable contemplation practices to which it referred fell out of favor in Chinese dhāraṇī practice (as they seem to have early in the first millennium of the Common Era), it is unclear what utility the rubric had for later practitioners. We can see that the semantic range of dhāraṇī as "grasp" or "hold" is more complex than it is usually understood to be: referring variously to learning, absorbing, contemplating, and using.

"DHĀRAṆĪ" IN THE TREATISE ON THE GREAT PERFECTION OF WISDOM

In keeping with the main theme of the treatments found in the Bodhisattvabhūmi, I will now explore the nature of dhāraṇī as the name for a kind of spiritual capacity and its close connections with samādhi and kṣānti. In order to do so—and to root this discussion more securely within the medieval Chinese exegetical sphere—I turn now in a more focused way to the Treatise on the Great Perfection of Wisdom, the Dazhidu lun, translated, or compiled, or perhaps composed, by the great Kuchean translator and exegete Kumarajiva in the early years of the fifth century.[66]

The prominence of the Treatise (and the Bodhisattvabhūmi) in modern understandings of dhāraṇīs and the term dhāraṇī is in large part due to the work of the Belgian scholar Etienne Lamotte. His translation of the Treatise—Le traité de la grande vertu de sagesse—and accompanying discussion of the nature of dhāraṇī, the first part of which was published in 1946, has

become perhaps the most often-cited work in discussions of the term.[67] But, once again, we must be careful to keep in mind the context of Lamotte's original discussion and not overgeneralize from his account. Like the various citations of the *Bodhisattvabhūmi*'s discussion, Lamotte's characterization of dhāraṇī (which is, for the most part, that of Kumarajiva's *Traité*) has often been taken to be universally normative for the term and allowed to float free of its conditioning context, rather than being seen as inextricably tied to specific lines of the *Scripture of the Great Perfection of Wisdom*. These scriptural lines shaped Kumarajiva's explication of them—his statements about the nature of dhāraṇī took the form they did because of the assertions they were comments on. It is crucial to keep this fact in mind. Neither these assertions nor their later explications were meant as portable or universally applicable definitions of every form of dhāraṇī. Instead, each account was specific to the case at hand, a fact made more clear when we note that elsewhere in the text (as we have already seen) very different descriptions of dhāraṇīs are given.

The first treatment of the term deals explicitly with dhāraṇī as a spiritual attainment, or faculty, of the kind discussed previously. The scriptural line on which the *Treatise* comments here states that "[bodhisattvas] attain dhāraṇī, as well as all the samādhis; moving in emptiness, formless and unconditioned, they achieve patient acceptance."[68] The commentary, as so often in the *Treatise*, is in the form of a dialogue. A question is posed: "How is it that these three things, in this order, are used to praise the bodhisattva-mahāsattva?" The inquiry is concerned primarily with the nature of the bodhisattva-mahāsattva, not with the individual natures of his qualities of dhāraṇī, samādhi, and kṣānti as such. In fact, as will become clear below, dhāraṇī here (like the other two qualities) characterizes the wisdom and power of the bodhisattva of a certain level of attainment, not something detachable from him. Thus, it seems incorrect to speak of dhāraṇī here as referring to "things" at all. They are primarily qualities of the bodhisattva rather than independent entities like mnemonics or spells.

The commentator replies: "Because [the Buddha] wants to put forth the real merits of the bodhisattvas, he must praise what must be praised [so that] others will trust in what must be trusted. Since beings cannot [on their own] trust in the exceedingly profound and pure Dharma, [the Buddha] praises bodhisattvas. Furthermore, although he has spoken the names of the bodhisattva-mahāsattvas, he has not yet spoken of that by means of which they are bodhisattva-mahāsattvas. It is because of their attainment of

the merits of dhāraṇī, samādhi, and patient acceptance that they are named bodhisattva-mahāsattvas."

The question then turns to the nature of each of these three attainments, starting with dhāraṇī, a capacity of the person that includes memory, but is clearly not limited to it. The commentator continues:

> Dhāraṇī, in the language of the Qin [that is, the version of Chinese used by the court of the Latter Qin Dynasty], is "able to grasp" (nengchi), or alternatively, "able to block" (nengzhe). As for being able to grasp, once one has collected all manner of good dharmas, one is able to keep hold of them so that they do not scatter or become lost. One is like an intact vessel, which, when it is filled with water, does not allow water to leak out and disperse. As for being able to block, the evil roots that [are wont to be] born in the mind are blocked and not born. If there is the desire to commit evil deeds, one will take hold and not allow oneself to commit them. This is called "dhāraṇī." Dhāraṇī either corresponds to the mind or does not correspond to the mind (huo xin xiangying huo xin buxiangying); is either defiled or undefiled (huo youlou huo wulou). It is formless, invisible, and unhindered; it is contained within one element, within one sense field, within one aggregate[69] This is the meaning of dhāraṇī. Moreover, one who becomes a dhāraṇī bodhisattva, due to the power of his memory, is able to keep [in mind] every teaching he hears. What's more, like a chronic fever, this dhāraṇī-dharma will ever accompany the bodhisattva; like a ghost that haunts him, this dhāraṇī-dharma will never part from the bodhisattva; like good and bad habits, this dhāraṇī-dharma will ever follow the bodhisattva. In addition, this dhāraṇī will keep hold of the bodhisattva and not allow him to fall into the two earth pits. This is like the benevolent father who loved his son—when his son was about to fall into a pit he grabbed him and kept him from falling in. Furthermore, when the bodhisattva attains dhāraṇī power, the demon king, his demon horde, and other demons will not be able to move him, harm him, or overcome him. In this way he is like Mount Sumeru, which is not moved when an ordinary worldling blows on it.[70]

The interlocutor then inquires into how many kinds of dhāraṇī there are. "Many," replies the commentator, who goes on to elucidate three of them. All three are basically different forms of "grasp/hold," whether of what one has heard, or of the nature of phenomena, or of one's composure

and understanding amid the essenceless flux of phenomenal reality. The text states:

One kind is called the dhāraṇī of retaining what is heard. When one attains this dhāraṇī, all speech and every teaching that the ears hear will not be forgotten.

This is called the dhāraṇī of retaining what is heard.[71] Next there is the dhāraṇī of discriminating awareness.

He who attains this dhāraṇī is able to distinguish the largeness or smallness, the beauty or ugliness, of all beings and all dharmas.

It is as the verse has it:

Elephants, horses, and metals;
Wood, stone, and clothing;
Men, women, and water—
All are different.
All things [of a kind] bear one name
[Although] some are noble and some base.
Attaining this encompassing grasp (zongchi),
He can make distinctions.

There is also the dhāraṇī of entering sounds. The bodhisattva who attains this dhāraṇī will feel neither joy nor antipathy upon hearing the sounds of speech. Even if all beings were to speak foully and curse them for kalpas numerous as the sands of the Ganges, their hearts would not be angered.

"But bodhisattvas are not yet wholly free of the defilements," the interlocutor objects. "How is it that they can forebear through such abuse for kalpas as numerous as the sands of the Ganges?" The commentator responds:

As was said earlier, it is only because they have attained this dhāraṇī strength (li) that they are able to do so.[72] Yet, although the bodhisattvas have not yet exhausted the defilements, they have great wisdom, sharp faculties, and can think. They rid themselves of angry thoughts by

thinking this thought: "If my ears had not encountered it, to whom would this foul sound attach?"[73] In addition, once the insults are heard, they go away immediately. Without distinctions, who would be angry? The minds of ordinary worldlings attach to "me" and "mine"; they distinguish between "right" and "wrong", which then gives rise to hostility and anger. If one can understand that speech arises and disappears of itself and that in it before and after are not connected, then one can be without hostility or anger, and understand as well that dharmas have no inner master. Who insults? Who is hostile?

The discussion of the "dhāraṇī of entering sounds" is quite extensive—it dwarfs those of the previous two kinds of dhāraṇī. The author describes the dhāraṇī in terms of a dispassionate abiding in the awareness of no-self and the clear understanding of the ceaseless arising and passing away of the world of contingent, essenceless phenomena—in short, it is dhāraṇī as forbearance and patient acceptance (kṣānti) in which we see once again the close connection between these two ideas in the early dhāraṇī literature. In this the dhāraṇī is simply the attainment of a higher level of the practical wisdom, or spiritual maturity, common to a great range of Buddhist teachings, not something at all unique to dhāraṇīs per se. For the bodhisattva who has attained this dhāraṇī—and here the meaning of the term, clearly, is "this full grasp of the nature of things"—just as there is no reason for rancor over being verbally abused, there is no cause for pleasure at being praised. As the text states,

Moreover, the bodhisattva has insight into the fact that all dharmas are like dreams or echoes. Who praises? Who is happy? I who have not yet attained liberation from the three worlds, who have not yet extinguished the defilements, who have not yet attained the Buddha Way—tell me, how could I then be joyful at the praise I am given? . . . These marks characterize what is named the "Dhāraṇī of Entering Sounds." Additionally, there are those named "Dhāraṇī of Extinction,"[74] "Dhāraṇī of Limitless Revolutions,"[75] "Dhāraṇī of Contemplation According to Stages," "Dhāraṇī of Mighty Virtue-Power," "Dhāraṇī of the Flower Garland," "Dhāraṇī of Sound and Silence," "Dhāraṇī of the Empty Storehouse," "Dhāraṇī of the Oceanic Storehouse," "Dhāraṇī of Distinguishing all Dharma Stages," "Dhāraṇī of Understanding the Meaning of All Teachings." This is but a sampling of the five-hundred dhāraṇī gates; were one to discourse on them extensively there would be no end to it. It is on this basis that we say "the bodhisattvas all attain dhāraṇī."[76]

The next line of text that the *Treatise* comments on also deals with dhāraṇī, this time with what is named "Unimpeded Dhāraṇī" (*wu'ai tuoluoni*), which the bodhisattva is said to achieve. Here the voice of the interlocutor is given a mildly exasperated tone. "It was said before that the bodhisattva achieves dhāraṇī— how is it that the text now emphasizes that he achieves *Unimpeded Dhāraṇī?*" "Because Unimpeded Dhāraṇī is the greatest," comes the reply. The commentator stresses at this point that not all dhāraṇīs are equal, that there are lesser and greater varieties, and that there is a king among them, Unimpeded Dhāraṇī. "Moreover, though I said before that all bodhisattvas attain dhāraṇī, we do not know which grade of dhāraṇī [they achieve]. There are the petty dhāraṇīs attained by wheel-turning kings, sage kings, and transcendents,[77] such as the "Dhāraṇī of Hearing," the "Dhāraṇī of Distinguishing Among Sentient Beings" (*fenbie zhongsheng tuoluoni*), and the "Dhāraṇī of Saving, Protecting, and Not Renouncing Those Who Have Taken Refuge (*guiming jiuhu bushe tuoluoni*)." These sorts of petty dhāraṇīs are attainable by normal humans, as the author states.

> Those of the outer paths, the original disciples, pratyeka-buddhas, or those newly embarked on the bodhisattva path, however, can never attain Unimpeded Dhāraṇī. Only bodhisattvas of unlimited merit, wisdom, and strength can attain this dhāraṇī. It is for this reason that it is given special mention. Moreover, this kind of bodhisattva, whose self-benefit is complete, seeks only to aid others by preaching the dharma and converting them unceasingly. They take Unimpeded Dhāraṇī as their root. Because of this, these bodhisattvas constantly practice Unimpeded Dhāraṇī.[78]

These examples from the major classical sources on the nature of our subject demonstrate the basic contours of doctrinal discussions of dhāraṇī as a capacity, or at times an activity, of the bodhisattva. As should be clear now, this material does not support the idea that the term refers primarily to "memory" or to mnemonic aids. Memory is but one part of the semantic range of the term *dhāraṇī* and should not be privileged in our understanding of its use in Buddhist writings.

"Dhāraṇī" as a Concept in Later Chinese Works

"Grasping," "keeping," and "holding" (Ch. *chi*) are crucial ideas in Buddhist practice and thought—not here in the negative sense of "attachment" or "clinging" (usually denoted in Chinese by words such as *zhi*, *zhao*, and *ai*) but in the sense of the possession, memorization, recitation, or wielding of

texts, whether they be incantations or scriptures.[79] The Chinese translation of dhāraṇī as "encompassing grasp" (zongchi) marks it as part of this larger family of usages. The ideas and practices indicated by these technical uses of the component term chi are present at many conceptual depths in the tradition. They are perhaps most commonly found, in Chinese Buddhism, in those behaviors indicated by the notoriously slippery word shouchi. As one scholar has pointed out, this word's range of meanings includes: to receive and keep a text in one's possession, to receive and memorize a text or teaching, and/or to devote oneself to a text or teaching.[80] This semantic range is partly coextensive with that of dhāraṇī—not surprisingly, as I say, given that dhāraṇī was translated as zongchi, "encompassing grasp." Chi does much the same conceptual work in both words; its presence connects them in a family of notions, a fact that should help us to get a firmer grasp (as it were) of what medieval usages of the term shouchi really indicate. Future studies of that term might explore the extent to which the "receiving and keeping" or "upholding" (two of its common translations) of a text implies something more like its absorption within the person of the Buddhist in a way that echoes the "grasp" of spiritual ideals and of the nature of reality itself displayed in the dhāraṇī of the bodhisattva described in early Mahāyāna texts. As I showed before, the deeper ranges covered by this set of concepts are typically the province of dhāraṇī, or zongchi, which is after all the "encompassing grasp." At this level of usage (again, taking chi in both cases to be fundamentally the same concept) one holds things in mind, or as part of oneself—whether texts, concepts, or the knack for spells—and one keeps hold of oneself (however paradoxical this turns out to be on the philosophical and experiential levels), steadily, both in the face of temptation and within the empty non-arising of phenomena, which, as well, one may be said to grasp. One can also take full hold of harmful karmic or psychological attributes in order to remove them. A tenth-century ritual manuscript found at Dunhuang offers yet another evocation of this holding, asserting that one should take an "encompassing hold (zongchi) of polluted blockages and get rid of them. [Thus] will one's merit be perfected and completed" (zongchi gouzhang xiaochu, gongde manyuan)."[81] Connections such as the close relationship between zongchi and shouchi are not simply incidental, they are suggestive of deep metaphorical continuities in the Chinese Buddhist practical imagination.

 There is one final set of permutations in this complex of concepts (and here the doctrinal sense of the term starts to blend with that of "spell," and this introduction turns once again toward the narrower subject of the rest of

this book). Dhāraṇīs also held things within them, just as in English a "hold" is also a thing that holds. This understanding of the term became more prominent in the later centuries that are the focus of this book. The biography of Śubhakarasiṃha in the *Song Biographies of Eminent Monks* gives a good example of the ways that dhāraṇīs were seen in certain Tang traditions (or Tang permutations of contemporary Indic traditions) to encompass all Buddhist teachings and practices within them.

> As for the meaning of the "Three Baskets" (*sanzang*) [a term indicating both the full range of the written tradition and the monk who has mastered it]: within, they are the precepts (*jie*), concentration (*ding*), and wisdom (*hui*) [that is, the 'Three Trainings,' a metonym for all Buddhist practices and for the structure of the Buddhist path itself]; without, they are scriptures (*jing*), monastic codes (*lü*), and treatises (*lun*) [that is, all Buddhist teachings]—dhāraṇīs utterly encompass them all. Dhāraṇīs are the quick vehicle to *bodhi* (*puti suji zhi lun*), the auspicious sea of liberation. All buddhas of the three times are born within them (*shengyu ci men*).[82]

This seemingly infinite capacity of textual dhāraṇīs—like that of the bodhisattva indicated by earlier uses of the term—was in fact one of their central features in Buddhist ritual and doctrinal writings, most strikingly expressed in claims that chanting one dhāraṇī (or mantra) but once is equivalent to chanting the entire Buddhist canon.[83]

One final example of the term in a brief text of Tang vintage will help to further clarify these matters, at least as they were understood in certain circles (we should be wary of taking any idea or usage to have been doctrinally normative beyond the scope of its original scholastic context): Huizhong's preface to Xuanzang's *Heart Sūtra*.[84] Introducing the text, Huizhong says that "this scripture is like the great earth—is there a creature not born from the earth? All buddhas simply point to the one mind—is there a dharma whose existence is not due to the mind? (*buyin xin zhisuo li*) Indeed, understanding the mind-ground[85] (*liao xindi*) is called 'wholly grasping' (*zongchi*). Realizing that dharmas are unarisen is named 'wondrous awakening'."[86] These statements accord well with certain of the positions expressed in the *Bodhisattvabhūmi*, the *Treatise on the Great Perfection of Wisdom*, the biography of Shanwuwei, as well as in the philosophical discussions of the nature of dhāraṇīs that we will return to in chapter 4. We can note, in addition, the way that the *Heart Sūtra*, a brief

text of only 313 characters, is said to be like the "the great earth," which gives rise to all creatures, a simile that brings out the densely synecdochic character of dhāraṇīs.[87]

Equipped with these understandings of the nature of the term *dhāraṇī* and of Buddhist incantations more generally, we can now narrow our focus to the nature of written spells and their histories in medieval China.

1. SCRIPTURE, RELIC, TALISMAN, SPELL: MATERIAL INCANTATIONS AND THEIR SOURCES

"WRITE THIS DHĀRAṆĪ DOWN"

For the reader of the literature on Buddhist spells—both traditional and modern—what is most arresting about written spells is not the natures or workings of the potencies attributed to them or their sometimes intricate and beautiful forms. It is the simple fact that they were to be written down at all. Buddhist spells, as one scholar has quipped, "unlike children, were to be heard but not seen; that is, they were to be spoken but not read."[1] The writing of incantations, however, despite oft-repeated claims for the essential orality of these "utterances," turns out to have constituted an important and complex part of medieval Buddhism. An examination of spell writing practices evidenced both in dhāraṇī-sūtras rendered into Chinese from the fifth through the eighth century and in the later material record reveals a set of profoundly rich traditions rooted in both Indian Buddhist and traditional Chinese cultural ground. The continuity of these practical traditions, including their discursive practices, within (at least) the area ranging from the Indian subcontinent in the West to the Japanese archipelago in the East will become clear, beginning in this chapter and then more fully in the next two. Part of this continuity was due simply to the spread of Buddhism, the fact that Asians of this period took up its practices and interpretive styles throughout a far-flung region. But that spread was not the only important vector in the growth of East Asian Buddhist traditions of material incantation. Another was constituted by the spread and elaboration—according to logics at times quite different from those of Buddhism—of native Chinese incantation and amulet techniques.[2] The extensive Chinese cultural resonances of, and perhaps in some cases sources of, certain of these techniques become clear when we examine them alongside closely related native talismanic and medical arts involving charms,

seals, medicines, and elixirs. Simply looking to Buddhism's spread, and to the accounts in its scriptures, is not enough to grasp the complexities of this strand of medieval Chinese religious life.

But, beginning with those scriptural accounts, what becomes clear after even a brief survey is that the functions and roles of written spells, not surprisingly, changed over time. Chinese translations dating from the seventh century,[3] contemporary with or slightly earlier than the Indic scriptures of the incantations of *Wish Fulfillment* and *Glory*, the two incantations that are the main exemplars in this study, reflect pictures of dhāraṇīs consonant with those of these two spells. That is, like talismans or medicines, written dhāraṇīs were powerful in their own right and in their own ways, quite apart from any oral performance, or, in the case of native Chinese talismans and seals, the spells that would often accompany them. If we can take the texts preserved in the Chinese Buddhist canon to have been typical of their respective ages (an assumption that should not go unquestioned),[4] this seems to have been a new development. I have not found many prescriptions for spell writing in either Chinese versions of Indic sūtras or in native Chinese Buddhist sūtras dating from before the seventh century that take the inscription to be potent in this way. In earlier texts, dhāraṇīs were to be written down as part of the kinds of contemplative practices discussed in the introduction, or because they were included in scriptures to be copied according to the logics of the "cult of the book" in Mahāyāna Buddhism. No special potency is attributed to the act of writing or to the particular natures of objects inscribed with spells; writing is for the most part either taken for granted or put in a position secondary to vocal enactment and auditory reception. Yet by the seventh century things had changed dramatically. Spell writing changed from an incidental practice to a central one, and descriptions of dhāraṇīs transformed correspondingly. Over its history in the medieval period, conceptions of and bodily engagements with written dhāraṇīs (what in this book I will often simply call their "imagination") follow three models: written dhāraṇīs as simply the recorded speech of the Buddha, as textual relics of the Buddha, and finally, imagined in line with their spoken counterparts, as inscribed charms.[5]

These changes can be mapped according to two distinct historical trajectories. The first includes the earlier two categories of spell writing just mentioned: written spells as simply parts of Buddhist scriptures and as relics. The close relationship between these two forms is quite well known. The second basic trajectory resulted in the third set of practices: those that treat written spells as potent in ways that resemble their spoken counterparts. In terms

of its appearance in Chinese versions of Buddhist scriptures, this model of written spells seems to have been a product of two parallel trends in Buddhist ritual practice. The first includes the practices in which inscribed dhāraṇīs were employed in ways that echo ancient Indic uses of spoken incantations to enchant bodies for healing or protection: spells were applied to the body directly or through media such as ash, oil, or dirt; or, alternatively, objects that had been enchanted were worn on the body as amulets. Beginning in Chinese translations of the late seventh century, we find the same prescriptions for the use of written spells. Though in these sources I have found no instances of inscribing spells directly onto the body, in the case of the *Incantation of Glory* and others of its kind, objects that had been inscribed with the dhāraṇī were said to be able to impart their efficacies physically, whether directly or via media such as dust, shadow, or wind. Likewise, objects inscribed with other dhāraṇīs, most notably for my purposes the *Incantation of Wish Fulfillment*, were worn as amulets in forms directly traceable to earlier practices centering on spoken incantations. The second trend that shaped the imagination of inscribed incantations was the assimilation of spell writing practices to those involving amulets, medicines, and seals—practices that, by the seventh century, when talismanic spell writing seems to have appeared, had already had long and prominent histories in India, Central Asia, and China.

This chapter offers an overview of these three modes of Buddhist spell writing, moving quickly through the first two, which are both better covered in previous (and current) scholarship and of less importance to my project in this book. I explore the practical and metaphorical background for the third form of spell writing in more detail here to set the scene for the two chapters on individual traditions of dhāraṇī practice that follow.

COPYING SŪTRAS AND THEIR DHĀRAṆĪS

The earliest clear scriptural statement about the writing of dhāraṇī incantations[6] that I have found is in the *Qifo bapusa suoshuo da tuoluoni shenzhou jing*, the *Great Dhāraṇī Spirit-Spell Scripture Spoken by the Seven Buddhas and Eight Bodhisattvas*, a large compendium of spell rites that dates from sometime between 317 and 420.[7] The text does not draw special attention to the inclusion of writing as a proper form of dhāraṇī reception;[8] it treats its spells simply as normal examples of Mahāyāna scripture, which are to be reproduced as often and in as many forms as possible, in order both to spread the doctrines they contain and to instantiate the great spiritual power, or "merit," they embody. From

their earliest days, Mahāyāna texts contained passages asserting that their realization in material form as inscriptions produced tremendous spiritual power, phenomena that scholars, following Gregory Schopen, have identified as features of a cult of the book in the tradition.[9] Passages noted by Schopen include one from the Aṣṭasāhasrikā, one of the earliest of all Mahāyāna scriptures, asserting that "where this perfection of wisdom has been written down in a book, and has been put up and worshipped, there men and ghosts can do no harm, except as punishment for past deeds."[10] A sūtra's incantations, in these contexts, appear to have been included simply because they were parts of these scriptures.

A typical example of a passage in the *Scripture of Seven Buddhas and Eight Bodhisattvas* mentioning the writing of spells runs as follows: "If practitioners copy (*shuxie*) or recite (*dusong*) this dhāraṇī they will earn the protection of thousands of buddhas in this very lifetime. Such a person at the end of his life will not fall into any of the evil paths of rebirth but will be reborn into Tuṣita Heaven and see with his own eyes Maitreya."[11] Sometimes the further verb "practice" (*xiuxing*) is added to the set of modes of reproduction listed above.[12] Since these verbs are also commonly used to describe what one should do with sūtras, dhāraṇīs do not seem to be special classes of text or utterance in these passages.

Another early passage that mentions the writing of dhāraṇīs—in a text roughly contemporary to the *Seven Buddhas and Eight Bodhisattvas*—treats the practice in a similar way, including it among a group of other modes of practice but not calling special attention to it. Here, however, writing is set slightly apart: it is not mentioned in the same breath as the others. This gives us a better view of the way the practice is seen in the text. The passage in question, from Dharmakṣema's (Tanwuchen, 385–433) translation of the *Karuṇāpuṇḍarīka-sūtra*, the *Scripture of the Lotus of Compassion* (*Beihua jing*),[13] is part of a discussion of dhāraṇī practices that clearly draws on early understandings of dhāraṇīs as dense, all-encompassing encapsulations of the teachings, and reflects the early associations of dhāraṇī with samādhi that were discussed in the introduction (it may in fact be a key moment in the merging of incantation practices with the earlier philosophical and contemplative practices).

At that time the Buddha spoke to all the bodhisattvas.

"Good sons, if there is a bodhisattva who can cultivate this understanding of all dhāraṇīs, he will immediately attain the eighty-four thousand dhāraṇī gates, the seventy-two thousand samādhi gates, the sixty

thousand dharma gates, and immediately attain merciful and compassionate understanding of the thirty-seven teachings that aid the Way. He will attain the all-knowledge that is without obstruction. This dhāraṇī encompasses all the teachings of the buddhas. All buddhas have understood this dhāraṇī, and have long remained in the world preaching its peerless teaching to all beings. Good sons, what you see now you should understand—you should comprehend the awesome spiritual might of the dhāraṇīs, which causes this great earth to shake with the six kinds of earthquakes, which [shines with] subtle, wondrous, pure radiance, universally illuminating buddha-worlds of the ten directions more numerous than the sands of the eternal river.[14] The light reaches bodhisattvas of numberless worlds, who all [follow it and] come here to this Dharma assembly to receive and understand all dhāraṇīs. It also illuminates numberless heavens of the desire and form realms, which are brought together [by it]. All dragons, yakṣas, asuras, humans and non-humans also come here to listen to and understand all dhāraṇī gates. If a bodhisattva hears and comprehends dhāraṇīs, he will [attain] and never regress from anuttarā-samyak-saṃbodhi.[15] If there is one who writes it down, that person [will attain] unsurpassed nirvāṇa, be eternally present in the Buddha's assembly, seeing the Buddha and hearing the teachings. If one is able to recite it, all evil paths of rebirth will be utterly extinguished forever."

In other words, a dhāraṇī is like the teachings of which it is a perfect capsule. Like a Mahāyāna sūtra (or like the Buddha himself), it emits worlds-illuminating radiance and stimulates the famous "six kinds of earthquakes." It is also to be treated like a sūtra: read, copied, memorized, and chanted. It is in this way that we should understand the role in this passage of writing the spell, and by extension in the earliest category of dhāraṇī incantation writing as a whole—not as the special talismanic, or relic-like, practices of later texts but as a sign that dhāraṇīs were understood to be the same sorts of things for which they were substitutes: the long texts of sūtras.

WRITTEN SPELLS AS RELICS: DHĀRAṆĪS IN STŪPAS

The medieval Buddhist practice of putting spells into small stūpas and treating them as relics of the Awakened One is the best-studied form of dhāraṇī writing, perhaps largely because it so clearly demonstrates the cross-fertilization

of two of the most powerful movements within Mahāyāna Buddhism. As Paul Harrison notes in a study of this phenomenon, "the cult of the relics eventually coalesced with the cult of the book."[16] Practices involving textual relics, including dhāraṇīs, were widespread in the medieval period across Buddhist Asia; the inclusion of spells in these activities constitutes what I refer to in this chapter as the second model of dhāraṇī writing. It was in many ways a direct consequence of the first. Both derive most basically from the identification of spells with sūtras, but here the chain of associations extends to include the identification of the latter with relics of the Buddha.

That Buddhist scriptures were understood and used as relics is well known, and the history of the idea can be very briefly summarized. Relatively early texts, such as the *Samyutta-Nikāya* and the *Majjhima-Nikāya*, equate the teachings of the Buddha with the body of the Buddha, and thus with his relics. Some texts, such as the *Pratyutpanna Sūtra*, extending the logic of this association, advise practitioners to place copied sūtras (or, at least, "what the Buddha taught") physically into stūpas, reliquary structures that serve as architectural markers of the Buddha's body. We see this practice described in a passage in Lokakṣema's third-century Chinese translation of the scripture:

Here, in the present age they receive my teachings;
They will distribute and make offerings to these relics;
Calmly and carefully they will accept and study what
 the Buddha has taught,
They will recite it and have their commission.
They will place it in stūpas and in the mountains.[17]

Perhaps because of the ungainly size of large texts such as the *Pratyutpanna*, however, their use in these practices seems not to have been popular, at least as evidenced by the archeological record.[18] Yet at least by the seventh century, in a period remarkable for transformations in Buddhist material culture, new practices involving much shorter texts are both described in written accounts and encountered in the archeological record. These practices involved the use of inscribed miniature stūpas and stamped clay tablets along with texts still more dense in their epitomizations of the Buddhist teachings. In a well-known passage describing one form of this practice, the great traveler Xuanzang (602–664) reported that on his journey in India he saw people inserting fragments of scriptures—explicitly called "dharma relics"—into small stūpas, which were then gathered together and placed

into larger stūpas. "The Indian method is to fashion small stūpas five or six *cun* tall out of incense, then write out the text of scriptures and place them inside [the stūpas]. They call these 'dharma relics.'[19] Once a number have been collected, a large stūpa is constructed and all [the smaller stūpas] are placed inside."[20] Judging from the archeological record, by far the most commonly used text in these practices, at least at first, was the famous *Pratītyasamutpāda gāthā*, the "Verse on Dependent Origination," or "*ye dharmā*," for short, a text once so ubiquitous in Buddhism that earlier generations of scholars called it "the Buddhist creed." In a strikingly dhāraṇī-like move, the text simply gestures to the fundamental teaching of dependent origination rather than encapsulating it. It reads, "Those dharmas that arise from a cause, the Tathāgata has declared their cause; and that which is the cessation of them, this the great renunciant has taught."[21] This verse, as Daniel Boucher writes, "appears on clay seals and miniature stūpas virtually everywhere in the Indian Buddhist world during the medieval period (ca. 600–1200 CE)."[22] Thanks to the work of Peter Skilling, we can now add "mainland South-East Asia" to this region as well.[23]

I did not employ the phrase "dhāraṇī-like" in the previous paragraph lightly. Not only did the use of dhāraṇīs come to be common in these practices, the "*ye dharmā*" verse was itself called a dhāraṇī in at least one scripture.[24] Given the understandings of dhāraṇīs as encapsulating or indexing larger sections of the Buddhist teachings, this is hardly surprising. The great popularity and relative brevity of dhāraṇīs made them natural additions to text-relic practices. Moreover, a subgenre of dhāraṇī sūtra may have been created at least in part through these practices. As Gregory Schopen points out, the dhāraṇīs chosen were "not at all *ad hoc* compositions but specific dhāraṇīs taken from a specific group of texts. And these texts tell us quite explicitly why these dhāraṇīs were placed in stūpas. . . . [All] of them are preoccupied with the problem of death and with either the procurement of a means to avoid rebirth in hells or other unfortunate destinies, or with the release of those already born there."[25]

Yael Bentor notes that these uses of dhāraṇīs seem to have appeared during the middle centuries of the first millennium, based on the fact that this is when the Buddhist scriptural genre of the dhāraṇī sūtra, which often prescribes this practice, began to appear.[26] This is confirmed, at least for the later reaches of that period, in the transmitted Chinese evidence: only in the seventh century did texts prescribing this specific activity appear, slightly later than the first accounts of its actual practice in India. Early dhāraṇī sūtras, as noted in the first part of this chapter, do not include this practice.[27]

When looking for prescriptions for the use of dhāraṇīs as dharma relics well known in China, we do not have to look far afield. Many dhāraṇī scriptures translated in China around the turn of the eighth century contain instructions to put their dhāraṇīs into stūpas for veneration and for the power generated thereby. In the *Scripture of the Incantation of Glory*, for example, the very passage that tells one to write the spell on a *chuang*, or "banner"—a practice that would become one of the two most famous material incantation practices—also includes instructions to place the written spell into a stūpa.[28] Later in the version of the text attributed to Buddhapālita, the reader (and the audience at a recitation or lecture) is told to "secure the dhāraṇī within a stūpa at a crossroads, put palms together, circumambulate it with veneration, devote yourself to it wholly and worship it." The Buddha then tells the god Śakra that "one who can make offerings in this way is named a *mahāsattva* and is truly a child of the Buddhas, a pillar of the teachings." In one of the most characteristic statements of the mysterious identity of dhāraṇīs and corporeal relics, he adds that such a stūpa is a "stūpa tower of the complete body relic of the Thus-Come One."[29] Images of the devotion growing from this identity were painted on the walls of cave shrines at Dunhuang, as elsewhere, where they served as emblems of dhāraṇī cults and practices. Though I do not emphasize this second form of Buddhist spell writing in this book, its importance, alongside images and practices emblematic of the third form, was widespread in the medieval period. Caves 217 and 33 at Dunhuang, in paintings dating to the middle years of the eighth century that have only recently been identified as depictions of the scriptural narrative of the history of the *Incantation of Glory*, contain images of the second and third modes of enacting written spells side by side: a stupa and a banner topped with a spell.[30]

In closely related practices that also figure spells as relics, dhāraṇīs were to be placed inside *vajras* and images. The *Putichang zhuangyan tuoluoni jing*, the *Scripture of the Dhāraṇī for Ornamenting the Bodhi Site*, the Chinese translation of which was attributed to Amoghavajra, includes the following prescriptive account:

Copy this *Bodhi Site Ornamenting Dhāraṇī* onto birchbark and secure it within vajra clubs (*jin'gang chu*), within [sculpted] images of the Buddha, or atop painted images. Secure it within seal towers and within stūpas.[31] Each instance of installing this dhāraṇī itself creates hundreds and thousands of them. If you secure it within one stūpa, good sons and good daughters, this immediately makes hundreds and thousands

of stūpas. One who does this will reap the good roots planted by the merit of making [so many] stūpas. Vajrapāṇi, were bhikṣus, bhikṣuṇīs, upāsakas, upāsikās, good sons or good daughters, to make a great stūpa at a crossroads, on a high mountain, on a riverbank, at a city gate, or on the king's road, and copy out this dhāraṇī and its sūtra and secure it within the dish [atop the stūpa], then, as I stated in a metaphor earlier, dharma-body *śarīras* [that is, relics], dharma-realm *śarīras*, bone *śarīras*, and flesh *śarīras*, numerous as infinitesimal dust motes, will fill the three thousand worlds.[32]

The infinitely self-duplicative nature of the practice is striking: copying a dhāraṇī once simultaneously creates an unimaginably large number of copies, each the body of the Buddha, spread throughout the multiverse. This passage, translated in the latter half of the eighth century, takes to a cosmic level a practice we know to have been important on a smaller—yet still imperially grand—scale around the turn of that century. Dhāraṇī sūtras prescribing the use of stūpas appear to have been especially widespread in the decades spanning the turn of the eighth century. Many of the canonical texts prescribing them were translated then, and scholars have recently argued convincingly that this sudden interest in the practice was due to several factors involving the Chinese Empress Wu Zetian, including her desire to justify her imperial reign by homologizing it with that of the great Indian emperor Aśoka, and her son's (the emperor Zhongzong) move to honor and pacify her spirit after she died in 705.[33] Timothy Barrett has argued that the latter concern explains the quick spread of the *Wugou jin'guang tuoluoni*, the *Incantation of Stainless Golden Light*, to both Korea and Japan, where the spell (like the *Incantation of Glory*) achieved great popularity.[34] This dhāraṇī, a close relative of the *Incantation of Glory* in terms of its described potencies, has been studied by scholars of both early printing technology and Tang Buddhism; the earliest printed text yet discovered is a copy of the *Wugou jin'guang da tuoluoni jing*, the *Great Dhāraṇī Scripture of Stainless Pure Radiance*, found in a Pulguksa stūpa on the Korean peninsula dated to 751.

The fact that at Pulguksa (and in the scripture of the *Bodhi Site Ornamenting Dhāraṇī* cited previously) the entire dhāraṇī sūtra, and not simply its spell, was placed inside the stūpa further suggests that these practices entailed a different understanding of the nature of inscribed incantations than that featured in the third category of spell writing, where inscribed spells act simply as spells, the model that, as we will see, lay behind early carvings of spells

onto stone "dhāraṇī pillars." Spells in stūpas, like sūtras and like the "Verse on Dependent Origination," were said to act as the body of the Buddha; incantation pillars, on the other hand, followed quite different logics.

It is important, however, to make clear that these differing logics should be taken not as rigidly exclusive categories of thought or material practice but as ideal types, conceptual resources that were interpreted and applied as desired. In the *Wugou jin'guang jing*, the *Scripture of the Incantation of Stainless Pure Light*, for example, we find a blend of the second and third models in accounts of the efficacies of its spell, which, when housed in a stūpa, is described as spreading and infusing in the manner of material incantations (this is, however, as far as I can tell, the only such instance of this particular conceptual "mixture"). Though they worked to shape incantation practice at deep levels—and as I will show, for the most part they exhibited notable differentiation—these twin logics do not seem to have been conscious or explicit categories of practice, still less markers of orthodoxies.

The consonance of accounts and material uses of inscribed incantations with other forms of textual, recitative, or material practice, furthermore, made up a much broader and internally complex field in the medieval Chinese Buddhist practical imagination. Robert Campany, in a now-classic 1991 article, has shown that in China sūtra texts—the physical scrolls and sheets—were treated by characters in religious tales as talismans, as protections against calamity, and as insurers of good fortune.[35] In an example that closely parallels practices involving written spells, Campany describes how a man tied a sūtra to his head to keep him safe as he forded a swiftly flowing river. Campany explains that "the sutra text performs a double religious function: on the one hand it is thought of as a vehicle which can be used to make a bodhisattva or buddha present; on the other hand, more radically, it stands in the place of, and (functionally speaking) is, a bodhisattva or buddha."[36] Campany's account here of this double function vividly illustrates the sūtra-as-deity homology in play in these behaviors. In the context of my own discussion in this book, we can enfold it into a consideration of the more basic *practical* dimension in play in such accounts: the wearing/holding of talismanic texts as a general family of religious behaviors. It is tempting, when reading accounts such as Campany's after having read a large body of incantation sūtras, to take them as figuring a reversal of the direction of influence suggested before. Whereas earlier, spells seem to have been assimilated to sūtra conceptions and practices, here it is possible that sūtras were conceived and used in accordance with ritual actions usually associated with spells and talismanic objects. It is

more likely, however, that these sorts of behaviors were seen as proper for any object taken to be sacred or spiritually potent; only the convenient size and relative accessibility of written spells and talismans (compared to images or relics, for example) make such practices seem tailored to them alone. As I argue at several points in this book, it is the practical frame that was primary; the particular objects employed within those frames were often secondary. The subtle differences in conceptual frames are best kept clear: a spell in the reliquary portion of a stūpa is a relic of the Buddha; a spell in a box tied in one's hair is something else.[37]

THE WRITTEN SPELL AS SPELL

In Chinese translations dating from the mid-seventh century, contemporary with or perhaps slightly later than the appearance of dhāraṇīs as text relics, the picture of Buddhist spells as seen through the practices of writing them underwent further transformations. Though as noted the earlier styles remained as options, in certain newly appearing texts written dhāraṇīs were no longer treated primarily like sūtras, whether as texts to be recited or as objects to be venerated as the body of the Buddha.[38] Instead, new forms of reception and reproduction appeared: incantations in written form were now often said to work as their spoken counterparts long had been. In ritual manuals of earlier centuries, objects such as knotted strings, called "incantation cords" (zhou-suo) were enchanted with dhāraṇīs and other spells and then worn around the neck, arm, or waist. Newly translated manuals said to wear incantations inscribed on paper and silk at the same positions; writing had joined speech as a way to enchant. When the manuals specified how the incantations should be worn, in precise echoes of the older practices they called for the inscribed sheets to be wrapped in the same knotted cords, which now bore incantatory power on the body in this new form. In a parallel shift in ritual imagination, old methods of the direct application of spells to the flesh—through media such as smeared oil or ash or chewed wood—were also adapted in claims about the efficacies of silk- or stone-inscribed charms. As the next two chapters will explore in detail, these two ritual adaptations were at the roots of two of the most popular forms of dhāraṇī practice in late medieval China: amulets bearing the Incantation of Wish-Fulfillment and stones carved with the text and tales of the Incantation of Glory.

It is unlikely that these new ideas about the efficacies of writing sprang fully formed out of nowhere, yet there are few, if any, mentions of dhāraṇī

writing in texts from the previous era that differ from those discussed under the category of the earliest form of spell writing. The new understandings of inscription as a form of enchantment, and of spell-inscribed objects as material incantations, appear to have been drawn from two sources. The first and no doubt most important source consisted of the practices and tropes of practice just noted: styles of vocal enchantment wherein objects or substances were empowered by chanted spells and then either worn on the body (as with the incantation cords) or used to anoint it (as with the enchanted oil)—and, following from these practices, underlying ritual figures of adornment and unction. Indic incantation practices, however, do not provide all the answers, especially when our interest is in understanding the Chinese versions of these practices and the Chinese figurative language in which they were described. Medieval Chinese accounts of written dhāraṇīs (as well as, at times, their actual ritual manipulations) drew also from other, often more local, forms of practice and imagination. The second set of relevant sources thus consisted of Chinese techniques originally external to Buddhist incantation practice, such as those centering on amulets, seals, medicines, and fu-talismans.[39] Many native amuletic styles had been taken into dhāraṇī and other Buddhist practices in China by the fifth century, well before the appearance of the third mode of Buddhist incantation writing, making them clear precursors.

In the next two chapters, in my exploration of the Mahāpratisarā and the Uṣṇīṣavijayā dhāraṇīs in late medieval China, I will trace the ritual genealogies of these incantation traditions among the first set of sources, the absorption of time-honored styles of vocal enchantment (and, indeed, of some Indic amuletic techniques) within the new forms of spell writing. It remains for the rest of this chapter to sketch the place of Chinese amulets and talismans (which were features of nearly all traditions of Chinese religious practice, including Buddhist) within the landscape of techniques and their descriptions in which inscribed dhāraṇīs came to figure prominently. Not only were dhāraṇīs, both in their descriptions and in the forms of their practice in the late medieval period, steeped in the Chinese literary and practical cultures of native amulets and talismans, but the medieval Chinese makers of amulets, seals, and fu-talismans also at times took dhāraṇī practices as models in their developing crafts. Examining this material takes us deep into contexts that scholars such as Christine Mollier have called our attention to, where Buddhists and Daoists, and many others beside, worked "face to face."[40]

An Aside on Spells and the Permeability of Chinese Religious Traditions

It is impossible to make sense of Chinese dhāraṇī practices, of the ways medieval Chinese engaged in them and transformed them, if one assumes that Buddhism in China was impermeable to the influence of the other religious, literary, and philosophical traditions of the culture. Dhāraṇī practices show that medieval Chinese Buddhism was both faithful to the broader trans-Asian Buddhist tradition and deeply woven into native religious cultures. This statement, which may seem self-evident and banal, turns out to be a point of contention among scholars who study the family of practices to which spells belonged. It is necessary, then, to at least briefly contemplate the general picture of the religious life of medieval China, especially the traditions that partly constituted it, that is afforded by the study of Buddhist incantation practice in medieval China.

It seems useful to begin with a clarification of the phrase "the religious life of medieval China" itself, which might imply a too-seamless unity among the many and complexly interrelated (or entirely distinct) traditions and practices of the age. It would be misleading to say that the distinction between Buddhist and Daoist practices (to take only those examples) is merely a cosmetic difference—certainly the histories of these discourses and practical traditions are importantly (and obviously) distinct. But it is just as crucial to take them together, especially when thinking about tropes enacted in practice. Traditions were permeable; images and practices jumped from one to another, partly no doubt in the play of mimetic desire, and took on different discourses as they did so. This circulation of tropes and activities constituted what we might see as an ever-transforming matrix of possibilities in the world of medieval Chinese religion. The protean complexities of these possibilities, naturally, present difficulties for the historian. Faced with what can at times (especially from the perspectives of the academy or the various religious orthodoxies) seem a rather confusing jumble of practices and ideas (like "Buddhists" writing "Daoist" talismans),[41] scholars coin phrases such as "Buddho-Daoism," or "sinification," to make sense of it. Such notions entail a picture of human action as unavoidably hybrid, as composed of two or more essentially discrete parts that remain identifiable, and privileged, even after having been mixed with other such components. To the extent that these constructions offer a framework in which to understand the complexities of human action, they are clearly very helpful in our projects of knowing the

past. But there is a degree to which they do little more than buttress the vantage points of what have sometimes been known as the "great traditions." To that same degree, they may simply get in the way of better pictures of the past than the ones we inherit. "Buddhism" and "Daoism," in the example given, remain the principal agents, not the long dead author of a tale, or improviser of a spell rite, and the myriad contingent conditioning factors of his decisions, only a rather small part of which can meaningfully be subsumed under religious categories. Given that those contingencies are difficult—indeed, too often, impossible—to recover, recourse to descriptions based in what is most readily available to the scholar, the vast corpus of canonical writing, offers an attractive solution. Though the pictures of Tang religious life that emerge from text-centered styles of historical scholarship are often compelling, there are dangers built into them. For my purposes here, chief among these dangers is the tendency to relegate anything that does not fit the established patterns of the "great traditions" to the catchall category of the "popular," a realm too often considered beneath the interest of the serious scholar of Buddhism. This remains true, to a great extent, even decades after Peter Brown's now famous and widely admired argument that two-tiered pictures of religions create more problems than they explain.[42]

In the course of this book, I will often widen the scope of my analysis to include more than simply Buddhist phenomena. I bring these issues up now, as I said, in order to anticipate criticisms of this sort of move that have at times been voiced in the field of Buddhist Studies, a particularly clear statement of which can be found in Henrik Sørensen's response to aspects of Michel Strickmann's book *Chinese Magical Medicine*.[43] Sørensen faults Strickmann for thinking that there were larger areas of commonality between Chinese Buddhism and Daoism than there in fact were. "In his penchant for understanding the common ground of Buddhist and Daoist practitioners—a ground that in many ways does appear to have been one of shared values and patterns of belief—Strickmann seems to have overlooked the fact that it is mainly in the area of popular beliefs and practices that this would seem to hold true."[44] Once one turns away from this set of beliefs and practices, however, and looks instead to the "concerns and purposes" that guide the two traditions, Sørensen argues that there are crucial differences between the two. His specific characterizations of the two religions are familiar: Buddhism, in its true form, is primarily concerned with "enlightenment, transcendental wisdom, and on the more popular level, a fortunate rebirth." Daoism, on the other hand, finds its most essential expression in the quest for "immortality,

bodily purity, and cosmic order." He continues with a statement of the nature, and location, of the distinction. "I believe that this view, which maintains the distinction between the two traditions, is sustainable and may even be seen as 'norm-giving' as soon as we move beyond the realm of the myriad practices that deal with the fulfillment of material and health-related concerns, that is, the so-called worldly practices under which demonic possession and the all-consuming fear of ghosts [Strickmann's main concerns in his book] . . . belong."[45]

Let us consider Sørensen's use of the phrase "norm-giving." In this last sentence he draws a set of stark boundaries between (from one angle) pure and impure versions of each tradition and (from another) among the three realms of "normal" Buddhism, "normal" Daoism, and the anything-goes intermediary space of "popular religion." Yet, the realm he assigns to what I think is fair here to call "real Buddhism" is so confining that it is hard to make many, if not most, of the tradition's most cherished classics fit into it. Most tellingly, for the purposes of this book, is the fact that the two incantations it centers on, with their focus on spiritual protection and good rebirths (not to mention the *Scripture of the Incantation of Glory*'s obsession with pure bodies) would seem unfit to be called works of true normative Buddhism in this model. Yet they were included in the lists of canonical works compiled by the scholarly elite of the religion—its norm givers, in Sørensen's view—and as far as I know their presences in them were never questioned. But more broadly than this, it seems to me that most works that carry the traces of actual medieval Chinese Buddhist practice could hardly be considered "Buddhist" either, in Sørensen's reading.

It turns out to be rather difficult to find areas within the sources for medieval Chinese Buddhism that are not at least in part concerned with the sorts of things he labels "popular" and thus nonnormative for the tradition in its putatively true from. Leading with "norms," even leading with the idea of purely discreet religious traditions, often leaves the historian with very little that is acceptable according to them.[46] Far better, I think, to simply examine the sources available and try to understand the human activities of which they are remnants primarily as human activities, and not as exemplars of this or that set of traditional norms. This is not, I hope it is clear, to say that there were no such things as individual traditions in medieval China—that would be a ridiculous claim. My point is merely that what those traditions were, and what they were not, is perhaps not as well understood as is often thought. Further, given the complexities of history and society, without having a clearer picture

of the common repertoires of practice and trope they both drew upon and contributed to, and much else besides, we are unlikely to ever gain a better understanding of them. What a long tradition of scholarship calls the "popular" may have had as deep a role in the Buddhist high tradition as did ideas of emptiness and insight—certainly we should keep in mind that many of the tropes that Sørensen's essay consigns to lowly status were significant parts of the religion's high literary tradition. Calling some aspects of the canon "popular" and others "normative," I think, simply confuses things beyond all hope of clarity.

Medieval Chinese religion was partly made up of written spells and tropes like those I explore in this book—for example, infusion, adornment, material efficacy—and in this regard I hope my project contributes to our understanding of both Buddhism, in its separatist mode, and the varieties of Chinese religion writ large. By repertoires, inspired by the recent work of Robert Campany, I mean simply the myriad historically determined practices and images available (in canons, on cliff faces, in the tales told in city lanes) as well as the social capital and practical possibilities each had in any given moment: its attractiveness, the charm it could have to inspire the mimetic desire that is surely an element in the fuel of a tradition's growth and change. One need only note the fact that the same tales are sometimes told in both the Buddhist and Daoist canons to see that their commonalities, even at the canonical level, were greater than Sørensen, in his essay, allowed.[47]

With this framework in place, we can turn to some key areas of the interfusion of Chinese and Buddhist practice and conception.

WEARING AMULETS AND WEARING SPELLS

When Chinese versions of Indic Buddhist texts tell their readers to write dhāraṇīs down and then wear the objects on which they were written—paper, silk, tree bark—the ways they describe that wearing resemble very closely the ways older Chinese texts recommend that one wear other potent things, such as objects of jade or wood, talismans, magical and/or governmental seals, medicines, and elixirs. These practices were part of a larger family of techniques that included wearing potent objects (seals, medicinal drugs and elixirs, talismans) on the body or placing them in strategic locations where their protective beneficence might extend over a chosen area, whether a home, a town, a tomb, or a particular ritual arena. These practices marked the wider religious culture that shaped Chinese receptions of written Buddhist spells

(particularly the ways they came to be described in texts) and that was in turn reshaped by them. The language employed in prescriptive accounts of the wearing and placing of material dhāraṇīs fits seamlessly alongside that of parallel accounts found in older Chinese idealizing texts such as the *Shanhai jing*, the *Classic of Mountains and Seas*, and the *Baopuzi neipian*, the *Master Who Embraces the Unhewn: Inner Chapters*, as well as a great many specifically Daoist works, for example, those anthologized within the *Wushang biyao*, *Highest Mystic Essentials*. In China, dhāraṇī sūtras became, at the level of discourse and the practical imagination, so assimilated to specifically Chinese traditions of adorning bodies and locales with protective objects that it is impossible to consider the imported and native practices apart from each other.

To take two particularly resonant examples, the wearing of written spells in Chinese translations of dhāraṇī scriptures is often described using the words *dai* and *pei*, to wear on a cord or sash.[48] These are the terms commonly used to describe the wearing of seals, swords, and the other regalia of state, as well as the various adornments of bodhisattvas and divinities. Though originally simply descriptive and neutral, the terms came through long association with imperial and religious practices to become in themselves figures of considerable power within Chinese religious culture. Their prominence in descriptions of dhāraṇī amulet practices helped to bring these practices into the fold of native techniques and to increase their resonance in traditional China in subtle but crucial ways.

Symbols of state power in premodern China—jade or gold emblems and seals—were worn dangling from a cord or ribbon at the belt. "In ancient days, the gentleman always wore jade at his sash" (*peiyu*), the *Liji*, the *Record of Rites*, famously reports.[49] Upon seeing a "great man" not serving at court but working his mulberry fields, a character in one of the tales included in Liu Yiqing's (403–444) *Shishuo shinyu*, *New Account of Tales of the World*, expresses his surprise: "I have heard that when a great man lives in the world he should be wearing the gold seal and purple ribbon at his girdle" (*daijin peizi*).[50] The modern translator of this tale explains that "the highest officers . . . are distinguished by wearing the gold seal and purple ribbon at their girdles."[51] "Seal-wearer" (*peiyin*), as well, to take a final brief example, was a common metonym for imperial officers.[52] In a work that offers vivid illustrations of the ways that imperial and religious practices were twins in traditional China,[53] Liu Zhaorui has recently outlined the early history of seals employed by practitioners of Chinese occult ways, for whom the seals record titles such as *tiandi shenshi* ("spiritual master of the heavenly god," sometimes shortened to

tianshi, "heavenly master"), or *tiandi shi* ("envoys of the heavenly god"). Based both on transmitted accounts and on excavated evidence, such seals appear to have been among the most important techniques in the repertoires of their spirit-medium practitioners. Following in part ancient royal logics, the seals bore the traces of the divinities to which they were consecrated. Liu cites a passage from the *Shiji* (Records of the Historian) stating that such envoys "each bore their seals at their sash, which enabled them to communicate with the spirits." Some excavated seals, indeed, appear to have been keyed to particular techniques for channeling divine power, for example a group of seals clearly intended for combat with demonic forces, all of which bear variations on the phrase "kill demons" (*shagui*) engraved upon them.[54] Recent work on religious seals in medieval China has made clear the close kinship their techniques bore to incantation practices, including those of Buddhism.[55] The fact that spells were to be worn at the girdle or sash is further suggestive of these parallel practices and semiotics.

But here we must be careful to distinguish between the textual and archeological evidence, the latter of which strongly suggests that, more often than not, in actual practice the wearing of dhāraṇīs was guided not by Chinese but by Indic styles and metaphors. The at times striking difference between the archeological and textual bodies of evidence, in fact, points to a split in Chinese dhāraṇī amulet practice between what we can characterize as its Chinese descriptive discourse and its predominantly Indic styles of actual bodily practice. The recognizably Chinese character of the former is so pronounced, in fact, that were one to look only to the texts one would get the strong impression that the amuletic practices described in them were entirely a Chinese insertion into the imported tradition, one hewing closely to native styles and concerns. The material record, however, makes clear that they constituted an extension of Indic and Central Asian cultures of amuletic techniques, though one naturally at times reshaped, especially over time, to meet local needs and desires.[56]

As noted, I will explore the archeological evidence and its sources in the next chapter; I turn here to the discursive textual background. The parallels between Buddhist spells and native practices of adornment were not lost on the highly literate class of monks who translated the Indic texts and composed commentaries and indigenous sūtras. In a discussion of the term *shoudai,* the cord or ribbon attached to official regalia such as seals or jade emblems, Huilin's (d. 820) *Yiqie jing yinyi, Sound and Sense of the Scriptures*—the standard Chinese Buddhist linguistic encyclopedia of the late Tang—quotes statements

from the *Record of Rites* and the *Hou Hanshu*, the *History of the Later Han Dynasty*, about the wearing of jade emblems on cords and sashes by court officials.[57] The passage containing these citations comments on a lost Buddhist text, the *Qi juti fo muzhunni daming tuoluoni jing*, the *Great Vidyā Dhāraṇī Scripture of Cundī, Mother of Seven Koṭī of Buddhas*, which Yuanzhao's late eighth-century catalog attributed to Vajrabodhi (Jin'gangzhi, d. 732).[58] Because we cannot consult the original text, it is impossible to tell the context of the use upon which Huilin comments here. However, since most uses of the terms *dai* and *pei* in texts attributed to Vajrabodhi and his student Amoghavajra—and Huilin had studied with Amoghavajra—refer to the wearing of written spells, images, seals, and talismans, it is very likely that this instance does as well. It is also likely, then, that the use of the terms *dai* and *pei* in Chinese versions of Buddhist texts were at least in part understood as conscious echoes of imperial practices, and by extension native religious practices that themselves borrowed the power of the cosmically rooted imperium. In the case of the talismanic and spiritual adornments, such as flower garlands and jewels, that bodhisattvas wear (that is, that they "*dai*" and "*pei*"), another line of Huilin's also suggests that the imagery of Chinese imperial practice was consciously put into play in these accounts. Discussing the senses of the term "flower garland" (*huaman*), one of the key adornments of bodhisattvas as described in sūtras and ritual texts, he specifically equates the term with that used to describe the wearing of imperial insignia: one "places it [that is, the flower garland] on one's body as an adornment, just like the cords [of state emblems]."[59]

More important than echoes of imperial practice, however, were the connections with the broad and ancient family of Chinese amulets and talismans, a family that included, but was not limited to, medicinal drugs, alchemical elixirs, mirrors, *fu*-talismans, seals, and of course scriptures and spells. The simplest (and perhaps thus among the oldest) amuletic practices in China featured the wearing of plants, stones, metals, and medicinal substances for protection from both the normal shocks that flesh is heir to (difficulties in childbirth and illness) and the special dangers of the wilds—demons, storms, brigands, and animals chief among them. That these are, as we will see, precisely the main targets of the *Incantation of Wish Fulfillment* as described in its scripture, marks this set of practices as the incantation's true family, at least on its Chinese side. Travel magic in particular constituted a rich tradition. Given that the creators of such techniques themselves had continual need to venture out "into the wilds in search of spirits and magical substances that confer immortality," and consequently had much to fear from "demonic

machinations" in the wild places, this is not surprising.[60] The Warring States period *Shanhaijing* opens with a section on how to prepare for travel that contains prescriptions to wear (*pei*) pieces of various plants and animals to be found in the outlandish locales it describes—said to be rich in gold, jade, and other resources—in order to prevent maladies such as getting lost, experiencing hardship in childbirth, deafness, and terror. "There is a tree on the mountain which looks like the paper mulberry, but it has black markings. Its blossoms light up everything around it. Its name is the lost-mulberry. If you wear it in your belt, you won't get lost. . . . The river Sveltedeer rises here and flows westwards to empty into the sea. It has a lot of breedsurge herbs in it. If you wear some on your belt, you won't suffer from worms."[61] And so on.

Prescriptions grow more detailed in the early fourth-century *Baopuzi neipian* of Ge Hong, and in later medieval traditions carried out in his name. The simplest (which mostly are found in the received edition of the *Baopuzi*) bear a close resemblance to those of the *Shanhaijing*. Of the arboreal exudation (*muzhi*)[62] named "Awesome Joy" (*mu weixi zhi*) that one may encounter in the deep forests, for example, the text states, "if you carry it at your belt (*dai*) you will avoid weapons . . . and will never be harmed."[63] Realgar (*xionghuang*), one of the most common ingredients in traditional Chinese medical and alchemical preparations, was also said to be effective if worn (*pei*). "Anciently," Ge Hong reports, "Round Hill (*yuanqiu*) was infested with large snakes—but it also grew good medicines. The Yellow Thearch (Huangdi) climbed it and Guangchengzi taught him to wear realgar at his sash—the snakes all fled."[64] Realgar's special effectiveness as a cure against the venoms of snakes and other poisonous creatures was in fact widely credited in the traditional cultures of both India and in China.[65] A reddish-yellow egg-shaped pellet of realgar, which seems to have originated in eighth-century China, is preserved today in the collection of the Shōsōin in Japan.[66] As Edward Schafer noted already in 1955, the object was most likely used in precisely the sorts of practices that medieval authors such as Ge Hong describe in their works.[67] Protection from snakes was also a concern in later texts, as seen in the tenth-century Japanese collection of mainly Chinese medical techniques, the *Ishinpō*, which attributes the method of mixing aconite and Chinese anise and placing them in small pouches to be worn on the head to Ge Hong, and in Sun Simiao's collection of magical and medical prescriptions, the probably seventh-century *Qianjin yifang*, *Appended Prescriptions Worth a Thousand Gold*.[68] Simply as an aside, and bringing Indic traditions briefly back into the picture, it is notable both that one of the earliest known Buddhist spells, the *mora paritta*—an ancestor

of the *Mahāmayūrī dhāraṇī*—was also for protection from snakes and that the *Atharva Veda*, largely a manual of incantations and other occult techniques dating, it seems, well into the centuries preceding the so-called "Common Era," features many spells against demons, snakes, and the other dangers of the ancient world.

In closely related behaviors, alchemical elixirs—the ultimate in medicinal drugs—were as well not only to be ingested but also to be worn. Fabrizio Pregadio, in his comprehensive study of Taiqing, "Great Clarity," alchemical traditions in early medieval China, notes the use of elixirs as periapts for their protective and exorcistic powers. He quotes a text of the Taiqing tradition that describes the potencies of worn elixirs—very possibly in forms like that of the Shōsōin realgar egg—in what we can now recognize as the standard terms: "If you want to keep away the five sorts of weapons . . . you should carry [the Divine Elixir] at your belt. Divine beings will offer their protection and keep the weapons away." And again: "If you walk keeping in your hand one pill [of the Fixed Elixir] of the size of a date stone, the hundred demons will be exterminated This elixir will also keep off thieves and robbers, and even tigers and wolves will run away. If a woman who lives alone keeps one pill the size of a large bean in her hand, the hundred demons, thieves, and robbers will flee and dare not come near her."[69]

In terms of the Buddhist tradition in China, adorning the body with protective medicinal or alchemical substances was not only a "popular" activity, in the sense of a behavior engaged in only outside the closely monitored precincts of monastic halls, out in the "wilds" where traditions freely commingled. Buddhist ritual texts, particularly the cluster of dhāraṇī scriptures that feature the wearing of spells, called for their own versions of the practice. In line with standard dhāraṇī ritual methods, however, and in a practice that echoes the ancient prescriptions of the *Atharva Veda*, these texts often insist that the drugs first be enchanted with a dhāraṇī. One of the earliest is Zhitong's (fl. 605–653) translation of the *Guanzizai pusa suixin zhou jing*, the *Scripture of the Bodhisattva Guanzizai's Incantation of According with One's Wishes*, which claims that no evil demons will be able to harm the traveler who enchants sweet flag (*calumus*) root one thousand and eight times and wears it constantly on his arm.[70] Bodhiruci's eighth-century *Guangda bao louge shanzhu mimi tuoluoni jing*, the *Scripture of the Well-Established Occult Dhāraṇī of the Vast Treasure Tower*, also recommends sweet flag, though for different reasons: "if one takes sweet flag root and enchants it with this incantation 8,000 times, and then either wears it at his sash or carries it, he will cause all beings who gaze upon him to feel

joyful."[71] Śikśānanda's eighth-century *Guanshiyin pusa mimizang ruyilun tuoluoni shenzhou jing*, the *Scripture of the Dhāraṇī Spirit Incantation of the Bodhisattva Guanshiyin's Secret Treasury Mind-According Wheel*, prescribes a compound of medicines, including (among other things) cow bezoar, white sandalwood, camphor, and two kinds of lotus, to be enchanted and then applied in various ways to the body, including as a periapt. Wearing it, the text asserts, "sinful blockages will be eliminated and one will achieve release from all hardships."[72] As we will see in the next chapter, drugs and spells also came together in another way: when drugs were used to *write* spells.

The most relevant practical context for the wearing of incantations as periapts is not the one outlined by accounts of the wearing of substances such as plants or drugs, but that limned by other accounts—like that of the man who tied a sūtra to his head—of the wearing of texts for protection and blessings. By the mid-sixth century, over a century before the first translation of the *Scripture of the Wish Fulfilling Spell* and its accounts of Indic textual amulets, Chinese Buddhists had been treating religious texts as talismanic and wearing them in native styles long enough for such practices to be enshrined in newly composed scriptures. Here too, connections with Chinese normative literature are clear. Ge Hong's *Baopuzi* praises the apotropaic might of the physical texts of the *Sanhuang wen*, the *Text of the Three Sovereigns*, and the *Wuyue zhenxing tu*, the *Charts of the Real Forms of the Five Peaks*, two of the most storied scriptures of native Chinese religious practice. Of the former text, Ge Hong relates by now familiar claims and methods: "if someone is on the point of death because of an illness, let him hold this text and, providing he has full faith in its methods, he will not die. If a woman is having a difficult delivery and is in danger of exhausting her vital force, let her hold this text and her child will be born immediately. If a practitioner who wishes to search for long life enters a mountain holding this text, he will keep off tigers, wolves, and mountain sprites."[73] Earlier, I noted the development, out of early Indic practices of wearing what Buddhist texts name "spirit threads," of one family of spell-wearing techniques constituted by incantation cords and armlets—a family (as I will explore in the next chapter) well represented by passages in the *Scripture of the Wish Fulfilling Spell* and instantiated in some Chinese tombs of the late medieval period. But the amulet-inspired wearing of dhāraṇīs and other puissant Buddhist texts on the belt (*dai*) or sash (*pei*), also present in that text, was frequent elsewhere, and nowhere more so than in the native Chinese Buddhist composition known as the *Consecration Sūtra*. That text asserts: "If there is one who can hold this consecratory document, then that one will

be far from all the numberless terrors. If he holds this spirit incantation his dreams will be secure and he will wake joyful."[74] Or: "If one in the final age writes out this scripture and wears it on his body (*peidai zai shen*), then when he travels in the ten directions there will be nothing he fears."[75] The text later, presenting an incantation in the form of a list of the names of thirty-six "spirit kings" (itself a time-honored sort of Chinese incantation),[76] speaks of its efficacies and modes of activation in the same manner: "You should write out the names of these spirit kings and wear them on the body. When you travel there will be nothing to fear; you will sweep away evil and extinguish what is not wholesome."[77]

In the eighth century, the period immediately following Maṇicintana's 693 translation of the *Scripture of the Wish Fulfilling Spell*, the wearing of spells entered a period of great popularity in Chinese Buddhism, at least if the frequency of accounts of the practice in translated scriptural texts and actual amulets in archeological finds dating to the age are any indication. Aside from Bukong's retranslation of the *Scripture*, several other texts dating to this era advocate the practice, including Bodhiruci's translations of the *Bukong juansuo shenbian zhenyan jing*, the *Real Word Scripture of the Spiritual Transformations of the Unfailing Lariat*,[78] the *Scripture of the Well-Established Occult Dhāraṇī of the Vast Treasure Tower*,[79] and the *Yizi foding lunwang jing*, the *Scripture of the Wheel Turning King of the Single Syllable Buddha's Crown*,[80] as well as the *Great Dhāraṇī Scripture of Stainless Pure Radiance*.[81]

Canonical Buddhist texts also mention the wearing of talismans and other kinds of amulets—including the seemingly related practice of wearing images[82]—though they do not always approve of the behavior. The earliest nonscriptural discussion of the practice I have found is contained in Xuanguang's (fifth c.) excoriation of early Daoist practice, *Bianhuo lun*, "On Delusions," in a section called "Wearing Talismans Because One Fears Ghosts—The Extreme of Un-Lawful Activities" (*Weigui daifu feifa zhi ji*).[83] Indeed, the question of the "lawfulness" (where the Dharma is the law) of talismanic practices was a key feature of the earliest discussions of the practice. The piece condemns those, like the early Celestial Master Zhang Jue (d. 184), who wear (*peidai*) talismans such as the "mark of the Great Ultimate" (*taiji zhang*) or the "Kunwu iron" (*Kunwu tie*), in order to achieve mystic powers. It praises, instead, those who, like the "perfect saints and eminent sages" (*zhisheng gaoxian*) of Buddhism, achieve even greater powers through spiritual and philosophical transcendence of the myriad vicissitudes of the world (*wuqing yu wanhua*).[84] Such attitudes, aside from displaying Chinese Buddhism in its

separatist mode, echo the age-old injunctions in the sūtras and *vinaya* against the use of sorceries by Buddhists noted in the introduction.

The prominent Buddhist exegete and teacher Zhiyi (538–598), in his commentaries on the *Fahua jing*, the *Lotus Sūtra*, and the *Jin guangming jing*, the *Sūtra of Golden Light*, takes the opposite tack in his treatment of these practices. Tellingly, his comments in both cases treat quotations of the *Sūtra of Trapusa and Bhallika* (*Tiwei boli jing*), a Chinese apocryphon that one scholar has seen as evidence for the "earliest folk Buddhist religion in China."[85] Though this scripture was not accepted by canon makers such as the Tang cataloger Zhisheng (669–740)—and, no doubt partly as a result of this, has not survived in its entirety—Zhiyi shows no ambivalence about its injunctions to employ talismans, drugs of immortality, and seals, which he recommends for practitioners of the doctrinally relatively modest "Teachings of Men and Gods" (*rentian jiao*).[86] In his *Miaofa lianhua jing xuanyi*, *Abstruse Meaning of the Lotus Sūtra*, Zhiyi aligns the attainment of the "Buddha Way" and arhatship through reading (*du*) the *Lotus* with that of the long life and happiness achieved through the use of seals and related practices. "If you want to attain the stage of immortality (*busi di*) you should wear (*pei*) the talisman of long life (*changsheng zhi fu*), take the medicine of immortality (*busi zhi yao*), and wield the seal of long happiness (*chi changle zhi yin*)." He strongly affirms that such practices are genuinely Buddhist: "the talisman of long life is indeed part of the teachings of the Three Vehicles."[87] The four celestial kings, omnipresent guardians of the Dharma and its practitioners, as well, "all take medicines of long happiness and wear talismans of long life."[88] In his commentary on the *Sūtra of Golden Light* he is similarly uncompromising on this issue, quoting the *Sūtra of Trapusa and Bhallika* as going so far as equating the practices of the precepts with those of wearing talismans and seals: "The five precepts consist in wearing the talisman of long life and the seal of immortality."[89] Though one might sense a bit of doctrinal hedging, or even sleight of hand, on the part of Zhiyi when he lets slip that the "Seal of Long Happiness" is actually "the Dao of Nirvana," as he does in his *Lotus* commentary,[90] such equations were common and indeed central to the Buddhist appropriation of talismans and seals.

Zhiyi's passages offered elite scholastic reframings and imprimaturs for what was clearly, by his time, a widespread culture of borrowing among practitioners of Buddhist, Daoist, and local cultic ways. Practices of wearing dhāraṇīs as amulets, or carving them into stones then taken as talismans, were deeply enmeshed in this culture, and were in fact one of its chief exemplars,

along with the talismans and seals practical styles of which they echoed. Not everyone was happy with this aspect of medieval Chinese religion, as we have seen. The apocryphal *Longshu wuming lun*, Nāgārjuna's *Treatise on the Five Sciences* is filled with recipes for talisman rites, including the wearing of talismans, and may in fact exemplify the very sort of practices that Xuanguang inveighed against, though the provenance of the text is far from clear.[91] But texts such as Xuanguang's date from a rather early period in the history of Chinese Buddhism. Even a few hundred years later practices involving the wearing of talismans and spells seem to have been less troubling; at least, there are few clues that suggest widespread dissent on this issue from the later medieval period. Certainly by the eighth century, when the dhāraṇī amulets and talismanic stones examined in this book were growing in popularity, the use of *fu* in Buddhist rites, and by extension the wearing of a wide range of amulets, whether of traditionally Buddhist provenance or otherwise, seems to have been considered normal. Later authors, at any rate, apparently felt no need to ring their presentations with claims to orthodoxy.

To wear drugs or incantations as amulets, or to speak the names of drugs as a spell, and to consider these practices powerfully efficacious is, from the perspective of modern understandings of these objects, quite bizarre—an upending of seemingly inherent and inalienable relationships of substance, form, and function.[92] But such behaviors, which might at first seem rooted in forms of category mistake, make better sense when the frame for one's understanding shifts from modern notions of the nature and functions of the individual substances to the basic logics of the overarching practices, whether amuletic or incantatory. The essential similarities in the behaviors surveyed in this chapter—both physical and discursive—make this fact clear. When taken as a large family of behaviors, the specific contents of any of its specific versions do not seem to matter; or they matter only in that they instantiate particular local styles and doctrines. That is, whether it was an elixir or a dhāraṇī that was to be worn mattered a great deal within particular local traditions but not at all to the practice when it is reduced to its most basic form. At the heart of the Chinese practices, alongside the styles that grew out of the wearing of bits of plant and stone in ancient times, lay the social poetics of the wearing of amulets, especially of seals and *fu*-talismans.

These objects did not merely provided wellsprings of practical logic, however—they themselves continued to be popular components of the family of practices they in part gave rise to, within both later native Chinese and imported Buddhist traditions. As seen in a range of sources (including

transmitted scriptures of the printed canons, manuscript ritual manuals found at Dunhuang, and small iconographic details), stamp seals and *fu*-talismans remained elements of Buddhist practice in China through the imperial period, often in ways that demonstrate their ongoing kinship with the dhāranī techniques and traditions examined in the following chapters.[93] Emblematic of these practices is a manuscript *fu* whose colophon explicitly identifies it with dhāranīs and their practices. The talisman, known today as Stein Painting 170, is perhaps the most cited talisman from Dunhuang (figure 1.1), or indeed from the medieval period as a whole.[94] It is notable among other reasons for being one of the few *actual* talismans discovered in the "library cave," as opposed to talisman (or for that matter talisman-seal) *models*, the most common form in which we find evidence for these ritual implements.[95] The images and texts on the sheet figure a striking (and, as we now see, perfectly ordinary) hybrid of Buddhist and native Chinese forms. Atop the sheet are two celestial gods named in their accompanying invocations: Mercury, the "Planetary Deity of the North" of Chinese cosmology and the Indic divinity Ketu.[96] The vermillion ink of the talismanic glyphs and statements tallies well with the canonical intensifier of incantations included at the end of the colophon: "Quickly! Quickly! According to the Statutes and Ordinances!" As in other Buddhist talismans and seals, this command is the finale to a set of conventionally Buddhist statements of desires attainable through wearing (*dai*) the talisman as a periapt, here for the gaining of the *abhijñā*, or Buddhist spiritual powers, for freedom from the life-shaping taints of past wrongdoing, and for the attainment of a transformative vision of all the buddhas of the ten directions. The first of the colophon's statements, where the nature of the talisman is made clear, is startling: "This talisman," the passage begins, "is a dhāranī-talisman" (*tuoluoni fu*). Though we must be careful not to generalize too much from this unique object held in a cache at the edge of the Chinese religious world, this is a powerful statement of the close similitude of the imagined natures of incantations and their ritual cousins. It is one reflected elsewhere among the talismans and seals of Dunhuang.[97] The rhyming metaphorical and ritual characters of dhāranīs and talismans, so often only implied in parallel details of amulet practice such as those explored earlier, are here made explicit and perfect. The amulet serves as a vivid emblem of the culture of religious practice in which the dhāranī traditions I turn to in the next chapters were shaped and lived out.

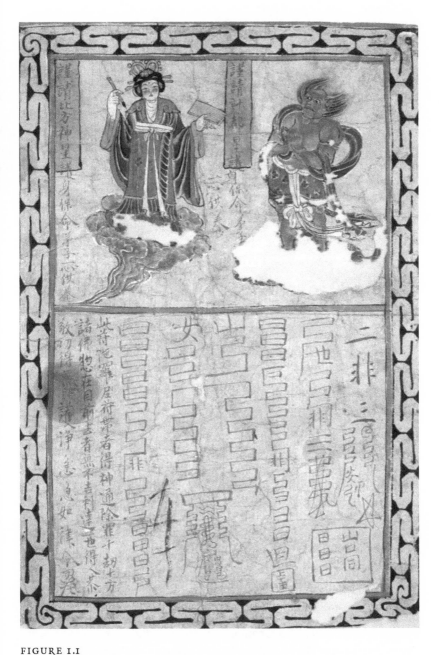

FIGURE I.I

Dhāraṇī Talisman ["Talisman of the Pole Star"]. Stein Painting 170 (Ch. lvi. 0033). Ink and colors on paper. 42.7 × 30 cm. © The Trustees of the British Museum.

CONCLUSION

In this chapter, in part as a way to provide background for the Chinese dhāraṇī practices I explore in the next two chapters, I have traced two contexts of historical change relevant to Buddhist spell writing: transformations within Indic Buddhism of the natures of inscribed dhāraṇīs as they were imagined in practice (from elements of scriptures to relics of the Buddha and materially realized incantations) as well as transformations within Chinese religious history, whereby inscribed dhāraṇīs of the third variety came to be described in part along the lines of native amulet practices and came to be absorbed in part within their culture in China. These ritual cultures converged within and helped to shape the style of Chinese religiosity sometimes called "Buddho-Daoist," wherein new and uniquely Chinese techniques of Buddhist incantatory practice took root and grew, and within which the affinities among talismans, seals, and dhāraṇīs as imagined objects that I have explored here became central figures. This style has at times been denigrated by both scholars and priests as merely "popular," as consisting of poorly understood mishmashes, neither Buddhist, Daoist, nor (since shot through with Buddhist elements) even truly Chinese.[98] This view has distorted our picture of Chinese religious history. As Christine Mollier has said, though the works we call Buddho-Daoist were not, perhaps, "representative of the highest religious scholasticism," neither did they "emerge from an undistinguished religious background." More to the point, taken on their own terms, in many cases these works were not "Buddho-Daoist" at all, but simply Buddhist or Daoist or otherwise. As Mollier rightly notes, their authors were often "keen to make their religious affiliations explicit and to affirm a strong commitment to their denominational identities."[99] Analytical distinctions, according to which a scholar wishes to understand the material he or she studies on a continuum from foreign to native, can easily slip unattended into a picture of how religious history was actually lived and understood by those who lived it. Most of the material explored in the last section of this chapter was considered Buddhist by those who created and enacted it (though the case of the dhāraṇī-talisman is ambivalent, and my observations here are not meant to obscure a truly "nondenominational" style of medieval religious practice that coexisted alongside more strictly aligned forms—or, better to say, forms more strictly aligned within our current understanding of medieval Chinese "denominations"). They were, among other things, the products of Chinese Buddhist appropriations of the store of practices and emblems ready to hand,

as available to the Buddhist as to anyone else, and not intrinsically less his, given that native high traditions such as Daoism themselves often consisted in great part of techniques and images appropriated from those who had come before. When medieval Chinese Buddhists are understood to be, first and foremost, simply medieval Chinese people (and not avatars of ideology, foreign or domestic), then it is clear that the common store of Chinese culture was as rightfully theirs as it was the Daoists'. As Robert Sharf said of a related historical context: "Whatever else it may be, Buddhism is the product of Buddhists, and the Buddhists in the case at hand were Chinese."[100] The situation seems parallel to that of Buddhism's South Asian homeland, where Indra or Hārītī could be Buddhist or otherwise depending on who was shaping a particular practice or carrying it out. For the historian of Buddhism, there is as little to be gained from questioning the "buddhistness" of Chinese Buddhist talismanic seals as there is from questioning the Buddhist status of Hārītī dhāraṇīs or Buddhist Tantric rites imported into China.

2. AMULETS OF THE *INCANTATION* OF *WISH FULFILLMENT*

In April 1944, archeologists Feng Hanji and Yang Yourun excavated a small Tang-era tomb on the campus of Sichuan University, in Chengdu. The simple single-chamber tomb, located near a bend in the Jin River, contained one occupant, whose head was oriented toward the southwest (figure 2.1). Along with a number of other objects placed carefully around it, including urns, dishes, and bowls, and along with coins placed in its mouth and hands, and a jade slip in each hand, the skeleton bore a silver armlet on its upper right arm. Its beauty and workmanship aside, the armlet did not especially attract the attention of the archeologists. Later, however, during the work of cleaning and conserving it, sections of the badly oxidized ring came apart in the hands of one of the scholars, who then made a momentous discovery. Inside the ring, folded and tightly rolled, was a sheet of paper, roughly square at 31 by 34 centimeters, with a text in Indic characters printed in a spiraling square formation around an image of a multiarmed bodhisattva figure. Images of Buddhist ritual implements adorned its outer rim—hand mudras and objects wreathed in flame and buddhas encircled by haloes of light. On the right side of the sheet was a colophon in Chinese, badly damaged and difficult to read, but with the words *Chengdu*, "Dragon Pool Workshop" (*longchi fang*),[1] and "spell text printed for sale" (*yinmai zhouben*) legible enough.[2] The paper, according to the archeologist who wrote the report, was exceedingly thin, nearly transparent, yet still possessed of remarkable tensile strength. This, he notes, was characteristic of the silkworm cocoon paper (*jianzhi*) of the Tang period, a paper made from the mixture of silkworm cocoons, mulberry bark, sesame, and sandalwood that shone in the glare of the sun.[3]

The colophon did not identify the Sanskrit text printed to its left, but though this was (as far as I can determine) the first such sheet ever discovered in a tomb or in an armlet—or in any other context of actual use—other similar

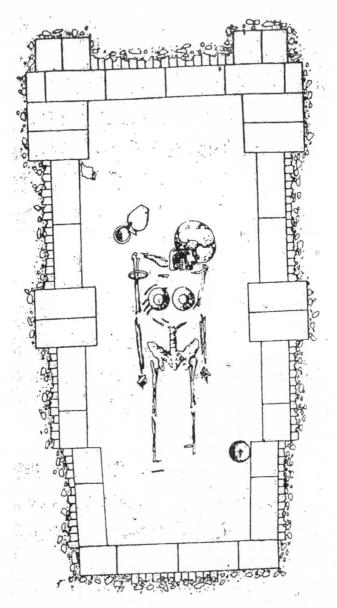

FIGURE 2.1
Drawing of anonymous Tang-era tomb, Sichuan. After Feng, "Ji Tang yinben tuoluoni," 70.

xylographs, bearing labeled Sanskrit texts of the *Incantation of Wish Fulfillment*, had been discovered far to the north of Chengdu, in the cache of manuscripts and paintings in one of the Mogao caves near Dunhuang, nearly a half-century earlier. Feng Hanji, in his account of the amulet's discovery, makes clear that these earlier finds, particularly the incantation xylograph known today as Stein Painting 249 (figure 2.2), were crucial in identifying the Chengdu example.[4] Indeed, the Chengdu armlet and its contents have in turn proved just as important for the ways they help to complete our understanding of the Dunhuang finds, the sutra, and the larger practical traditions both related to. Stein Painting 249, a dazzlingly elaborate printed sheet dated 980, quotes a scriptural passage describing its intended use and the modes of its efficacy.

> The *Great Dhāraṇī of Wish Fulfillment.* If one practices[5] this spirit-incantation, one's position will be victorious. If there is one who can copy it out and carry it on his head or on his arm, he can complete all the meritorious acts of utmost purity. He will ever be held in the protective embrace of gods and dragon kings and will be remembered and kept in mind by all buddhas and bodhisattvas. This spirit-incantation can bestow the utmost security and bliss upon all beings. They will not be bothered or attacked by yakṣas, rakṣas, or any other demons or spirits. Neither can loathsome *gu*-sorcery or spells or curses harm him. Practicing [this spirit-incantation] eliminates disasters from the sins of past acts. The one who wields this incantation will ever be secure and blissful; will be without sickness; will be brilliant and full in form; will be perfect in his auspiciousness. His blessings and virtues will increase. All his spell arts will be successful. If one practices [this spirit-incantation], and makes offerings to it, one will be fit for protection and purification.

This text, which squarely places the sheets in a trans-Asian culture of Buddhist amuletic practice, is a slightly modified passage from a Chinese translation of the *Mahāpratisarā dhāraṇī sūtra*, a title its earliest and most widely influential Chinese rendering translates as *Foshuo suiqiu jide dazizai tuoluoni shenzhou jing,* or *The Scripture of the Dhāraṇī Spirit-Spell of Great Sovereignty, Preached by the Buddha, Whereby One Immediately Attains What Is Sought.*[6] This scripture was an important feature in the amulet practice instantiated within the Chengdu tomb, both as one vector of its transmission in China and as the prescriptive anchor for at least some of its practitioners (though, as I will explore later, this last point is not as clear as one might expect). *Pratisara,* the Sanskrit word that lies at the heart of the title (and its practical tradition), means most basically

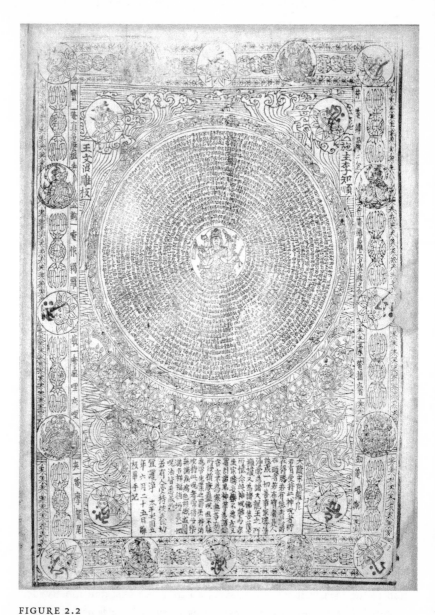

FIGURE 2.2

Li Zhishun Mahāpratisarā amulet ["Mahapratisara Bodhisattva with text of *Da Sui qiu tuoluoni*"]. Stein Painting 249 (Ch.xliii.004). Xylograph, ink, and colors on paper. 41.7 × 30.3 cm. © The Trustees of the British Museum.

a "circle," or "garland," and was the name for "a cord or ribbon used as an amulet worn round the neck or wrist at nuptials, etc."; for "the dressing and anointing of a wound"; and for spoken charms of protection.[7] One scholar has suggested that the term's basic sense of "circle" gave *pratisara* amulets a sense of "counter-magic," of returning violence back upon its sender.[8] Thus, the Sanskrit name for the incantation means something like "the Great Bracelet," or the "Great Amulet," senses that, as we will see, though they were invisible within the Chinese translations, had very literal referents in the practices in which the spell was enacted (a fact that hints at the very different levels at which medieval Chinese Buddhists engaged the imported tradition).[9]

In medieval China, the *Scripture*'s injunction that its spell should be carried "on one's arm" (it makes no special reference to bracelets or pendants) might normally be taken simply as one among countless ritual imperatives, the popularity of whose actual practice remains unknown. Yet after 1944 it took on new, even singular, importance, as did the text as a whole. For in that small anonymous tomb by the bank of the Jin River lay a figure actually wearing it on his arm.[10] The silver armlet, along with other similar carrying cases that would be found in later years, provides something we only very rarely have: evidence that the small ritual prescriptions of the sutras were actually carried out in the late medieval period; even better, it shows precisely how they, or at least this one, were carried out. The armlet, and others like it, as well as what appear to have been necklaces or pendants, and the amulet sheets within them, suggest a complex history of religious practice in which scriptures and their accounts were not fully normative, were not the primary sources for the traditions they were parts of. The conventions of the wider trans-Asian Buddhist amulet traditions, along with local contingencies of economics, craft traditions, and human desire, seem—unsurprisingly—to have played at least as prominent a role as did the scriptural texts and their quoted fragments. But though we must dislodge them from any uniquely central place in the tradition, normative scriptures did, naturally, play important roles in the history of religious practice within which the Chengdu armlet was made and worn. Before I examine that wider history, including its practical logics and the other objects that remain of it, it will be useful first to survey its normative discursive side, as found in the *Scripture of the Incantation of Wish Fulfillment*. In order to keep the focus on the traditions of physical practice the spell helped to shape, rather than giving a full study of the sutra, its structures and its sources, I will survey the portions of the text that seem to have been most operative within the practical tradition—the tales of the spell's efficacies and the guidelines for the creation of the amulets.

THE SŪTRA AND ITS SPELL

The Incantation of Wish Fulfillment first appears in the historical record in China within the first translation of its sūtra, The Scripture of the Dhāraṇī Spirit-Spell of Great Sovereignty, Preached by the Buddha, Whereby One Immediately Attains What Is Sought.[11] This text is credited to the Kashmiri monk Baosiwei (d. 721), whose original name was reconstructed by Antonino Forte as Maṇicintana.[12] His translation is dated to December 693, the year of his arrival in China, the second year of the Changshou reign period of Empress Wu Zetian, a singularly productive age in the history of dhāraṇī practice in China, particularly for those spells that require bodily engagement.[13] The text seems, in fact, to have been translated simultaneously with another dhāraṇī manual that features related practices of wearing cords that have been empowered by incantations, the Dafangguang pusazang jing zhong Wenshushili genben yizi tuoluoni jing, or The Scripture of Mañjuśrī's Root One-Syllable Dhāraṇī.[14] A later, much more elaborate and in many ways quite different scripture of the Incantation of Wish Fulfillment is credited to the powerful mid-eighth-century monk Amoghavajra, or Bukong.[15] For the sake of simplicity, in this chapter I will refer to both versions as The Scripture of the Incantation of Wish Fulfillment, noting which translation I mean in each case.

Unlike the other main incantation studied in this book, the Incantation of Glory and its tale of the vicissitudes of the god Shanzhu, a unifying plot of redemption does not structure the Baosiwei version of the Scripture of the Incantation of Wish Fulfillment. Instead, like most Buddhist incantation scriptures of its period, it consists almost entirely of a series of "just-so" stories that account for the miraculous powers of its incantation and a set of ritual formulae for their activation. In this it resembles both a number of other medium-sized dhāraṇī scriptures and the genre of large occult compendia such as the Consecration Scripture and the Dhāraṇī Miscellany—as well as a number of untitled manuscripts consisting of dhāraṇī collections discovered at Dunhuang.[16]

As in all texts claiming the status of Buddhist scripture, the tales and formulae of the Incantation of Wish Fulfillment are framed as teachings given by the Buddha at a particular place and time. In the case of the Baosiwei translation, that place is Mt. Gṛdhrakūṭa, or "Vulture Peak," the site where according to tradition the Buddha preached many important scriptures, most famously, perhaps, the Lotus Sūtra.[17] The god Brahmā, who requests an incantation at the outset of the framing story, serves as the Buddha's interlocutor throughout. Brahmā initiates the conversation after he arrives and takes his place within

the Buddha's audience on Vulture Peak by announcing, "My only wish is that the World-Honored One preach a dhāraṇī spirit-incantation in order to benefit all beings. May he cause all humans and gods to universally attain security and bliss!"[18] This generous wish marks the text at the outset as belonging to the mainstream of dhāraṇī-incantation manuals translated or produced in China, most of which are similarly directed toward securing the welfare of their practitioners amid the great dangers of this life and the next. In this, indeed, the incantation scriptures were themselves solidly in the mainstream of Buddhist scriptural concern, which featured from an early stage images and promises of the protection of sentient beings from the myriad dangers of the triple world.[19]

The most widely read Western scholarship on Buddhist incantation books in China has stressed the part spells and fears of demons played in the early medieval cultural drama of the dreaded "final period of the Buddha's Teachings" (mofa), or "final age" (moshi), the time long after the extinction of the Buddha when his teachings, along with their beneficent protective aura, were said to have faded from the world and thus no longer hindered the depredations of the evil forces that threaten it. Though one finds mention of the "final age" in dhāraṇī books through to at least the eighth century, including in the Scripture of the Incantation of Wish Fulfillment, the spell book that is most centrally concerned with apocalypse is the Consecration Scripture. Michel Strickmann demonstrated that text's deep connection with Daoist and other native Chinese practices that were explicitly framed by eschatological fears of demonic infestations, plagues, and human decline, fears that were part of a cultural climate that contributed importantly to the rise of the Daoist religion. Indeed, the doom-laden Consecration Scripture and its Daoist apocalyptic cousins exhibit features of a religious discourse that in important ways characterized the early medieval period, the age when dhāraṇī-incantation texts first flourished. This discourse, in fact, is an important part of what makes the distinction between "early" and "late medieval" seem useful to historians of Chinese religion. The early medieval period, an intensely fertile age for Buddhist and Daoist ideology, stretched from the decline and final collapse of the 400-year regime of the Han Empire in the late second century—a series of events that helped unleash a wave of millenarian activity that, among other things, contributed to the rise of religious Daoism—to perhaps the final and most impressive project driven by such apocalyptic fears, the carving begun in the sixth century of the entire Buddhist canon on stone slabs at Fangshan in the northeast, near the modern city of Beijing, to be stored against the coming darkness.[20]

Though the culture of apocalypse was a feature of the age, the dread of demons and other agents of catastrophe already had had a long history in China and in the lands to its west by the early medieval period.[21] It needed no special millenarian framework in which to flourish. The *Incantation of Wish Fulfillment* targets, for the most part, older enemies, which the text discusses in tales of mothers, travelers, warrior-kings, and criminals. As Gergely Hidas has pointed out in his study of a later Sanskrit edition of the scripture, the text seems originally to have been composed within a wider set of amulet cults that had appeared within Buddhist communities by at the latest the middle of the first millennium CE, cults that adapted much older Indic practices, including those of *pratisara* amulet cords themselves.[22] Given the Chinese contexts in which *Mahāpratisarā* amulets have been discovered, we might note in particular that the *Scripture* also features a tale of the horrors of hell: most of the amulets recovered by archeologists have been found in tombs, a fact that showcases the spell's role in mortuary practices of the late Tang, Five Dynasties, and early Song periods.[23]

The Buddha responds to the god by praising his wish and by introducing the *Incantation*, summarizing the dangers it wards against and the blessings its enactments bring.[24]

This is the "Dhāraṇī Spirit Incantation of Great Sovereignty Whereby One Immediately Attains What Is Sought." It can give all beings surpassing security and bliss. They will not be bothered or harmed by any *yakṣas*, by any demons of plague or famine, by any *skandha* demons, or by any other sorts of demons or spirits. Neither will they be attacked or stricken by sicknesses of cold or heat. The positions they take up will ever bring victory; they will not suffer harm from the attacks of enemies in war and can destroy their opponents. Hexes, incantations, and curses cannot harm them. All wrongdoings of past lives will be eliminated. Poisons cannot harm them nor fires burn them. Blades cannot wound them and they will never drown. They cannot be hurt by thunder, lightning, or hail, or even by ill winds or terrible storms.[25]

So far in the text, these powers are all presented simply as general attributes of the spell—no specific means for their activation have yet been described, nor any specific needs that would condition them. At this point, dhāraṇī sūtras typically list the standard modes of scriptural enactment: first and foremost "practicing" (literally, "receiving and holding," *shouchi*), meaning (as

described in the introduction) to memorize, absorb, and make use of in the broadest sense. Next, like all teachings of the Buddha, spells are to be chanted and listened to. In the case of dhāraṇīs, oral, or sonic, performance and reception was usually paramount. The mystic tones of the Sanskrit were said to embody in themselves, rather than in their sense, the cosmic efficacies of the spell. Thus, the reader of the *Incantation of Wish Fulfillment*'s scripture reasonably expects the Buddha to teach first of all the proper incantation of the spell and to praise the efficacies of this practice.

The text confounds this expectation. The first mode of practice given, and the one consistently featured in the text, is copying the spell and wearing it on the arm or at the neck as an amulet, not intoning it or hearing it intoned.[26] The scripture as a whole, in fact, with the exception of a few sections later on where vocal and mental incantation of the spell are advocated, is best understood as a manual for the creation and use of dhāraṇī amulets—just as earlier and contemporary dhāraṇī texts were largely manuals for the creation and use of particular sounds. The archeological evidence provided by the amulets suggests that this was indeed how the text was taken during the late Tang and afterwards, from Dunhuang in the far northwest, all the way to the region south of the Yangtze River in the southeast, where other *Mahāpratisarā* sheets have been discovered. After indicating its proper form of practice, the Buddha then begins to describe the ways the incantation confers its protections and blessings.

> One who can write the spell down and wear it at his neck or on his arm will be able to complete all the meritorious acts of utmost purity and will ever be held in the protective embrace of gods and dragon kings. Furthermore, he will be recollected and thought upon by buddhas and bodhisattvas. The Secret Adamantine Lords and the Four Great Heavenly Kings, even the god Śakra and the Great God of the Brahmā Heavens, the god Viṣṇu, the god Maheśvara, the legions of *kumāra* Indra, hordes of vināyaka, the Great Black God (Mahākāla), Nandi, and Jishuo tian— day and night they will ever closely follow and keep in their protective embrace the bearer of this spell.[27]

The Buddha, soon after listing these protector gods, generalizes the bodily reception of the spell. Not only the neck and arm offer efficacious positions at which to secure an amulet. He states simply that "if this spirit-incantation is kept on the body or in hand," its magic is activated, and general protection and benisons flow from it. But elsewhere, in this text and in others, much is

made of the different circumstances that call for holding the spell, and the different ways the dhāraṇī may be worn as an amulet. Each endows and figures its own special virtue. These are central elements of dhāraṇī-amulet practice—in fact, one might argue that they are what basically constitute it. Since most of these techniques are neither attested in the archeological record nor much discussed in scholarship, a sample of prescribed forms for the wearing of the incantation will be useful.

The first specific circumstances described by the Buddha are those faced by women who, according to both Indian and Chinese societal dictates, are required to give birth to sons, and whose positions in the families they have married into are perhaps thus never fully secure. Along with freedom from physical pain and illness during childbirth, the spell offers women security and blessings within the family and offers their children the same within the womb.

> If a woman receives and holds this spirit spell, she will have great positional power[28] and will ever give birth to males. If she receives and holds it while pregnant then what is within her womb will be secure in its fastness. While giving birth she will be secure and joyful and without any sickness. The sins she committed in past lives will be eliminated and she will surely be without karmic obstructions. Because of the power of the spell's blessings, her household will prosper and the teachings and commands she speaks will all be trustfully received and will always be treated as honored matters.[29]

This passage does not mention any particular style for wearing the spell, but later in the text the neck or throat is prescribed for women wishing to conceive. A king named Merciful Hand, who is singularly blessed in all things save in his queen's inability to conceive, is visited one night by a god.

> Later, one night, the king saw the god of the pure abode (jingju tianzi)[30] who came over to him and said, "Great king, you should know that there is a great spirit-incantation named Seeking and Immediately Attaining. If the king can, according to the rite, copy it out and give it to your queen to tie about her throat, she will immediately attain a son." When the king awoke, dawn had already arrived. He then straightaway copied out the great spirit-incantation according to the rite and gave it to his queen to wear. There was a mystical response and she became pregnant. When the sun and moon were full, she gave birth to a son who was completely

endowed with all the visible marks [of a great man] and such a superlatively austere demeanor that all who saw him were joyful. Great Brahmā, [the Buddha continues,] you should know that the might of this spirit-incantation is such that those who seek it will always attain satisfaction.[31]

For children already born—boys or girls—the Buddha next describes the particular forms of safety, health, ease, and happiness during childhood conferred by wearing the incantation. Several of the usual dangers said to be warded off by the dhāraṇī—disease, the effects of previous karma, spiritual and physical attack—are present here, but in forms that speak particularly to parents' fears for their children, including bad dreams and the predations of evil people.

If boys or girls hold this spell, they will be secure and blissful, without any illness, and will have bright and fulsome appearances. They will be complete in their good fortunes and their blessings will increase. All of their enchantments [zhoufa] will be successful. If they wear this charm, even though they do not enter altars they will, through this practice, attain the entering of all altars, and will engage in the same practices as those who have entered altars.[32] They will not have evil dreams and their heavy transgressions of previous lives will be eliminated. If those who have given rise to evil thoughts come towards them they will not be able to harm the holders of this incantation. All the joys and desirables sought by the holder of this incantation will be attained. [33]

Parents were not the only target audiences. After chanting the syllables of the incantation so that those surrounding him could learn them, the Buddha tells other tales of their usefulness.[34] Though the text clearly emphasizes writing and wearing the spell as an amulet, it also gives a few examples of more traditional ways to enact it as a spoken or memorized incantation. These accounts are mainly sandwiched into the middle of the narrative, immediately following the Buddha's own oral presentation of the dhāraṇī, a fact that further suggests the secondary status of traditional incantation practices within it. After intoning the spell, the Buddha says, "If good men or good women even briefly hear this dhāraṇī, all their sinful blockages without exception will be completely eliminated. If they chant and hold it, then you should know that these people are the Diamond Body [that is, the uncreated indestructible true nature of reality]. Fires cannot burn them." The motif of the Diamond body, of the transformation of mortal impure flesh into the rarefied and luminous substance of

ultimate reality, recurs in the text and is, as I will explore in more detail in the next chapter, perhaps the central trope of dhāraṇī practice, even of the incantations themselves. Enacting the spell works an inconceivable alchemy:

> You should know that this person is the body of the Thus-Come One. You should know that he is the Diamond Body. You should know that he is the body of the Storehouse of the Thus-Come One. You should know that he is the eye of the Thus-Come One. You should know that he has donned the armor of the Thus-Come One. You should know that he is the brilliant and luminous body. You should know that he is the indestructible body.[35]

At times the tradition asserts that this transformation is effected through the figurative "embrace" of the Buddha, at other times simply through physical or mental contact with the incantation. In this text, this contact comes in the usual two main forms of bodily enchantment: direct enchanting and adornment with an enchanted amulet. The direct application of incanted tones onto the body is less emphasized in the *Scripture*, but does occur, as in the tale of a Buddhist layman who came to the aid of a sorcerer poisoned by the bite of a takṣaka (*dechajia*), a dragonlike beast the *Lotus Sūtra* identifies as a lord of his kind,[36] which the sorcerer had summoned but been unable to master. The layman, enchanting the sorcerer's body with the *Incantation of Wish Fulfillment*—"but once," the text emphasizes—is able to cure him completely of the poison (and, naturally, to convert him to the practice of the dhāraṇī).[37]

The *Scripture of the Incantation of Wish Fulfillment* gives several examples of such spell amulets, all in the form of tales of the spell's power, but a look at three—of a criminal, a warrior-king, and a deceased monk—will give a clear sense of the pattern.

> Great Brahmā, in the city of Uddyana (*wuchanna*) there was a king named Brahmadāna (*fanshi*). A man of the city had committed a crime against the king and been condemned to death. The king decreed that the execution be carried out and the man was taken into the mountains and the executioner's blade made ready. The man wore upon his right arm this incantation, and because of its spiritual might the blade burst into flame, burned, and scattered as ash. The official of the law who witnessed this thought it strange and unprecedented. He straightaway went back to the king and completely reported what had happened. The

king told the officer of the law that in the mountains there was a yakṣa demon cave, within which dwelled innumerable yakṣa demons. The officer was to send the guilty man into the cave. Thereupon the officer of the law, upholding his commands, went to send the man into the cave. When the guilty man entered the cave the yakṣas came to eat him. However, because of the awesome might of the incantation the yakṣas and other beasts all saw the man's body shining with brilliant light. They then escorted the guilty man out of the cave and honored and worshipped him. Once again, the officer of the law reported these matters to the king. The king then ordered that the guilty man be cast into a great river. Upholding the order, the officer of the law went and cast the guilty man into the river. When he had been cast in, however, he did not sink and drown but stepped upon the water as if it were land. The officer of the law returned and made this matter known to the great king. The king was terribly shocked at the strangeness of it all. He called for the guilty man and asked about his methods. "How have you escaped?" The guilty man answered the king, "Your vassal has not escaped. On my body I merely wear the Dhāraṇī Spirit-Incantation of Great Sovereignty Whereby One Immediately Attains What Is Sought." The king thought this wondrous beyond all measure.[38]

The spell is, however, as useful in the expression of royal power as it is in its vexation. Curiously, though the following describes a different man, the king in it is also named "Brahmadāna":

Great Brahmā, the city of Varanasi had a king named Brahmadāna. Once, a neighboring king of great majesty and power roused the four troops of his army [that is, elephants, chariots, cavalry, and infantry] and came to attack him. When the fourfold army arrived at Varanasi city, King Brahmadāna knew what to do. He commanded the people within the city: "Do not be afraid. I have a spirit-incantation named the Dhāraṇī of Immediately Attaining That Which One Seeks. The might of this spirit incantation can crush even a fourfold army." At this time, Brahmadāna bathed himself clean and donned new clean robes. He wrote out the spell and held it on his body. Then he went out alone onto the battlefield. The fourfold army submitted to him and came over to his side. Great Brahmā, you should know that such is the might of this spirit-incantation.[39]

As the king's ritual preparations suggest, the *Scripture* also makes clear that purely physical modes of enacting the spell—that is, simply wearing it—were at times combined with devotional or meditative practices. The Buddha asserts in the text that "the Seal of the Thus-Come One"—that is, given the context, the written *Incantation* worn as an amulet—"ever responds to recollection and mental recitation."[40] Such statements complicate any too-simple picture of the spell's practice as consisting solely of physical contact or adornment that might arise from a study of the material record alone, since the excavated objects are mute about the full nature of the ways people engaged them in practice. There are, however, hints in that record that the spell amulets were considered more than simply protective physical adornments, the wearing of which alone was thought to be enough. The colophon printed on Stein Painting 249, discussed previously, interestingly diverges from the text of the sutra, which it otherwise simply quotes, by adding the statement "if one . . . makes offerings to it [that is, the written incantation], one will be fit for protection and purification." This addition reminds us that dhāraṇīs were at times understood to function as buddhas and bodhisattvas—to respond to contemplation and devotion, for example—and, more than that, in the logic of certain forms of worship to *be* buddhas, or at least synecdochic fragments of their bodies (relics). Aside from, once again, complicating any too-simple distinction between the three ways of imagining written spells explored in the previous chapter, this fact reminds us that cognitive and emotional engagement is never far away in Buddhist practice, even in its most apparently mechanical forms.[41]

Yet most descriptions of wearing Buddhist spells as phylacteries from this period do not emphasize the cognitive or devotional component. The third of the sutra's tales I offer here as emblematic starts us back toward the excavated amulets, providing what would seem to have been scriptural warrant for using them to adorn corpses to protect and bless the dead.

Great Brahmā, you should know that in ancient days there was a bhikṣu of little faith, a monk deficient in his practice of the precepts who committed theft. He went into and made use of both the personal belongings of monks and the common property and provisions of the saṃgha. Later, this bhikṣu became gravely ill and experienced terrible vexations. A Brahmin *upāsaka*,[42] great compassion arising within him, wrote out this spirit incantation and tied it to the monk's neck. As soon as he tied it, the monk's illnesses and sufferings, without exception, were

all extinguished. Later, when his life span came to an end, the monk tumbled into Avīci Hell. The corpse of the bhikṣu entombed in its stupa, however, still bore the spell upon it. The stupa was located to the south of today's Fulfilment City.[43] Because the bhikṣu entered into hell he experienced all its agonies for a time, [yet] they ceased and he attained [instead] security and bliss. The flames of hell went out completely.

A soldier of hell, witnessing these events, was greatly astonished. He reported it all to King Yama, who then told the soldier: "This is [due to] the awesome virtue of a remainder from a previous life. You must go to the south of Fulfillment City and see what manner of object it is." Receiving this command, the soldier left. Arriving at the stupa just at the beginning of evening, he saw light coming from it like a great fire. Within the stupa he saw the monk's corpse adorned with this very *Dhāraṇī Spirit-Incantation of Great Sovereignty Whereby One Immediately Attains What Is Sought*. Furthermore, there were gods surrounding and protecting it. The soldier of hell, then, perceiving that the power of this incantion was inconcievable, named the stupa "Immediately Attaining What is Sought." The soldier of hell thereupon returned and reported all that he had seen to King Yama. The bhikṣu, having absorbed the power of the incantation such that all his sins were eradicated, attained birth in the Heaven of Thirty-Three. Because of this, this god [the former bhikṣu] was named Immediately Attaining What is Sought.

Great Brahmā, you should know that one who writes out this incantation according to the proper rite and wears it on his body will ever be without suffering, will be benefited in all things, and will have all his fears swept away.[44]

This last story achieved popularity well beyond that of the others contained in the sutra. The eleventh-century collection of Buddhist miracle tales, *Sanbao ganying yaolüe lu*, or *Abridged Essentials of the Spiritual Resonance of the Three Jewels*, compiled by the monk Feizhuo (d. 1063), contains (as its title suggests) a shortened version of the tale, entitled "The Spiritual Resonance of Writing the *Dhāraṇī of Wish Fulfillment* and Fastening It To the Neck To Eliminate Sins."[45] The version is a slightly altered retelling of the first section of the *Scripture's* tale (its first paragraph, in my translation above), which recounts the basic feat of the spell—the releasing from torment of the sinners imprisoned in the worst of all Buddhist hells, and the complete dousing of its terrible flames.

With its transformation of the hell-bound deceased into a god through the power of a dhāraṇī, this narrative echoes a popular tale of the *Incantation of Glory* I will discuss in the next chapter, where afterlife concerns will feature prominently. The present tale, along with the others I have translated here, offers, in several ways, a convenient capsule of the incantatory imagery and promise featured in the *Scripture of the Incantation of Wish Fulfillment*. It contains many of the basics not only of the mortuary imagination of dhāraṇīs, but of dhāraṇīs in all practical contexts common in this period: the protection of divinities invoked by the spell; the luminous, fiery substance of the spell itself, which quells all other fires, whether the intense flames of the lowest and worst hell or the normal worldly fires of earth; as well as the promise that all agents of evil destinies, structural and personal, are impotent against it. The very workings of karma itself, inexorable in the mainstream doctrines of monks and scriptures, dissolve when the transcendent power of the spell is brought into play.

These are central features of the imagination and practice of dhāraṇīs. In the next chapter I will confront questions of what they reveal about the ways Buddhist incantations were imagined and understood, and what such imaginings as we find in these tales of their inconceivably potent, pure, and luminous substances suggest about how medieval Chinese Buddhists understood their own mortal and corruptible human bodies, as well as what the tales suggest about the mortal anxieties and desires that were in many ways the engine of the tradition itself. In this chapter my interest focuses more narrowly on small details of physical practice and on broad practical history. Why were spells to be tied to one's neck or arm, or fastened in one's hair or to the corner of one's robe? How were such seemingly common and innocuous practices understood in China in the latter centuries of the first millennium CE, where there existed an extremely rich palette of similar but culturally and religiously distinct options?

Keeping in mind, then, the Buddha's tale of the transfigured monk and his necklace of potent syllables, as well as the other promises and techniques of redemption and ease promised in the scriptural tales of the spell, we can now turn back to our anonymous skeleton, mute in its tomb by the Jin River, those same syllables on its arm.

Wearing Dhāraṇī Amulets

To date, at least twenty-three *Mahāpratisarā* amulets have been found in China, consisting, usually—as in the Chengdu example sketched before—of a sheet containing intricate combinations of text and image and a case in which the

sheet was carried on the body.[46] The sheets come in three basic forms: manuscripts (of which nine have been discovered), xylographs (eleven), and sheets that were partly printed and partly hand drawn (three). The dates of many of the amulet sheets remain highly tentative, but their chronology appears in general to follow along the lines of the development of xylography in China in the late centuries of the first millennium CE, proceeding from pure manuscripts, to sheets partially printed but with crucial sections drawn or written in by hand, and finally to fully printed examples, whose structures are in essential ways quite different from those of the earlier manuscripts. Most of the sheets are of paper, though three examples, including two that seem very early, were done on silk. The sheets range in size from 21.5 × 21.5 cm (Madame Wei's amulet) to 44.5 × 44.3 (the monk Xingsi's), with later examples often (but not always) larger than those of earlier periods. The first two formats, manuscripts and half-manuscripts, tend to share many features, which in general follow the dictates of the Scripture—imagery of empowerment and bearer's names included within the texts of the spells, for example— enough so that I will take them in this chapter to constitute the "early style" of amulet production. Amulets in the "late style," in contrast, depart in key respects from the earlier-style amulets, and from the scripture that in part inspired them, containing features that appear to have been drawn both from newer developments in Buddhist ritual practice and from those in the craft of block printing.

The earliest among all extant amulet sheets appears to be the manuscript once carried by a certain Madame Wei (Wei Daniang), now held in the collection of the Yale University Art Gallery, dating to the early mid-eighth century, and probably (according to the judgment of Ma Shichang) to the reign of the Tang emperor Xuanzong (685–762; r. 712–756)[47] (figure 2.3). The latest example with a clear connection to amulet practice is the Dunhuang example mentioned at the start of this chapter. It was found without a case and is clearly dated to 980, early in the Song Dynasty, in an age known in Dunhuang more specifically as that of the "Army of Returned Righteousness" (Guiyijun, 848–1036), which was marked by a return to the region of Han Chinese rule after many years of Tibetan control. Two others are still later—dating to 1001 and 1005—but were discovered in reliquary (or quasi-reliquary) contexts, though as I will discuss later they remain important for this study.

I will describe and analyze the sheets, and the great amount of Buddhist history and culture they reveal, later in this chapter. I focus my attention here

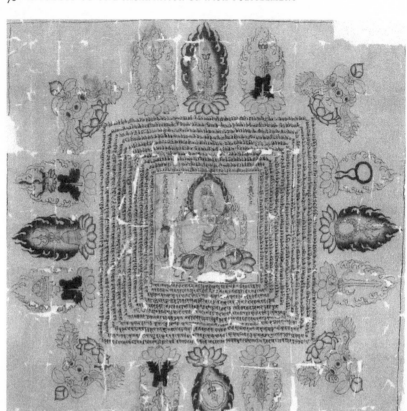

FIGURE 2.3

Madame Wei Mahāpratisarā amulet. Eighth century? Yale University Art Gallery ("Tantric Buddhist Charm," 1955.7.1a). Hobart and Edward Small Moore Memorial Collection, bequest of Mrs. William H. Moore. Ink and colors on silk. 21.5 cm × 21.5 cm.

first on their much simpler (and much less studied) carrying cases, analysis of which reveals equally rich and storied histories of Asian religious practice and imagination. The cases come in three basic kinds: simple containers—either round, as in the case of Madame Wei's amulet (figure 2.4), tube-shaped, or in rectangular boxes—that seem to have been carried in pockets or in pouches; pendants worn around the neck (and some of the tube-shaped cases may have been worn on cords around the neck);[48] or armlets fastened to the upper arm. These latter two forms are, given the meaning of *pratisara* as bracelet or necklace, clearly of special resonance in the spell's tradition across Asia. Four

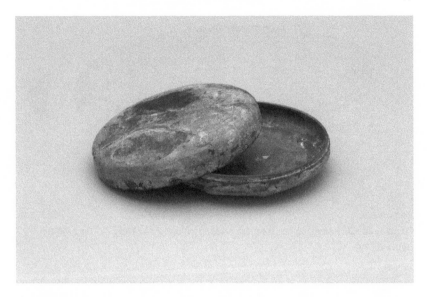

FIGURE 2.4

Madame Wei Mahapratisarā amulet case. Bronze. Yale University Art Gallery ("Tantric Buddhist Charm," 1955.7.1b). Hobart and Edward Small Moore Memorial Collection, bequest of Mrs. William H. Moore (1955.7.1).

examples of armlets have been discovered in Chinese tombs, the most of any one style of amulet case; a few others seem to have been worn as pendants. The armlets range from simple rings, as in the Chengdu amulet (figure 2.5) and its twin (see below), which was also printed in Chengdu but discovered outside of Xi'an; and slightly more involved pieces, including an amulet once belonging to a man named "Iron-head Jiao" (Jiao Tietou), which include a tube-shaped or square box fastened to the arm ring—perhaps a combination of the rings and boxes noted above (figure 2.6).[49]

These armlets, especially, dramatically widen the context for our understanding of Tang dhāraṇī practice out into a broad trans-Asian sphere and help us to connect back in a concrete way to the region in which the sūtra itself was originally produced. In doing so, they reveal striking continuities between Tang China and the Buddhist lands to its west. Though there is little historical information about the immediate practical and conceptual contexts of any one Chinese amulet, given the long history of pratisara-style cord and amulet practice, there is a wealth of material with which to consider the broader contexts of their practical and conceptual history. The rings

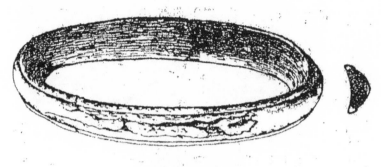

銀鐲(及剖面)

FIGURE 2.5
Drawing of silver armlet from Tang-era tomb, Sichuan. After Feng, "Ji Tang yinben tuoluoni," 70.

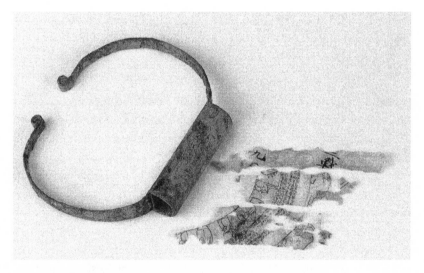

FIGURE 2.6
Armlet. Tang Dynasty. Gold-enameled bronze (1 cm w.) with copper box riveted to it (4.5 × 2.4 cm). After Li and Guan, "Xi'an xijiao chutu."

(along with the parallel group of dhāraṇī pendants) are vivid evidence of Chinese connections with this long and geographically far-reaching history of Indic Buddhist practice that included both ancient rites of bodily enchantment as well as, perhaps, mimetic responses to the visual splendor of bodhisattvas and their jeweled adornments. It is to accounts of those practices that I now turn.

INCANTATION CORDS AND ARMLETS

Though Chinese had by the eighth century CE worn textual amulets for (at least) hundreds of years, the styles for doing so (not to mention the specific texts) evidenced in these tombs seem to have been wholly new to them.[50] The question, then, of why Iron-head Jiao and his anonymous cousin in dhāraṇī practice buried by the Jin river in Chengdu wore their incantations in metallic armlets takes us deep into the details of the normative accounts of bodily incantation practice that survive in dhāraṇī scriptures. Examined in that context, it becomes clear that Jiao's incantation-bearing armlet was part of a set of practices that in Buddhism was already at least hundreds of years old by his day, a set whose contents ranged from the enchanting and wearing of knotted cords, sometimes strung with pearls, seeds, or beads, to armlets filled with similar enchanted objects or the texts of spells—and note that from one perspective, an enspelled seed and a written spell are the same in the sense that both serve as delivery methods for the potencies of incantations. In parallel with dhāraṇīs themselves, these ritual objects were in their earliest textual descriptions the foci (usually along with one or two others) of the rites that featured them. That is, the rites described center on the construction of objects such as enchanted armlets. In the later longer and more elaborate ritual texts of the Esoteric Buddhist tradition, such as the eighth-century Chinese version of the *Susiddhikara*, these objects, like the incantations used to enchant them, recede into the background, becoming but one among a number of objects ancillary to the main focus of the rite. But within the earlier simpler practical tradition and its later exemplars—such as those instantiated within the Chinese tombs under discussion here—they remained the principal focus. [51]

The practice of tying an amulet to the body with a cord called a *pratisara*, or of treating the cord itself as an amulet, was already very old in Indic practice—described already in the *Atharva Veda*—by the time it appears in Buddhist sources.[52] Such cords were not only used to spiritually secure the

person in Indic practices, but as Anna A. Ślączka has recently described, they were also used to secure and empower the bricks used in the construction of shrines in ancient India.[53] The ritual and material logics governing the securing of bodily persons and locales thus appear to have been as closely related in Indian practices as they were in China, where, as we saw in chapter 1, practical continuities connected zhaifa, the "methods of [the protection of] the abode," and hushen, the "[methods of the] protection of the bodily person."

In the case of protective threads, Indic and Sinitic practices appear to have been especially close. Quite similar techniques were practiced in both cultural regions. Though I have found no direct links between native Chinese practices of protective threads and those used by bearers of amulets of the Wish-Fulfilling Spell, it is possible that already by the first two centuries of the Common Era five-colored cords were employed to protect gates in China, as reported in the fifth-century Hou Han shu. Further, though mention of this practice postdates the earliest Buddhist examples by a century or so, by the mid-sixth century such techniques had been extended to the bodily person. Zong Lin, in his Jingchu suishi ji, which dates to around the 550s, reports: "One fastens threads of five colors to the arm. This is called a 'weapon averter.' It wards off illness and plague."[54]

The oldest account of wearing an enchanted arm ring or cord that I have found in a Buddhist work also characterizes its cord as a "weapon averter." It is in the late fourth- or early fifth-century text called in Chinese the Wuming luocha ji, the Collection of the Ignorant Rākṣasa. In one of the central tales of this work, a king ventures out of his palace alone to do battle with demons who have laid waste his capital city. The monarch girds himself for the fight in a way reminiscent of the preparations of King Brahmadāna described in the Scripture of the Wish-Fulfilling Spell. Along with rubbing his body with powerful medicines, donning "the armor of the Wish-Fulfilling Jewel" (ruyibao kai), and taking up a sharp blade, he "ties an incantation cord (zhousuo) to his body."[55] This small detail—which reflects the practice of wearing "sacred threads" seen in Indic cultures even today, and which are found in dhāraṇī manuals as "spirit threads" (shenxian)—reappears in later ritual manuals, where it is enlarged and described in more detail.

In Buddhist ritual texts, the enchanting and wearing of an incantation cord is usually one among a few different means for the application of the potency of spells to the body, including direct enchanting and the spreading

of spell-empowered substances, such as ash, onto the body. Jñānagupta's (523–600) late-sixth-century *Rulai fangbian shanqiao zhoujing, The Incantation Scripture of the Thus-Come One's Skill in Means* offers two versions of a typical rite whose objective, protection from plague, demons, and enemies, shows once again the somewhat narrow purview of bodily incantation rites and their conservatism over time.

Should any good sons or daughters wish to eliminate illness, they should take a five-colored twine and knot it into an incantation cord. If there is a plague, they should take *sumanā* flower oil, and enchant it one hundred and eight times, then apply it to the body. A cure will immediately be effected. To protect your own body and make it secure and remote [from illness?], enchant water one hundred and eight times and scatter it to the four quarters in order to secure the ritual space. Take a five-colored twine, knot it into an incantation cord and wear it where you go.[56]

Should any good sons or good daughters be in the grips of evil demons, they should take a twine and make it into an incantation cord, enchant it one hundred and eight times and wear it whether they walk or sit. This will rid them of all such evil demons. They should as well take *sumanā* flowers, good and pure cow butter, white mustard seeds, or other such things, and, establishing a [ritual] place, chant the spell each time one part of these is cast into the fire, continuing in this way one hundred and eight times. At the one hundred and eighth time the cure will be effected. Should an evil person desire to do you harm, take a blade of fine iron and enchant it one hundred and eight times. Cut the road the man walks; he will then not be able to do harm. Alternatively: enchant water and scatter it to the four quarters, forming in this way the four quarters of a ritual space. Occupy its center. No evil will be able to attach itself to you. Should one wish to protect oneself and be safe from harm, take a five-colored twine and make it into a rope. Enchant it one hundred and eight times and wear it whether you walk or sit.[57]

Xuanzang's mid-seventh-century translation of the *Amoghapāśa-dhāraṇī-sūtra,* the *Bukong juansuo shenzhou xinjing,* or *The Heart Sūtra of the Spirit-Incantation of the Unfailing Lariat,* a central text of the cult of one of the so-called "esoteric forms" of Avalokiteśvara, places the creation and wearing of incantation cords

within, once again, a larger field of practices for securing both bodies and spaces from harmful influences.

> For misfortunes of cold or heat and for feverish illness, one should enchant a knotted twine twenty-one times and tie it either to the neck or to the arm—all illness will immediately dissipate. Alternatively, enchant butter, oil, or water twenty-one times and give it to the patient to ingest—he will immediately be cleared of illness and cured. Those who wish to be freed from another's incantations and curses should take a substance such as mud, dough, honey, or wax and use it to form his image [that is, that of the offending sorcerer]. Orally chant this spell while holding in your hand a hard blade. With feelings of great compassion and mercy for the sorcerer, cut the image. Furthermore, with an enchanted twine tie up the wearied body [of the image?]. This will cause all fear immediately to be cleared away and cured. For all pains of the abdomen, one should enchant salty water and give it to the patient to be ingested—the pains will thereby be dissipated and cured. For all bites or stings of venomous creatures such as snakes or scorpions, enchant water and have the patient drink it, then enchant mud and spread it on him—he will immediately be cleared and cured. For all ailments and pains of the eyes, one should enchant a white twine and tie it to the ears—one will immediately be cleared and cured. For all tooth ailments or pains, one should enchant acacia wood twenty-one times and then chew on it—one will immediately be cleared and cured. For all terrifying places, one should seal a ritual space (jiejie) there and dwell within it. Here is the method for sealing the space: enchant a five-colored twine twenty-one times and wrap mountain stakes (shanjue) in it, then nail the four corners of the space with the stakes—you will then immediately achieve fearlessness.[58] All who desire self-protection should enchant twine and wear it on their bodies. Alternatively, they can enchant water and ash and sprinkle it over their bodies. All those whose bodies have been possessed by demons, spirits, or faeries should enchant five-colored twine and constantly wear it—they will immediately be released from the hold of these beings.[59]

Most of these techniques, with the notable exception here of the ritual manipulation of a simulacrum, are from one perspective, reductive but illuminating, a single technique: the application of a dhāraṇī to afflicted parts

of the body through a physical medium such as twine, oil, water, wood, ash, or mud. Their bodily focus also connects them within a larger set: the securing of some locality, whether it be the physical person, the home, the city, or the nation against harm from such menaces as storms, plagues, enemies, or demonic attack. The basics of the rites in this larger set, again, are in general the same as those we see in this passage: an incantation, through the medium of a physical object or substance, is physically placed in a way that it confers protection (from a conventional and rather small set of dangers) over the chosen area.[60] This, in broad strokes, is the nature of the family in which we find the practices of the dhāraṇīs of Wish Fulfillment and Glory.

Within that deceptively simple family, however, and sticking for now only with bodily techniques, revealing distinctions in the precise logics of its members' enactments can be discerned. As I began to explore in the previous chapter, two principal distinctions in that logic, which in fact structure the central portion of this book, are at play in this passage: that between the direct application of an incantation to the body—through such means as the chewing of enchanted wood or the smearing of enchanted mud onto the flesh—and the wearing of an incantation-empowered object. In both modes the physical presence of the incantation is key. Yet the styles of interaction with it differ in ways that, when they are spun out, outline rather different modes of human behavior, and contrasting metaphors and ritual poetics: anointment and adornment. Granted, in the three passages quoted above this analytical distinction is faint, and given that no distinctions at all are made in the texts themselves it may perhaps be questionable in those specific contexts. Yet, when one situates these small objects (strings, bits of wood, handfuls of mud and ash) and practices (wearing, biting, smearing) within broader trends in the history of Buddhist practice, as I do in this chapter and in the next, small distinctions such as this one grow large. When the family of practices of which they were part is traced out in larger sets of ritual behavior, wider and separate realms of practice and imagination are revealed. Iron-head Jiao's armlet and its cousins are best understood as part of a family of adornment practices, rather than one consisting of images of simple bodily contact or unction such as those featured centrally in the rites of the Incantation of Glory. I thus leave aside exploration of the latter set of practices until the next chapter and turn now to a more focused discussion of the wearing of enchanted objects and inscribed enchantments.

In later texts of the more ritually integrated Buddhist Tantras, somewhat more elaborate armlets (bichuan)—though not yet it seems the metallic variety found in Tang tombs or (as we will see) figured in statuary—take the place of

the simple knotted incantation cords in some ritual milieus. These rings, consisting primarily of pearls or seeds, often "seeds of the Tree of Awakening" (or their ritual stand-ins),[61] strung together and enchanted, become (along with "spirit threads" and other objects) standard parts of the protective armor the spell caster—the *mantrin* or *vidyādhara*—dons as he prepares himself for his rites. Such "personal protective objects" (*hushen zhi wu*), as they are called in the eighth-century Chinese translation of the *Susiddhikara-sūtra*,[62] an early Esoteric text of pivotal importance in the history of the ritual use of apotropaic armlets, hark back to the king in the *Ignorant Rākṣasa* tale and his incantation cord, as well as to the neck circlet of the *Incantation of Wish Fulfillment* worn by King Brāhmadāna. The ritualist girds himself for entry into the mystic arena in the same way, and for the same reasons, as does the warrior king on the verge of the battlefield. Here again we can note the "dual track" development of ritual methods: the pre-Esoteric use of protective rings, taken in one direction via dhāraṇī practice into the elaborate preparations of Esoteric rites, yet maintained in non-Esoteric practices (those of the Chinese tombs, for example, along with those of our kings and wanderers) as wards against the perils of this life and the next.

It is on images of deities, however—often painted as the devotional foci of dhāraṇī and Esoteric rites—and in the written prescriptions for their creations, that we most often find the sort of metallic armlets evidenced in the Chinese tombs. Such images and accounts provide the final ingredient in the practical history connecting the tomb armlets to their cousins in earlier Indian Buddhist ritual practice. The creation of devotional images, whether in geometric maṇḍalas centered in the ritual arena, or on walls to its side, is in most dhāraṇī and Esoteric rites a key element in the setup of the ritual space. The texts are very specific about the images to be depicted; in fact they often consist in fairly large part mainly of iconographic descriptions detailing not only the visual character and number of arms, heads, and eyes possessed by each divinity but importantly as well the specific shape, color, and placement of its adornments. Among these divine accoutrements armlets figure prominently. A description of how to render the image of Hayagrīva Avalokiteśvara from the *Dhāraṇī Collection Scripture* provides a representative example, and one that makes clear the fact that armlets are among the most standard features of bodhisattva images—to the extent that they often do not require special iconographic descriptions of their own. After relating the expressions, colors, and dispositions of the image's four heads, and the positions of its arms and legs, the text notes: "aside from these, its armlet and divine apparel should

all be in accord with bodhisattva images painted elsewhere."[63] In other texts more specific renderings are required. Amoghavajra's version of the *Scripture of the One Syllable Wheel-Turning Ruler Spoken at the Seat of Enlightenment* specifies that in painting one particular armlet, it should be made to appear of "pure gold." "Make it the color of Jambūnada gold," the text says, indicating the surpassing golden hue of the sands of the river that passes between the jambu trees of Buddhist legend.[64]

The adornments of deities, furthermore, their specific characters and positions, mark each divinity as itself. Visually, but also in terms of Buddhist ritual imaginations, they are the very substance and nature of the deity, to the extent that many divinities—most notably "Vajra-Wielder" (*Vajradhara* or *Vajrapāṇi*) and "Unfailing Lariat" (*Amoghapāśa*)—are defined and identified nearly entirely through what they hold in their hands. This idea of the specialized characters of individualized gods (perhaps not unlike pantheons of other traditions that feature gods of "the forge," etc.) is elaborated in Buddhist tradition in part through the concept of *samaya* (*sanmeiye*), the class name for these divine emblems. The polyvalence of this term, whose meanings range from "vow" to "communion" and "to rouse," as with so many important Buddhist terms—including "dhāraṇī" itself—is one key to understanding its resonance in the tradition. The adornments and implements of the bodhisattvas and other deities figure their particular potencies and concerns, or vows (in ritual manuals and spaces, in paintings and sculptures, in scriptural narratives) and offer important sites of communion, or interface, between human and divinity, and vivid objects of longing and devotional mimesis.[65] As Martin J. Powers has recently noted in a similar vein of materials from classical China, "every ornament is a *demonstration* of a set of human qualities. Whoever possesses the ornament possesses these qualities."[66] Emerging already in Dharmarakṣa's (d. 316) late-third-century translation of the *Jātaka Sūtra* we find prayers in Buddhism for the transcendence of human life that focus on the ornaments of bodhisattvas as metonyms for the divine state: "I would attain," a figure in the text declares, "the hundred necklaces and adornments [of the bodhisattvas], the armlets of jasper"[67]

In the context of the present study, the mimetic style of longing and devotion in Chinese religious history is perhaps best suggested by a juxtaposition of the image figured by the skeleton in the Jin River tomb (figure 2.1) with those of bodhisattva statues that survive from the first millennium CE. Armlets as standard features of bodhisattvas and other Buddhist divinities are not only found described in the ritual manuals of dhāraṇī and Tantric practice.

In line with the scriptural iconographic injunctions sampled above, bodhisatt-vas are very often depicted in Gandhāran sculpture with elaborate rings on their right arms—in precisely the position the nameless Chengdu Buddhist wore his simpler dhāraṇī-bearing armlet. I do not know of any text that tells Buddhists to mimic the adornments of bodhisattvas on their own persons, but such modeling was, along with the tradition of enchanted cords outlined before, perhaps part of the reason for the placement of the Chengdu armlet.[68]

But there is another and simpler reason why both corpses and statues bore armlets at the same location: the bodhisattva arm rings and the enchanted armlets described in the ritual manuals and dhāraṇī scriptures were part of the same ancient heritage of pratisara amulets, a heritage that found one of its most explicit and canonical forms in the Mahāpratisarā Sūtra. These small objects and their practices connect in an identifiable subtradition of practice and legend the Gandhāran bodhisattvas and their beautiful adornments, the kings of legend bearing incantation cords onto the field of battle, the man-trins of the scriptures preparing for their rites, and our Chinese laypeople in their tombs. The richness and complexity of the practical tradition these figures represent comes into yet clearer focus when the dhāraṇī armlets are considered more closely in relation with the tradition's other objects. Though Buddhists such as Iron-head Jiao carried forward, perhaps consciously, what was by their time a centuries-old practice of wearing enchanted arm rings, or pratisara, the new forms of their amulets appear to have been in a crucial way unprecedented. The physical inclusion of an inscribed spell (whether handwritten or printed) though carrying forward the old logic of empower-ment by incantation, was an important technical innovation from the simpler sonic enchantment of an arm cord. As far as I have found, there are no explicit accounts of what lay behind this change in material religious practice, but one might speculate that, as a purely technical innovation, it may have been an adaptation at least in part inspired by the textual reliquary practices sur-veyed in the previous chapter—the insertion of a brief text within a stupa—and other styles of amulets, evidenced also on the Gandhāran statues and explored later, which by the eighth century had widespread and ancient cur-rency across Asia. Simply based on the historical chronology and the family resemblances among this group of objects, it would seem that the incantation cords, the metallic armlet adornments of Buddhist deities, and the tradition of placing potent phrases within cases for various purposes came together, as it were, in the form of the dhāraṇī armlets. These objects were thus (at least) triply resonant in practical tradition and religious imagination.

Though they describe not arm rings but cords to be tied to the neck—also, as I have noted, an important site of dhāraṇī interventions on the body and another basic form of *pratisara*—there are scriptural tales that give somewhat more specific instructions for the construction of dhāraṇī amulets combining the forms of incantation cords and the wearing of written spells told of in the *Mahāpratisarā* scripture. Descriptions such as these may help in the historical connect-the-dots I engage in here in an attempt to give a useful account of the armlets and their practices. The *Dhāraṇī Collection Scripture*, an anthology dating in China to the early 650s, or only a few decades before the translation of the *Scripture of the Incantation of Wish Fulfillment*, contains for example the following instructions:

If there is a sick child of twenty years old or younger, make a spell-cord of five-colored twine with fifty-four knots. Grind cow bezoar as ink and copy (*chao*) this spell onto a piece of silk. Wrap [the silk] within the spell cord and tie it to the nape of the sick child's neck.[69]

This prescription recalls the monk of the *Wish-Fulfilling* incantation's scripture who was saved from the tortures of hell when a compassionate Buddhist tied the incantation to his neck. Taken with the other evidence, the passage offers a further example of the continuities and innovations that characterized this amulet tradition, here illustrated by the (quite literal) tying together of incantation cord and inscribed spell. Furthermore, two amulets found in Chinese tombs might offer yet more important evidence in this regard. One, dating to 927 and found in a tomb in Shijiawan, to the east of Luoyang, seems to have been tied to the neck of the corpse—no doubt that of the layman named Xu Yin, to whom the print was inscribed in its colophon.[70] The other, discovered in a tomb near the Tang capital of Chang'an, inscribed to a layman surnamed Wu and dating perhaps to the eighth century, was found in a device that may have been a kind of necklace as well.[71] The tombs preserve what seem to be relatively late versions of these instruments of practice: not strings binding enchanted seeds or inscribed silks, but copper and silver cases bearing spells encased and protected within them. Objects in the older styles would have been far more fragile against the corruptions of time; if Chinese corpses were adorned with them they would likely not have survived. At the moment we cannot know if they ever existed in China in those contexts, whether in tombs or otherwise. But taken together, the textual accounts and the archeological discoveries, in both their clear basic resemblances and stark differences, offer beguiling objects for historical analysis.

Dhāraṇī Amulets from Gilgit, Khotan, and Lands to the West

Examples of textual charms found in Gandhāra, nearby in Gilgit, and in much more distant Khotan present suggestive evidence for the kinds of textual amulets, including those featuring dhāraṇīs, that were in use on the roads and in the kingdoms to the west of China. Indeed, if we expand for a moment the relevant field to include all textual amulets rolled and placed in capsules that were either carried or worn on the body, the Chinese tombs appear to have been part of a very broad landscape of practice, indeed. As scholars such as Don C. Skemer and Roy Kotansky have demonstrated, textual amulets have been discovered in such forms in sites located "in every corner of the Roman Empire,"[72] as well as in Egyptian sites dating to the Byzantine periods, in Iranian sites from the sixth and seventh centuries CE, in Arabic materials of a similar age, among many other areas.[73] The material containers of some of these textual amulets, and the ways they were worn, bear striking resemblances to Chinese examples, in particular to the capsules that seem to have been worn as pendants. Talismanic texts that were folded, rolled, then slipped into leather pouches or capsules, or into metal tubes, and then worn around the neck as pendants, have been found in a number of sites, including sixth- and seventh-century examples written in Eastern Syriac from Iran and others in Greek from Byzantine Egypt with elements drawing on Christian, Gnostic, and pagan sources.[74]

Returning to regions closer to China, the Gandhāran examples, some of which date to the fourth century CE, consist of small rolls or "twists" of birch bark inscribed with texts such as prayers and the *ye dharmā* "creed"[75] whose uses, though they remain difficult to determine for certain, scholars such as Richard Salomon have connected with dhāraṇī amulets.[76] Birch bark was one of the surfaces most often mentioned in texts calling for the inscribing of spells, whether for use as relics or as amulets, in texts going back at least to the middle centuries of the first millennium CE. Indeed, as Salomon notes, "It is clear that birch bark texts were used as amulets, in both Buddhist and Hindu practice, for many centuries." He cites, for a very late example of this practice, the observations of G. Bühler, published in 1877: "[The] use of birch-bark for writing still survives in India, though the fact is little known. *Mantras*, which are worn as amulets, are written on pieces of *Bhûrja* [that is, birch]. . . . The custom prevails in Bengal, as well as in Gujarât."[77] As noted, Salomon emphasizes the difficulties in being sure about the functions of the small birch bark texts found in Gandhāra, but connects them implicitly with amulets. Given the wide spread of amulet practices in the greater South, Central, and East

Asian regions, the depictions we have of Gandhāran versions of these practices, and the seemingly perfect amenability of the bark-inscribed texts for such purposes, it would seem safe to follow him in seeing this connection here and to consider these manuscripts within the larger family of religious practices that included those of *Incantation of Wish Fulfillment*.

The Gilgit examples are much more obviously related to it. Small slips of paper handwritten with dhāraṇīs that Oskar von Hinüber has called "protective charms" (*Schutzzauber*), they are particularly relevant for this study, since at least one of them bore the text of a dhāraṇī labeled the "*Mahāpratisarā*."[78] These manuscripts are important as well because the texts of many of the dhāraṇīs, including the *Mahāpratisarā* example, contain inserted within them the names of the individuals (usually kings) whom the spells were to protect—as I will discuss in detail later, this feature is also found within dhāraṇī manuals in use in China.

The Khotanese amulet texts that have been discovered take a greater range of forms, from dhāraṇīs in Sanskrit to brief prayers or statements in Khotanese. An example of a dhāraṇī amulet contained in this material—actually, what seems to have been a model for the creation of such amulets included within a manuscript collection of brief and apparently unrelated texts—contains a version of the refrain common to its kind: using the Khotanese version of "dhāraṇī," the text promises benefits to "he who holds the *dāraṇī* of endurance [firmly] and recites it."[79] Though recitation of the spell seems, clearly, to be the main way the text enjoins one to enact it, the text's injunction to "hold the dhāraṇī" seems to refer not to the more abstract or spiritualized "grasp" or "absorption" of its text and powers seen in some accounts of dhāraṇīs (i.e., in the phrase *shouchi*) but the literal taking in hand of the medium the spell was inscribed upon while reciting it. Skjærvø's addition of the modifier "firmly" in brackets would seem to signal his agreement on this point. Evidence for other Khotanese amulets provide clearer evidence of their natures. One, another amulet model, consists of a rather cryptic assertion of protection in a cursive Middle Khotanese script that recalls certain Chinese genres of magico-religious charm. Skjærvø translates it as follows:

 . . . we shall not make *them weak.
 We shall not make him sick.
 Where
 this protection may be found
 of (= from) bhūtas and kalabutanas,
 there for seven leagues
 the dominion![80]

Most of the evidence we have for particular amulets, *fu*-talismans, and seals comes in the form of models for their creation found in manuscripts and in received editions collected in canons. Thus—as in the case of the "dhāraṇī-*fu*" discussed in the previous chapter and the *Mahāpratisarā* amulets discussed in this one—when we have what appears to be an actual example of an amulet it is precious indeed. The object known both as "CA Khot 10" and "Kha. i 50" seems to be another example. It is a strip of paper containing line drawings on one side of four human-looking figures in four different poses.[81] On the top is the lower half of a figure, possibly Vaiśravana, truncated when the sheet was torn, in recognizably Central Asian attire. His boot-shod feet are held in the hands of a reclining, or perhaps flying, figure wearing only a wrap around his waist and (perhaps) a necklace. Beneath these obviously divine figures kneel two men, clearly human and apparently naked, their hands in attitudes of supplication or prayer. On the reverse of the sheet is a short text identifying it as a protective amulet. Prods Oktor Skjærvo and Roland Emmerick, in their translations of the text, read this text quite differently. Emmerick, in his 1968 article "Some Khotanese Inscriptions on Objets D'Art," translates it as follows: "Sūrade (be my) protection at all times, by night and by day." Comparing this sentence with another similar one, he finds Sūrade to have been one among a set of "patrons of painters and scribes, who claimed their protection."[82] Skjærvo, in his 2002 survey of Khotanese manuscripts, takes "Surade," instead, to have been the name of the amulet's bearer. "May [this] protective amulet of Surade's protect him all the time, by night [and] by day."[83] Without needing to attempt a judgment on whose rendering is correct, we can simply note the presence of an amulet featuring, like the Chinese examples of those of the *Incantation of Wish Fulfillment*, the juxtaposition of text and image (perhaps, like on some of the Chinese amulets, images of bearer and deity), and, if Skjærvo is correct, the inclusion of the name of the charm's bearer.

THE AMULET SHEETS

The pendants and armlets were made and worn within a tremendously resonant and far-reaching tradition. Indeed, from a certain perspective, they were the single most important part of the tradition of dhāraṇī amulet practice in medieval China; after all, these rings, whether simple or ornate, were at least in practical contexts all that people would have seen of the incantations in their forms as periapts. The dazzling sheets rolled within them, intricately adorned with text and image, were invisible, perhaps in some cases even

forgotten. However, even setting aside their visual splendor, the sheets are, naturally, crucial to any study of the amulets and to their incantations. If the rings help answer the question "How were the incantations worn?" the sheets provide evidence to answer equally central questions such as "How were they written down?" and "What were the sociocultural situations in which that writing occurred?"

The *Scripture of the Incantation of Wish Fulfillment* is explicit in its own answers to the first question. Dhāraṇī sutras typically give clear instructions for setting up the ritual spaces in which their incantations are to be chanted. Such spaces, often named maṇḍalas, drawing on ancient pre-Buddhist Indic ritual traditions, involve careful demarcation of the boundaries of the space, sometimes by driving spikes into the ground at its corners and using them to rope off the sides—often using cords described in the same ways as the "incantation cords" surveyed before—and sometimes by other means. The internal ground was cleansed by digging out any impurities and structured by setting out various ritual implements, including bottles of water, butter lamps, flowers, and other objects, in the prescribed manner. The *Scripture* describes its own version of these altars in the following way:

Great Brahmā then said to the World-Honored One, "If one wants to copy out this spirit incantation, what is the rite?" The Buddha told Great Brahmā, "One should secure an altar. At the four corners of the altar set out bottles filled with fragrant water. Within the altar draw two lotuses, or three, or four, or five. Around the four sides of the altar make an awn of lotus blossoms. Make a single large open lotus flower, and suspend from its stalk a band of silk. Further, make an eight-petaled lotus flower. Upon each petal make one three-forked *ji* halberd. Suspend from it a band of silk. Make another eight-petaled lotus flower. Within the center of that flower make a vajra-club, with another club upon each of the petals. Suspend from it a band of silk. Further, make another eight-petaled lotus flower. Upon each of its petals make a *yue* hatchet. Further, make another lotus flower. Within its center make a knife; from its stalk also suspend a band of silk. Further, draw a sword. Upon the point of the sword make a lotus; from its stalk also suspend a band of silk. Make another lotus flower; within its center draw a conch shell. Further, make another lotus flower and within its center draw a lasso. Further, make another lotus blossom and within its center draw a burning pearl. Burn incense and scatter flowers; make offerings of food, drink, and fruit of

various kinds. If you are copying it out in order to wear the incantation, you should make an altar of this kind according to the rite. Other altar methods are not acceptable; they are mutually incoherent [*bu de*; *xiang za*]. Have the one who would copy the incantation first bathe clean and put on new clean clothes. Have him eat the three kinds of white food: cream, rice porridge, and rice. Do not ask whether one should use pure paper, bamboo, silk, or other kinds of objects. All are acceptable for use in copying incantations.[84]

The text then describes a number of different ways to compose the dhāraṇī sheets, depending on the person for whom they were to be made and the situations that faced them. Baosiwei's text lists fifteen different incantation and image configurations for, as I see it, fourteen different situations (the text gives two different sheets for women seeking to become pregnant).

1. If there is a woman who seeks a male child, then one should use cow bezoar to write it. On the silk surface, first write the incantation out towards the four corners. Inside [the incantation] draw a child adorned with jeweled necklaces. Raised at the level of his throat, [the child] should hold a golden bowl filled with precious gems. Further, in each of the four corners draw a child wearing armor. Also make various kinds of seals.[85]

2. If a wheel-turning king is to wear it, then within the center of the incantation make the forms of the Bodhisattva Guanshiyin and Śakra. Above them make various kinds of Buddha seals—all the good spiritual seals should be completely provided. Further, in the four corners make the Four Heavenly Kings, with treasure adornments appropriate to each direction.

3. If a monk is to wear it, then in the center of the incantation draw a single Diamond Spirit adorned with jewels. Below him make a monk kneeling in the hu-style with his palms together. The Diamond One has his hand upon the top of the head of the monk.

4. If a Brahmin is to wear it, then in the center of the incantation make a Great God of Sovereignty (Maheśvara).

5. If a Kṣatriya is to wear it, then in the center of the incantation make a Maheśvara.

6. If a Vaiśya is to wear it, then in the center of the incantation make a King Vaiśravaṇa God.

7. If a Śūdra is to wear it, then in the center of the incantation make a kinnara god.

8. If a male child is to wear it, then in the center of the incantation make a kumāra god.[86]

9. If a female child is to wear it, then in the center of the incantation make a Prajāpati. In the plans for [different] wearers described above, all the gods and spirits depicted within the center of the incantation should have youthful forms and joyful visages.

10. A woman who wishes to become pregnant should make a Mahākāla spirit within the incantation, its face black in color.

11. If it is to be suspended from a tall pillar (chuang) then the tall pillar should be erected at a high place. A fiery pearl should be placed at the head of the pillar and within it this spirit-incantation should be secured. All evil obstructions that exist and all sicknesses will without exception be eliminated.

12. If there is a drought make a nine-headed dragon within the center of the incantation. If there is lingering excessive rain then also make this dragon. Secure it within waters where dragons are. If there is a drought then it will rain; if there is excessive rain then the skies will clear.

13. If a merchant is to wear the incantation, then make the form of a merchant leader within the center of the incantation. Those merchants they take [under their command] will all attain ease and joy.

14. If the one who holds this incantation wears it for the sake of pleasure, then make a goddess within the center of the incantation, and also make within it the stars, the sun, and the moon.

15. If an ordinary person (fanren) is to wear it, simply copy out the spell and wear it.[87]

SUBSTANCES OF THE SPELLS

Though ritual manuals typically claimed that any surface was suitable for the writing of spells, they tended to be much stricter about the nature of the "ink" to be employed. The Scripture only mentions one substance, "ox yellow" (niuhuang, Skt. gorocanā), a term referring usually to ox bezoar but sometimes, and especially in medieval China, to hardened formations from the animal's bile duct.[88] Ox yellow was in fact one of the most commonly prescribed medicinal/magical substances in dhāraṇī manuals; it was to be smeared on the body, on incantation cords, or enchanted directly on its own or when mixed with other potent substances.[89] Gorocanā, furthermore, is one of the central ingredients in the tilaka, a mark made on the forehead in Indic cultures.[90] It was (and remains)

one of the most prized drugs of traditional pharmacopeias. Edward Schafer noted that "[among] the drugs of animal origin none had more repute in China than the bezoar."[91] Tao Hongjing, a central figure in the early Daoist tradition, observed around the year 500 that "cow's bezoar was the most highly prized and costly of all medicines."[92] The best Chinese bezoars, which were valued in lands as distant as Persia, were thought to come from what are today the provinces of Shandong and Sichuan.[93] The use of bezoar in Daoism and other native Chinese traditions was also prominent, particularly in seal rites. The association with these techniques was especially close: As Strickmann notes, "there is no doubt that, early on, seals were identified metaphorically with the wonder-working bezoar."[94]

In terms simply of their material substances, written spells were often indistinguishable from many of the other objects that, as discussed in the previous chapter, were to be worn on the body (or smeared upon it, in ways not unlike those in which incantations were to be smeared-spoken onto the body). Just as one was to wear drugs such as bezoar for their efficacies, and to enchant them as doubly potent media of spell application, just so was one to use them to make material incantations. Realgar was another of the most commonly called-for substances in the writing of dhāraṇīs, as well as one of the most popular substances to enchant in other forms of dhāraṇī and Tantric ritual, at least in Chinese versions of their texts.[95] The connections that were obtained between worn spells and the sorts of mineral and vegetal amulets long popular in China, then, were not merely semiotic or discursive: on a basic material level they were often *precisely the same things*—at least as they were described in the normative texts. One could wear a bit of enchanted realgar as a periapt, or one could wear an incantation drawn with (and thus consisting of) realgar for the same purposes. Just as seals and certain drugs were closely related in native Chinese religious practice, dhāraṇīs and those same drugs— again, at least as their practices were described in texts—were at times very close indeed. The idea that Buddhist texts, or texts connected with the religion, were sometimes written with medically efficacious substances seems at times to have achieved the status of popular legend. Jonathan Chaves, in what he describes as a "curious footnote to the study of the relationship between calligraphy and Buddhism," noted that the Northern Song Dynasty poet Mei Yaochen (1002–1060) complained that the calligraphy decorating a certain Buddhist temple had been scraped away in so many places by people believing that its ink possessed curative properties that it "looked as if birds had pecked at it."[96]

The caveat suggested in the previous paragraph is once again crucial, for, turning away from the normative accounts of the dhāraṇī amulets and back to actual surviving examples, these alchemical substances and their traditions appear to be nowhere in evidence. The texts are simply written and/or printed in ink (though it is possible that chemical analysis of the inks used may one day find in them traces of substances such as bezoar, bile, or realgar). We have here, once again, the now familiar divide between the prescriptive manuals, which at least in the language of their translations drew heavily on ancient Chinese idioms and traditions, and the actual material traces of practice, which for the most part seem to have been structured according to other logics and dictates. Even a layman's glance at the paintings preserved on the walls of the Mogao grottoes, or the objects discovered at Famensi, readily confirms that by the eighth century Chinese artisanal and image-making traditions had attained an exquisitely high level of development. In crafting the amulet sheets, it is clear that their makers followed not the pharmacological/magical heritages of Ge Hong and the Indic dhāraṇī adepts but their own traditions.

VISUAL STRUCTURES OF THE AMULET SHEETS

The designs on the sheets tend to be concentrically displayed in three zones: an outer zone consisting of images of ritual implements, Sanskrit syllables, and/or deities; a middle range consisting of the inscribed incantation itself, whether in transliterated Chinese or in Indic script; and in the center an image either of a tableau of the empowerment of the donor/wearer, featuring a vajra-wielding deity, or a simpler image of the eight-armed bodhisattva Mahāpratisara, sometimes also including an image of the donor in a worshipful pose to its side. The arrangement can be either of concentric circles or squares.

Taken as a whole, the tableaux on the sheets appear to be diagrammatic representations of the rites of dhāraṇī incantation found in surviving ritual manuals, specifically those of the Incantation of Wish Fulfillment. Their centers render the focal point of the rite—either the action of empowerment or the icon of the incantation deity; the outer borders figure the ritual setup, which takes the form in Buddhist incantation texts of both physical implements and their bodily and mental/sonic counterparts, visually represented on the amulets in the forms of mudrās or seed syllables; linking them we have the dhāraṇī itself. Because of this ritual imagery, scholars such as Ma Shichang have taken to calling these objects "dhāraṇī maṇḍalas" or "dhāraṇī altars."[97] Indeed, as we will see, the visual structures of the sheets not only reflect medieval

prescriptions for the setting up of ritual spaces but they also closely mirror *sketches* for the creation of such physical as well as visual spaces found among the Dunhuang documents, including two that appear to have been models for the creation of amulets that make the connections between altar and amulet particularly clear.

Let us begin our examination of the visual structures and components of the sheets with their border zones. In order to understand their arrays of objects and figures, we turn once again to scriptural accounts of rites for the inscription of the *Incantation of Wish Fulfillment* and their descriptions of the designs of its amulets. It is immediately clear that this outer ring of imagery is not prescribed in them. The Baosiwei translation of the *Scripture* mentions only that the spell is to be written down and that an image reflecting the nature and needs of the donor is to be made in its center. Comparing that account with early surviving sheets—the "Yale," and "Jing Sitai" sheets, for example, (figure 2.3) and (figure 2.7)—however, the scriptural basis of the images that surround the spell is revealed. Though the matches are not perfect, the surrounding images bear a close resemblance to the objects that are either to be placed physically or depicted in drawings within the actual ritual space in which the sheets were to be fashioned. Vases adorn the four corners of both sheets, likely representations of the "bottles filled with fragrant water" that are to be physically set at the four corners of the ritual space. Similarly, among the images arrayed along the sides of the sheets are weapons sporting ribbons that are no doubt pictures of the silk ribbons suspended from weapons such as knives, swords, and halberds that one is to draw upon the ground of the ritual arena. Further, the scripture's injunction to "make [a] lotus blossom and within its center draw a burning pearl" would also seem to have been taken up by the amulets' makers, who executed images that, as we see, seem to represent exactly such lotuses and pearls. Though, again, the three sets of images (the scripture and the two amulets) are not identical in every detail, the resemblances are striking enough to make the sheets appear to have been conscious renditions of the rite as a whole. This resemblance becomes even more interesting, and opens out further into the world of the historical creators and buyers of the sheets, when we read the parallel account from the slightly later Amoghavajra versions of these scriptural passages into the mix.

In the Baosiwei translation it is clear that the silk-adorned weapons and fiery pearls are to be drawn onto the ground of the ritual site—but the Amoghavajra version makes it equally clear that the images are to be made instead *on the amulet sheets themselves*. After describing a ritual space demarcated

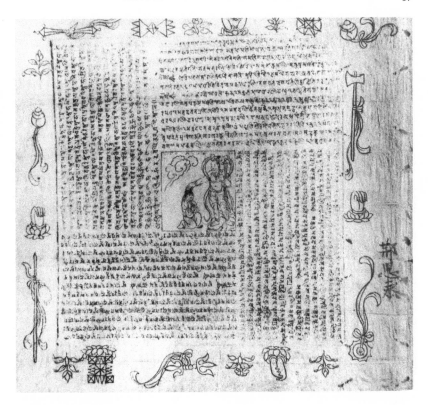

FIGURE 2.7
Jing Sitai amulet. Eighth century? Stamped and handwritten on paper (32.3–32.7 ×
28.1–28.3 cm).

by five-colored cords anchored at the four corners to spikes of khadiraka (acacia)
wood and adorned within with flowers, fruit, and incense, the Amoghavajra
text finishes with a statement echoing the Baosiwei version's assurance that
any kind of writing surface suffices for the creation of the amulets.[98] The
account then proceeds, as in the earlier translation, to prescriptions of spe-
cific renderings for specific donors or situations. Taking as an example a kind
of donor not mentioned in the earlier translation, we note the amulet to be
made for "a man who seeks sons." The amulet model that precedes this one
in the text, for women seeking sons, has "jeweled mountains" at each of its
four corners, a feature that seems to be included as well in the present design.
"You should use turmeric to write [the spell amulet]," the account begins (the
previous example was to be written with ox yellow). "That which you seek will
be achieved in its entirety. To the four sides of the zhenyan [that is, the spell]

you should draw various kinds of seals, and further draw lotus flowers—either two or three or four or even five lotus flowers. These flowers should all be open and spread out, their eight petals set close together, their stalks bound with silk ribbons. On the flowers draw a trident;[99] on the halberds further [draw] tied ribbons of silk. Further, draw a *yuefu* ax, also on the lotus flowers. Further, [draw] a white lotus—upon it you should draw a sword. Also on the [white?] lotus draw a conch. The lotuses that you draw should all [float] within a treasure pool.[100] Since a man is to wear it, you should not draw a child [in the center of the sheet, as is done with the amulet for a woman seeking sons given just previous to this one], but instead draw the shape of a god adorned with various gems."[101] For the most part, this tableau provides the template for all the remaining amulets described in the text—though in the case of the sheet to be made for monarchs, its four corners feature not bejeweled mountains but the four heavenly kings, figures we indeed find adorning the xylograph Li Zhishun amulet dated to 980 found at Dunhuang and discussed earlier (figure 2.2), though in other details that sheet is unlike any described in either translation.

Again, the images to be rendered in these accounts do not match those of any surviving amulet that I am aware of, but the shift in medium from the ground of the ritual space to the amulet sheet is striking and clearly of great significance for understanding the tradition in which the sheets were made. It is difficult, however, to be sure precisely how to understand this change. Given that most of the amulets show no sign that their makers followed the Amoghavajra version of the sutra—indeed, as noted earlier, what evidence we have suggests that it was the Baosiwei version (or, more likely, elements adapted from it) that was the favored text of the artisans—it is unlikely that the shift in design was a direct result of the new version's appearance on the scene. Instead, particularly given the other "deviations" from scriptural warrant that I will discuss later, it is far more likely that the direction of influence was the reverse of this. That is, it was the Amoghavajra version itself that reflected the visual structures of the amulet sheets then in circulation, as well as new practices of ritual icon painting, and not the other way around.

ALTARS AND AMULETS

Preparatory drawings found at Dunhuang, apparently for use in the construction of altars, both actual spaces and their visual idealizations employed in ritual practice, help both to clarify the nature of the amulet images and to place

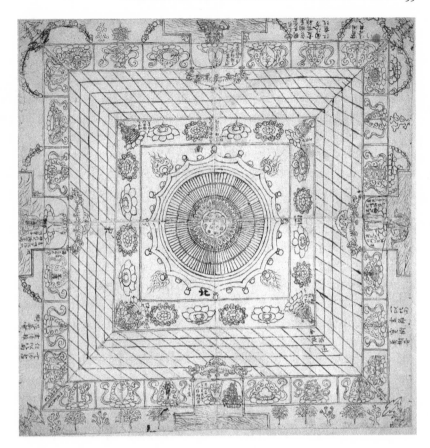

FIGURE 2.8
Altar Diagram ["Painting"], 1919,0101,0.172 (Ch. 00189). Ink and colors on paper.
58.5 × 57.5 cm. © The Trustees of the British Museum.

the sheets within wider traditions of ritual imagery and practice. Comparison
with altar diagrams such as Stein Painting 172 (figure 2.8), in fact, confirms
that the images on the amulet sheets belonged to the same family of ritually
potent images that included the iconic altar, or maṇḍala, used in Buddhist
incantatory rituals. This is clear not only in their general configurations—
the three zones characteristic of the amulet sheets are present as well on the
altar maps, though in necessarily more generalized form—but especially in
the small details of their outer sections. A comparison of the border zone of
Stein Painting 172 with those of the amulets reveals that many of the images—
plants, fungi, weapons, gems, and wheels—are nearly identical.[102] More than

this, the dynamic, even *activated*, nature of the images rendered on both Stein Painting 172 and the amulets is striking. The swords, for example, are not simply inert metal objects placed in a certain way: their coronas of flames visually suggest that these swords are active in their particular efficacies, in keeping with the ritually active nature of both types of image. The wheels, gems, and other motifs are also figured in this way. Were the diagrams simple maps for the placement of objects and images on the ground of the *daochang*, the arena in which bodily action was engaged, such visual flourishes would hardly have been necessary. Indeed, on other altar sketches such as Stein Painting 174 (figure 2.9) a map of an altar for use in the recitation of the *Incantation of Glory*, the images of lamps and water bottles were drawn much more simply. They are not aflame with ritual transformation; they are merely lamps and bottles depicted in the flatter utilitarian frame of everyday action. The incipient state of our understanding of all these images imposes the need for caution in our claims about them, yet we seem to have two different types of altars here, each with its distinctive type of map. The first type, including Stein Painting 174, apparently depicts a space to be constructed out of actual objects placed in certain ways on the ground or the floor of a temple or other sacred space. The second type, including Stein Painting 172, is composed of far more intricate images whose components are anything but simple. Stein Painting 172 seems, in fact, to be a drawing of a drawing: a sacred image of the sort indicated by the term *maṇḍala* in its later usage in the Esoteric Buddhist tradition, where the "altar" space is not to be physically entered—does not structure the physical performance of a rite—but is instead an image offering blessings and divine presence. Altars of this second type are potent objects rather than fields of human ritual action.[103]

The close relationship between the Dunhuang altar diagrams and the amulets is clear in the instructions found in the two Chinese versions of the *Scripture*. It is clearest in the case of the Amoghavajra version, which (as noted) instructs its reader to draw an altar on the surface of his amulet sheet rather than on the ground. But the iconic nature of the altar is suggested as well in the more influential Baosiwei version by the absence of instructions in the text to enter the altar space physically. If we consider Stein Painting 172 as a representation of the kind of altar alluded to in the Baosiwei text, the iconic nature of the sutra's altar becomes even more apparent—for the image on the diagram also provides no space for the practitioner. Thus, it could hardly be the image of a space for actual ritual activity, such as those described in many other ritual manuals. Some *dhāraṇī* manuals, in fact, enjoin the practitioners

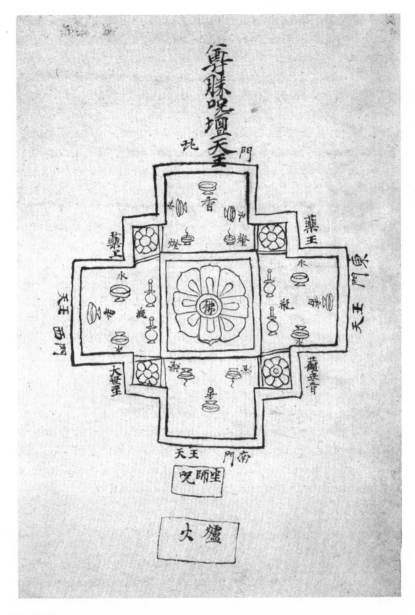

FIGURE 2.9
Altar for the recitation of the *Zunsheng zhou* (*Incantation of Glory*). ["Painting / Mandala"].
1919,0101,0.174 (Ch.00186). Tenth century. Ink and colors on paper. 39.9 × 17 cm.
© The Trustees of the British Museum.

to copy out the spells to the sides of altars.[104] Renderings like Stein Painting 172, in this regard, appear to have been intended to be placed to the side of the spots where ritual actions, such as the inscription of a dhāraṇī, were to occur.

Sarah E. Fraser has suggested that the employment of the verb *to use* (*yong*) rather than *to draw/paint* (*hua*) in the corrections made to the details of Stein Painting 172 indicates that the images were not to be painted or drawn but to be rendered using sand in the manner of the "sand mandalas" common in Tibetan Buddhism today.[105] This is indeed very likely, though the material used was more likely the substance known in a range of ritual texts simply as "powder" (*fen*).[106] The diagram would seem, in fact, to be the earliest material evidence in China for the "powder altars" that had been in use in Buddhist ritual since at least the middle of the fifth century, and in Śaivite and other Indic ritual traditions before that. Such altar forms seem to have come especially into vogue in China during the tenth century—the age, most likely, when Stein Painting 172 was executed.[107]

Most importantly for our purposes, the iconic nature of the altar mandala to be rendered near the dhāraṇī practitioner suggests that altars and amulets were in key ways—functionally as well as visually—identical. Once a *tan* ("altar") comes to be conceived as an iconic representation of a ritual space rather than as an actual space in which a practitioner enacted a ritual, the efficacies of its presence on the ground beside one are clearly very much like those of its presence on one's arm, or tucked within one's sleeve. Distinctions between amulets and altars collapse in that particular ritual frame wherein sign and signified are one: an image of a sacred space is the sacred space, with all its attendant potencies; an image tucked in a ring or a *vajra* coruscating with blessings is none other than the very thing it depicts.

TRANSITIONS IN AMULETS AND AMULET CRAFT

Returning to the amulets, we come next to the Indic syllables of the spell itself, whether transliterated into Chinese characters or rendered (with varying skill) in Indic script in the intermediary zone of the sheets. Like the amulet sheets taken as wholes, the texts of the incantations fall into two stylistic groups: earlier and later. In the early style examples—again, manuscripts and half-xylographs—the spells and central images often take a personalized character, featuring the names of the donors who wore them and the imagery of personal empowerment; in the later style examples, which are all xylographs, the incantations are almost never personalized, images of personal

empowerment rarely occur, and (interestingly, since they more often quote the *Scripture*) the central images pertain to iconographical traditions quite different from those evidenced in either extant Chinese version of the *Scripture of the Incantation of Wish Fulfillment*.

This shift in the format of the amulets seems in part the result of a shift in the techniques of their production. Whereas the older examples carried forward a trans-Asian tradition of Buddhist incantation amulets, later versions, fully xylographic, were shaped in key ways by local versions of later traditions, including those of Esoteric Buddhism (particularly its systematic practices of eidetic contemplation) and the maturing Chinese craft of woodblock printing (which seems to have absorbed certain elements of Chinese Buddhist painting practice). This transition saw the loss of the widely-evidenced custom of personalizing the potencies of the spells themselves, and of designing the images and texts entirely as blessings for the specific individuals who were to wear them. With the transition to full block printing, the names of the donors were, in keeping with the conventions of most of the other Chinese merit-making images of the age, relegated to colophons located at the lateral or bottom margins of the sheets, away from the main action of the incantation. Coincident with this marginalization of the donor was a shift in the iconography of the central images away from those inspired by the *Scripture* to images of the multiarmed forms of the Bodhisattva of Wish Fulfillment (Suiqiu *pusa*) then spreading across Buddhist Asia, as sculptures, as paintings, and as descriptions in ritual and iconographic manuals for visualization practice.

MANUSCRIPTS AND HALF-MANUSCRIPTS

A striking difference between amulets of the earlier style and those of the later style is the presence in the former of bearers' names within the incantations. We encounter names such as Madame Wei, "Iron-head" Jiao, Jing Sitai, Xingsi, Chen Chouding, and "A-luo" written into blanks left in the texts of the incantations.[108] This feature, which is part of the dhāraṇīs as they are found in their scripture, reflects wider Indic dhāraṇī amulet culture; it points, once again, to a trans-Asian set of practices extending well into China. The modern Taishō edition of the Baosiwei translation includes two different versions of the dhāraṇīs, one based on the Koryŏ edition and another on the Ming edition. The great disparities between the two sets of incantations extend to the number of times the spells call for the insertion of the name of the intended beneficiary within them. Though some scholars have argued that the insertion of

the donor's name within the dhāraṇī he or she wore was a Chinese innovation based on native traditions—the inclusion of the names of ritual beneficiaries within religious texts having long been common in China—this was not the case.[109] The version of "your name here" included in the incantations clearly drew on Indic conventions and was reflected elsewhere in Indic and Central Asian practice.[110] In a feature common to Chinese versions of dhāraṇīs, the relevant passage in both versions of the Sanskrit text of the *Mahāpratisarā* spell contains an explanatory note in Chinese. The texts read, "*Meme (moujia) xie:*" "*mama* (that is, 'I') copy."[111] Though, as noted, scriptural versions of the *Incantation of Wish Fulfillment* seem to call for the writing of the name within the spell, the only glosses we have on the meaning of the spell emphasize that, as in the *Incantation of Glory*, the name was to be verbalized along with the rest of the incantation. The Heian period monk Myōkaku's (b. 1056) eleventh-century glosses on the Amoghavajra edition of the spell, the *Dazuigu darani kanchū*, or *Collative Commentary on the Dhāraṇī of Wish Fulfillment*, translate/explain the passage in this way. After an incantatory passage that asks for the capture and destruction of all who hate, the spell proceeds with an interlinear gloss, given here in parentheses: "'Protect! Protect me!' (That is, the bearer: at this point call out your own name or the name of another, or say 'all beings,' or run them together: 'me and all beings')."[112] These glosses, clearly, were made for those chanting the spell, rather than wearing it as an incantation, but they give a valuable sense of how the spell was understood as a text.[113]

The Koryŏ version of the text of the *Incantation of Wish Fulfilment*—which the Taishō editors (as a matter of general practice) took to be standard—calls for the name to be included nine times in the main incantation and once within the ancillary spell known as the *Guanding zhou*, the "Spell of Consecration." The Ming edition calls for eight insertions within the main dhāraṇī and one each within the *Guanding zhou* and the *Yiqie foxin zhou*, the "Spell of All Buddha Minds." There is evidence that neither edition of the *Incantation* was fully normative in late medieval China, at least in the Dunhuang region—examples found at Mogao, including a model for the creation of *Mahāpratisarā* amulets, contain versions that combine features of those found within the Koryŏ and Ming editions. Of the six amulets containing names within their dhāraṇīs, the two that seem to be the earliest, the "Madame Wei" and "Jing Sitai" sheets, both include nine examples of their bearers' names. The monk Xingsi's amulet (Pelliot no. 3982) also contains nine instances of his name, which is inscribed "the disciple Xingsi (*dizi Xingsi*). The copyist, however, missed one opportunity to insert the name within the main "root" spell, which would bring the total

number to ten, nine within the "Root Spell" and one within the "Spell of Consecration," numbers matching the Koryŏ edition (though there are variations from that version elsewhere on the manuscript). Given its tattered state, the number of names included on the "Iron-head Jiao" amulet—which, recall, was hand painted (thus seeming early) but which contains an image of the eight-armed deity with the image of Jiao figured to its side as worshipper rather than as direct object of blessings (thus, as we will see later in this chapter, seeming late)—is impossible to determine. The "A-Luo" sheet, an apparently late xylograph that harks back to earlier amulet conventions, contains only five instances of its bearer's name, a number that doesn't match any received edition of the dhāraṇī. Chen Chouding's amulet (Pelliot no. 3679), a singular example in many ways, appears to contain at least two short spells, including a version of the "Spell of Consecration" in which his name is inscribed. Instead of saying that he "copied it" (xie), however, it states that Chen "receives and keeps" or "bears" it (shouchi), a statement echoed four times around the perimeter of the spiraling spell by the statement "the disciple Chen Shouding wholeheartedly bears [this amulet]" (dizi Chen Chouding yixin shouchi).

The two Dunhuang manuscript amulets are worth considering in more detail here. They are composed entirely of incantations surrounding a simple central image, with no representations of ritual implements, buddhas, or seed syllables, such as are found on all other known examples. Chen Chouding's amulet is smaller than most other examples. It was inscribed on a sheet of paper of light beige color, 23.6 × 24.6 cm, and had clearly at one time been folded (figure 2.10). It is unique among known amulets for the holes punched into it, which the Pelliot Catalog describes as showing possible traces of stitching.[114] The holes at either side of the unfolded sheet line up, indicating that they had been punched when the sheet was folded. If it had indeed been sewn at one time, it is possible that Chen wore the amulet folded and stitched into his clothing—a method otherwise unattested in the material record. The amulet is unique in other respects as well. It was inscribed upon its sheet half in black ink and half in red, in a progressively loosening spiral outward from the center. Its central image, too, is not found on other known amulets: the Chinese character an, the standard Sinitic transcription of the mantric syllable oṃ, placed at the heart of an eight-petaled lotus. Though this is not a feature (as far as I can tell) of Mahāpratisarā conventions in medieval China, an understanding of the nature of the Incantation of Glory elaborated in an eighth-century commentary may shed light here. That spell is said to be in effect an emanation of its first incantatory syllable, oṃ, described as a burst of radiance and sound—the

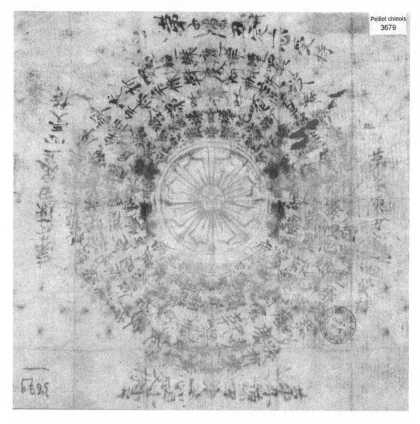

Pelliot chinois
3679

FIGURE 2.10
Chen Chouding amulet. Pelliot Chinois 3679. Tenth century? Ink and colors on paper.
23.6 × 24.6 cm. © Bibliothèque Nationale de France.

rest of the spell is said to simultaneously recount and enact the transformative efficacy of that initial burst.[115] The syllables on Chen's amulet clearly belong to those of the Mahāpratisarā set, but an overall incantatory figure similar to those of the Incantation of Glory may have been intended, though without any corresponding textual affirmation this remains speculation.

The monk Xingsi's amulet is also made up almost entirely of text—incantations following an introduction and brief ritual invocation—figured around a simple image at its heart (figure 2.11). It is relatively large, at 44.5 × 44.3 cm, and composed of two sheets mounted together.[116] The introduction and spells—consisting of all those listed in the Baosiwei translation—are arrayed in four triangular ranges centering on an image painted in color: an eight-petaled lotus surrounded by a square structure, with forms resembling (perhaps) leaves of

FIGURE 2.11
Xingsi amulet. Pelliot Chinois 3982. Tenth century? Ink and colors on paper, mounted on *mousseline*. 44.5 × 44.3 cm. © Bibliothèque Nationale de France.

the *bodhi* tree pointing inward at the cardinal points and floriate designs at the corners. The central image resembles those of architectural structures found at the tops of the ceilings of certain Mogao caves, which in turn were depictions of architectural features of temples. The triangular ranges containing the spell on the manuscript, which point inward to this quasi-architectural center, seen in this way take on the aspect of a four-sided ceiling angled inwards and upward toward the lotus blossom at its peak. The direction in which the spell was inscribed adds to this impression. Rather than starting from the center and moving outward, as the incantations of most other amulets do, the vertical lines of spell text begin at the bottom right corner of one range and proceed

leftward, expanding progressively upward until peaking in the six lines that reach the central square, then shrinking again until reaching the far left corner of that range. The text picks up again in the adjacent range and follows the same pattern. According to the architectural logic of the image, rather than beginning at the central peak and emanating downward, the spell begins close to the ground, the human level, and moves upward.

Jing Sitai's amulet sheet, dated to the middle of the eighth century, is also of particular interest in regard to the ways his name appears within the incantation (figure 2.7).[117] Unlike the hand-drawn central image and the ritual objects drawn at the periphery of the sheet, these syllables were either block printed or stamped—the latter more likely given the uneven distribution of ink—in four sections. Spaces on the block or stamp were left blank, suggesting a sophisticated amulet "business" capable of considerable flexibility in the production of sheets, and probably high output as well. As An Jiayao and Feng Xiaotang, the scholars who have most thoroughly analyzed the sheet, observed, the calligrapher who inscribed Jing's name does not seem to have been very skilled, certainly not at the same level as the makers of the sheet as a whole. The character *tai* in his name, for example, was written quite unsystematically, taking five different forms in the ten instances of the name (the tenth being the large inscription at the side of the sheet).[118] Here we may have hints of a tripartite division of labor: those who made the stamps (whose high level of ability, as evidenced by this sheet, An and Feng underscore); the artists who skillfully rendered the drawings within and around the stamped spell (the stampers and free hand artists may have been the same people); and the calligrapher, who seems to have been neither a "professional" nor very highly educated. Perhaps the scribe was Jing Sitai himself and the sheet represents his autograph—a tantalizing possibility, given how precious few are the actual material remains of individuals from the eighth century. Whether it was Jing or not, in the amulet sheet we would seem to have a physical trace not only of the "medieval imagination" of mystic potency and the visual translation of ritual processes but a trace as well of the sort of economic exchange that was the lifeblood of Buddhist institutions.

An and Feng, in a move the reader of this book will understand, trace part of the historical lineage of the stamps used in the creation of the sheet to Chinese practices of magical sealing such as those found in Ge Hong's *Baopuzi*.[119] Ma Shichang, too, noted that the uneven distribution of ink left by the blocks suggests the incantation was stamped onto the paper rather than truly block printed, a fact he further suggests might display an early stage of

printing technology.[120] Scholars such as Jean-Pierre Drège and Su Bai have also noted the important place of the amulet sheets in the early history of block printing in China, and others, especially Michel Strickmann and T. H. Barrett, have explored the close relationship between ensigillation practices and the beginnings of that history.[121] But in the case of Jing Sitai's amulet sheet, close examination of the forms left by the individual printing blocks on it allows us, I think, to suggest more precise possible historical connections between this particular object and that wider history. It requires, as Barrett and others have also noted, that we look not to the Chinese cultural heartland but to the Indic cultures to its west. The practice, discussed in the previous chapter, of stamping incantations and other brief texts onto clay stupas, where they then functioned as relics, inspired the creation of high quality stone stamps, such as the example from Kashmir shown here (figure 2.12). The dhāraṇī on this soapstone (steatite) stamp, which has been dated to either the seventh or eighth century, was carved in reverse onto the stone in a script identified as "proto-Sarada."[122] It has been identified as the *Bodhigarbhālaṅkāralakṣa*.[123] Both in its rectangular shape and in the visual character of the text carved in relief upon it, it resembles the stamps that would have been used to print each portion of the spell on Jing Sitai's amulet sheet, at least insofar as we can extrapolate such information from the impressions left by those stamps. We might speculate, then, that this stamp is a member of a family of objects that may have had a direct relationship with the stamping or crude block printing

FIGURE 2.12
Kashmiri *dhāraṇī* stamp. 1880.168. Seventh–eighth century. Steatite. 3 × 6.3 cm. © The Trustees of the British Museum.

technique used to produce the Jing Sitai sheet. We know that the Indian practice of stamping texts onto clay stupas was known in China from, at the latest, the middle of the seventh century, when Xuanzang published the account of his travels—though we should never assume that the discursive accounts of elite monks, or of scriptures for that matter, contained the earliest news of practical innovations, whether native or imported. It is very likely that, in the present case, Indic practices of dhāraṇī stamping had made their way into China before Xuanzang made his report in the imperial capital. But whatever the facts of its introduction into China, by the mid-eighth century, when Jing Sitai got his amulet, the practice had clearly been known in China for some time. Building on Strickmann's and Barrett's work, we can further note that the shape of this Kashmiri stamp and the shape of the printed impressions on Jing's sheet suggest the possibility that the printing technique evidenced there may have resulted from the adaptation of specific text-relic practices imported along the trade routes. Differences in ritual logic and doctrinal imagination aside—issues likely of little interest to artisans whose business was the improvement of their methods—specific techniques of producing incantations as relics and as talismans closely connected those two styles of Buddhist spell craft. But whether or not this particular Chinese technical innovation did in fact come to pass in this way, inspired by imported instruments, South and Central Asian practical connections are evident not only in the forms the spells took on the early group of sheets but in the names inserted within the texts of the incantations. As we have seen, examples of dhāraṇī charms from Gilgit, now northern Pakistan, display precisely the same forms of name insertion within their incantation texts, and may in many cases have been produced in similar ways.

The personalized dhāraṇī charms from China and Gilgit were, however, quite different in other ways. The Gilgit charms, which seem to date to the first half of the seventh century, are simple slips of paper shorn of imagery, bearing only the text of a spell and the name of the intended target of its protective influence; whereas, as we have seen, the Chinese examples are multilayered hybrids of text and image. The sociological locations of the two sets of charms also differed: surviving Gilgit examples were all made for royalty, while (at least so far) the Chinese amulets that have been found belonged to men and women of humbler station. There is, however, evidence of an exception to this trend within the Chinese evidence, one that suggests that a member of the imperial house wore a dhāraṇī amulet at least once. In 758 (Qianyuan 1), in the midst of the chaos of An Lushan's (d. 757) and Shi Siming's (d. 761)

rebellion against Tang rule, Amoghavajra, translator of the second Chinese version of the *Scripture of the Incantation of Wish Fulfillment*, made a gift to the Tang emperor Suzong (711–762; r. 756–762) of "one text of the *Great Dhāraṇī of Wish Fulfillment*, written in Sanskrit" (*Fanshu Dasuiqiu tuoluoni yiben*). Though it might initially seem that this gift consisted of the Sanskrit text of the *Scripture* itself, perhaps the one whose translation Amoghavajra would himself oversee, we next read that Amoghavajra urged the emperor, in by now very familiar terms, to "think on this seal and wear it at your belt" (*nian jian er dai zhi*), promising that benefits to his turbulent reign would result.[124] This detail, clearly, reveals the manuscript to have been an amulet sheet of the *Incantation of Wish Fulfillment*.[125]

The Gilgit charms and the early set of Chinese amulets point once again to a common culture of dhāraṇī amulet practice that traveled the trade and pilgrimage routes from the northern reaches of Indic culture, in Gandhāra and Gilgit, through the desert oases of Khotan, Turfan, and Dunhuang, to the medieval Chinese cultural centers of Chengdu, Chang'an, and Luoyang, and on to the eastern shores of the Asian continent. The presence of the practitioners' names within the texts of spells from both Gilgit and China adds a new level of detail to this picture. Not only are general similarities in basic form revealed in the material evidence from these far-flung sites—that is, that people wore dhāraṇī periapts in all of them and probably did so in similar ways—but we can now see that at nearly the eastern and western edges of this region even small details of practice were maintained. The material record, in this way, brings to life the abstract statements of the scriptures and peoples them with historical individuals: kings of Gilgit and emperors of China engaging in the same practices as humbler, and now often nameless, Buddhists of late Tang, Five Dynasties, and early Song China.

Like the images that adorn the outer rims of the early sheets, those at their centers rarely match scriptural accounts. The early manuscripts and half-manuscripts, in their depictions of vajra-wielding gods offering blessings to their bearers, are for the most part evidence instead of adaptations made in either partial knowledge of scriptural guidelines or only partial allegiance to them. The Yale amulet, dated to the mid-eighth century, wholly hand drawn and inscribed without any printed elements, bears at its center a tableau of empowerment similar to one prescribed in the *Scripture* (figure 2.3). Dominating the scene, slightly off-center and filling its portion of the square from top to bottom, is a majestic figure seated with legs crossed on an upturned flower that, convention indicates, must be a lotus. The figure's upright, half-naked

torso and rather feminine head are each wreathed in fiery aureolae, the latter's dark oval of fire contrasting strikingly with the lighter flames of the larger and rounder mandorla set slightly behind and below it. A faint mark on the divinity's forehead might be a third eye. A crown of jewels and (it appears) leaves adorns its head; it wears a necklace, an armlet high on its left arm, and bracelets on its wrists. Both according to scriptural accounts and in terms of the action of the scene, its hands figure the clear meaning of the tableau. In its left hand it holds a large *vajra*-club, marking the divinity as a "Vajra-Wielder" (*vajradhara* or *vajrapāṇi*)—clearly a representation of the "Vajra (or "Diamond") Spirit" (*jin'gang shen*) mentioned in the *Scripture*. Its right arm is extended with hand resting just above the black hair of a kneeling woman in robes, her palms together in an attitude of devotion and supplication. This woman is, of course, Madame Wei, the bearer of the amulet. An inscription flanking the tableau reads, "Received and borne in her 63rd year; the bearer (*shouchizhe*) Madame Wei wholeheartedly makes offerings."

The presence of the "Diamond spirit," as noted, recalls the scripture's manual for the construction of amulets and the multiple configurations listed in it for a range of possible bearers and needs. However, when the image is checked against those prescriptions it becomes clear that, strictly speaking, it does not really match any of them. The two prescriptions for female bearers in the received editions of the scripture—both for women seeking to become pregnant—call either for the depiction of a child bedecked with gems or one of a black-faced Mahākāla, the "Great Black God" (*daheitian*), like Vajrapāṇi a major figure in the then-developing Esoteric tradition. The only amulet described in the *Scripture* that calls for a vajra-bearing figure is intended for monks. "If a monk is to wear it, then in the center of the incantation draw a single Diamond Spirit adorned with jewels. Below him make a monk kneeling in the *hu* [or Central Asian] style with his palms together. The Diamond One has his hand upon the top of the head of the monk."[126] This description, clearly, is very close to the image on the Yale sheet—change "monk" to "female donor" and remove the foreign style of kneeling and we have a precise account of its central image. The "Diamond One" is indeed adorned with jewels, and its right hand reaches out above the head of the one it blesses.

This iconographical near miss becomes more interesting, and is revealed as further suggestive of Tang practical traditions, when we notice that at least one and perhaps three other Tang era amulets bear strikingly similar images at their centers, all of which come slightly closer to the details of the textual description than does the image on the Yale sheet. In the case

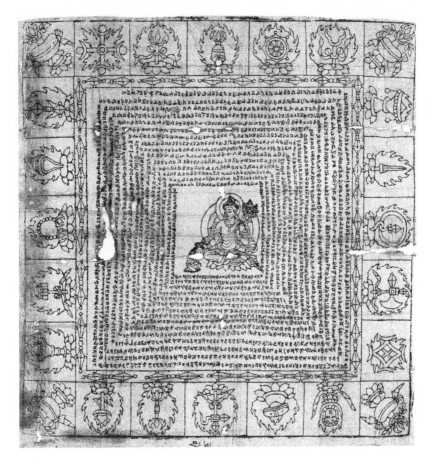

FIGURE 2.13
A-luo amulet. Tang Dynasty. Xylograph, ink and color on paper. 23.5 × 24.5 cm. After
Cheng, *Xi'an beilin*, 153.

of one of them, the "Jing Sitai" amulet, the resemblance is especially clear,
and I will focus on it. A possible second is found in the center of the "A-luo"
amulet sheet (figure 2.13). The object in the hand of its seated central deity
is unclear to me, though it certainly might be a stylized vajra. The possi-
ble fourth image in this group is a sheet found at the site of a metallurgy
works, which, like Jing Sitai's amulet, has been deemed partly printed with
spaces within the spell (between *meme* and *xie*, as directed in the scripture)
left blank for individualization. The image rendered in its central space is
partly damaged—the arms of the standing robed figure, which depict the

crucial action of the scene, have been erased through wear on the image at its folds, as have the head and upper torso of the figure who kneels before it, apparently "in the *hu*-style," which Ma has identified as female based on what can be seen of its clothing. As too little of this tableau's crucial details can be discerned, however, I will not consider it here, other than simply to mention it; but it does seem likely that it belongs to this set of empower-ment imagery.[127]

In the case of the Jing Sitai amulet, hand drawn in the center of the spell stamped upon it is a tableau that, like the "A-luo" and "Metallurgy Works" sheets includes the image of a donor "kneeling in the *hu*-style," with one knee on the ground. But, like Madame Wei, neither Jing nor A-luo were monks, as their portraits makes clear: both are shown wearing headscarves popular among Tang men,[128] and Jing has a beard. An and Feng, in their analysis of the sheet, noticed the discrepancy between the *Scripture* and this particular instru-ment of its enactment. They suggested that Jing, or the makers of his amulet, understood *seng*, the word for monk used in the sūtra translation to refer not only to monks but also to laymen.[129] As An and Feng did not offer any other instances of such construal in the historical record, however, it seems unlikely that this usefully accounts for a possible discursive source of the image. But the question of how to understand the relationship between the image and the scriptural account remains intriguing.

It is clear, however, that the appropriateness of the image of a Diamond Spirit for monks' amulets was indeed known, at least at one time, in the region near Dunhuang. Though we should recall that no actual amulet sheets bearing this precise image have been discovered there, two models for their creation, explicitly for monks to wear (*seng dai*), are among the manu-scripts discovered in the Mogao library cave (figures 2.14 and 2.15). They appear to be versions of the same diagram, the one in figure 2.14 perhaps left unfinished at an early stage of its drawing, and that in figure 2.15 more (or wholly) complete. Taking the more complete example as our focus, the manuscript known today as Stein 4690, both its prescribed central image and its incantations are (at least ultimately) traceable to the Baosiwei trans-lation of the *Scripture of the Incantation of Wish Fulfillment*. The rest of the man-uscript, as with all known amulets, seems to have been an improvisation based on local conventions.

The model centers on an eight-petaled flower set within two concen-tric circles, a form that overall resembles the "lotus platforms" upon which images of buddhas and bodhisattvas sit or stand. In the center of the flower,

FIGURE 2.14
Amulet model (unfinished). Tang Dynasty? Ink on paper, 31.5 × 37. © The British Library Board (Or.8210/S.6264).

reading vertically and from left to right, a text states, "[For] monks to wear: within the incantation make one Diamond Spirit." If we take "make one" (or, "make only one," *jinzuo yi*) to be an error for the *Scripture*'s "draw one" (*huazuo yi*)—the crucial characters being quite similar—then the two texts match perfectly, though the amulet model leaves off the rest of the description of the deity as well as the instructions to draw a monk "kneeling in hu-style with palms together, the Diamond One's hand pressing down on his head."[130] The spells, which are inscribed in Chinese script in two rows in square formation around the central image, match spells included in the *Scripture*. Interestingly, they include not the main incantation or any of those that are to be personalized with their beneficiary's name but a group of four ancillary spells that do not: the "Spell of the Consecratory Seal" (*guandingyin zhou*), the "Spell that Establishes the Ritual Space" (*jiejie zhou*), the "Spell of

FIGURE 2.15
Amulet model. Tang Dynasty? Ink on paper. 30.5 × 39.9 cm. © The British Library Board
(Or.8210/S.4690).

the Buddha Mind" (*foxin zhou*), and the "Spell of the Mind Within the Mind"
(or, perhaps, the "heart of the heart," "essence of the essence," or "spell
within the spell"; *xinzhongxin zhou*).[131] The texts of the incantations begin in
the inner row at the southeast corner of the diagram and spiral clockwise
onto the outer row, ending in the northeast corner. (If we take the text
describing the inner image as orienting the diagram's ideal reader, the sheet
was designed to have the western side at the top.) The first two spells make
up the inner row, the second ending once again at the southeast corner. That
the designers intended this is suggested by the fact that the final character
extends to the end of (in fact, slightly beyond) the frame described by the two
rows, which makes the outer row appear to extend the inner in the manner of
a spiral. The third spell begins there; it and the fourth travel three-quarters
of the distance around the central square. The remainder of the manuscript
consists of brief spells, often featuring the word *vajra* (*bazheluo*)—the "dia-
mond" (*jin'gang*) of the central deity's name—and the names of deities of the
directions arranged systematically. These include generalized figures such as
"the God of the Southeastern Direction," etc., as well as the famous spirits

of the four directions known as the Four Heavenly Kings. Just beyond the central image, at the intercardinal corners, are four invocations: "Veneration to incense!" (*nanwu xiang*), at the southeast position; "Veneration to blossoms!" (*nanwu hua*), at the southwest; "Veneration to lamps!" (*nanwu deng*), at the northwest; and "Veneration to scented water!" (*nanwu xiangshui*), at the northeast. These invocations clearly perform crucial functions in the amulet's basic nature as a ritually active image of a ceremonial space.

A final example of a manuscript amulet, also from Dunhuang but in many respects unique, shows that the amulets were used for more than purely personal empowerments. Known today as EO 1182, it is the only early style amulet I am aware of that features at its center an image other than an adaptation of the *Scripture*'s account of the amulet for monks.[132] It is a silk sheet, whose central image depicts a fierce deity brandishing a club, no doubt a vajra, striking a vital standing pose, with one foot on a raised lotus platform, before two kneeling figures—perhaps a mother and her son. It seems in fact to be a rendering of the amulet for women seeking sons, which the *Scripture* says should feature an image of the god Kumāra, here transliterated as *Jumoluo tian*. This deity is often called the Diamond Lad (*Jin'gang tongzi*), or Vajrakumāra, the name he is given in a range of dhāraṇī and Esoteric sources. The incantation just beyond this tableau is quite crudely inscribed, the seeming jumble of its arrangement made worse by the fact that it is sandwiched between an inner circle and an outer square (as far as I know, the only sheet with this combination). The spells do not match those of the *Scripture*, as far as I can determine; unlike other amulets, as well, the incantatory space contains the syllable oṃ (*an*) inscribed at each of the four intercardinal points around the inner circle, a fact suggesting that, despite the appearance of a jumble, the inscription was executed after some planning. The remainder of the surface space is made up of sections containing a wide array of images, some of which match those described in the *Scripture* and found on other amulets—tridents and vajras sporting ribbons resting on lotus blossoms, etc.—and others that do not. These include swastikas (one with an eye within each interior quadrant) and images of buddhas, bodhisattvas (including multiheaded figures), and holy men of various kinds (siddhas?). The amulet is hard to date or place, either in the picture I have given here or in the chronology of the other amulets, but the fact that it was hand drawn and inscribed on silk and contains a central image not found outside the *Scripture* suggests that it was made at an early date, outside the mainstream of the production of the amulets or perhaps before its conventions had taken hold.

XYLOGRAPHS, EPISODES, AND ICONS

The absence of names inserted within the spells of all but one of the full xylographs marks them as quite different sorts of objects from those of the earlier group.[133] These sheets do often contain personalizing features, but they reflect practices then popular in China—of appending colophons or inserting cartouches with names and dates and adding images of worshipful donors—rather than those of the Indic amulet traditions that I have surveyed. Further, the new central images and the place of the donors within them helped to transform the character of the sheets from "episodic" to "iconic," the latter indicating here a species of religious image that by the ninth century had become standard in Chinese Buddhist paintings and prints, and whose conventions were parallel with developments within the then-burgeoning tradition of Esoteric Buddhism. These shifts in style, in part byproducts of the rise of the new iconography and its place in contemplative rather than amuletic practices, seem as well to have been abetted by the shift to full block printing and the subsuming of the amulets within image conventions familiar to its artisans. Now included on the sheets were colophons containing not only the names of the donors but at times those of the printers as well, and sometimes not only the date of the initial block carving but that of individual printings. New, too, were quotations (or seeming quotations) from the spell's scripture that make explicit the powers of the amulet and how they are to be engaged, an element reflecting, among other things, the cartouches on hanging silk icons of longstanding popularity, and those of the newer genre of printed votive icons, all of which would have been well known to the xylographers.

The inclusion of the colophons and cartouches and the absence of the inserted names—along with the shift in central iconography from an image of the empowerment of the donor to an iconic image of a deity—stripped the amulets of their formerly personal character, including their continuities with broader Asian amulet traditions, and transformed them into rather standard Chinese Buddhist images to whose potent physical presences the names and dates (and sometimes the images) of mortal Buddhists were merely attached, no longer the direct objects of their blessings. In this, perhaps tellingly, they resemble the basic formats of the dhāraṇī pillars of the *Incantation of Glory* whose specific stone forms (when constructed primarily as media for incantations) seem to have been wholly Chinese creations without any known specific Indic models. Like those of all but one of the xylograph amulets, the pillars' makers ignored the injunctions of ritual practice

to include the names of the targets of the spells within their texts and added them within colophons beneath the incantations.[134] The later-style amulets in this way joined the pillars—and dhāraṇī inscription more generally—in becoming normalized according to the conventions of Chinese Buddhist icons and inscriptions.

Though in general terms their structures are identical with the earlier man-uscripts—all remain structured by three zones the contents of which, when reduced to their basics (ancillary images, spell, central image), remained the same—their details make clear that the xylographs were very different kinds of objects. Though both kinds of images qualify as "iconic," as I used the term earlier in this chapter to indicate the ritually active nature of certain images, here a further distinction must be made. No longer in themselves *enactments of ritual action* (in this case that of empowerment) the prints were shaped according to logics of *contemplation* and *prayer*, which had become normal in the Buddhist imagery of the age. In reshaping the amulets in this way, follow-ing in part the dictates of the new multiarmed iconography, the xylographers brought the images into line with the logic and conventions of most of the other painted and printed Buddhist images of the ninth and tenth centuries, which, like the new style of the printed amulets, figured deities in the iconic mode, with donors depicted to their sides, and included the wishes of the donors and purposes of the images and makers in colophons, whether to the side of the images or in cartouches within them.

The basic categorical distinction between "episode" and "icon" delineated (in different ways and using different terms) by Wu Hung, Stephen F. Teiser, and Victor Mair in their studies of Chinese images, though not perfectly appli-cable here, proves very useful in understanding the shifts in practice and imagination figured in the later sheets. The specific terms of the dyad "epi-sode" versus "icon" are Wu Hung's,[135] who divides the issue partly in terms of whether the design of an image is "self-contained" in its logic (episodes) or whether it assumes "a direct relationship between the icon and the viewer."[136] One might object that, in the case of amulets sealed within armlets or other carrying cases (or sewn into clothing), all of the sheets were, in a very literal sense, "self contained" and none could reasonably be thought to have had any kind of relationship with viewers, direct or otherwise. In terms of the reception of the amulets, this was certainly the case; however, my purpose in this section is to explore not their reception but the sources and logics of their making and conception. Considered in this way, concepts such as "icon" remain useful, however the icons were employed. In fact, the concepts—and

especially, in the case of the icons, as Teiser's analysis makes clear, their typical Buddhist examples[137]—help to clarify the ways that the new designs of the amulets entailed an essential shift in their character and in the ways the dhāraṇīs inscribed upon them and their cult were imagined.

In episodic images, as Wu Hung describes them, "the significance of the representation is realized in its own pictorial context. In contrast to an iconic representation, the viewer is a witness, not a participant."[138] In the case of the amulet sheets that figure episodes of the empowerment of their bearers—both in text and image—we can take the first of these statements in the strongest possible sense: not only is the "significance" of the depiction realized, the very action it depicts is carried out. The empowerment of Jing Sitai through his amulet, for example, is not merely a scene in a narrative of empowerment whose telling we witness; according to the ritual logic of material incantation, we are witness to *the actual event itself.*[139] With the later iconic images of the multiarmed deity, the image is there for the viewer to venerate in the manner seen in some cases in the accompanying image of the donor. The viewer, there by happenstance, and the pictured donor are both in this sense "participants" in the activity figured by these sheets. But here lies the difference between the earlier and later amulet sheets: in the later examples this participation is indirect, contingent, and inessential to the basic fact of revealed divinity, the icon itself. Though depictions of worship are sometimes described in texts accompanying paintings as being in themselves "eternal" and meritorious enactments of ritual, clear distinctions in intensity and in kind must be drawn between the ritual actions figured in the two sets of images. Veneration is a central and powerful ritual action in Buddhism, but it is one that situates its actors at a distance, in another order of reality, from the divinity worshipped. Empowerment sites its human object directly within the stream of blessings and divine power. Thus, the dhāraṇī episodes are self-contained, of a piece, while the icons figure a divide that those on the human side (our side) cannot truly bridge.

The spells inscribed on the two kinds of sheets, in this way as well, figure very different sorts of presences. The spells of the empowerment images envelop the human traces within them, nourishing them like fish within a stream; mortal life partakes of their power. The incantations surrounding the icons, however, are in themselves icons to be venerated, extensions of the majesty of the central divinity. Dhāraṇīs, when they are spoken in sutras, often become part of the light said to circle the buddhas who speak them, emanating out from them in this way until they fill the cosmos. Such images of spiraling incantatory light were likely part of what the xylographers

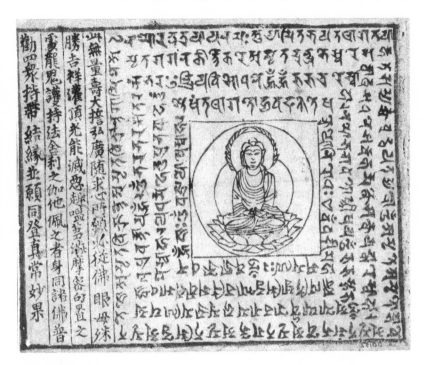

FIGURE 2.16
Amitāyus amulet. Stein Painting 247 (Ch.00152). Tang Dynasty. Xylograph, ink on paper. 12.9 × 16.2. © The Trustees of the British Museum.

intended to evoke by the wheels of syllables that surround the central figure in many of the most visually (and technically) sophisticated amulet prints. It seems, indeed, to have been part of the allusive content of the square-formed spells, too. A printed dhāraṇī amulet, Stein Painting 247, closely related to those of the *Incantation of Wish Fulfillment* but featuring instead an image and incantation of the Buddha Amitāyus (Wuliangshou), makes clear the connection between spell and light (and, as well, between luminous spell and consecration) (figure 2.16). The simple and apparently mass-produced xylograph, approximately 13 × 16 cm, features an image of Amitāyus surrounded by an incantation in spiraling square formation with a colophon alongside it that equates its spell with the "consecratory radiance" (*guanding guang*) of the eye of the Buddha, here personified as the deity "Mother of the Buddha Eye." "This great vow of the [Buddha of] Limitless Longevity vastly accords with prayers: what is prayed for in the mind will certainly come to pass. The supreme and auspicious consecratory light of the Mother of the Buddha Eye can eliminate

the evil paths of rebirth The spot where these mystic words are placed will be protected and held by dragons and demons. The body of the one who wears these śarī-gāthā [that is, "reliquary verses"] of the Law at his belt will be the same as all the buddhas. . . . "[140]

The circular forms of spell texts on Suiqiu amulets (and it must be emphasized that sheets bearing them are in the minority, perhaps due to the relative technical difficulty of producing them) resonate with a family of iconic visual structures central to contemplative forms of dhāraṇī practice, a family deriving from the circular objects of contemplation and visualization known as "moon discs" (yuelun) that includes "syllable wheels" (zilun), "incantation wheels" (zhoulun), and "dhāraṇī wheels" (tuoluoni lun). These various "wheels" (or "discs" or "circles," depending on the context) were employed in a range of contemplative practices in dhāraṇī and early Esoteric rites, most of which in their most basic forms involve the imagination of a disc, likened to a full moon, upon which syllables, either alone or in series, are made to appear. Though in the more elaborate practices of later Esoteric traditions these visualizations can be very elaborate indeed, in their earlier forms, dating to the age of the Mahāpratisarā Sūtra, they were much simpler. A passage from the later Bodhiruci version of the Amoghapāśa, an incantation whose close relation with the Mahāpratisarā we have already seen, should make clear enough for the purposes of this chapter the connection of these objects of active imagination to the middle structuring ranges of the amulets. In the midst of imagining the visual form of the Buddha Mahāvairocana, one perceives (guan) above the deity's heart (a standard site for the visual imagination of the discs) a "great moon disc, brilliant and utterly pure. At its round edge are arrayed a hundred shimmering syllables (zi) of burning gold, each moving along [the edge of the disc]."[141] This spinning wheel of syllables then becomes the site of more elaborate perceptions/imaginings, but the basic form of the wheel and its characters—which in many cases are explicitly said to be those of incantations—makes clear, I think, the connection with the amulets. The prints made to be worn as amulets, with cousins of the incantation wheels figured upon them, were not, it is worth restating, used in contemplative or other ritual practices of active veneration (at least such were not the uses for which they seem to have been constructed).[142] Nevertheless, the iconic character of their visual forms, which we now see included their inscribed spells as much as their central deities and their larger mandalic structures, were products of a religious culture that emphasized the potent ritual presence and often the devotional contemplation of the visual forms of

deities. This culture, particularly its manifestations within Esoteric Buddhist circles, exerted a strong shaping influence on the new styles of amulets and on those who made them.

We see this shaping influence most dramatically in the case of a *Mahāpratisarā* sheet, dated to 1001, that was discovered not in an amuletic context—not, that is, within an armlet or other carrying case—but within a reliquary stupa. Indeed, though the print bears a close resemblance to amulet sheets, it seems to have been intended not as an amulet but as an object to be used in devotional rites. The incantation of this print, given in Chinese script and printed in the form of a centrifugal spiral emanating outward from the buddha, begins with the text of an invocation that is evidenced among the Dunhuang materials, one that seems to have been chanted within ritual practices centering on the worship of the Bodhisattva of Wish Fulfillment.[143] Neither this sheet nor the other print it was found paired with appears to have been intended as text relics. Both seem instead to have served a function ancillary (perhaps offering protection or enhancement) to relics, given that they were found folded and rolled around nine relic grains inserted within a *chuang* pillar-shaped section of a votive reliquary contained within a large stupa.[144]

Both xylographs are in key ways different from any other yet discovered. Neither features images of either the empowerment tableaux of the early style amulets or the eight-armed bodhisattva of those of the later style. The second sheet, dated to 1005, contains an image of the Buddha Tejaprabha, a figure closely associated with stellar deities in this period—and, indeed, his image on the print is in this vein. The 1001 print features a more conventional image of a buddha at its center, probably Mahāvairocana. As noted, they seem not to have been intended for use as relics, yet neither were they created as amulets to be worn on the body. Both appear instead to have been made as aids to devotional practice, in ritual contexts quite different from those I focus on in this chapter. Though for this reason I consider these two prints for the most part beyond the scope of this study, we might cautiously take them as examples of what the sheets became after their amuletic uses fell out of favor (no amulet sheets postdating the Ruiguangsi prints have yet been found).[145]

Taken in this light, the two Ruiguangsi prints—and the example dated to 1001, especially—seem to exemplify both a more advanced stage in the movement toward iconic/contemplative logics and a deeper stage of absorption within the ritual worlds of high Esoteric Buddhism. The shift in the character of

the amulets from episodic and intimately personal to iconic appears in part to have been related to a larger shift in the history of Buddhist incantation practice from the diffuse styles of what Arthur Waley called "Dhāraṇī Buddhism" to the much more systematic world of the high Esoteric lineages. Though the older styles clearly remained a vibrant loose tradition through at least the tenth century—the Dunhuang evidence is clear in this regard—the more recently arrived "Esoteric synthesis" exerted a powerful cultural pull soon after its arrival, in contexts ranging from the imperial court to print shops out toward the periphery.[146] Given that all the amulets, both early and late, were—quite obviously—parts of dhāraṇī practice in medieval China, it is only natural that this larger historical transformation was manifested upon their inscribed faces. Yet, the Ruiguangsi prints aside, our evidence for the uses of those amulets never points directly to Esoteric ritual milieus but instead to personal practice—usually of laymen—and to tombs, the nameless occupant of the Jin River tomb, for example. The Dunhuang evidence is harder to gauge, for nearly all evidence for the uses of those amulets was lost when the prints were added to the general store of texts and images hidden there.[147]

The iconography of the xylographs—both the central deity and the peripheral supporting cast—shows progressively greater signs of the influence of contemplative ritual practice: the mantric syllables on lotus blossoms, a prototypical image of eidetic contemplation, in particular. But the presence within the text of the print dated 1001 of the invocation of the incantation's deity, a text that as we will see was clearly a product of an Esoteric milieu, is the strongest evidence yet of the influence on the amulet makers of high Esoteric ritual practice, a fact that is especially clear when taken together with the non-amuletic intentions of the designers.

The non-amuletic character of the two sheets is clear. The colophon accompanying the text in Indic script on the 1005 print features not the practice of wearing the spell but that of inserting it into *chuang*, a term referring originally to tubular or octagonal banners but by the Tang also indicating stone pillars in that form—the latter being, of course, the very sort in which both prints were found. Like the colophons on earlier amulet prints, it does cite and adapt the claims of the scripture; it simply focuses on different claims and prescriptions. Though as always it is difficult to infer intentions from their products, the fact that the *chuang* practice is featured most centrally in the text (not to mention that it was, in fact, found within a miniature *chuang*) seems a solid basis for taking the designers at their word and seeing in this print a kind of object very different from the earlier amulets.[148]

The 1001 print bearing the spell in Chinese script makes its particular ritual context clear. The invocation, which precedes a version of the spell attributed to the later Amoghavajra edition (something that in itself sets the sheet apart and signals its ritual milieu), makes no mention at all of wearing the inscribed spell on the body for simple protection and blessings. Instead, it locates the spell and the print as a whole within the high tradition of Esoteric Buddhist mandala practice.

We invoke the Saint of the Lotus Blossom Womb, the infinite and pure portal of the encompassing grasp [dhāraṇī], whose all-pervading radiance illumines the world, whose fiery garland appears in response to the three-thousand-fold cosmos. The Mind-According Jeweled Seal appears from the mind; the invincible[149] lord, the great incantatory king, who is ever within the three mysteries of the Thus-Come One. He is victorious in yoga, vowing to attain the stage of awakening. Lord Vairocana preaches and Vajrapāṇi receives the marvelous words of reality [zhenyan; the incantation]. Compassion arouses the mystic words that embrace all beings. Cultivate the siddhis and the methods of success [sādhana]: fully conceive within the mind a moon disc appearing; quiescent in samādhi, contemplate the root lord[150]

The language of the high Esoteric tradition is clear here, particularly in the imagery of the Lotus Womb Realm, an alternate name for the Womb Realm Mandala (taizang jie; Garbhadhātu)—one of the two basic subsystems of the tradition in East Asia—whose central "root lord" is Mahāvairocana, the buddha figured at the center of the print. As well, the language of siddhi, the "perfections" of Esoteric practice, sadhāna, the general term for the rites in which these perfections are enacted, and yoga, one of the most common names for the tradition as found in its Chinese texts, mark the text as a product of Esoteric ritual conventions. Marked in this way, in fact, the iconic visual structure of the print itself connects with Esoteric practice. Icons of deities, as objects first to make and then to venerate, are often central components in surviving ritual manuals from the Tang tradition, where they are described as surrounded by images from ritual practice—water jars, vajras, jeweled wheels, etc.—that recall those found on the amulets and altar models. In addition to the amulets and the Ruiguangsi prints themselves, there is evidence that such Esoteric ritual icons were produced in print shops, perhaps the very same ones in which late-style amulets were made. The Dunhuang xylograph held in Paris known

as EO 1232, an iconic representation of the Thousand-Armed Guanyin sur-
rounded by his retinue and framed by vajras and, at the corners, wheels, bears
a strong if general resemblance to accounts found in ritual manuals for the
rendering of icons for veneration and contemplation.[151]

As usual, however, the Esoteric sources do not tell the whole story. The
amulets, and the Ruiguangsi prints, bear a feature that is neither called for
in ritual prescriptions nor found on the printed icon of the Thousand-Armed
Guanyin that resembles them so closely: colophons and images of donors.
When looking for possible sources of these conventions, particularly within
the Dunhuang cache, evidence is near to hand, for these elements were found
on a great range of painted and printed religious images found there. Painted
icons on silk (often bearing the images and names of their donors or intended
beneficiaries) and block-printed versions (mass produced without individu-
alizing features and containing instructions for their proper worship) bear
just as crucial a relation here as do the contemplative icons of the monastic
altars. We must recall, once again, that the amulets found in contexts of actual
practice were found in tombs of laymen that contained no other signs of Bud-
dhist practice; they were not at all features of high ritual. Images from outside
the Esoteric lineages further clarify the nature, and, no doubt, contemporary
sources for the execution of, our iconic amulets.

The evidence provided by the Dunhuang collections suggests, in fact, that
deity icons were among the most popular forms of portable Buddhist imagery
in the ninth and tenth centuries. In common with amulet sheets that center
images of the eight-armed deity, such images feature representations of divin-
ities, typically either buddhas or bodhisattvas depicted in full frontal posture
whose presence and radiating divinity are the focus of the image as a whole.
In the case of silk paintings, they often include an accompanying image of
their donor(s) as well as texts ancillary to the image that explain its nature
or the facts surrounding its creation (or both). For an example let us take a
typical icon of Guanyin from the Stein Collection of Dunhuang paintings, the
painting on silk known as Stein Painting 14, dated to 910, of the bodhisattva in
standing posture flanked by two much smaller human figures, a deceased nun
and a young man identified as the younger brother of the donor (figure 2.17).
Like the xylograph dhāraṇī amulets, this painting prominently features texts
of the sort common to its genre, among which is one in praise of the bod-
hisattva, including the stated intention that the image will "perpetually enact
fulsome offerings" to him (yongchong gongyang) of the kind mentioned above.
Other wishes include those for the peace and stability of the Tang Empire as
well as a wish for the rebirth of the donor's deceased relatives and Buddhist

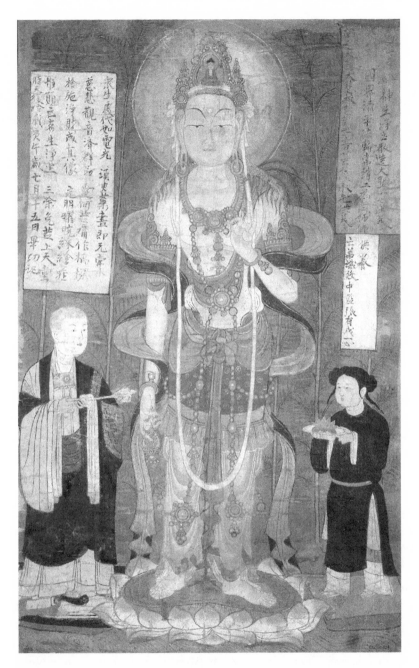

FIGURE 2.17
Guanyin icon. Stein Painting 14 (Ch.liv.006). 910 CE. Painting, ink and colors on silk.
77 × 48.9 cm. © The Trustees of the British Museum.

teacher (the nun pictured) in a pure land.[152] Most importantly, for a comparison with the amulets, are statements of the potency of the deity, and by extension his image, which parallel statements of the efficacy of the dhāraṇī xylographs.[153] Such statements, naturally, served to *create* the efficacy—at least in the minds of their readers—of the objects they were inscribed upon.

Portable images such as these, which had long been popular by the time of the transition to the wood block printing of amulets, appear to have provided key elements of the basic iconic template according to which the carvers of wood blocks made their images (a template that had, it would seem, been adapted in turn from still older iconic images such as those of the buddhas that lie at the centers of pure land tableaux on Dunhuang cave shrine walls). Though some notable episodic xylograph images remain from the period— the most famous being sutra illustrations (a genre that for Teiser was emblematic of the narrative mode)[154] such as those serving as the frontispieces of early printed editions of the *Diamond Sutra* and the *Sutra of the Dhāraṇī of Stainless Pure Radiance*, two of the earliest known printed texts in the world—most early printed Buddhist images are iconic in character.[155] These include a great many block printed ritual icons, some of which, though they were very different sorts of objects from the amulets, bear a basic visual resemblance to them, from the iconic deity to the accompanying texts, which sometimes included incantations. Stein Painting 237 (figure 2.18), a ritual icon that proclaims, in two rows of text to either side of the main figure, "The Great Saint Bodhisattva Mañjuśrī universally urges all to resolve to make offerings to and receive and hold [this icon]," provides a typical and clear example.[156] The text below the icon proper proclaims that its image figures the "true figure" (*zhenyi*) of the great deity on his adopted seat in the Wutai mountains, proper devotion to which—according, the text makes clear, to the spiritual and economic capacities of each devotee—fulfills all prayers, ultimately bestowing the "return to eternal bliss" of all sentient beings (*huishi youqing tonggui changle*). Toward this end, the text provides two incantations for its worship: "The Five Syllable Incantation of Mañjuśrī, The Bodhisattva of Child-Like Truth" (*Wenshushili tongzhen pusa wuzi zhenyan*), "a-ra-pa-ca-na," the famous and ancient basic mantra of the Indic deity found in a great many Buddhist texts; and an otherwise unattested incantation called the "Dhāraṇī of Mañjuśrī's Awesomely Potent Dharma Treasure Store Mind" (*Wenshushili da weide fabaozang xin*).[157] Xylographs such as this one would very likely have been produced within the same print shops as those amulets, for which they would have provided ready-to-hand resources for the new dhāraṇī iconography and its attendant transformations in the visual character of the amulets.

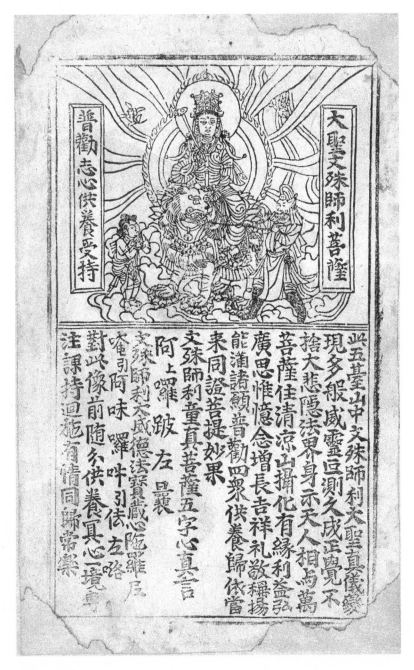

FIGURE 2.18
Mañjuśrī icon and liturgy. Stein Painting 237 (Ch.00151.b). Tenth century? Xylograph, ink and color on paper. 27.9 × 16.8 cm. © The Trustees of the British Museum.

New Iconography

Narrowing our focus from considerations of the overall visual format of the later-style iconic amulets to the particulars of their central imagery, connections with Esoteric Buddhist ritual practice and iconography once again become clear. Eight amulet sheets feature at their cores images of the bodhisattva Mahāpratisara bearing his characteristic implements in his eight arms: lariat, ax, sword, trident, wheel, book, banner, and vajra. These amulet sheets (with one possible exception) are later than those that feature the image of empowerment explored previously. They include the nearly identical ninth-century Sichuan University and Shaozhen amulets (the latter figure 2.19]; the Xu Yin example, dated to 927 (figure 2.20); the Xi'an city piece; the

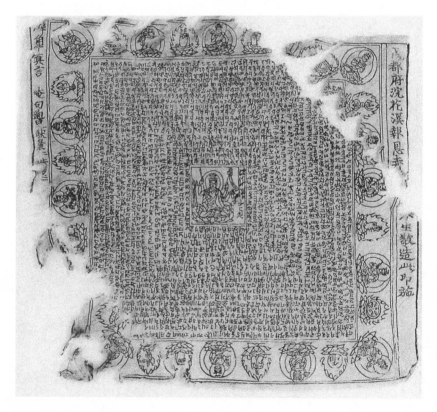

FIGURE 2.19

Shaozhen amulet. Late ninth century? Xylograph, ink and color on paper. 30 × 31 cm. Courtesy of the Shaanxi History Museum.

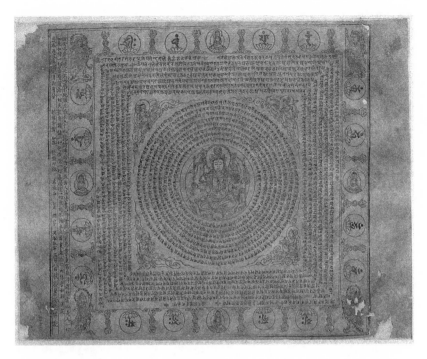

FIGURE 2.20

Xu Yin amulet. 926–927 CE. Xylograph, ink and color on paper. 38 × 28.5 cm. After Drège, "Les premières impressions," fig. 7.

Li Zhishun amulet (Stein Painting 249) (figure 2.2); and the undated Yang Fa and "Bodhi-nature" xylographs. The eighth example is Iron-head Jiao's (figure 2.21), a singular object in several ways.[158] Published photographs of the sheets are not always clear enough to allow certain identification of the implements in the deities' hands, but they all seem to follow the template that, as we will see, was found in images in India, Indonesia, and China, and which predates the four-headed form of the deity described in Esoteric scriptures beginning in the tenth century. As noted, these central images bear no relation to the prescriptions of either Chinese translation of the Mahāpratisarā Sūtra. They were, however, found in a range of media and contexts across Asia in this period, including (aside from those of the amulets themselves), murals, ritual manuals, and sculptures. Consideration of these images and their relationships with the amulet tradition reveals further details about the world of practice of which the amulets were part and within which they transformed. The iconography of the dhāraṇī bodhisattva, which appears in

FIGURE 2.21

Jiao Tietou ["Iron-head Jiao"] amulet. Xi'an Beilin Museum. Late eighth century? Ink and color on silk. 26.5 cm × 26.5 cm. After Cheng, *Xi'an Beilin*, 152.

the Chinese material record not long after the early amulets and their scripturally inspired imagery of empowerment, seems originally to have constituted a separate but parallel tradition of Mahāpratisara visual culture, one (in China at least) initially found in Esoteric Buddhist circles. It appears that as the cultural power of the Esoteric ritual and iconographic traditions grew, their conventions for the imagination of the *Incantation of Wish Fulfillment* came for the designers of the amulets to replace those of the earlier scripture—even those of the translation attributed to Amoghavajra, the preeminent Esoteric ritualist of the age.

Cave 148 at Dunhuang, dated to 776, which features an iconographic program centering on multiarmed "esoteric" forms of Guanyin, contains what

FIGURE 2.22
Dasuiqiu bodhisattva from Mogao Cave 148, Dunhuang. Drawing copyright Dawn
Brennan.

appears to be the earliest extant image of the Bodhisattva of Wish Fulfillment
(figure 2.22). The image is located on the southern slope of the cave's ceiling,
where it is the central figure in a mandalic tableau constituted by eight flank-
ing figures: three bodhisattvas and one heavenly king to each side. Accompa-
nying labels identified all the figures, originally, though only a few of them
remain legible. The identity of the central figure, determinable already based
solely on the implements in his eight hands—axe, lariat, sword, vajra, tri-
dent, book, banner, and mudra (though a wheel would be expected here)—is
made much more secure by what remains of his accompanying cartouche. Of
the four characters inscribed there in the late eighth century, only the first
survives—sui—which given known possibilities (and the makeup of the image
itself) can only have begun the name Suiqiu pusa, the Bodhisattva of Wish Ful-
fillment.[159] Based on their iconographies and the two legible cartouches, the
six bodhisattvas arrayed around the central figure are pāramitā bodhisattvas,

figures associated with the six "perfections" of Mahāyāna practice: charity, ethics, patience, effort, meditation, and wisdom. The two legible cartouches identify the bodhisattvas of charity (bearing a bowl of fruit) and forbearance (bearing a mirror). As Liu Yongzeng has noted, these bodhisattvas, and the *Suiqiu pusa* himself, all appear in these iconographic forms within the Womb Mandala system of Esoteric Buddhism, though they are not associated there with each other in any clear way. The two heavenly kings represented in the tableau, Virūḍhaka (*Biliulecha*) and Dhṛtarāṣṭra (*Titoulaizhai*), are also in some Esoteric systems associated with the Bodhisattva Guanyin, particularly in his thousand-armed form. Yet, once again, these relatively late Esoteric systems are only tangentially relevant to an understanding of the *Suiqiu* imagery in the cave, which was likely drawn instead from looser traditions of dhāraṇī practice. The fact that Cave 148 features three versions of Guanyin—of the Mind-According Jewel and Wheel (*Ruyilun*; *Cintāmaṇicakra*), of the Unfailing Lariat (*Bukong juansuo*; *Amoghapāśa*), and of the Thousand Arms—is clearly crucial here, though further research will be needed to clarify the precise nature of all these connections. Dorothy Wong argues that the source of much of the Esoteric iconography of the Dunhuang caves of this period, including that of Cave 148, is Bodhiruci's translation of the *Amoghapāśa dhāraṇī sūtra* (T no. 1092).[160] Such a basis in dhāraṇī practice (rather than in an Esoteric mandala system) makes sense for this period, given both the layout of this cave and the great popularity of dhāraṇī practice at Dunhuang at the time—Arthur Waley noted, after all, that the Buddhism of Dunhuang evidenced in the manuscript hoard was well characterized as "Dhāraṇī Buddhism."[161] The *Suiqiu* icon and its cave present fulsome and compelling images of the visual imagination of dhāraṇī practice glimpsed more narrowly on the xylographs.[162]

The lineages of the formal Esoteric tradition do offer important evidence, however. The earliest textual accounts of the eight-armed bodhisattva, which date from early in the period of the amulets, are found not in Chinese translations of scriptures but in manuals from Sino-Japanese Esoteric ritual tradition, including those reported by Kūkai (774–835), once a disciple within Amoghavajra's own ritual lineage. The xylograph amulets, taken as wholes, figure precise iconic images of ritual practice—indeed, Katherine Tsiang has observed that in this context their three registers may be taken as emblems of the three modes of activity (*sanye*), or "three mysteries" (*sanmi*), which are said in Buddhist doctrine to comprise human action, especially ritual action: "body" (the hand mudras and physical objects in the outer rim), "speech" (the incantation), and "mind" (the icon in the center, which in the case of

the eight-armed bodhisattvas was often the object of visualization and devotional practices).[163] Among the early textual traces of the presence in China of the eight-armed Bodhisattva of Wish Fulfillment is the description contained in Kūkai's *Notes on the Secret Treasury* (Hizōki), a text that, as Ryūichi Abé describes, "consists of one hundred fragmentary sections of [Kūkai's] handwritten record of the oral instructions he received from Huiguo," one of Amoghavajra's disciples.[164] Among those instructions we find the following for the depiction of the Great Bodhisattva of Wish Fulfillment within a maṇḍala: "Deep yellow in color, with eight arms. The upper left hand [holds] a golden wheel of fiery brilliance atop a lotus; in the next hand is an Indic book;[165] in the next a jeweled banner; and in the next a lariat. His upper right hand holds a five-pronged *vajra*; in the next is a halberd; in the next a jeweled sword; and in the next a hook-ax."[166] Kūkai's notes would seem to date to 805, the year of his teacher Huiguo's death, but this description was maintained in Japanese ritual practice for at minimum another century and a half, and in at least one text it became part of the guidelines for visualization practice. In the Shingon monk Junnyū's (890–953) *Contemplations of the Ritual Spheres of the Essential Deities* (Yōson dōjōkan), the practitioner is told, in the "Contemplation of the Ritual Sphere of the Great Bodhisattva of Wish Fulfillment," that in this meditation the syllable "a" transforms into an Indic book, which then transforms into the bodhisattva complete with its eight arms, each holding the items as described in the Hizōki.[167] Another Japanese manual states that the syllable can first be transformed into a vajra, which then should become a book, before becoming the bodhisattva.[168] The eight-armed figure does not appear in a Chinese translation of a sùtra until the tenth century—the *Foshuo yuqie dajiao wang jing*, or *Scripture of the King of the Great Teachings of Yoga*, translated by Fatian (a.k.a. Faxian, d. 1001)—and then only in a four-headed form reflecting an apparently later South Asian iconographic transmission that seems to have had no impact on East Asian developments.[169]

Icons of the single-headed eight-limbed *Mahāpratisara*, the form present on the xylographs and in East Asia more generally, had by the ninth century been spreading across Buddhist Asia for decades, appearing in sculptural form in eastern India and central Java and as painted and printed images in Tang, Five Dynasties, and early Song China. Gerd Mevissen has suggested that surviving metal and stone statues and stone temple reliefs from India and Java may date from as early as the eighth century.[170] The most securely datable of these images seems to be "a large stone relief carved in the centre of the north-eastern wall of the Candi Mendut, a temple in Central Java of the late 8th or

early 9th century, about 3 km to the east of Borobudur."[171] Assuming that the iconography originated in India, then, an early or mid-eighth-century date for its birth seems easily possible. The details of these three-dimensional images, like those of their two-dimensional Chinese counterparts, vary within a limited range of options; while for the most part the implements carried in the deity's hands are the same, their relative positions are often different.[172] Indeed, based on Mevissen's descriptions of twelve Indian and Javanese examples, only two of them—one from each location—may match, though wear to the sculptures, as well as the subjectivity inherent in the art of identification, makes absolute certainty in this matter impossible.[173] None of the non-Chinese images, furthermore, precisely match any of those found in China, and with the exception of the nearly identical Sichuan University and Shaozhen prints, none of the Chinese amulets matches another. Clearly, details such as the locations of the implements or the specific seated postures of the deities mattered little to the sculptors in figuring the god Mahāpratisara, or, it would seem, the ritualists associated with them.[174]

Questions of precisely how these images spread as far as they did—as Mevissen notes, "the countries from which the images originate mark the boundaries of the Buddhist world"[175]—and particularly the reasons for their presence in both China and Indonesia, are intriguing but rarely answerable in any detail. In surveying the evidence of the armlets and their own nearly equally wide spread, I could merely point to their far-flung traces and to the trade routes that stretched between the westernmost and easternmost of those traces. Here one can only do the same. In the present case there is, however, a legend that might (at least at first glance) help begin to offer hints about the travels of the eight-limbed deity. It involves none other than Amoghavajra and his sea journey in 741 to Buddhist lands in South and Southeast Asia, particularly the leg of that journey that brought him to Java. Given Amoghavajra's close association with the Mahāpratisarā, as its translator and as advocate for its efficacies to the imperial court—recall the account of his gift to the emperor of a Wish Fulfilling amulet to be worn on his belt—the possibility arises that he was a key link between the two regions where the incantation was practiced and worshipped (or, perhaps, that his biographer wished to hint that he was). As the account given in Zhao Qian's (fl. 766–774) biography of Amoghavajra relates:

When [Amoghavajra's ship] reached the border of Kaliṅga (Heling) [that is, Java],[176] it met with a heavy storm. In his terror, each merchant

on board had recourse to his own spiritual methods [for ending the storm]—all without effect. They then bowed down together and begged the master [to save them]. Huibian, the Lesser Master, also cried out. The Great Master said to them: "I have a method. Do not worry." Thereupon, taking up in his right hand a five-pronged "bodhi-mind" mallet [that is, a *vajra*] and in his left a volume (*jia* [= *qie*]) of the *Scripture of Prajñā* [*pāramitā*], *Mother of the Buddhas*, he extended [his arms] and performed the rite of empowerment (*zuofa jiachi*), chanting the Wish-Fulfilling [Dhāraṇī]. He chanted it but once. Huibian was astonished: The winds immediately ceased and the sea grew placid. Such was the Master's power.[177]

Taken on its own, this tale of the incantation's marvels (and note that here it is an incantation, not an inscribed talisman) might be taken as suggesting a role for Amoghavajra in the transmission of the sutra, a link between these two regions of the spell's practice.[178] However, any possible accuracy in the tale's account is immediately called into question when one turns to the *Scripture of the Incantation of Wish Fulfillment* and finds a much more elaborate version of this very story. As Amoghavajra's own translation relates:

There was a layman named Vimalaśaṅkha. His clan was large and wealthy, their coffers overflowing with silver and gold and piled high with treasure and grains. The layman was a merchant leader and traveled the seas in a great argosy collecting treasures. On the high seas a timiṅ fish (*dimi yu*)[179] beset his ship and the dragon king of the seas, his eyes wide with anger, added to this by stirring up great roaring thunder and lightning and raining down adamantine hailstones. The merchants beheld this lightning and hail and were terribly afraid. They cried out for aid but none came. The merchants then approached their leader, crying out to him with sorrowful voices, "Noble sir, you must think of some plan to save us from these troubles!" At this time the mind of the merchant leader, strong with the great wisdom, was without fear. He looked upon the merchants crushed with fear and said to them, "Merchants, do not fear! Do not fear but have courage. I will help you evade these horrors." His merchants then took heart and said to him, "Great merchant leader, we pray that you quickly tell us of your method for averting disaster and preserve our lives." Thereupon, the merchant leader said to the merchants, "I have the Great Incantatory Kings' famous Dhāraṇī of

Wish Fulfillment. It can defeat all that is hard to control with its great spiritual power and free you from this sorrow." He then immediately wrote out this *Dhāraṇī of Wish Fulfillment* and secured it atop the mast. At this time, the timiṅ fish saw the ship shining brilliantly like a great flaming fire—the mighty wisdom fire of the dhāraṇī consumed the timiṅ fish.[180] When the dragons saw this mark (that is, the flames of wisdom), compassion arose within them and they flew down from the sky to make offerings. They caused the argosy to reach this treasured continent [where the Buddha resides].[181]

The connection with the tale of Amoghavajra's wizardly prowess is tightened when we read in his biography that some time after he subdued the storm by chanting the spell, he encountered a "great whale" (*da jing*), which he defeated by employing a different potent text. Clearly, the author of his biography simply adapted the scriptural tale to his account of Amoghavajra's life. The question of why he did so will likely never be answered, but, in the context of the present discussion of the spread of the *Mahāpratisara* iconography to Java and Tang China, it is very interesting that the author chose to insert this tale into the narrative just as Amoghavajra was nearing Java. Perhaps it was indeed meant to signal Amoghavajra's relationship with the *Mahāpratisara* cult then thriving there.

The tale of Amoghavajra's incantation of the spell connects in fascinating ways with both the iconography and the ritual invocations of the Bodhisattva of Wish Fulfillment. Recall that when Amoghavajra incants the spell against the storm, he holds a vajra in his right hand and a book in his left hand. Though Amoghavajra had only two hands to employ, his actions might be taken here to mimic the image of the spell's deity, who as we have seen, is depicted as employing these very objects. Kūkai's *Hizōki*, in fact, describes the deity as holding a vajra in one of his right hands and a book in one of his left— a fact that may not simply be coincidental. Furthermore, as noted earlier, ritual manuals from the Sino-Japanese Esoteric tradition say that images of the bodhisattva summoned to the mind in ritual practice should be produced as a transformation of the image of an Indic-style book, an image that, in some cases, should itself have been made from an imagined vajra. Do such details of iconography and eidetic contemplation reflect incantation practices—or those of biography—of the eighth century? I have not, so far, discovered any similar instances, but it remains a fascinating possibility. The text containing the tale dates, furthermore, to 774, the year of Amoghavajra's death, which also

makes the passage the earliest datable trace (if trace it is) of the multiarmed iconography in China—two years before the mural in Cave 148. The late 770s may have been a particularly important era in the spell's history in China.

CONCLUSION

Returning now full circle to the Chengdu tomb that began this discussion, we have a much clearer understanding of the amulet found on the arm of the one buried there, of the wide-ranging and complex practical traditions it exemplified, and of the picture of the body and its relationship with the cosmos its use implied. That amulet and those like it, we have seen, make manifest a wide range of Buddhist practice in eighth- through tenth-century China, a range, in fact, wider and deeper than nearly any other available to the historian of late medieval Chinese Buddhism. This range extended from the impersonal—canonical prescriptions for practice that took their places on temple library shelves among a great many others, often with little to distinguish their relative importance—to the highly personal: sheets inscribed with the names of the men and woman who bore them on their bodies, often found on those bodies in their tombs, the final intimate spaces of corporeal existence and the final arenas of Buddhist practice in this world. The amulets provide, as well, vivid evidence of how transformations in religious practice in late medieval China could be driven by "external" factors such as, in this case, advances in textual production and the rise of xylography and its cultures, as well as by regional shifts in trade that closed off the traditional sources of dhāraṇī amulet forms to the northwest of China and opened up new sources to its south. The amulets make clear in this way that Chinese Buddhists took part in a living trans-Asian culture of practice and imagination that was continually renewed through trade, pilgrimage, and conversations with Buddhists of the wider world. These changes were not only products of the evolving logics of the ritual traditions of Esoteric Buddhism but were enacted within a far more open and wide-ranging technical culture that carried forward an ancient heritage of protective magic connecting Indic, Central Asian, and Chinese religious cultures in a complex whole.

In this chapter, aside from introducing the amulets within some of their practical contexts, I have tried to show how they were exemplars of one of the two modes of material efficacy central to Buddhist incantation practice: that is, adornment, as opposed to direct application (which is the subject of the next chapter). Both of these modes were adopted by the makers of talismanic

dhāraṇī inscriptions from ancient ritual practices of the speaking of spells; they were, in fact, among the structuring conventions of Buddhist practice writ large—the ways in which expectations about the workings of the world were enacted. Practices of the form of material incantation characterized by logics of adornment reveal expectations about the world and its spirits, its dangers, its interconnections among human, divine, and demonic spheres, and about the ways that the spiritual ornamentation of bodily persons was said to transform those persons utterly, to remake them at the level of essential substance from the fleeting imperiled stuff of humanity into the diamond-like luminosity of the truly real. Descriptions of such fundamental transmutations in the human stuff are even more vivid and explicit in accounts of the other basic mode of material efficacy, that of direct anointment or unction, to which I now turn.

3. DUST, SHADOW, AND

THE *INCANTATION OF GLORY*

Late seventh-century transformations in material dhāraṇī practice, as we have seen, can be mapped according to two very simple practical logics: *wearing* spell-enchanted objects as amulets and directly *anointing* the body with enchanted material, whether oil, ash, dust, or (as we will see) shadow. Unlike the spell inscriptions with which they came to be associated, these two basic models of efficacy were not themselves late products of Buddhist incantation practice; their histories stretch back to much earlier forms of Indic spell craft. Indeed, it was the assimilation of material dhāraṇīs to these (and other) ancient styles of incantation that marked what I call in this book the third understanding of written dhāraṇīs—where they are taken not simply as parts of the scriptural texts they were included within and not precisely as textual relics of the Buddha but instead as true forms of incantation, active now in written as well as spoken form. To further root this chapter in earlier discussions, a passage examined earlier from Jñānagupta's (523–600) late sixth-century Chinese translation, the *Rulai fangbian shanqiao zhoujing*, the *Incantation Scripture of the Thus-Come One's Skill in Means*, once again offers a convenient contrast in these two modes of enchantment from a time well before they had come to shape the rites of written spells.

> If there is a plague, one should take *sumanā* flower oil and enchant it one hundred and eight times, then apply it to the body. A cure will immediately be effected. To protect your own body and make it secure and remote [from illness], enchant water one hundred and eight times and scatter it to the four quarters in order to secure the ritual space. Take a five-colored twine, [enchant it and] knot it into an incantation cord and wear it where you go.[1]

The simple difference between the two modes is clear. The ritualist can enchant the body through a medium, here oil—that is, physically apply empowered oil such that it is absorbed into the body—or he can adorn the body with an enchanted object, here a knotted cord that has been enchanted with mantra. Both sorts of practices assume that the aural potency of an incantation can be transferred into a physical object such that it is still active there and then transferred yet again into another object, such as a human body. As we saw in the last chapter, knotted cords were the most often-prescribed forms of spell wearing in the early texts; their forms and ritual logics maintained a strong hold over the practical imagination for centuries, coming to govern, at least in part, the styles of armlets containing inscriptions of the *Incantation of Wish Fulfillment*.

Styles of direct application were more various. Returning to Xuanzang's (602–664) mid-seventh-century translation of the *Amoghapaśa-dhāraṇī-sūtra*, the *Bukong juansuo shenzhou xinjing*, or *Heart Sūtra of the Spirit-Incantation of the Unfailing Lariat*, we encounter once again the same incantation cord method alongside two forms of direct bodily enchantment: chewing enchanted wood and sprinkling enchanted water and ash onto a body.

> For all tooth ailments or pains, one should enchant acacia wood twenty-one times and then chew on it—one will immediately be cleared and cured. . . . All who desire self-protection should enchant twine and wear it on their bodies. Alternatively, they can enchant water and ash and sprinkle it over their bodies. All those whose bodies have been possessed by demons, spirits, or faeries should enchant five-colored twine and constantly wear it—they will immediately be released from the holds [of these beings].[2]

The use of ash as a vector of incantatory power takes us directly into the subject of this chapter, the material practices of the *Foding zunsheng tuoluoni*, the *Incantation of the Glory of the Buddha's Crown* (Uṣṇīṣavijaya dhāraṇī). Ash or soil as means to apply enchantments to bodies—in this case, the corpses of unfortunate beings experiencing difficult rebirths—are featured in the *Scripture of the Incantation of Glory*; images of the practice, moreover, were painted at Dunhuang and seem to have been well known. The inspiration for this mortuary technique and its images are traceable to a brief passage in the text, the substance of whose account will now be quite familiar: "Take a handful of soil and enchant it with this dhāraṇī twenty-one times, then spread it upon

the bones of the deceased and they will attain birth in a heaven."[3] The technique took on a life of its own within the mortuary repertoire evidenced at Dunhuang. Ritual invocations (qiqingwen) sometimes intoned before formal recitations of the Incantation of Glory featured these mortuary uses of dhāraṇī-enchanted soil in their panegyrics to the power and majesty of the incantation. These invocations, examples of an important but as yet little-studied genre, serve ritual purposes comparable to those of the colophons appended to printed amulets of the Incantation of Wish Fulfillment, and to those inscribed on the pillars bearing the Incantation of Glory that are in part the subject of this chapter. That is, they describe, and thus in part create, the power of the spells they accompany for those chanting them and for those who hear them chanted. Like the colophons, too, they are invaluable to the historian of religious practice in that they give the specific terms of devotion and desire in which the spell was to be imagined, as well as the features of its cult most prominent within the communities in which the invocations were composed and received. One invocation associated with the Incantation of Glory found on a few Dunhuang manuscripts lingers over the practice and its efficacies. It mentions them both in passing early on—"withered bones blessed with its enchanted dust are reborn in pure lands"—and then again at relatively greater length toward the end, where it includes a brief tale of the legendary monk Ānanda spreading enchanted dirt upon human bones he encounters in a forest.[4] Other renderings of the spell's use in mortuary practice are found in the small details of recently identified cave shrine murals depicting scenes from the Scripture of the Incantation of Glory. Here one encounters a figure spreading dirt on a corpse—whose soul, in the form of a wisp of smoke, rises upward, doubtless to a pure land or heaven—while another figure kneels with palms together to the side[5] (figure 3.1). That the practice was a member of a set of rites common in Buddhist circles of the northwest is further suggested by a fragmentary manuscript found at Dunhuang that describes a formal rite for the washing of sin-soaked bones in water infused with the Incantation of Glory.[6]

But spells were not only spread upon the bodies of the dead. An incantation manual of late Tang (and perhaps early Japanese) Esoteric Buddhism, the Zongshi tuoluoni yi zan, Encomium on the Complete Explication of the Meaning of Dhāraṇī, notes practices whereby the bodies of practitioners were transformed through the direct application of spells from coarse and heavy bodies ridden with affliction (cuzhong shen) to bodies of subtle and marvelous substance (weimiao seshen).[7] Such practices offer striking examples of the deep corporality of the person—and the modes of its salvation—central to dhāraṇī Buddhism

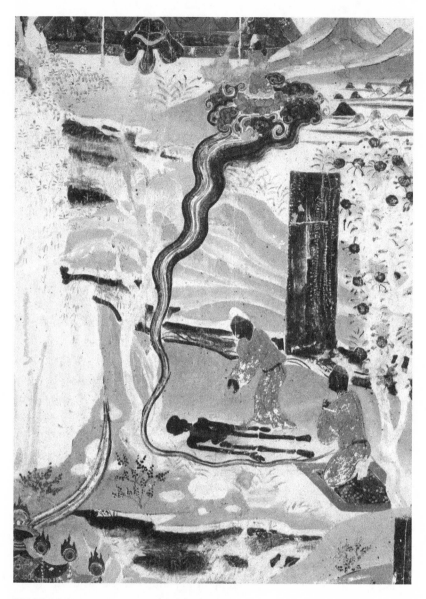

FIGURE 3.1
Enchanting a Corpse with the *Incantation of Glory*, Mogao Cave 217, Dunhuang.
Photo courtesy Dunhuang Academy.

(and, in the case just mentioned, of the high Esoteric tradition that incorporated its basic stance toward the nature of the person). Indeed, in the following discussion we will see how deep the roots of this corporality were in a wide range of medieval Buddhist practices. Yet, perhaps even more than with the practices of the incantation amulets discussed in the previous chapter, it is proper here to speak of the imagination of "incantatory bodies" central to the practices of the *Incantation of Glory* in late Tang and tenth-century China. Here I mean both the tales of the transformed bodies of the practitioners and the incantatory "bodies" of sound, light, and substance—the spells themselves—that were said to enable these transformations. The transformations the *Incantation of Glory* (and the *Incantation of Wish Fulfillment*) were said to work were never, as far as I have discovered, described in terms of cognitive or affective change. "Awakening" to the true nature of reality, for example, often seen as the true goal of Buddhist practice, had little if any place in these accounts. What was at stake, rather, was an essential transmutation in the bio-spiritual stuff of the person, from the polluted material of mortal, womb-born, animal and human life to something else entirely, a body pure and luminous, formed of the substance of pure lands.

Though formal ritual practices of infusion were important in the history of the spell, other images from the *Scripture* closely connected to them—and rooted in the same ancient notions of physical enchantment—became the most widely known images of the dhāraṇī's particular efficacies in China: the wind-blown movement of dust off objects inscribed (and so enchanted) with the spell, as well as the enveloping movement of the enchanted (and enchanting) shadows they cast. The passages in which these images were elaborated became the warrant for a new genre of ritual object in medieval China, the "dhāraṇī pillar," whose material efficacies were said to be activated not through techniques of active ritual unction requiring a human agent, but more implicitly, and continuously, through legends of the powers of the inscribed stones erected at crossroads, on hilltops, in courtyards, and alongside tombs.[8]

The cult of the spell, in this way, was the site of striking changes in Buddhist material incantation practice, both in the nature of its infusing media and in the means of their infusion—a shift from traditional substances such as oil and ash, which required human activation, to self-generating natural phenomena such as wind and shadow. The genius of the pillars, in terms of the history of the rites they transformed, was that they were all-in-one ritual objects that needed only to be made and placed to generate their blessings. By the mid-eighth century, only a few decades after the scripture had been introduced into

Tang China, Buddhists—monastic and lay—had begun to plan and build the pillars across the Tang landscape such that they spread with a speed only rarely seen in the history of religious practice in China. Though the spread and formal development of the pillars naturally followed from a range of desires and contingencies, their originating inspiration, like that of the spell's mortuary practice, lay in a few lines of text in the translation of a scripture that, as we will see, having caught the eye of Empress Wu Zetian, became a tool in the construction of her imperial legitimacy. The passage tells that were one to

> inscribe this *dhāraṇī* upon a tall banner (*chuang*)[9] and place it on a high mountain, a tower, or within a stūpa, then, Heavenly Emperor,[10] if monks or nuns, male or female donors, men or women, were to see this banner or come close to it, and were its shadow to fall upon them, or wind to blow the dust from the dhāraṇī banner onto them, then, Heavenly Emperor, all these beings' sinful deeds, which should ordinarily cause them to fall into the evil paths of hells, or animal births, or the realm of King Yama, or the world of hungry ghosts, or birth in the body of an āsura,[11] would have no ill effects at all. They will not be polluted with sinful taints. Heavenly Emperor, these beings will receive the prophecies of future buddhahood from every single buddha. They will attain the stage of non-regress within *annutāra-samyak-sambodhi*.[12]

The imagery of dust and shadow, especially, became a key focal point in Tang accounts—those inscribed upon pillars and elsewhere—of the power of the incantation in material form, imagery that, in these accounts, drew not only on ancient ritual techniques but also on deep wells in the Buddhist imagination of efficacy, of the nature of the Buddha, and of the nature of bodies both perfected and gross. As an opening into this material, we can take a Chang'an pillar carved with the *Incantation of Glory* erected in 818 beside the tomb of a Buddhist nun named Wei Qiyi. It is in many ways a typical example. Its colophon praises the spell in terms that by the ninth century had long been familiar:

> The mystic store (*mizang*) of all the scriptures, the wisdom seal of the Thus-Come Ones, they are all located here [in this dhāraṇī inscription]. The pillar's shadows, absorbed into the body, its dust floating and alighting on beings, can purify the evil paths of rebirth so that all will experience *bodhi* [awakening].[13]

The enchanted dust and shadow in this account are said to function precisely as do the ash and oil of the older passages translated earlier: the potency of the incantation, here not vocalized but carved into stone, passes through them to the bodies on which they alight, bringing healing and, here, spiritual benefit. The pillars, like the amulets discussed in the previous chapter, carried forward old practices in new ways. Just as incantation cords lay at the heart of later dhāraṇī amulet practices, so the ancient and simple act of enchanting ash, oil, or water as mediums to be spread on bodies, both living and dead, remained the structuring logic of these later enactments of written incantations. In this we see the deeply conservative nature of Buddhist ritual practice, the continuity of its basic logics even in the midst of startling transformations.[14]

Dhāraṇī pillars—such as this example dated to 877 from the Foguang temple in the Wutai Mountains (figure 3.2)—grew common in the landscape of medieval China (and in tombs beneath it) starting in the early eighth century.[15] Following in part scriptural command, the pillars were placed where they could do the most good, where their beneficence (and their announcements of the piety of their sponsors) could reach the most people:[16] at crossroads, at entrances to temples, or within or beside tombs, where their blessings would seep into the bones of the beloved dead.[17] Even today they are among

FIGURE 3.2
Dhāraṇī pillar, Foguang si, Shanxi, China. Stone, 4.9 m. Photo courtesy Sun-ah Choi.

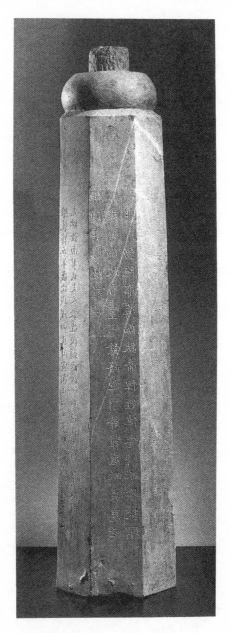

FIGURE 3.3
Dhāraṇī Pillar Inscribed with Buddhas and the "Uṣṇīsa-vijaya Dhāraṇī" (Foding zunsheng tuoluoni jing). 878 CE. Inscribed stone pillar. Calligraphy: h. 124.5 cm.; Base (diam.): 27.9 cm. Princeton University Art Museum. Gift of James Freeman, Class of 1965, in honor of John B. Elliott, Class of 1951 (1995–115 a). Photo: Bruce M. White

the most often-encountered artifacts of the Buddhism of the period, whether in museums or in the field, having been discovered beside or within tombs, in temple ruins, in open country, and carved onto cliff faces. Simple stone posts at first, consisting usually of a single register of text containing the spell and a brief colophon (as in this example from the collection of the Princeton Art Museum; figures 3.3 and 3.4), the pillars over time became much more elaborate structures. These later versions often contained three registers of

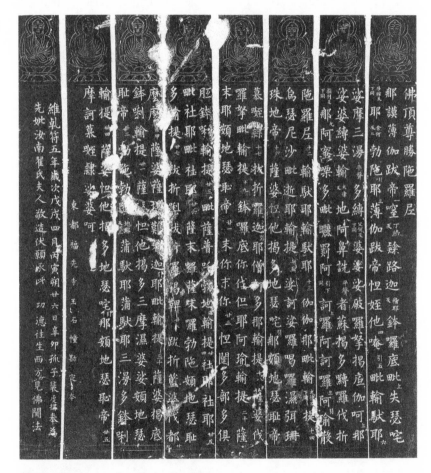

FIGURE 3.4

Rubbing of Dhāraṇī Pillar Inscribed with Buddhas and the "Uṣṇīṣa-vijaya Dhāraṇī" (*Foding zunsheng tuoluoni jing*). 878 CE; modern rubbing. Calligraphy: 98.1 × 92.2 cm. (rubbing); 118.4 × 132.7 cm. (mount); 49 1/2 × 55 1/2 in. (frame). Princeton University Art Museum. Gift of James Freeman, Class of 1965, in honor of John B. Elliott, Class of 1951 (1995–115 b).

text—usually the *Scripture*'s preface, the spell, and a colophon praising the majesty of the spell and the intentions of the pillar's sponsors—as well as multiple layers of imagery and architectonic structure reflecting East Asian stūpa forms. Liu Shufen has described their great variety over the centuries of the late Tang, Five Dynasties, and Song periods, their evolution from simple inscribed posts to towers with designs that drew on those of other objects of Buddhist power, such as stūpas, as well as the ways the pillars came in time to shape temple architecture, taking their place at the entranceways to courtyards and halls.[18]

The pillars, in these and other ways, came to be important elements of the material and visual cultures of medieval Chinese Buddhism, quite apart from the incantation practices that are the concern of this book. They were remade, to take but one example, as relief images carved into cliff faces—in such contexts they were clearly objects of the same ritual species as the sculptures of deities they took their places among and at times replaced. Such cliff pillars were especially common in Sichuan during the late medieval period; one finds them today at nearly every major Buddhist site of the region, whether on their own (figure 3.5) or sculpted (often as a later addition) into tableaux

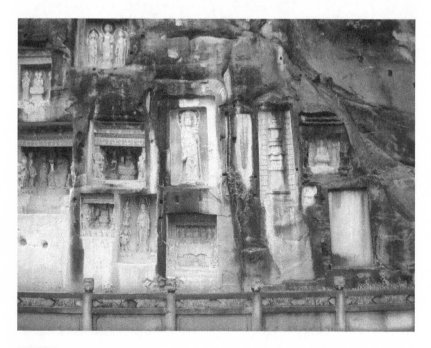

FIGURE 3.5
Cliff-carved Dhāraṇī pillar relief, Bazhong, Sichuan, China (author photo).

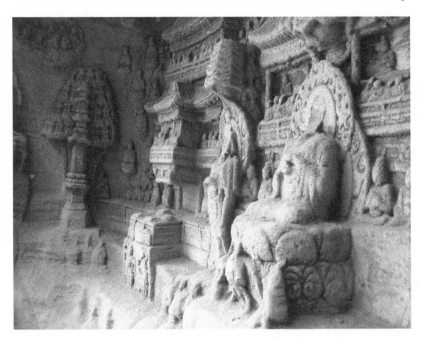

FIGURE 3.6
Cliff-carved Dhāraṇī pillar relief, Leshan, Sichuan, China (author photo).

of buddhas and their realms, where they often took the place of protective deities (figure 3.6). In Sichuan, as well, the pillars became closely associated with Dizang, the bodhisattva savior of damned souls, perhaps because of their legendary power to save beings from the sufferings of hells. At Beishan one finds numerous examples next to images of the Bodhisattva (figure 3.7).[19] The most astonishing of all incantation pillars is doubtless the famous Kunming pillar in Yunnan to the south of Sichuan. It stands over eight meters tall and is ornamented not only with thirty-eight incantations (which occupy a relatively insignificant space on the pillar) but also with nearly three hundred vividly executed images (figure 3.8). As Angela Howard and others have made clear, this pillar—far from being simply a materialized incantation—was a complex figure of the rich culture of occult Buddhism in Yunnan, a region that was a crossroads of Indic, Inner Asian, and Sinitic religious worlds during the age of the Dali Kingdom (937–1253).[20]

The pillars, for all their popularity and variety, were but the most famous and prominent example of incantatory objects associated with the *Incantation of Glory* and its scripture. Other objects were, as the pillars often were, built within or beside tombs as elements of mortuary practice, techniques—like

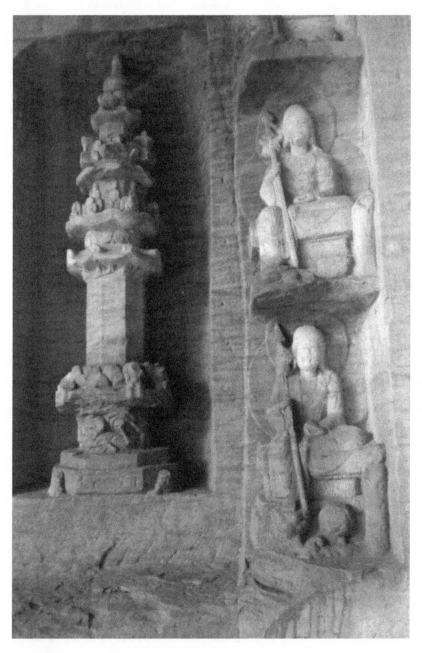

FIGURE 3.7
Cliff-carved Dhāraṇī pillar relief, Beishan, Chongqing, China (author photo).

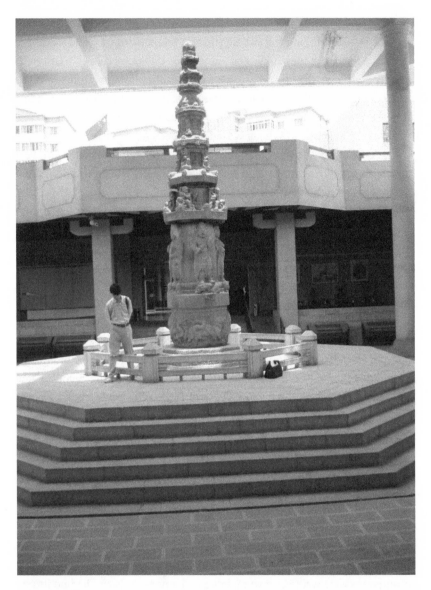

FIGURE 3.8
Dhāraṇī pillar, Yunnan Provincial Museum, Kunming, China (author photo).

the *burial ad sanctos* that was as much a feature of Buddhist as it was of Christian practice[21]—for bringing the corpse (that is, the person) into direct contact with transformative blessings. The simplest of these objects yet discovered, and the ones most like the pillars, were stone slabs placed in tombs with the spell cut into them.[22] Other objects were made not to stand near the remains of the dead but to envelop them. Jars inscribed with the spell, fired to contain the cremated ashes of the deceased, have been found in Yunnan and near Xi'an, the site of the ancient capital of Chang'an, in Shaanxi (figure 3.9). Perhaps most striking of all, a coffin enveloped in the inscribed incantation was discovered in a tomb dating to the Liao Dynasty.[23]

INFUSION AND MATERIAL EFFICACY

The idea that objects inscribed with sacred words take on the power of those words and pass it along to those who touch them is not limited to medieval China or to Buddhism as a trans-Asian tradition. Like the resemblances and possible historical connections between the amulets of the *Incantation of Wish Fulfillment* and very similar examples from the Near and Middle East—not to mention those from regions much closer to China—the modes of efficacy exemplified by the *Incantation of Glory* resonated within a geographically far-flung set of images and practices. Those of Egypt offer a particularly illuminative comparison. Indeed, the term *material efficacy* that I use in this book to describe the conceptions of scriptural potency I am concerned with, is an adaptation of David Frankfurter's term *concrete efficacy*, which he uses in his 1994 essay "The Magic of Writing and the Writing of Magic: The Power of the Word in Egyptian and Greek Traditions."[24] In that work he notes a sharp distinction between ancient Greek and Egyptian notions of the "power of words"—a distinction that, it turns out, offers interesting parallels with certain Chinese Buddhist conceptions of the nature of the infusing class of material dhāraṇīs, such as the *Incantation of Glory*.[25] In brief, his essay argues that while for Greeks incantations were written down mainly as mnemonic aids and had no intrinsic power in their written forms, Egyptians, for whom the written word was powerful in itself, wrote spells down for the magic they had in that form.[26] "The written word . . . was a *sacred* object," for ancient Egyptians,[27] Frankfurter notes. We find close parallels in the Chinese Buddhist tradition.

The Egyptian practices in which these ideas were performed include some that are strikingly similar to those of dhāraṇī pillars, as well as many of the other Chinese incantatory practices explored in earlier chapters. It is not my

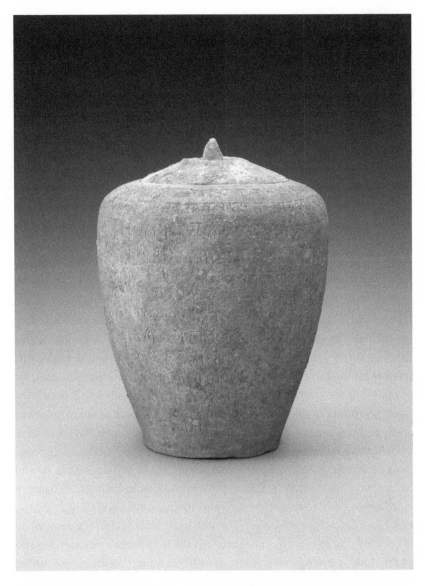

FIGURE 3.9
Funerary jar inscribed with incantation. Gray earthenware body with reddish pigment
and encrustations. Fourteenth century? 24.448 × 19.05 cm. Yale University Art Gallery.
Gift of the Rubin-Ladd Foundation under the bequest of Ester R. Portnow (2006.240.4a).

purpose here to imply historical or essential connections between them, but their parallels make Frankfurter's analysis of special interest to my project. In both cultures literacy was relatively rare and confined to the highest levels of society, though this appears to have been much more extreme in the ancient Egyptian case—he notes that, there, "literacy was exclusively the provenance of the priesthood."[28] In the Chinese case, we might see a parallel here especially in the case of dhāraṇīs, which would have been fully understandable only to a scholarly few. Because most people would not then have had the skills required to read spells, or to understand them when they were spoken aloud, other modes of reception were practiced. Frankfurter describes "three routes of [the] accessibility" of Egyptian spells. The first is the "vicarious," where one simply "observe[s] or trust[s] in the proper performance of rites by sections of the priesthood." The second is "direct ritual." In this style, "a client submits to healing or other rites, gestures, and incantations for his or her immediate or imminent benefit." Of the sources available to us for the Chinese medieval period in these ritual modes, fruitful comparisons might be made with the liturgical texts found among the Dunhuang manuscripts known today as *yuanwen* or *zhaiwen*, which describe various versions of rites for the transfer of merit on behalf of donors who are sick or facing other difficulties, or for the dead.[29] When dhāraṇīs were spoken in such contexts, trust in their efficacy, largely trust in the monks reciting them, would have been key to the power of the rite. It is Frankfurter's third mode of the reception of spells that concerns me here. In this mode, Egyptians would "'tap' the letters or words of inscribed letters by pouring water over them," a practice that suggests for him a conception of the spell's power he calls "concrete efficacy," and for my purposes strongly recalls the ways wind, dust, and shadow off banners or pillars was said to transmit the powers of the *Incantation of Glory*, a process that I have called "material efficacy."[30] I have altered Frankfurter's term, while acknowledging my debt to it, because it is the transformed physical *substance* of the thing inscribed that is key to the picture I am presenting here, rather than the sensory particularity of the transmission of its power: the movement of the spell, from sound (if we take the Indian model) to writing, to the substance inscribed, to the contingent (and contiguous) "stuff" around it, such as dust and shadow, which resembles something like contagion in the modern sense.[31] And note here that in these accounts "shadow" does indeed seem to be a substance, to be "stuff," and not just the absence of light—we must bracket modern assumptions about the nature of "things" like shadow or dust motes when exploring the medieval Chinese world considered in this book.

When incantations such as those I study in this book were written in ritual con-
texts of material efficacy, the resulting texts did not simply encode their sounds
for future recitation; the spells were communicated into the ink or stone *as
ink or stone*, in a kind of synesthetic contagion: sound into sight and touch.[32]
Indeed, late medieval accounts of the *Incantation* found it to be synesthetic
to its very core, in substance, and in action, and in the "tale" its words were
understood to tell (the words of the spell, that is, not those of its scripture).
Such accounts reveal profound continuities within Buddhist ritual that connect
simple modes of physico-spiritual healing like incantatory anointment, mate-
rial practices of erecting stone pillars said to radiate power via shadow and
wind, and grand ceremonial acts of consecration and empowerment.

FANTASIES OF THE SPELL

Taken as parts of what I would like to call, affirmingly, the fantasy life of late
Tang Buddhism, the pillars, in their scriptural warrants, in their physical
placements, and in the imagery associated with them in inscribed colophons
and literary texts, embodied in the age of their constructions ideas of conta-
gious physical efficacy enacted through the spell's famous "shadow-soaked"
(*yingzhan*) potency.[33] This is especially true of the early style pillars, those that
centered the incantation itself rather than other texts, images, or architec-
tural features, as well as the other material forms that served primarily as
simple delivery mechanisms for the spell, such as the jars, coffins, and other-
wise unadorned incantation stones. These forms were rooted in what I argue
was the early (perhaps original) nature of the *Incantation of Glory* as a vector of
infusing potency.

Fantasy and imagination, expressed in textual, material, and visual images,
are basic components of what we indicate by the words *culture* and *religion*,
and though Buddhism in particular has often been characterized as a ratio-
nal tradition centering unadorned experience, as George Tanabe observed,
"[the] Buddhist tradition is as much a history of fantasy as it is a history of
thought."[34] It is, consequently, crucial to acknowledge that incantations were
fantasies, at least in the texts that tell of them—fantasies of agency (both
human and divine), of the nature of the cosmos and of the human place, and
the human *body*, within it. This is true regardless of the actual effects of spells
(or lack thereof), a fact made clear in Susan Sontag's treatment of "illness
as metaphor": analysis of the "punitive and sentimental fantasies concocted
about" tuberculosis and cancer, she emphasized, in no way denies the terrible

actual effects of those diseases.[35] In a like way, analyses of the fantasies written of dhāraṇīs are not comments on the actual spiritual, physical, or social effects of the spells. Instead, such analyses clarify the shapes of the desires and prayers they were embedded within.

It is striking that textual sources for the cult of the *Incantation of Glory* (or those of any other spell, for that matter) only rarely claim that it has worked. When they do so, it is always because the genre of the telling, whether scripture or miracle tale of "numinous efficacy" (*lingyan*), demands it. Genre expectations also shaped noncanonical accounts of the *Incantation's* power. Such texts, inscribed on stone to memorialize the dead, or on behalf of the eventual dead, express not achievement but hope. Their descriptions of the substances, actions, and efficacies of the inscribed incantations figure particular forms of desire, usually of the longing for new life and for a new body free of gross mortal taint and pain. In addition to textual conventions, these expressions of desire were also shaped by the details of the scriptural accounts of the incantations that were chanted again and again in ritual gatherings, by monks and by the members of lay societies, and that were lectured on in public assemblies and exhorted in the lanes by monks seeking audiences for those lectures. The imagery of infusion, of envelopment, and of shadow and dust—the most famous and widely reported figures of the spell—relate the incantation and its literature to a larger body of textual and visual material, which in turn enables a deeper look into the Buddhist practical imagination embodied (sometimes quite literally) within the sorts of spell-writing practices I explore here in the central chapters of this book. Before I turn to this imagery and its wider resonance in Buddhist and other Chinese discourses, however, an outline of the *Scripture of the Incantation of Glory*, its history and the tales of its spell, will help to set the scene.

THE SCRIPTURE AND ITS SPELL

The *Incantation of Glory* first rose to prominence in Tang China as part of the narrative and prescriptive frameworks of the various versions of the *Uṣṇīṣavijayadhāraṇī-sūtra*, a text that was translated a remarkable five times within the span of a generation or so, from 679 to 710 (though the spell at least seems to have been known in China much earlier than 679). The *Scripture* was important in Tang imperial circles—in Empress Wu Zetian's (a.k.a. Wu Zhao, 625–705; r. 690–705) project to ground her reign at least in part in

Buddhist ideology and in the pro-Buddhist (and rather desperate) policies of Emperor Daizong (Li Yu, 726–779; r. 762–779)—as well as in the elite forms of the Buddhist religion known as Esoteric Buddhism that thrived in their orbits. The spell was also featured in Buddhist lay societies, often on the pillars that served in part as their emblems, and it seems to have achieved some popularity in the northwestern frontier of Chinese Buddhism—as evidenced by the many examples of texts containing the *Incantation of Glory* found at Dunhuang. Though only a single pillar has been found in this region,[36] at least 107 copies of the full sūtra were found in the cache sealed in one of the Mogao caves at the start of the eleventh century, counting it among the most often-copied texts at the site. By comparison, a general index of Dunhuang manuscripts lists approximately 160 copies of the *Flower Ornament Scripture* (*Da fangguang fo huayan jing*) and about 100 of the so-called "*Pseudo-Śūraṃgama Scripture*" (*Da foding rulai miyin xiuzheng liaoyi zhu pusa wanxing shoulengyan jing*), both of which tend to be thought in modern scholarship to have been vastly more important in medieval China than the *Scripture of the Incantation of Glory*.[37] Finally, legends associated with the spell were foundational to the establishment of the Wutai Mountains as a space sacred in China and ultimately throughout Asia.

Interest in the early history of the *Scripture of the Incantation of Glory*, in fact, has only rarely been due to the spell itself. Scholars have instead explored the tales of its introduction into China and subsequent translations in order to illuminate such topics as the ideological nature of Empress Wu's Buddhist projects (especially in the early years of her reign and the years immediately leading up to it),[38] the impetus behind the origins of block printing in China,[39] the spread of Esoteric Buddhism in China,[40] and the textual origins of dhāraṇī pillars understood primarily as social phenomena.[41] The spell's implication in the projects of Wu Zetian and her coterie have proved especially interesting to contemporary scholarship, and constitutes the best understood aspect of its history. Antonino Forte, who did the most work in this area, called the tale of its entry into China and early translations "a special kind of Buddhist apocryphon . . . essentially an ideological document."[42]

That document, the preface to the Buddhapālita (*Fotuoboli*) version of the *Scripture*, contains a tale that is even more closely associated with the spell, at least in China, than the narrative contained in the sūtra itself. An Indian monk named Buddhapālita[43] has traveled to the Wutai Mountains to

visit the great Bodhisattva Mañjuśrī (Wenshu), said in the text to be the last bodhisattva left in the world, who has taken up residence there. The text continues:

> When he [Buddhapālita] reached the Wutai Mountains he prostrated himself upon the earth.[44] Facing the mountains he ritually touched the crown of his head to the ground and said, "After the extinction of the Tathāgata, the holy ones all hid their spirits[45]—only on this very mountain does the great one Mañjuśrī still guide common beings and teach bodhisattvas. What I, Pālita, bitterly regret is that, having been born among the Eight Hardships,[46] I may not see the holy countenance of the Buddha. Long have I wandered the flowing sands to pay respect and gain an audience. I submit to and beseech the all-encompassing great kindness and compassion [of Mañjuśrī] to allow me to gaze on his venerable form." When he finished speaking, tears of grief fell like rain; he once again faced the mountain and ritually touched his head to the ground. When he finished he raised his head and, unexpectedly, saw an old man coming out of a mountain[47] who spoke to the monk in an Indic tongue.
>
> He said, "Dharma Master, you have longed for the Way in your heart and searched out the remains of the holy ones. You have not feared hardship but searched far for the traces. However, many are the beings of the Han [that is, Chinese] lands who commit sinful acts and many are those among the renunciates, as well, who break the precepts and rules of the Buddhist order. Only the 'Glorious Dhāraṇī of the Buddha's Crown' can destroy all the evil deeds of beings. I do not know, Dharma Master, if you have brought it with you or not."
>
> The monk replied, "This poor man of the Way has simply come to pay his respects and has not brought any scriptures."
>
> The old man said, "Since you have not brought the scripture you have come in vain! What benefit could there be? Even if you were to see Mañjuśrī, how would you recognize him? Master, you might return to the western countries and bring the scripture back and transmit it to the Han lands. In this way you would widely serve all the holy ones and vastly profit beings. You would save those who dwell in otherworld darkness and repay the benevolence of the buddhas. Master, if you bring the scripture here I, your disciple, will show you where the bodhisattva Mañjuśrī dwells."

The monk, hearing this, was filled with both unsurpassed joy and tears of grief, which he struggled to hold back. He bowed wholeheartedly. When he raised his head the old man was gone. The monk was stunned and redoubled the sincerity of his religious practice. Binding all his thoughts to his devotion, he returned to the western countries and procured a copy of the *Scripture of the Glorious Dhāraṇī of the Buddha's Crown*.

Second year of the Yongchun era [683].[48] When he returned to the Western Capital [Chang'an] he told the aforementioned events, which were made known to the Grand Emperor[49] in a memorial. The Grand Emperor then had the text taken into the Inner Palace, invited Rizhao [Divākara], the Dharma Master and Master of the Three Treasuries, and commanded Du Xingyi, the director of the Office of Reception of the Court of State Ceremonial, to translate the scripture. He commanded that the monk [i.e., Buddhapālita] be given thirty bolts of silk, and that the text of the scripture be confined and not allowed out of the Inner Palace. The monk wept bitterly and petitioned the throne, saying, "This poor man of the Way has sacrificed his body and dedicated his life to bringing this scripture from afar. My dearest hope is to save all beings and rescue them from suffering and hardship. My thoughts are not of wealth—I do not nurture the desire for fame. I beg you to return the text of the scripture to me so that I may spread its teachings and sentient beings (*hanling*) may benefit from them."

The emperor then kept the translation of the scripture, but returned the original text to the monk. When he had obtained the text, Buddhapālita took it to the Ximing monastery, where, after making inquiries, he met the Han monk Shunzhen who was skilled in Indic languages. They petitioned the throne with a request to translate the scripture together, which the emperor granted. The monks then translated the text together in front of the great worthies of the monastery. When the translation was complete, the monk Buddhapālita took the original text and journeyed to Wutaishan and entered the mountains, from which he has not emerged.

Today, the two translations of the scripture, earlier and later, both circulate in the age. Between them there are but few phrases that differ. Happily we have no call to think them strange.[50]

Scholars interested in the spell, noting the "spurious nature of this legend," have tried to discern the political contexts within which it was composed and the political designs it served, focusing on the period of Wu Zetian's rise to

imperial power in 690.[51] Though wide knowledge of the story—and of the further details provided in the preface of Buddhapālita's translation—cannot be traced to earlier than 730, when Zhisheng (669–740) published it in his catalog *Kaiyuan shijiao lu*, or *Record of the Buddhist Teachings compiled in the Kaiyuan Era*,[52] the text itself was probably composed in (or just after) 689, the year before Wu's ascension, since this is the latest date mentioned within it.[53] It seems to have been intended to contribute to the religious scene being set on the eve of her declaration of a new dynasty (the Zhou), wherein she would declare herself to be a Buddhist monarch, a "wheel-turning king."

The preface's tale seems indeed to have been wholly fictitious. A monk named Buddhapālita was once active in China, as recent research has shown, but it seems impossible that he ever did what the preface says he did. Both Antonino Forte and Chen Jinhua have argued forcefully that "a Northern Indian monk called Buddhapālita did arrive in China and that he left China in or shortly after 677."[54] The author(s) of the preface seemed to have chosen him because his name would have been known to, and presumably respected by, people familiar with the Buddhist life of the capitals and because he was no longer around to deny the preface's tale. Though his good name has long been associated with the *Scripture* and its spell—and as we will see later, with the magic of the Wutai Mountains—he seems never to have had anything to do with any of these things and to have been but a narrative pawn of Empress Wu's faction.

The tale itself would have been helpful to Wu on several counts. As Timothy Barrett has noted, it paints an unflattering portrait of her predecessor (and deceased husband), the emperor Gaozong (Li Zhi, 628–683, r. 650–683), who is portrayed as intentionally withholding a text said to be the best hope of the Chinese people. As is very well known, Wu sought in Buddhism grounding for her incipient reign denied her elsewhere among China's traditions, both by the patriarchal structures of Ruist (or "Confucian") ideology and by the Tang Dynasty's avowal of Daoist connections.[55] The way the text reinforces the legend of Mañjuśrī's presence in the Wutai Mountains, which seems to have first arisen during the Sui period (581–618), would have been doubly attractive to Wu. In general terms, the legend gave a great boost to her efforts to establish the centrality of her lands to Buddhist cosmology—the preface, after all, states that Mañjuśrī is the sole remaining deity from the golden age of the Buddha—and thus of her status as a Buddhist monarch. More specifically, since the Wutai Mountains are located near her home of Wenshui, an account that furthered the sacred Buddhist status of the area would have reflected very well indeed

upon a woman seeking to establish her status in terms of the Buddhist cosmos (she would later be declared an avatar of the future buddha Maitreya).[56]

Buddhist practices engaged in within the Wutai Mountains in earlier times also proved central to her projects. Barrett notes that "large numbers of miniature pagodas in stone were discovered in the mountains, the carvings and (according to one passage) inlaid patterns (wen) on them still visible."[57] Barrett ties Wu's use of this event to her interest in furthering her Buddhist monarchial credentials by associating herself with the legendary King Aśoka (r. 273–232 BCE), who was said to have seeded his realm with thousands of pillars and pagodas. Wu followed his lead—and that of her relatives, the former Sui imperial family—in supporting the spread of similar Buddhist monuments through her lands.[58] Barrett's, Forte's, and Chen's work, taken together, make a very convincing case that the appearance of the *Scripture of the Incantation of the Glory of the Buddha's Crown*, with its injunction that one should inscribe its dhāraṇī on pillars and insert it into stūpas, was a product of this milieu. Though we should be careful not to overestimate the power of imperial designs on the behavior of Buddhist practitioners across Tang China, it is likely that the remarkable spread of the dhāraṇī pillars inspired by this text— the earliest datable example of which (though it is unlikely that it was in fact the earliest) dates to 702—attests in part to the success of her project.

The association of Buddhapālita, and by extension, the *Incantation of Glory*, with the Wutai Mountains would remain central to the legends of both throughout the eighth century and beyond. Miracle tales reported that when Fazhao (fl. 766–774), a monk famous for his special five-toned (or, perhaps, five-rhythmed) way of chanting the name of Amitābha, the *wuhui nianfo*, traveled to the range (where he founded the Zhulinsi in 770) he encountered Buddhapālita, still apparently alive and well.[59] The Indian monk had taken up residence in the Diamond Grotto (jin'gang ku), Mañjuśrī's abode in the mountains. Raoul Birnbaum has noted that this site was "without a doubt . . . the cave at Mt. Wutai that has been the best known to travelers and pilgrims," one that "has remained an important pilgrimage site until recent decades."[60] One tale of the encounter, which quite obviously carries forward the narrative of the *Scripture*'s "Preface," goes as follows:

During the Dali period (766–779), the śramaṇa Fazhao of the Yunfeng Monastery of Nanyue entered the Wutai Mountains in search of the Diamond Grotto. When night had not yet reached its midpoint, he struck the ground in self-reproach. Suddenly he saw a monk about seven chi in

height. The monk spoke in ringing tones, calling himself Buddhapālita. He asked Fazhao: "Master, to what end do you give yourself such grief? What joy is it that you seek?" Fazhao replied: "I desire to see Mañjuśrī." Buddhapālita said: "If your strength of purpose is solid and forceful, true and without delusion, you can remove your shoes and place them on the board and approach respectfully. Then the sagely countenance will allow itself to be seen. Fazhao was then blinded and suddenly whisked inside a grotto, where, [his sight returned], he saw a temple (*yuan*). Written on the tablet above its entrance was "Diamond Prajñā Monastery" (*jin'gang bore si*). The characters were exceedingly fine and sparkled with a golden light. The temple was all adorned with strange gems—its fame should never lessen! Its halls were packed tightly together such that their roofs were joined. Their screens were finely woven and their bells sounded harmoniously. There were about two hundred halls. Within the temple there was a secret storehouse, sealed within which was a copy of the *Diamond Prajñā Sūtra* along with those of all the sūtras. Even the greatest of men rarely sees such treasures as these. The Great Saint Mañjuśrī, awesome on his throne, was surrounded on all sides. He declared that Fazhao be cared for, given tea to drink and food to eat. After he had eaten, Buddhapālita led him out: though Fazhao begged to remain in the monastery, Buddhapālita would not allow it. Just as they were about to depart he tried to force the issue and re-enter the grotto and stay there. Fazhao returned to the board to find his shoes, but in the blink of an eye, Buddhapālita had vanished.[61]

The tale suggests that the Buddhapālita-Wutai association outlasted the eventual death of the empress and the dissolution of her brief interregnum. The timing of this "event," moreover, is telling. The year 770, the date of Fazhao's construction of the Zhulin Monastery in the Wutai range—for which the tale of his meeting with Buddhapālita, and through him Mañjuśrī, must surely have been advertisement—was the year of the next major recorded event in the life of the spell.

In 770 (*Dali* 5), in the midst of Amoghavajra's campaign to "disseminate the [Mañjuśrī] cult in China,"[62] a project naturally centering on the Wutai range, Amoghavajra requested in a memorial that the Tang emperor Daizong command that fourteen specially chosen monks chant the *Incantation of Glory* in memory of the dynasty's founding by the emperor Gaozu.[63] No record of the emperor's response remains, but no less an authority on the history of

the Chinese Saṃgha than Zanning (919–1001) recorded that the emperor had indeed so ordered.[64] The coincidence of these two sources—the tale of Fazhao in the Wutai Mountains and the memorial of Amoghavajra's—suggests continuing connections between the spell, Buddhapālita, and Wutaishan. Amoghavajra's interest in the spell may in fact have been a direct result of his interest in Mañjuśrī, which continued to the end of his life. He became, along with Śubhakarasiṃha, its chief monastic patron in the mid-eighth century. At the very least, the Incantation of Glory's connections with the deity could only have increased his interest. Two years after the decree, in 772 (not long before his death in 774), Amoghavajra "elicited an imperial order directing the establishment of a [Mañjuśrī] chapel in every monastery in the empire."[65]

The final recorded event in the spell's nearly century-long relationship with the Tang imperium occurred in 776, two years after Amoghavajra's death. It is also the best-known event in contemporary scholarship having to do with the spell. As Forte notes, "Chou Yi-liang remarked long ago [that] in 776 (Dali 11) Daizong 'issued an edict ordering monks and nuns of the country to memorize the Uṣṇīṣavijayadhāraṇī within one month. From then on they were to recite it twenty-one times every day, and to report to the Emperor in the beginning of each year how many times they had recited it in the past year'."[66]

The next major source for the spell allows us to make a transition from the imperial court to the wider world of the spell's reception and reproduction in the Tang. The text—Jiaju lingyan foding zunsheng tuoluoni ji, the Record of the Verified Efficacy of Adding Syllables to the Glorious Dhāraṇī of the Buddha's Crown[67]—composed by Wu Che (fl. late eighth c.), a distant relative of the now-long-deceased Wu Zetian, makes clear that as the popularity of the dhāraṇī spread, its forms and practices diversified.[68] The text consists of tales of the efficacy of a modified form of the Zunsheng zhou and a version of the spell itself attributed to Śubhakarasiṃha. Wu begins the text, after a brief paean to the might of the incantation, by relating that he had "often chanted the spell since he was a boy," but that since the death of his wife at the beginning of the Yongtai era (765) he had increased his desire to be "free of things." He tells that he learned of the augmented version of the spell's special efficacy from a man who had received it from a certain "Bodhisattva Wang" (Wang Kaishi), who had in turn received it from the great Esoteric Buddhist master Śubhakarasiṃha. Interestingly, the text reports that Śubhakarasiṃha claims to have himself brought the original text of the spell—"rare even in the West"—to China, a detail that suggests that the popularity of the spell had reached such great heights by the mid-eighth century that separate lines of

textual transmission of the "true spell" were being claimed. Tragically for Wu Che, just as his friend is about to give him the text of the spell he dies, leaving Wu bereft. Wu then spends the next years searching for the augmented spell, seeking it from every Buddhist (*jingshi*) he encounters. Finally, he meets someone who has the spell, a certain "Master Ji" (Jigong).[69]

Wu Che then relates tales that illustrate both the efficacy of the new spell and the uselessness of the "incomplete" versions that had been circulating in China since its arrival in the hands of Buddhapālita. In every instance, the issue is the same: someone is earnestly chanting the old Buddhapālita version of the *Incantation of Glory* without effect. In the first tale, a layman named Wang is deep in the mountains, chanting it with a pure heart for the benefit of his deceased father, yet nothing is happening. One day, as is so often the way in such tales, Wang "sees an old man" who tells him that the problem lies not in him but in the text of the spell he chants. The old man reports that the Buddhapālita version of the spell is riddled with errors and incomplete and thus that it won't matter how many times the man chants it or with how pure a heart he does so—the spell itself is faulty. The old man gives Wang the Augmented Spell, which Wang proceeds to chant. Almost immediately the miraculous efficacy of the new spell is revealed: Wang's father appears as a heavenly transcendent (*tianxian*) descending from the heavens trailing an awesome retinue—all as a result of the spell, his father the newly born deity assures him.

Intimations such as these tales provide of the rapid spread and diversification of the uses of the *Incantation* extend to its most plentiful sources: the spell's inscribed forms found on pillars. In these objects and texts the transformations of dhāraṇī practice—and of ideas of this spell—are very clear. An account of their significance takes us out of the realm covered by this sketch of official history and legend and back into an exploration of the logic of spells, the true subject of this book. Before turning to those texts, however, an account of the narrative of the incantation scripture—itself an important part of the spell's context, and a tale often indexed on the pillars—is necessary.

THE SCRIPTURAL NARRATIVE

The narrative portion of the sūtra—in the version attributed to Buddhapālita slightly less than three thousand characters long—is, like those of most dhāraṇī texts, mainly concerned with extolling the powers of its spell and the various ways given to actualize it. These practical concerns are framed within

the story of a god named Shanzhu, who, in the midst of enjoying the greatest heights of pleasure and good fortune, cavorting with gods and deva-maidens in the gardens of the Heaven of Thirty-Three, hears a disembodied voice tell him that in seven days' time he will die and tumble down to the lowest depths of misery in a series of terribly unlucky rebirths. In the Buddhapālita version, the voice says:

> God Shanzhu, in seven days your life will be exhausted! After your life ends you will be born on the continent of Jambūdvipa, where you will receive seven consecutive births in animal bodies. Immediately after that you will experience the sufferings of the earth prisons (diyu; that is, the Buddhist hells). Once out of the earth prisons you will receive a rare human birth, but in a poor and base family. Even while you are still in your mother's womb you will have no eyes.[70]

Shocked and disconsolate, the god turns for help to the ruler of the heaven, Śakra, "the strong," an epithet of the great god Indra, one of the old Indian gods prominent in the Buddhist tradition. Śakra confirms what the voice has said. Moreover, he discerns the specific forms of Shanzhu's future animal rebirths: he will be a pig, a dog, a jackal, a monkey, a python, a crow, and a vulture; all forms of life, as Indra notes, that "feed on filthy, evil, unclean things." Indra, at a loss as to how to remedy the situation, goes to the Buddha for help. The Buddha was at this time "dwelling in Śrāvastī within the Jeta grove of the gardens of the provider for the orphaned and alone,"[71] one of his favored locations in sūtra literature. After making properly devout and resplendent offerings to the Buddha, Indra pleads Shanzhu's case. The Buddha, somewhat uncharacteristically in a dhāraṇī sūtra, immediately and willingly offers an antidote in the form of the Glorious Dhāraṇī of the Buddha's Crown, to which title he later appends the further qualifier "that purges all evil paths of rebirth." He recites the dhāraṇī for Indra, at which point the text lays out each syllable of the spell. Most of the remainder of the sūtra's narrative is taken up with various accounts of the powers of the spell and how best to make use of it. After these descriptions are finished, the Buddha instructs Indra to teach the spell to Shanzhu and to return in seven days. The spell works, we are told, and at the appointed time Indra, Shanzhu, and a host of celestial beings return to the Buddha's assembly, where they listen to him preach the Dharma and predict Shanzu's eventual buddhahood, to the great joy of all those in attendance.[72]

The narrative offered in the scripture is simple and in broad terms quite familiar. More than anything else, the work is preoccupied with fear—so much so that Antonino Forte has called it a work of "psychological terrorism."[73] Shanzhu's terror of his future is quite literally hair raising: "he was in such great horror and shock that the hairs all over his body stood on end."[74] Fear is a familiar subject of Buddhist literature and art. Among the most common features of the early images of the Buddha are depictions of him holding his right hand out in the "fearless" (wuwei; abhaya) mudra, his hand opened with the palm facing out, "as if in blessing."[75] This posture, visually (and physically) construing the viewer as the fearful object of his blessings, figures a relation between supplicant and healer with deep roots in Buddhist traditions. The Prajñāpāramitā literature, to take a well-known example, contains many statements to the effect that its purpose is to quell the terrors of existence. More narrowly, and with more relevance to the present study, the horror that Shanzhu feels at his imminent fall from heavenly grace into animal lives of filth, and worse, found resonance in medieval Chinese religious life, much of which was focused on the task of overcoming the vicissitudes of the afterlife so dramatically depicted in stories and art dating from this period. The roots of the picture of the afterlife that arose by the ninth century were in part nurtured in the soil of texts such as this one and the practices it describes.[76]

This discourse of fear and salvation was a key feature of strategies used by monastic institutions to draw people into their influence. Scripts for both sūtra lectures and "Seat-Settling Texts" found at Dunhuang—archival scripts for talks given to advertise the lectures and, at times, to warm up the crowd before them—are filled with images of the eons of horrors that await the sinful, horrors that, as one text has it, would strike fear even into the heart of a man of iron. One lecture, probably delivered as part of a confession ritual, explains:[77]

Were one to speak of the pain and distress of the three unfortunate paths,
How hard to tell of those hundreds, thousands, myriads of kalpas! Hearing it told, even the heart of a man of iron would repent[78]—How could good men and good women not be afraid?

If you go your whole life without a good friend.[79] You won't be taught the rite of confession of past faults. Ordinary worldlings cannot abandon the ten evils; This morning you must strive to confess and regret. . . . [80]

The ten evil acts are the hardest to tell of, For hundreds, thousands, myriads of kalpas, you'll be bereft of good causes. Fast the heart today— you must confess and give thanks: In a ksana[81] your life will be over and you will be reborn as a god![82]

It is plain that this imagery of the terrors of existence was situated in a discursive framework where it functioned as a setup, as it were, for the punch line detailing the benefits of Buddhist practice. Imagery of "the ten evils" and "hundreds, thousands, myriads of *kalpas*" of misery, for example, create a pitch of emotional urgency assuaged at the end by talk of gratitude and rebirth as a god. The facts of cosmic existence as presented in works of Buddhist literature such as this sermon and the *Scripture of the Incantation of Glory* are more than the weak and solitary mortal can bear. The "good friend" offered by the tradition, who teaches in the Dunhuang text the rites of confession and atonement, is presented as the only way out of the endless suffering that the sins of ordinary mortal men and women have made otherwise inevitable. And note that the inclusion of women here is clearly called for by the content of our source: later in the text the lecturer addresses women in the audience—he sternly notes the facts of female (and male) marital infidelity, as well as the "pollution" of nuns by members of the laity.[83] The parallels between the incantation scripture and the precepts lecture are striking. In each, only one hope of salvation is presented: in the Dunhuang script it is the affective change wrought by ritual atonement; in the scripture it is the spell itself, reproduced either in an elaborate rite or simply spoken or inscribed. But though there are powerful structural similarities here, the differences are just as clear, and emblematic of what seems to be a deeper split in Buddhist discourse. In the atonement rite one is meant to undergo a change of heart—one regrets (*hui*), repents (*quan*), apologizes and confesses (*xie*)—while in the world described by the story of Shanzhu and the dhāraṇī, the only saving thing is contact with the purifying and radiant substance of the spell.

Though these works at times create terribly dark pictures of mortal life, the fearful scenario described by Shanzhu's encounter with the voice is not wholly unmediated by humor. There is more than a little irony in his predicament, a fact signaled by his very name. *Shanzhu* means "well established," and in the context of the story "suggests one who is 'firmly placed to enjoy all good things,' a fitting designation of a resident of the Trāyastriṃśa heaven."[84] But we find out immediately that his position in that heavenly place is not at all firmly established, a fact that reveals his name, humorously I would say, to be not at all "fitting." Or, perhaps it is closer to the point to say that it properly befits the butt of a joke or the hero of a fable. The irony, in other words, is a lesson in itself. The tale suggests that no one is "well established" in the wheel of life, at least not without the aid of the Buddhist teachings. This is equally true of the mightiest gods, even Indra himself, lord of the Trāyastriṃśa heaven,

where the future buddha Maitreya, according to some legends, waits for the times to ripen.

But issues of humor aside, central to the impact of the text is a haunting quality of unfairness in the newly discovered vulnerability of Shanzhu's position, one that might seem at odds with the usually inexorable ethics of cause and effect familiar in other works of Buddhist literature. We have no reason to think that Shanzhu has done anything wrong—there is no sense, certainly, that his frolics with the *deva*-maidens were immoral or inappropriate. He has, we can only assume, earned his sweet heavenly life through many past lives marked by ethical behavior, and that he spends it now in the pursuit of pleasures can hardly be unfitting. What else, after all, should a god do? On the matter of the nature of his frolics, one scholar has warned us, perhaps a bit too sternly, not to let our imaginations "run wild" here. He notes that according to the *Dīrghāgama*, "sexual relations between the Trāyastriṃśa's gods and goddesses involves no direct physical contact: they come near one another and enjoy the play of yin and yang only through their breath (qi)."[85] I think we might not go too far astray, however, if we let ourselves imagine that the sexual play of divinities involved at least the same intensity of pleasure and intimacy found in its more undivine carnal forms, lest we not feel the shock and extremity of his sudden brush with the loss of this pleasure and ease. The fear of their loss, and more, of the terribly painful alternative lives cosmic law casts us into, was a great deal of the point in these texts. To downplay the shock and terror of these images is to lose the force of the medieval Chinese responses to them that were cut into the pillars: the prayers that the roots of misfortune be destroyed through immersion in the purifying shadow and dust off the stones. To these prayers and their images we now return.

STEEPED IN SHADOW AND DUST

The striking idea that a spell was active not only through sound but through wind, dust, and shadow came to have wide currency in the East Asian Buddhist world as the image most closely associated with the workings of this dhāraṇī. In the "hymns" (zan), "records" (ji), and colophons cut onto dhāraṇī pillars along with the spell and its tales, authors used these images more often than any others to describe and praise the powers of the spell. The texts, indeed, suggest that the people who commissioned pillars were partly inspired to do so by these figures of the spell's might, by the idea of the efficacy in mute physical stuff of phenomena normally said to have power only as sound.

In 834, Lü Shou (d.u) composed a "preface" (xu) for a pillar inscribed with the *Incantation of Glory* that provides a good place to begin an exploration of this imagery. It is an exemplary text for us in that it eloquently presents a typical picture of the workings of the inscribed incantation. It is a helpful example to begin with in another sense as well. While we have almost no clues about either the physical makeup or original placement of most of the pillars whose inscriptions survive, we have at least a rubbing of this pillar. This is a very happy chance, for it helps us to keep in mind the physical makeup—indeed, the sheer material presence—of the spell and its ancillary texts, which would have been as important to the imagined potencies of the pillars as any literary or calligraphic skill their words might display. Even the traces of that substance that rubbings afford are invaluable to us as we imagine the life of the spell in the Tang.

Such rubbings are in fact nearly as valuable as the remaining pillars themselves; they present an image of their long-vanished faces, in some ways as they were in the past. Wu Hung has argued eloquently that rubbings preserve, snapshot-like, the ancient visages of stelae that have themselves long since worn away or changed. "Because a rubbing 'freezes' an object at a particular moment whereas the object itself continues to deteriorate, an older rubbing is always more 'authentic' than the real object."[86] Spells on pillars were more than simply the two-dimensional and now free-floating images of their calligraphic figures, but we should be grateful for all the "ruins" of their lost presence that we have. All-too-many pillar inscriptions are presented in collections such as the *Quan Tang wen xinbian, New Edition of the Collected Prose of the Tang*, as if they had been written as stand-alone literary texts, and not as pieces of larger packages consisting in various registers—words both discursive and magical, images, and physical objects placed within specific surroundings—as what Thomas Lamarre has described as the "multisensible figures" constituted by inscriptions. Since my aim in this chapter is to elucidate elements of traditional theories of inscribed Buddhist spells, for the most part through citations of canonical texts, I will do little better; as Lamarre aptly describes it, I will also for the most part "collapse these registers . . . into [only] the verbal."[87] Among the justifications for this approach is the fact that it resonates in important ways with the medieval culture of these works. Essays such as Lü Shou's "Preface," though written as I have noted for particular physical and social contexts, also circulated within wider literati and Buddhist circles, a fact that helps to account for the close similarities in phrasing that recur in pillars of far-flung regions—indeed, it was often as rubbings that the pillar

texts became most widely known among the literati hired to compose them.[88] Nevertheless, we do little justice to the history of the spell and its formats if we let the immediate material and social contexts of these texts slip from our minds. Judith Zeitlin has made clear the crucial importance of specific walls to the genre of poems written on walls (tibishi), a close parallel to the importance of original physical contexts to the spells and prose composed for individual pillars. "[Unlike] an ordinary published poem, whose point of spatial origin is largely irrelevant and blurred by the promiscuous circulation of print, a tibishi always remains at least theoretically defined by a specific location of space. Even when a later transcription of a tibishi is encountered in the printed pages of a book, the reader must imagine it located in a specific site."[89] This situation precisely reflects that of the pillar inscriptions considered here.

Lü Shou, after praising in general terms the Buddha Way and the people who were responsible for the pillar, turns his attention to the Incantation of Glory:

> Among the scriptures of the Buddha there is the Dhāraṇī of Glory. Its merit great and vast, its spiritual import [daoyi] profound and primordial, it can save all those born with sentience and broadly rescue beings of all kinds. When its shadow reaches you, the greatest sins are erased; when its flying dust infuses you, all-embracing good fortune arrives.[90]

The basic images of the last sentence are familiar: they describe the infusing or anointing actions of bodily enchantment. What is new here is the precise way that the dust and shadow are described as acting on the person. The dust might seem particularly remarkable, in that it is said to "infuse" or "soak" (zhan 1) the person it comes into contact with. This strong image, it turns out, occurs often in the stele literature on the spell; it is, in fact, one of the two central images of the anointing magic of the Incantation's inscribed form. When the texts employ a specific figure to convey the workings of the spell through dust or shadow, it is nearly invariably either this one or fu, to pour out, envelop, conceal.[91] The word zhan is not unique to this body of literature, and I do not wish to claim that in itself it fully governed the way the spell was imagined; neither do I wish to take it (or its companion, fu) as an object of contemplation divorced from writings on the spell. Yet a close—even naively literal—reading of these favored images not only clarifies precisely how the ritual trope of incantatory anointment was imagined within the cult of the Incantation of Glory, it takes us into a much wider body of literature that shaped

Chinese accounts of the workings not only of spells within small modules of ritual practice but of a great many forms of merit and power written about in premodern China, both Buddhist and otherwise.

The word, or words, indicated by the characters zhan (1) and zhan (2) have the basic sense of soaking, moistening, and infusing. Though in modern usage the graphs have taken on differing ranges of meanings,[92] in their appearances within descriptions of the *Incantation of Glory* they seem to have been interchangeable. The earliest canonical usage of the term zhan, at least as evidenced in modern etymological dictionaries, is in the song "Xin Nanshan," collected within the "Xiao Ya" section of the *Book of Songs* (Shijing), where we can note the early positive associations of a good soaking. "Soaked and enough, our grains grow" (jizhan jizu sheng wo baigu). Soaking-in was at times also the imagined action of virtue, as we can see in Yang Xiong's (53 BCE–18 CE) "Fu on Tall Poplars Palace" (Changyang fu), which takes as a metaphor the agricultural fact the *Songs* celebrate. "It is said of the sagely lord's nourishing of the people that his humaneness soaks in and his kindness suffuses" (ren zhan er en qia).[93] Here is soaking as a transitive action, the sage's virtue imbuing itself into those under his influence. In a morally neutral usage, the term describes the skin-deep infusion, or sticking, of a substance onto an object, perhaps in the ways that dust might be thought to adhere to skin or clothes, as in the seventh of the "Nineteen Old Poems" (Gushi shijiu shou)—among those works, usually dated to the second century CE, thought to stand at the source of the shi poetry tradition in China—where the "white dew" (bailu) of early autumn is said to "condense on the wild grass" (zhan yecao).[94] I do not wish to imply that these few prominent uses of the term somehow defined the contours of its reception among literate Chinese of any one period; clearly they could not have. Yet, these canonical appearances of the image(s) help us to see how the term does what it does, as well as the kinds of things it does, observations that thereby help to set the stage for an understanding of what is implied by the trope's centrality in discussions of the spell. Soaking, condensing on, transforming, as we will see, are precisely the actions of the spell. The other prominently used image, that of pouring and enveloping (fu) is, it seems to me, rather similar in its basic nature to zhan. They work as a mutually enriching pair, and I will let the latter stand for the whole of this relationship in this discussion.

Curiously, the imagery of infusion does not occur in the Buddhapālita version of the scripture. It does occur, however, in the version of the text attributed to Du Xingyi (fl. mid seventh c.), traditionally said to have been the first

translation, as well as in the second of the editions associated with Divākara, which is supposed to have dated from several decades later. The former work states that "if you draw near the pillar, or if the pillar's shadow infuses you, or if wind off the pillars blows your body, or if dust blown off the pillar attaches to you, your sinful karma will be destroyed . . . ".[95] Imagery of infusion is especially prevalent in the second Divākara text, the *Zuisheng foding tuoluoni jingchu yezhang zhouzhing, The Incantation Scripture of the Dhāraṇī of the Buddha's Crown of Utmost Glory, which Purifies and Disposes of Karmic Hindrances.*[96] Here the preferred ritual objects are stūpas rather than banners or pillars. The working of the stūpa's efficacy, however, is the same as that of the pillars in the other versions. "If wind, blowing the stūpa, blows onto someone and even slightly infuses their person (*chui ren shaozhan shenfen*), they will be reborn in a heaven and enjoy surpassing wondrous bliss; [afterwards] they will also be reborn in whatever pure land they desire." The parallels in imagery between these texts and those on the pillars are notable because most of the evidence indicates that it was the Buddhapālita text that most influenced the pillar tradition—this work is on almost all of the pillars that bear text from an identifiable version of the scripture. The other versions only rarely, if ever, show up on pillars, a fact that is one of the main reasons adduced for the oft-claimed preeminence of the Buddhpālita text within the spell's cult. But the other texts may not have been as inert in terms of influence and life in the culture as this picture implies. The wide usage in pillar texts of the infusion trope to describe the way the spell is transmitted through dust and shadow is reason to wonder if the other texts didn't also have significant communities of readers. Du Xing-yi's version clearly had connections with the literati prose of the inscriptions not shared by the Buddhapālita text, as did the second version attributed to Divākara. But since the latter text was the product of a later time, it may not so much account for the spread of this trope in the cult of the *Incantation* (as Du's work could have) as reflect it: dhāraṇī pillars would have already begun to dot the landscape, and their rubbings have entered the studies of literati, when this text was composed.[97]

The infusion image shows up twice in an undated Tang inscription from a pillar built to be placed at a crossroads, a location of both clear scriptural warrant and great popularity where the pillar's orbiting shadow and flying dust might reach the greatest number of people. The mystic nature of dhāraṇīs is introduced in familiar terms: "The surpassingly marvelous and sweet ambrosial gate of practice, the Buddha's mystic heart,[98] the great seal of the encompassing grasp. What forms the lynchpin of samādhis and gathers the active

essence of all dharmas? The subtle phrases of dhāraṇīs." The text then turns to the history and efficacies of the incantation: "The *Glorious Buddha's Crown*: Buddhapālita came from India to transmit it. Vowing to behold Mañjusrī he entered the Qingliang Mountains and never returned. Because of him the Sanskrit verses flow and spread throughout the realm. A pillar-shrine (*chuangcha*) at the crossroads, ornamented with fragrant words amid its hundred gems; its dust infuses, its shadow touches, and sins [. . .] melt in the morning sun. Your mind recites it, your eyes [gaze upon it] and the sea of blessings fills up in the night." After praising those who had had the pillar erected at the crossroads, the text returns to its earlier theme, put now in the form of a hymn (*zan*), first in lines of four characters and then of six.

> The phrases of the Buddha's Crown:
> Subtle, wondrous, inconceivable.
> Vehicles for the myriad kinds,[99]
> They benefit all beings.
> We carved [this pillar] of kingfisher blue
> Towering in its courtyard.
> With its infusing winds and saving shadows,
> Taints are destroyed and the dust [of delusions] lightened.
> We engraved these jade words that they might gleam and shine;
> Fixed these gemlike hues that they might glitter and glow.
> It is a kalpa-stone and will collapse [only at eon's end];
> These great blessings will never [fade].[100]

Another example dates from 909, just after the ultimate end of Tang Dynastic rule, in the short-lived kingdom of Shu (907–925) in Sichuan. This pillar was constructed not at a crossroads but in the courtyard of a temple, another favored location for dhāraṇī pillars. A monk named Chuan'guang (d.u.) composed the record of the construction of a pillar located outside the Luohan Hall of the Huiyi Monastery (*Huiyi si*), in what is now Hubei Province. Introducing the scripture of the *Incantation of Glory*, he tells us that it was "translated in the Dragon Hall. The Phoenix decreed that it be placed at the top of high towers that monks of Buddhist shrines [*focha*] might see it or draw near it,[101] and its shadow touch them or its dust infuse them. All were made to raise up dhāraṇī pillars."[102]

Though the imagery of infusion gives an immediate, sensual dimension to the all-important moment of contact—"interface," even—with the substance

of the spell, the imagined infusion was not always literal, in the sense of requiring the physical presence of the one who was to receive the spell's benefits. The potent shadows, for example, might operate at a distance, too, a fact that makes them much the same as other manifested forms of Buddhist power. The transfer of merit is among the key rites of Chinese Mahāyāna Buddhism, and the dust and shadow efficacies of the spell were, not surprisingly, at times subsumed within this basic practice. This seems to be the case with an 866 pillar constructed on behalf of a female disciple of a local Huang clan, who went by the religious name Shunyi, in the "western Vinaya hall" of the Fuxian monastery (*Fuxian si*) in the eastern Tang capital of Luoyang. It speaks of the "shadow-soaked merit" of the pillar:

> May the intended receive this shadow-soaked merit (*yingzhan gongde*), transcend suffering, and leave it below her. May she never fall into the three lower paths, but be reborn in a pure land.[103]

Images of the physical infusions of blessings in the form of holy substances are familiar to readers of Buddhist sūtras, which are filled with tales of things such as the rain of the Dharma soaking all beings with its transformative power, or of "sweet dew" raining down and doing the same. This broad family of images lay behind the ritual models of the direct application of incantatory blessings that were the more immediate sources for the ritual logic of the pillars and the other material efficacies of the *Incantation of Glory*. The images pervade ("suffuse," one is tempted to say) canonical Buddhist literature. In chapter 42 of Guṇabhadra's (394–468) translation of the Saṃyuktāgama (*Za ahan jing*), in a verse extolling the benefits of giving to the Buddhist order, the text states that

> . . . like thunder and rain on a good field,
> merit pours down, spreads, and soaks the donor's mind.
> Wealth and fame flow to him, and the final fruit of extinction.[104]

Similarly, in Prajña's (Bore, 744–ca. 810) translation of the *Dasheng bensheng xindi guanjing*, the *Great Vehicle Contemplation Scripture of the Mind Ground of [the Buddha's] Original Lives*, we are told "the treasure of the Law has but one flavor and is unchanging. Buddhas of the past, buddhas of the future, they all preach the same thing—just as rain, which is of a single flavor, drenches all. . . . "[105] When blessings were wished for, too, they were often imagined in the form of such drenching substances, as when, in an early Song era tale of an age long

past, a postulant beseeched the Buddha of that time, saying, "I seek the Way and wish to be soaked in its sweet dew flavor."[106]

Texts on pillars reflect such usages, for example, in their wishes that beneficiaries "be infused with this good fortune" (zhan ci fu). Modern dictionaries tell us that zhan, in such cases, should be taken to simply mean "receive." Yet by denaturing the image and robbing it of its force, such readings may simply read back modern prejudices about the nature of "reception," obscuring deep veins in the medieval Chinese Buddhist imaginary. This is not to say that the term, in phrases such as "X-drenched," etc., was never used simply as an evocative figure in literary texts. Doubtless it was. But when it appears in religious practices founded on the idea of the actual *bodily transference* of blessings or incantatory power, we must be careful to be true to its place there. Like pillar inscriptions, accounts of ritual practice are clear in their descriptions of the bodily nature of this absorption. What I describe in this book as the anointing or infusing action of material spells was but one instance of the body transformed by contact with the marvelous substance of the Buddhist divine, as when in a moment of a larger rite, where blessings are said to spread "like mist that disperses from light clouds or as the colors contained in precious blossoms," participants are urged to "go to the Dharma mats, bow their heads, curl their fingers and be infused with blessings and benefit."[107] The functions of images of transformative *substance* in the religious practices of medieval Chinese (not to mention of Buddhists the world over), and the force of the related tropes of its infusion and ingestion, must not be inadvertently erased by unfaithfulness to those images. Lines such as the following abound in the pillar inscriptions available to us: "May beings of the Dharma realm all alike be infused with this good fortune."[108] "May ten generations of the ancestral dead be infused with this surpassing good fortune."[109] "May beings of the Dharma realm all be infused with forgiveness from above."[110]

Yet though the imagery of soaking Dharma rains, etc., is found throughout transmitted Buddhist literature, these specific phrases are surprisingly sparse in it. In fact, an electronic search of transmitted Buddhist texts in Chinese turns up only four instances, all dating from the Tang period. One of the four, perhaps tellingly, is from a text associated with the *Incantation of Glory*: Wu Che's tales of the efficacy of the lengthened version of the dhāraṇī.[111] Another, traditionally dated to 733, is in a text on the figure of Mañjuśrī with a thousand arms and a thousand bowls, whose translation is attributed to Amoghavajra.[112] In that text, the phrase, closely in line with those above, occurs in the seventh of a set of ten vows made by the bodhisattva. Mañjuśrī promises to spread the

merit accrued from the construction of Buddhist halls and images. He states that if one constructs "temple lodgings, monk residence halls, *saṃghārāma*,[113] stūpas, meditation halls, *araṇya*,[114] solitary and quiet dwellings . . . or makes images of bodhisattvas and all the buddhas," he will then "spread throughout the Dharma realm the merit established by this practice of generosity, dedicate it to the *bodhi* of all buddhas, and cause all sentient beings alike to be infused with its good fortune."[115]

The infusion into others of a monk's virtue (or that of the spell he incants), however, like that of the Confucian sage alluded to before, can be much more active than the generalized, and rather abstract, soaking described here. In a sūtra dating from the 660s, there is a remarkable account of the active *zhan*-ing of those people with whom a dhāraṇī-chanting monk comes into contact. The text is called the *Qianshou qianyan Guanshiyin pusa guangda yuanman wu'ai dabeixin tuoluoni jing*, the *Scripture of the Broad and Great, Perfect and Full, Unimpeded Great Compassionate Heart-Dhāraṇī of the Thousand-Handed and Thousand-Eyed Bodhisattva Guanshiyin*.[116] The passage is especially interesting in this context because in it the chanter's body is described as acting in the same way a dhāraṇī pillar acts; more to the point, this description appeared in China only a very short time before the *Scripture of the Incantation of Glory*. It thus may have been part of a group of texts produced in the context of a conversation about, or a tradition of, the workings of scriptural and incantatory power. The passage goes as follows:

> If any men or gods chant and keep this dhāraṇī and then bathes other beings within a river or within the great sea, then the water that is used to bathe these persons will infuse them and condense on their bodies (*zhanzhao qi shen*) and dissipate all the heavy sins of their evil deeds and the person will be reborn in pure lands of other regions (*tafang jingtu*). They will be born as emanations on lotus flowers and will not receive birth through wombs, moisture, or eggs.[117] How much greater is the power manifested *while* one is chanting the spell! If one walks down a road while chanting it and a great wind comes and blows the body hair, hair, and clothes of the chanter, the wind that continues on (*yufeng*), passing any of the classes of beings, blowing them and sticking to their bodies (*chuizhao shenzhe*), will dissipate utterly all the heavy sins of their evil actions. These beings will not receive any of the evil rebirths and will ever be born before Buddhas. You should know that the fruit of blessings and virtue that comes from receiving and keeping this dhāraṇī is inconceivable.[118]

As I noted in the preface, this is a striking image of the body incantatory: the wind that blows through the hair and clothing of one walking and chanting a spell, continuing on and enveloping those downwind, evaporating the weight of past wrongdoings as it goes. The close homology between the one chanting this *Compassionate Heart-Dhāraṇī* and pillars inscribed with the *Incantation of Glory* is clear, and is further evidence that the images of the latter were part of a large body of scripture and stone inscriptions that seems to have been important in the seventh century.

The imagery is found in tale literature as well. I end this section with another vivid instance of this imagery of infusion that occurs in a dense little tale found in slightly different forms in various collections. It memorably depicts the transfusion of the power of sacred words from text to substance, and the drenching—here, in fact, the literal *drowning*—of a being in that potent stuff. Nearly all the elements featured in this discussion so far—words of power, physical contact, and infusion with blessed stuff—are present. The most important of the versions of the crux of this tale, for our purposes, is surely the brief one that occurs in the second of Divākara's translations of the *Scripture of the Incantation of Glory*.[119] But I will leave that one aside for the moment and take up the narrative versions that occur in otherwise unrelated collections of tales, a tactic that I hope will contribute to my demonstration of the larger web of images and significance within which the spell was imagined and remade.

The earliest known version of the tale is in Fazang's "Records of the Transmission of the *Flower Garland Sūtra*." After that, it was included both in the closely related collection "Accounts of the Spiritual Resonance of the *Flower Garland Sūtra*"[120] and in the Northern Song collection "Basic Record of the Spiritual Resonance of the Three Jewels" (*Sanbao ganying yaolue lu*).[121] In this last version, the tale is given a name (or perhaps simply a précis): "Spiritual Resonance: A man about to read the *Flower Garland Sūtra* washes his hands. A creature of the bug kind is drenched (*zhan 2*) [by that water] and reborn in a heaven." The full story, in Fazang's telling, goes as follows.

> [In a tale] passed on from the western nations, there was man who washed his hands in water before he read this scripture [that is, the *Flower Garland*]. The water drenched an ant. Because of this it relinquished its life and afterwards was reborn in a heaven. How much greater would the efficacy of receiving and keeping the text be! The merit from that would be inconceivable.[122]

It would be difficult, I think, to give a more vivid illustration of the infusing efficacies of sacred inscription, of its ability to transfer, contagion-like, through media rarely thought to carry the power of words, such as wash water, or shadow.[123] Here, the spread of the power occurs *before* the reader has even touched the scripture. Given that there is no explicit discussion of how this happens—and there very rarely are such discussions—we have little to go on here other than what accounts of related phenomena imply: that nearness to, or possession of, sacred documents is enough to receive their benefits; that even seeing them, or thinking about them, is enough. The version of the crux of this story that occurs in the second Divākara translation of the *Scripture of the Incantation of Glory*, however, does not leave us in doubt as to the method of transmission. It is not in the form of a narrative, actually, that we find the parallel account of the power of the Uṣṇīṣavijaya-dhāraṇī, but as one item in a list of ways the spell can work. Just after the text describes the working of the spell through wind and shadow it goes on to tell of further ways the spell is active:

If one who wields[124] this dhāraṇī washes his hands in water, and the water from this act falls to the ground, drenching ants,[125] all such ants will immediately be reborn in heavens.[126]

PURE BODIES

Infusion with spell-soaked stuff, as we have seen, was nearly always a *bodily* thing (where the physical body extends to the spiritual body of the afterlife). Returning to the *Scripture of the Incantation of Glory*, it is clear that, along with the fear of hell, the text is preoccupied with instilling aversion to the mortal human body, an aversion framed within an absolute distinction between the gross animality of the body and the pure sacred substance of the *Incantation* and other forms of Buddhist power and presence.[127] The contrast runs throughout the short text. The narrative, as we saw, culminates with Shanzhu's extended life as a god, though the work presents the dhāraṇī as being efficacious in the attainment of several different goals. In terms of its story the most cogent feature of divine existence is that it is "pure," which is in part to say untainted by the mess of animal biology and the bodily suffering it entails. As Paul Kroll, in his study of the text, reminds us, part of what this purity meant was sexual reproduction free of ("untainted by," our text might say) mammalian forms of conception and birth, notably birth from a womb.

Such purity is like the birth one experiences in a pure land, the attainment of which has long been one of the primary goals of Buddhist practitioners. As one translation of the *Scripture* has it, "those who hear this spell will all cast off sickness and suffering and transcend the forms [of life born of] wombs. They will mount lotuses and be reborn through transformation."[128] The scripture is also at pains to highlight the horrors of birth from a human womb. As noted earlier, after enduring seven incarnations as "filth-eating" animals, Shanzhu's next life is that of a poor eyeless man. It is not just the fact that he is blind that is meant to appall—it is that "already when situated in his mother's womb he will have no eyes."[129]

These details, taken in the context of the work as a whole, bespeak a visceral loathing of the sources of human bodily life, not to mention a strain of misogyny that is distressingly characteristic of male monastic life and the religious forms it produces.[130] Distaste for the "uncleanness" of the human body and the sources of its life, so evident in the *Scripture of the Incantation of Glory*, was an ancient strain in the Buddhist religion writ large and was (like the discourses of fear and punishment explored earlier) vividly reflected in the public sermons of the medieval period. The long and fragmentary script of a lecture on the *Vimalakīrtinirdeśa* found at Dunhuang contains a discussion that is particularly helpful in illuminating medieval Chinese versions of the theme. It is doubly illuminative, in a way, because while this work is an artifact of a public lecture, and thus reflects a presentation meant at least in part for the general laity, it draws, in the section I will highlight, mainly on the *Treatise on the Great Perfection of Wisdom* (*Dazhidu lun*), a text that is probably the preeminent example of the tradition of high scholastic commentary prevalent in medieval Chinese Buddhism.[131] As such it presents a particularly rich vein of contextualizing imagery, offering access to what many modern interpreters consider two separate and vertically ranked strata of social reception. The text, S. 561 in the Dunhuang catalogs, is untitled. In one modern edition it is called simply *Weimojie jing jiangjing wen (yi)*, "Text of a Lecture on the *Vimalakirti Sūtra* (1)."[132] In its commentary on the stock opening of the sūtra, "Thus have I heard," the author, in the manner of scholastic commentators, breaks down the four-character phrase that composes the translation of the Sanskrit original into meaningful Chinese components.[133] He focuses our attention on the latter half, the words *I heard* (*wowen*) and then more narrowly on the single word *I* (*wo*). He asks, "Since all of the teachings are in the service of the destruction of clinging to the I, how is it that the very beginning of the scripture is marked by the pronoun 'I'?" To answer his question he paraphrases a passage from

the *Treatise on the Great Perfection of Wisdom* concerned with the "five kinds of impurity" (*wuzhong bujing*) that echoes our theme.[134] He states:

> The *Perfection of Wisdom Treatise* states: "There are five kinds of impurity."[135] They all destroy the clinging to the self. The first is the impurity of the seed.[136] Within, this is none other than all deeds and vexations.[137] Without, it is the seed of the remnants of the father's and the mother's substances. The *Wisdom Treatise* states:
>
>> This body is unclean; it is not a marvelous jewel.[138]
>> It is not born from white purity, but issues from a filthy pathway.[139]
>
> Second, the impurity of the staying place[140] within the mother's belly. The *Wisdom Treatise* states:
>
>> This body is like reeking filth; it was not born from blossoms opening.[141]
>
>> It was not born from a [fragrant] Campaka tree (*zhanpu*); neither did it issue forth from a Jeweled Mountain (*baoshan*).[142]

The text goes on to elucidate all five kinds of impurity, but this excerpt should suffice for our purposes. Such a view of the impure and rather disgusting nature of bodily existence is common in Buddhist writings, where it is often part of a strategy to convince the practitioner to turn his back on the fleeting pleasures of the flesh. As Liz Wilson has pointed out, the *Aṅguttara Nikāya* contains some famously vivid evocations of the body as a putrid and faulty vessel, "like a boil with nine openings":

> Imagine, monks, a boil that has been gathering for many years which might have nine open wounds, nine natural openings, and whatever might ooze out from this, foulness would certainly ooze out, stench would certainly ooze out, loathsomeness would certainly ooze out; whatever might be brought forth, foulness would certainly be brought forth; stench would certainly be brought forth; loathsomeness would certainly be brought forth. This boil, monks is an apt metaphor for the body which is made up of the four great elements, begotten of mother and father, formed from a heap of boiled rice and sour gruel, subject to impermanence, concealment, abrasion, dissolution, and disintegration,

with nine gaping wounds, nine natural openings, and whatever might ooze out from this, foulness would certainly ooze out. Therefore, monks, you should be disgusted with this body.[143]

It is not just *human* life that inspires the sour view exhibited in the narrative—rebirth as an animal is, after all, considered one of the "bad" paths of rebirth, an idea underscored by our tale's emphasis of the fact that these creatures eat "filth." As noted before, the animals he is fated to become are a pig, a dog, a fox, a monkey, a viper, a vulture, and a crow—not the most auspicious examples, we might note, of what is inherently an unlucky class of existence. As the Du Xingyi version tells us, "in these seven lives you will always eat filth" (*rushi qisheng heng shi hui'e*).[144] The Buddhapālita version makes it even more graphic: "[you will] eat all manner of filthy, foul, unclean things" (*shi zhu suiwu bujing zhi wu*).[145]

The longing for a new and unearthly body free of taint and pain, implicit in these statements of loathing for the baser aspects of human and animal life, found voice as well within the practical tradition in promises of the ethereal and radiant bodies attainable even before rebirth on lotus blossoms. A lecture on the "Medicine King Bodhisattva" chapter of the *Lotus Sūtra*, also preserved by a happy chance among the Dunhuang scrolls, offers a picture of the pure and radiant body said to be accomplishable through the ingestion and application of sacred substances. The passage in this way is doubly reminiscent of the *Uṣṇīṣavijaya sūtra*. It echoes not only the scripture's emphasis on the *quality* of the body that is the result of the spell's power, but also the *means* by which that transformation is effected. Its description of the ingestion of sacred oils and other substances is not far from the spell sūtra's own images of near apotheosis through physical contact with the materialized spell—whether in the form of dust, stone, or shadow.

The passage is difficult to interpret because, due to damage to the scroll, the text of the lecture ends in mid-description. The passage in the chapter of the *Lotus Sūtra* it comments on describes the Medicine King's preparation of his body for self-immolation. The oils he ingests and consumes, for 1200 years, transform him into a torch, and he presents himself to the Buddha as the ultimate offering.[146] It is thus possible that the lecturer is instructing people on how to make their bodies *literally* radiant—that is, to set them on fire, a practice we know to have been all too real in medieval Chinese Buddhism, as James Benn's work has demonstrated.[147] The text of the lecture in the fragmentary state we have it ends, however, before it is clear whether or

not these are preparations for actual auto-cremation. If such *were* the lecture's aim, this would not at all make the following passage a counterexample of the kind of purification of the body that I am discussing here. As Benn notes, "the underlying concept [of ritual auto-cremation] was one of transformation of the body from something mortal and impermanent into something immortal and permanent."[148] In the following elaboration on the details of the Medicine King's ritual preparations, which describes how to engage in a very similar practice,[149] the description of the body echoes certain images we have become familiar with in this discussion. The lecturer is elaborating on the details of Medicine King's preparations:

> The meaning of this chanted measure[150] of the scripture is that the bodhisattva, having made the great vow to give up his body [through self-immolation], consumes fragrant oils . . . Having consumed the oils, his body is then light and suffused with radiance. . . .

> > If you want to manifest a body like the Thus-Come One,
> > Then ingest fragrant oils and fast for days and days.
> > Your whole substance will be rid of taint and filth;
> > Your whole body—where could there be dust or grime?
> > Your skin will be like a red lotus blossom;
> > Your bones like a stack of white jade.
> > . . . Your five organs will be fragrant, without grime or taint;
> > Your four limbs pure and clean, without the slightest flaw. . . .

The account goes on to say that this is not enough, that the bodhisattvas will be not be satisfied if you simply ingest the oils and fragrances—they must be smeared onto the surface of the body as well. "Inside the stomach it is [now] pure and clean like a lotus flower. Also take fragrant oils and smear them on your skin, make the flesh pure"[151]

The association of delightful fragrances with spiritual purity—and with pure lands—was common in the medieval period. We can note in passing that part of the creation of a pure environment within ritual arenas, *daochang* or *jie*, involved the application of fragrances (*tuxiang*) onto the bodies of the participants and to the enclosure itself. In this way ritualists created a space mirroring the pure lands and heavens of scripture and legend. In the world of medieval miracle tales, too, just as fright and a change of ways marked those who returned from temporary sojourns into the terrifying

underworlds of the Chinese Buddhist imagination, so were heavenly fragrances a sign that one had returned from the celestial realms. For an example we can take the tale of the Khotanese śramaṇera Bore Miqiebo, which was told to Fazang in 689 (Yongchang 1) by the Khotanese monk Yintuoluobore (Indraprajña?). This tale was collected in Fazang's Record of the Transmission of the Flower Garland Scripture, though, like the tale of the drowned ant discussed earlier, it is also found elsewhere in slightly different forms.[152] In this story the god Indra, hard pressed in his war against the asuras, summons the śramaṇera, a specialist in the recitation of the Flower Garland, to his heaven for spiritual assistance. The spiritual power manifested by his recitations of the scripture in the heavenly realm is so awesome that it overwhelms the asuras, who flee in utter defeat. Indra offers the śramaṇera anything his heart desires, but he wishes only to return to earth to continue his practice. Indra, much impressed by his devotion, reluctantly sends two of his servants to escort him home, where he finds that "his clothing was all suffused with heavenly fragrances and spiritual perfumes that, for the rest of his life, never dissipated."[153]

This association of pleasing appearance and odor—and even taste—with the purified and purifying efficacy of holy beings was not limited to the Chinese tradition. As Susanne Mrozick has shown, chapter 8 of the Śikṣāsamuccaya, the Compendium of Teachings, the important Sanskrit collection traditionally attributed to Śāntideva and dated to the seventh or eighth century,[154] describes bodhisattva bodies as pleasing and transformative in ways that recall our themes here. Like the Incantation of Glory, bodhisattvas are pleasing to the senses, and their substance purifies those who touch them—or, stunningly, those who eat them: "The enjoyment or consumption of a purified body will be healthy for bodied beings, just like well-prepared boiled rice without husk-powder."[155] As an example of the salutary effects of eating dead bodhisattvas that recalls the tales of ants discussed earlier, she notes that, according to the text, animals that eat them will be reborn as gods.[156] To my knowledge there are no similar instructions for eating the Incantation of Glory or any dhāraṇī from medieval China. The ingestion of fu talismans was, however, a common practice in China, and as I argued in the previous two chapters, fu and written dhāraṇīs were parts of parallel and overlapping traditions in the medieval period. However, the Compendium does include modes of contact with bodhisattva bodies that are strikingly in line with those under discussion here. The Bodhisattva benefits beings "even when they see him . . . even when they hear him, even when they touch him."[157]

The idiom of the physical "reception" of sacred, healing substance was not only a feature of Buddhist spell craft but was central to other Chinese religious traditions of the medieval period. Like that of the *Incantation of Wish Fulfillment*, the *Incantation of Glory*'s cult was as deeply situated within native Chinese traditions as it was within the wider cultures of Buddhist Asia. Beyond the material presented in chapter 1, the best introduction to relevant history is Robert Campany's comprehensive study of religious elements in the works of the great fourth-century author, collector, and spiritual adept Ge Hong (283–343)—the importance of whose works for a study of Chinese Buddhist spell craft I have noted repeatedly in this book—where he describes the pervasiveness of techniques based on the physical reception of the sacred in the works Ge compiled. "The gist of almost all of the methods collected by Ge Hong—save for the apotropaic techniques and spirit-deceiving subterfuges based on the bureaucratic idiom—could be summarized as salvation by ingestion, if we understand 'ingestion' in the broadest sense of anything absorbed into the body (with attention to what should *not* be ingested)."[158] For Ge Hong and others of his tradition, drawing on ancient magical/alchemical traditions in China, ingestion was conceived primarily in terms of qi, the spiritual–material energy pervading life and the cosmos,[159] and not of the Buddhist imagery of the transformative words of the Buddha, his body, or of spells.[160] The purification of qi in oneself, and the ingestion, refinement, and storage of beneficial qi from external sources, such as food, air, alchemical substances, and specially prepared talismans (among other things) are among the primary activities of the alchemical adept.[161] Though this idiom of ingestion is perhaps most famously associated with Chinese traditions, Mrozick's discussion of the *Compendium of Teachings* (and this chapter as a whole) make clear that Buddhists, and not only those of China, had rather similar practices and ideas.

But staying with the Chinese Buddhist tradition, another, delightful, example of redemptive bodies and material efficacy found in a Tang miracle tale is apropos here. A monk, again a chanter of the *Flower Garland Sūtra*, has been taken by a mysterious and powerful layman into a place deep within the Taibai Mountains where the monk is asked to make prayers and chant spells on the layman's behalf. In return for these services, the mysterious layman summons a magical child, who lives with his friends within the layman's compound, to offer aid to the monk.

> The child said to the monk, "Please open your mouth a bit." The monk opened it as he was asked. The child looked in and said, "The master has a great many illnesses!" The child then straightaway rubbed his

own body with his hand and took away three bits of medicine about the size of sesame seeds and gave them to the monk to swallow. Then he asked him to open his mouth again. When the monk had done so, the boy suddenly flew into his mouth. The monk then flew up into the sky and returned home to his dwelling, [where he reports to his companion monk that he has attained the Buddhist spiritual powers known as "spiritual penetrations" (shentong)].[162]

This tale, which some readers might want to categorize as an example of "popular" Buddhism, is consonant with the Compendium's account of eating the flesh of spiritual beings. The two exemplify an oddly compelling trope in Buddhist literature.

Returning once more to an examination of the Uṣṇīṣavijaya sūtra itself, we see that, aside from the pure and delightful bodies characteristic of births free from mortal wombs, there are other striking contrasts with the figures of noxious animal and maimed human lives in the text—the images of radiant spiritual substance used to describe the dhāraṇī itself and its associated phenomena and effects. It is "like a sun-treasury mani jewel," the Buddhapālita text states, "pure and flawless, pure like empty space; it flames and shines with all-pervading luminosity." It is "brilliant, pure, and soft like the golden [sands] of the Jambu river, a joy to behold, untainted by filth or foulness."[163]

These similes are among the common poetic stock of Buddhist literary traditions and worth our careful attention. It would be a mistake to take them simply as clichés, as merely the boilerplate of scriptural practice. Attention to them reveals the subtle ways these works construct the basic conceptual figures of the tradition, the metaphors it lives by, as it were, the channels and nature of the efficacies that lie at its heart. As I have shown, these similes were pervasive not only in canonical literature but in the texts that were part of the quotidian workings of temples as well—lectures to the public and their notices, for example—and would have been among the primary associations of the Buddhist teachings in the minds of Chinese of the Tang, Five Dynasties, and early Song periods. In our present context, more specifically, we can see in them significant elements in the composition of the Incantation of Glory—not its syllables but the ways it was imagined, the kinds of things it was said to be. I have traced some of the intertextual web in which these similes figured in order to better understand what the scholar of Chinese poetry Stephen Owen (borrowing it seems from Hegel's Phenomenology of Spirit) has called the "sensuous determinations" inherent in such accounts. Description, as Owen notes, is "the counterpart of perception: its language is of the senses

or modeled on a sensory paradigm."[164] That the *Incantation of Glory* was very much a sensuous object is one of its most cogent features. It was, in fact, said to be nearly synesthetic in its manifestations—the aural, the visual, and the tactile seem in the spell to bleed into each other—a fact that, along with the rich amuletic traditions discussed in the previous chapter, further belies any easy associations of Buddhist spells with sound alone.

ANOINTING WORDS

The most vivid descriptions of the synesthetic nature of the *Incantation of Glory* come from a member of Amoghavajra's Esoteric Buddhist lineage. They are found in a set of glosses on the words of the spell attributed to the little-known monk Fachong (fl. 760s–770s), the *Shi zhenyan yi*, "Unraveling the Meanings of the Real Word," contained in his commentary on the spell's scripture most commonly known today as the *Foding zunsheng tuoluoni jing jiaoji yiji*, *Doctrinal Traces of the Scripture of the Dhāraṇī of the Glory of the Buddha's Crown.*[165] The commentary, like others of its kind, presents the dhāraṇī as a highly meaningful, prayer-like text.[166] The text the glosses create is in fact as philosophically resonant as any scripture—not surprisingly, of course, given that as we saw in the introduction a dhāraṇī was said to encapsulate the vast expanse of the Buddhist teachings as a whole within its brief extent.

 Little is known about Fachong or the details of his position within the Buddhist community of the late eighth century. He was a monk of the Qianfusi, one of the most important monasteries of the capital Chang'an, and apparently deeply learned in Sanskrit.[167] He "verified the translation against the Sanskrit" (*zheng Fanwen*) in at least two major translation projects of Amoghavajra's, whose student he seems to have been—Amoghavajra's 765 retranslation of the *Renwang jing*, the *Scripture of Humane Kings*, and the 770s translation of the *Da xukong pusa suowen jing*, the *Scripture of the Inquiries of the Bodhisattva of Great Emptiness.*[168] He was clearly well regarded by Amoghavajra, who once chose him to take part in an imperially ordered recitation rite on behalf of the state.[169]

 Fachong's text, following the conventions of the genre, is a line-by-line elucidation of the sūtra; the discussion of the dhāraṇī follows this pattern.[170] It unpacks the meanings and doctrinal associations of the spell's constituent words. And there is never any sense that they are not words (that is, not lexically meaningful utterances): taken within the larger context of the work as a whole, the spell words (with a few notable exceptions) are not different

from the other words of the scripture. The treatment of the spell appears in the midst of the larger commentary on the sūtra as a whole. When Fachong reaches the dhāraṇī the momentum of his commentary does not slow down; no clear distinction is made between the words of the spell and the words of the discursive portions of the sūtra. Indeed, the way the spell is portrayed in this work has as much to do with the generic conventions of Tang Buddhist commentaries as it does with the "nature" of the spell itself. Commentaries, as objectivizing works, assume (and produce) texts of a certain nature—rational, explainable, highly structured—and the spell here is no different. Following the same basic pattern that guides his commentary as a whole, Fachong breaks the spell up into ten sections, or "gates" (*men*), as follows: (1) Devotion and respect to the Honored Virtuoso [that is, the Buddha] (*guijing zunde men*); (2) Proclaiming the Dharma Body (*zhangbiao fashen men*); (3) Clearing away the bad trajectories (*jingchu equ men*); (4) Clarifying consecration (*shanming guanding men*); (5) Spiritual protection (*shenli jiachi men*); (6) Life extended (*shouming zengchang men*); (7) The correspondence of meditation and wisdom (*dinghui xiangying men*); (8) Adamantine offerings (*jin'gang gongyang men*); (9) Universal attainment of purity (*puzheng qingjing men*); (10) Success in Nirvana (*chengjiu neipan men*).[171] In broad terms, the progression of the categories seems to figure a ritual process, though this is most evident in the ways they begin and end, moving from invocatory praise to "success." At the very least, these signposts, by signaling an arrangement of themes within the text of the incantation, make implicit claims for its rational construction, its meaningfulness.

The "translation" of the dhāraṇī—that is, the sum of the glosses Fachong provides—reads as follows:[172]

1. Veneration to the World-honored Ones of the three times! Most extraordinary and surpassing great awakening: World-Honored Ones!

2. Thus it is said: the three bodies [or "all dharmas are unarisen," or "the invisible mark of the [Buddha's] crown; ("oṃ")].

3. Pure universal radiance spreading everywhere, in the deeps [or: "in the dense forest of the Six Paths"], spontaneous and pure!

4. Consecrate me [*abhiṣeka*], well-gone [*sugata*]! The outstanding and surpassing teachings! Sweet dew [or "phrases of the undying"] consecration! Wishing only to gather in [or "pervasively expelling disasters, throwing off all suffering and distress"], sturdily abide and keep hold of life.

5. Clear and pure as empty space! Buddha's crown (*uṣṇīṣa*), surpassingly clear and pure! A thousand beams of radiance startling awake! Protection

by the spiritual might of all the Thus-Come Ones' seals (mūdra), adamantine hooks and chains! The body clear and pure, all blockages clear and pure!

6. All of life clear and pure! Vows to bestow and embrace [samadhiṣṭhā]! Gems of the world [maṇi (or "dharma gems")]!

7. All-pervading purity [or: "true and real"]! Manifest wisdom, surpassing, surpassing, mindful of meditation and wisdom, according [with principle]!

8. All Buddhas bestowing and keeping clarity and purity! Adamantine! Adamantine container! Vow to become like unto adamantine, I!

9. All sentient beings attain clarity and purity! All paths clear and pure! All the Thus-come comfort and bestow and keep! That which is awakened! That which is awakened! Able to awaken! All-pervading clarity and purity! That which is held by the spiritual might of all the Thus-come—the great seal!

10. Nirvāṇa![173]

Fachong's glosses frame the action of the spell in implicitly narrative terms. The enunciation of the syllable oṃ, we will see, is described as a burst of radiance whose light, which is also sound, purifies and transforms those beings it comes into contact with, much as does the light that emanates from the Buddha before he speaks in sūtras. The power of this light extends through the rest of the spell narrative as it is elaborated by Fachong's commentary. In its basic character the imagery employed in these descriptions is now familiar: the spell transforms through physical contact. The language used to describe this process, however, is here not that of the early simple imagery of enchanting (zhou) bodies, or that of their "infusion" (zhan 2) by dust, shadow, or wind; instead, Fachong employs the high ceremonial idioms of empowerment (or blessings; jiachi; adhiṣṭhāna), and consecration (guanding; abhiṣeka).[174]

Though it had its own long history in Buddhist ritual, consecration was, in the contexts of the Buddhist incantatory imagination, simply the latest and most conceptually elaborate idiom of bodily enchantment, though one that became more and more prominent in China as those spell arts were absorbed into the burgeoning Esoteric Buddhist traditions. Indeed, some have argued that consecration was the single most emblematic ritual figure of that tradition.[175] Fachong, as a student of Amoghavajra, would of course have been steeped in its language and imagery. He states in one of his glosses that "the syllable 'oṃ'"—the core of the incantation in his account—"has the sense of consecration."[176]

Though neither dust nor shadow figures in his picture, images of consecratory substance yet prevail: the spell is sound and light and "sweet dew,"

among other things. These images, he makes clear, were not randomly cho-
sen, for as he notes there were understood to be five kinds of ritual conse-
cration: consecration by light (*guangming guanding*), by sweet dew (*ganlu
guanding*), by seed syllables (*zhongzi guanding*), by the "wisdom seal" (*zhiyin
guanding*), and by the meaning of phrases (*juyi guanding*). He first gives a brief
definition of each of these.

> As for what is called "consecration" (lit, "sprinkling the crown of the
> head"; *guanding*), there are five kinds. The first is consecration with light,
> which is to say that the Buddhas and Bodhisattvas emit light rays in
> order to empower. The second is consecration with sweet dew, which is
> to say that the principal Buddha of the maṇḍala (*buzhu*) uses real words
> [that is, *mantras*] to empower incense water. The third is consecration
> with seed-[syllables], which is to say that the principal Buddha, employ-
> ing distinct real words (*zhenyan xiang*)[177] spreads syllables (*zimen*) upon
> the person. The fourth is consecration with the wisdom seal, which
> names the empowerment gained from the seals held by the principal
> Buddha (*suozhi qiyin*).[178] The fifth is consecration with the meanings of
> phrases, which is to say that the lord of the maṇḍala (*buzun*) empowers
> by means of both real words and their meanings.

Fachong goes on to give a slightly expanded picture of the place of conse-
cration in the style of practice in which his text was situated, as well as of the
metaphorical origins of consecration rites in royal enthronement ceremonies.

> If a beginning cultivator of the Way wishes to learn the practice of [liter-
> ally, "to enter the gate of"] real words (*ru zhenyan men*), he should go to
> an acārya master, set up a ritual space (*daochang*) and beseech the mas-
> ter to teach him the rite of consecration. He should begin to cultivate
> the Three Mysteries and vow to experience (*zheng*) Yoga. It is as in the
> transmission of the royal throne from worldly wheel-turning king to
> royal prince that serves to benefit the nation. One uses bottles made of
> the seven treasures filled with waters from the four great seas to pour
> the water onto the crown of the head (*jiaotou guanding*; that is, to conse-
> crate), thus passing the throne [to the crown prince]. It is like this, as
> well, in the true teachings of entering the secret door (*zhenjiao ru mimi
> men*). He becomes one with its ritual modes (*tong bi guiyi*) and thus is
> called a scion of the Buddha (*fozi*).[179]

Fachong's glosses, taken as a whole, articulate a narrative told by, *and enacted by*, the spell. The words that follow the description of the syllable oṃ in Fachong's gloss on the spell are contained in the "sentence" "purity and universally illuminating radiance unfold and spread" (*qingjing . . . pubian zhaoyao . . . shubian*). It is here that the narrative of the spell begins. Fachong states,

> Once the syllable oṃ has imbued its support (*anzi jiachi yi*), it sweeps away the two hindrances of the affective defilements and of what is known.[180] . . . The thick forest of the six paths are all illuminated without exception; only those sentient beings whose karmic effects are so heavy that they do not encounter real words wander the three [lower] paths without hearing these phrases . . . As for the unfolding and spreading of the spell (*shubian zhe*), nothing can hinder the light of this dhāraṇī; all who come into contact with its light, without exception, are purified. If one takes a handful of pure soil (*jingtu*) from the place where a dead person is and chants this real word 21 times into that soil, then spreads it over the substance of the dead person's bones (*san qi wangzhe renshen gu zhi ti*), that person will immediately be freed from suffering.[181]

The radiance of the dhāraṇī (*tuoluoni guang*) illuminates the cosmos, like the radiance that shines out from the body of the Buddha at the start of the sūtra (as it does in nearly every Mahāyāna scripture). Unlike that light, however, more than illuminating what it encounters, it transforms it upon contact. Later, this transformative contact is discussed in terms of consecration, and the nature of the dhāraṇī is described in more substantial terms, first as the "deathless" nectar (*amṛta*) of "sweet dew" (*ganlu*) and finally in idioms of infusion, seals, and sin-consuming flames. In his discussion of the dhāraṇī phrase *amiliduobishaiji*,[182] which he glosses as both "sweet dew consecration" (*ganlu guanding*) and "phrases of deathlessness" (*busi ju*)—in a nice juxtaposition of the aural and substantive imagery that, along with that of luminosity, lies at the heart of his account—he briefly explores both the medicinal and consecrative metaphors (and efficacies) at play in the "spell's sweet dew."

> Among the greatest medicines, none surpass sweet dew. Taking it, the poisoned are always cured. Even the very deeply poisoned, the faithless *icchantikas* who slander the dharma—receiving the empowerment

of consecration they certainly will attain the deathless [i.e., as Fachong had previously explained, release into the Dharma Body]. The sweet dew of the real word purifies all accumulated delusions. Letting go of all that is clung to and clearing away all delusions, seeing the emptiness of the universe,[183] this is named "release." Transcending your bounds and attaining release is none other than manifesting the dharma body. Cultivating both compassion and wisdom is called the "phrase of the deathless." Another explanation would be: just as when sweet rain[184] falls from the sky the grasses and trees sprout new growth, so when consecration soaks the body, one completes and verifies [the truth of awakening].[185]

The focus on the importance of contact with the substance of the spell is sustained in the text. Here, like the ambrosia of immortality, it is said to transform those who come into contact with it, purifying their sinful, life-times-spanning biographies and nourishing them such that they awaken, as rain nourishes grasses and trees such that they grow and flourish. At the end of his treatment of the spell proper, Fachong returns to this imagery. After describing the workings of the dhāraṇī in terms of the four forms of wisdom (sizhi) important in Yogacāra thought and explicated in *Cheng weishi lun*, the *Discourse on the Theory of Consciousness-Only*,[186] Fachong gives a final vivid rendering, turning to the spell's most famous mode of contact magic.

When dust and shadow [off pillars or banners the dhāraṇī has been inscribed upon] suffuse the body, one experiences elimination of sins, lengthening of the lifespan, and increase in blessings. One will not tumble into the evil paths of rebirth, but will attain rebirth as a human, a god, or in one of the pure and wondrous buddha lands. If one receives and chants this spell according to the rite, all disasters and misfortunes will disappear, all desired worldly results will likewise succeed, and one will verify the peerless *bodhi*. [The actualization of the spell can] also be explained [in this way]: When I chant this great seal, which is grasped by the bodies and minds of all the Thus-Come Ones, and seal my own body and mind, all karmic obstructions owing to sin are without exception eradicated. The wisdom-seal is like this: like the fires of wisdom that, once ignited, completely incinerate all grasses and trees. When one comes in contact with the light [of the dhāraṇī] there is no sin that is not eradicated.[187]

Note the deepening richness of Fachong's imagery of the efficacy of the spell and its nature. It is purifying light and flame. It is also a watery soaking: it suffuses and soaks like dew and as shadow and dust. It is a seal.[188] This shifting imagery of the spell—by turns sound, light, watery substance, and ritual object—is important within the sūtra as a whole. Fachong's account both relates it to that larger narrative and elaborates what seems usefully thought of as a tale within the tale here. That is, the images explored here do not simply constitute metaphorical descriptions of the nature of the spell, they describe what it does and form a narrative of that doing. This inner tale is more implied than explicitly elaborated; he gives the outline of a narrative sequence in the form of embedded clauses within the sentences that constitute his interpretation of the spell. For example, he inserts the grammatical particle yi, marking the completion of an action, into his statement that the "syllable oṃ imbues its support," changing this from a general claim to an event in a sequence. Later on, explaining the presence of the phrase meaning "startled awake" (jingjue) within the spell, he states, "since they were fortunate enough to have been touched by the light, they are startled awake in body and mind."[189] Taken within the context of his account of the sūtra as a whole, the dhāraṇī's synesthetic unfolding parallels, in microcosmic form, the larger narrative of the scripture and gives a powerfully evocative picture of the anointing potencies of the Incantation of Glory.[190]

THE NAMES OF THE BENEFICIARIES

In chapter 2, in a discussion of the ways the Incantation of Wish Fulfillment was construed in part as a prayer, I showed that the names of the beneficiaries of the spell were to be inserted within it—and that indeed we find the names of medieval Chinese men and women written into the texts of the spells they wore as amulets. The Scripture of the Incantation of Glory also calls for names to be made parts of its spell, and also at locations marked by the term meme;[191] and yet, unlike those of its incantatory cousin, its material instruments never (as far as I know) actually contained those names.[192] Instead of inserting the name—or ignoring the instructions to include it altogether—stones carved with the Zunsheng zhou simply quote those instructions as interlinear technical notes. These instructions come in different formulations, but a typical example is from the Dunhuang manuscript B. 7325 (run 70), a largely intact manuscript of the Scripture of the Incantation of Glory. At the relevant juncture in the text of the spell, an interlinear note reads, "whoever receives and keeps

[this spell should] call out his own name" (moujia shouchizhe zicheng ming).[193] As this manuscript is a fairly anonymous, perhaps archival, version of the text, it is not surprising that the injunction takes the general form with no specific name listed. Like the texts preserved in the canonical collections, it would not have had strong associations with particular donors.[194] Yet the same practice is evidenced even on those pillars made to benefit specific individuals, whose names were included in colophons cut into the faces of the stones. For an example we can return to the pillar contained in the Princeton Art Museum (figure 3.3). Though the stone as a whole, as we learn in its colophon, was dedicated to securing blessings for the mother of one Pei Qiangou, née Zhai, whose tomb it was probably erected near or within, the dhāraṇī inscribed upon it was not so directed. At the key moment in the text of the spell, when its power is to be targeted toward someone, instead of saying "Madame Zhai of Runan," as the colophon names her, it simply states in an interlinear note, "someone" (moujia; figure 3.4).[195] All extant inscriptions of the spell, on pillars or otherwise—again, as far as I can determine—are alike in this. Spells on pillars resemble in this way the "iconic" inscriptions of the Incantation of Wish Fulfillment, those that were made either in ignorance of earlier Indic incantatory practice or according to conventions in which it was to be ignored. This introduces what might seem a contradiction, at least in terms of the ideal-typical picture of material incantations that I have drawn in this book, between the colophons that speak in the old idiom of infusing material efficacy and the figures of the stone-cut dhāraṇīs themselves, which resemble sacred images on other stelae that were more icons of power than enveloping incantations. This contrast is, once again, best seen as a matter of reception history and local developments. Very much like the shifts in logic seen in the history of the Incantation of Wish Fulfillment amulets, we see here transformations wrought in China on the Indic logics received there. Iconic logics seem, again, to have won out over episodic styles of incantatory empowerment, at least in terms of the visual character of the pillars.

It is clear, however, that at least in the elite precincts of the Esoteric Buddhist cloisters the meaning of the interlinear instructions was well understood. The older incantatory logics were maintained there. Fachong's commentary explains that "if you are chanting [this dhāraṇī] on your own behalf, call out your own name [at this point]. If you chant it on behalf of another then call out his or her name here. Because all dharmas arise following thoughts, keep [the name] in your thoughts and do not pause in chanting it. This will reap blessings and benefit self and other. Thus one calls out a name."[196]

CONCLUSION

In this chapter I have explored the *Zunsheng zhou* as an exemplar of the forms of material incantation that featured the trope of infusion (or anointment), one of the two ritual figures that characterized written spells understood as spells, rather than as relics or as mere citations of scripture. Though in Chinese versions of the *Uṣṇīṣavijaya dhāraṇī sūtra*, and in the full range of its material practices, this trope was but one among many associated with the spell, in the early material and exegetical evidence it was clearly understood to be essential to the character of the spell. This fact is clear in surviving glosses on the incantation's meanings, in the early logic of the pillars and the other material instruments for its delivery, and in the literary figures used by the authors of colophons to describe its workings. Again, no single trope bound the life of the *Incantation of Glory*, whether in material practice or in ritual more broadly; in its material enactments in imperial-era China, the spell was absorbed within architectural conventions, both secular and monastic, and absorbed within the material and visual logics of reliquaries, lamp pillars, and the cultic figurations of cliff shrines and narrative paintings. Yet since this book centers on an exploration of dhāraṇīs as material incantations, as amuletic adornment and as infusing stuff, I have not examined these other inscribed forms of the *Incantation* in any detail—unlike in the case of the *Suiqiu* amulets discussed in the previous chapter, their material vicissitudes were not mainly governed by the basic logic of material incantation.[197]

Yet even more than the amulets of the *Incantation of Wish Fulfillment*, the early stones of the *Incantation of Glory* and the tales in which they were grounded reveal the vivid imagination of the body incantatory—images of the mortal human body transformed in its very stuff into the incantatory bodies of sound, light, and sacred substance, the spells themselves, that enable this transformation. Material dhāraṇīs were in these ways closely akin to what are commonly (though far too crudely) known as "pure land" styles of Buddhist practice. Both expressed ancient Buddhist desires to be liberated from the sinful actions, said to extend back deep into beginningless time, that bind one in suffering mortal flesh, and to be remade as trans-human sacred substance utterly free from old age, sickness, and death. The usual close connections drawn between Buddhist incantation rites and Esoteric Buddhism account for only a fraction of the history of the spells' practices. In the next chapter I will seek to further widen our understanding of the history of dhāraṇī practice as it was carried out in the China of its middle antiquity.

4. MYSTIC STORE AND WIZARDS' BASKET

Having explored two individual traditions and styles of material incantation in medieval Chinese Buddhism, we can now step back and begin to take a broader view of the history of which they were parts. Accounts of this history have tended to feature the rise of Esoteric (or Tantric) Buddhism, highly systematized traditions that were formed in part through syntheses of earlier and more diffuse ritual traditions that in India have been known by various collective names, such as the Mantranaya, the Vidyādhara-piṭaka, or more simply as "dhāraṇī literature."[1] In China, these rites—and the conceptual understandings of the incantations that lay at their hearts—were important features of the Buddhism practiced there for more than five hundred years before the Esoteric synthesis was imported from the West and then quickly arose to near preeminence within the elite Buddhism of the imperial court.[2] They were so prevalent in late medieval Chinese Buddhism, in fact, that after surveying the Dunhuang manuscripts held in the Stein collection, Arthur Waley declared "Dhāraṇī Buddhism" to be one of the principal forms of the religion evidenced in those manuscripts.[3] More broadly in medieval Chinese Buddhist practice, scholars have made clear the great extent to which spells were basic parts of the monk's standard repertoire of skills—at least as it was represented in the canonical biographical genre of the "traditions of eminent monks" (gaoseng zhuan), and in the mortuary and other epigraphical texts from which they were drawn.[4]

Yet, the long rich history of Buddhist incantatory practice that came before the birth of the high Esoteric traditions has usually been characterized as merely a kind of prologue, of interest primarily in relation to the main event to which it was seen, in certain quarters, to lead. One encounters stories of this kind in Japan, where the ancient heritage of Buddhist incantation practice was long subsumed within an implicitly teleological model in which

it was characterized as a "mixed" form of the later "pure" forms of Esoteric Buddhism;[5] in the West, where (drawing on the Japanese model) some scholars have been wont to label the early dhāraṇī traditions as "proto-Tantrism";[6] and in Tibet and other Buddhist cultures that also feature the Tantric traditions prominently, where it is similarly portrayed as a crude early form of the later tradition, mere "action" Tantra, say, as opposed to the "supreme" traditions of later eras. Models of history that seek to account for the rise of particular traditions have their important places, clearly, but their often teleological (or at least self-justifying) content creates dangers for the historian. In the case of these pictures, all drawn at least implicitly from the perspectives of highly institutionalized later traditions of Esoteric Buddhism, the danger is that the earlier history, in which the "roots" of those traditions are found, is seen nearly entirely through the lenses provided by those traditions. In this we recognize a now very familiar human activity: the creation of traditions (even of nations themselves) through retellings of history that reveal them as having always been there, from ancient days, if only in seed form.[7]

This is not to say that these models have no value, however; the scholars who created them often had great insights into the natures of the histories for which they sought to account. For my purposes here, the Japanese model of "mixed" and "pure" esotericism, or zōmitsu and junmitsu, is especially helpful to contemplate. The teleological framework of this dyad, as noted earlier, is not helpful.[8] Yet, when that framework is removed, the differentiation between later systematic traditions and the older heritage of the practices and concepts they systematized remains crucial. Ronald Davidson's work on what he calls the seventh-century "mature synthesis" of Indian Esoteric Buddhism, in fact, presents just this sort of picture. Davidson makes clear that we should "differentiate between the employment of mantras, maṇḍalas, fire sacrifice, and other specific ritual items, on the one hand, and the mature esoteric system, on the other." As I read him, Davidson does not understand the historical relationship between these two sets of phenomena to have been necessary or teleological in character: the "self-aware" esoteric synthesis he describes, which came in later centuries to rule the day for large groups of Buddhists, was a historical contingency shaped by the political and cultural situation of post-Gupta India.[9] To illustrate the character of this synthesis, he draws an analogy to the creation of the Bodhisattvayāna, the "Way of the Bodhisattvas." "The nomenclature and ideology of bodhisattvas (Siddhārtha, Maitreya) had been around long before it became embedded in a different ritualized 'way,' with new vows and a new path topography. In a similar way,

the identification and use of mantras (or *dhāraṇīs* or *vidyās*) had existed for centuries before there arose a new ritualized synthesis of different factors."[10] In terms of the Chinese history of these practices, the key observation to add to this picture is that their separate practice and development *did not come to an end* when versions of them were absorbed into the new syntheses of the Esoteric tradition. The older and simpler practices continued to thrive on their own, in contexts ranging from tombs and amulets to the courtyards of temples and private homes.[11]

When the retrospective impositions of tradition are seen through, what is disclosed is a Chinese world of Buddhist practice in which ancient heritages of protective techniques and deities, both native and Indic, were adapted; a history of practice that, as noted, was already half a millennium old in China when the high Esoteric tradition arrived there around the turn of the eighth century; a world that did not—and could hardly have—come to an end with that arrival. When one centers one's attention on late medieval China and disregards for the moment what would happen in later centuries, in China and elsewhere, the eighth and ninth century flourishing of Esoteric Buddhism in the Tang capitals looks not like an inevitable *telos*—oak tree from acorn— but instead simply like a particularly grand set of branches on a great tree of incantation-centered practice.

This is the very kind of picture suggested in a capsule history of dhāraṇī practice in medieval China composed at the end of that age: the prominent early Song Dynasty monk Zanning's (919–1001) *Chuan mizang*, "Transmission of the Mystic Store." The work is a section within his *Da Song sengshi lüe, Historical Digest of the Buddhist Order*, a text composed in part to convince the imperial elite of the central place of Buddhism within Chinese culture.[12] The "Transmission" not only gives the most explicit surviving discussion of the term "Mystic Store" (*mizang*) as a name for dhāraṇī practices, it also provides a valuable picture of the history of those practices as they looked in the late tenth century, near the end of the period explored in this book, to a member of the early Song monastic and imperial elite. In fact, it turns out that this brief history is a nutshell containing many varieties and contexts of dhāraṇī practice. It juxtaposes without comment senses of incantations and dhāraṇīs whose proponents might have bristled at the close association. Zanning's interest in the "Transmission," and in much of the rest of the *Historical Digest*, seems to have been in sketching a broad history of practice rather than in presenting the narrower self-defined contours of doctrinal traditions or other Buddhist institutions. He has several discussions of the

latter phenomena in his *Song Biographies*. In a section of the *Historical Digest* obviously parallel to the "Transmission" he gives another brief picture of a broad tradition of practice, *Chuan changuan fa*, the "Transmission of the Methods of Meditation and Contemplation." The contents of this text, like those of the *Chuan mizang*, suggest that Zanning saw the narrower elite traditions, at least from a certain perspective, as properly understood to be embedded within a broader practical heritage and history. In this case the narrower tradition is that of Chan, whose presence in this other transmission centers on the figure of its "ancestral master," Bodhidharma (Putidamo; sixth century). The history of practices and concepts Zanning describes, however—as in the *Chuan mizang*—does not begin where the later high tradition would have it; nor does what is said to have been transmitted precisely resemble what the high tradition tells of.[13] The elements of Chinese Buddhist history whose histories Zanning sketches in his *Digest* present a very different—and remarkably compelling—picture of the nature of that history than do those to which modern readers have grown accustomed. In the case of the "Transmission of the Mystic Store," it is the deep well of Buddhist incantation practice that is the focus, not those particular schools whose members drank from it.

Importantly as well, Zanning's text was closely aligned with the philosophical heritage of dhāraṇī thought outlined in this book's introduction. In fact—though it does not center material incantations—its skillful interweaving of the philosophical and the historical make it an ideal text with which to clarify the wider world of practice and imagination of which the amulets, pillars, and the body incantatory were part, as that world was described not by a proponent of a particular incantatory tradition but by a chronicler of late medieval Chinese Buddhist history as a whole. Zanning's picture of the history of dhāraṇī practice in China is explicitly framed by assertions about the mystical nature of Buddhist incantations, their complicated relationship with ideas of samādhi, and the nature of the bodhisattva. In his usage the idiom of the "Mystic Store" embraces both a singular vision of the history of Buddhist spell practice—the "Store" is a synonym for the "Incantation Basket" (dhāraṇī-piṭaka) or the "Wizards' Basket" (vidyādhara-piṭaka), the legendary canonical collection of incantations and recipes for their employment that Zanning takes as an emblem for Buddhist incantatory practice as a whole—and the philosophical or mystical understandings of "dhāraṇī." An analysis of Zanning's skillful deployment of the rich polysemy of "mizang," which echoes that of "dhāraṇī" itself, helps to clarify the conceptual heart of dhāraṇī practice as it was understood and carried out near the end of the medieval age.

THE "TRANSMISSION OF THE MYSTIC STORE"

Zanning's emblem for dhāraṇīs and their practice in this brief text, mizang, "Mystic Store" in my rendering, is an intricate knot of a compound that brings together diverse strands of Buddhist philosophical and literary culture and closely ties dhāraṇī-as-incantation with other senses of the term.[14] As we will see, the term "Mystic Store" at times indicated a spell functioning as a kind of microcosmic bearer of the essential meaning and power of larger texts (or a collection of such texts, in this case the legendary dhāraṇī-piṭaka, or "basket of incantations"). At other times it was a figure of the hidden marvelous nature of reality itself or, at still others, of an incomprehensible potency within the marrow of an inscribed sign or incanted phone (all of which, in the often dreamlike homologizing logic of Buddhist literature, could be one and the same). The term, as well, could refer simply to rooms where treasuries of scriptures were held, though such usages were often reserved for accounts of chambers within legendary temples, such as the "secret storehouse" within the Adamantine Grotto in the Wutai Mountains where the bodhisattva Mañjuśrī was said to dwell, a sight "even the greatest of men rarely see."[15]

THE "TRANSMISSION OF THE MYSTIC STORE" (CHUAN MIZANG)

The Mystic Store consists of the methods of dhāraṇīs. These methods are occult [mimi]; they are not in the realm of the two vehicles. [The Mystic Store] is what enables all buddhas and bodhisattvas to roam among and encompass all beings. The old translation [of dhāraṇī] was "grasp" (chi);[16] the new translation is "nature" (xing). [The Store's] root is the subtle and marvelous nature of dharmas; formed into speech it is the mother of dhāraṇīs.

The investigation of their sounds is called phonology (shengming); exploring their letters is called philology (zi jieyuan). The Collected Records of the Translation of the Three Storehouses (Chu Sanzang ji[ji]) states: "Spirit incantations (shenzhou zhe) are encompassing grasps and subtle and sublime grasps" (weimi chi).[17]

Within the Biographies of Eminent Monks [there is the story of] Śrīmitra [Boshilimiduoluo, d. ca. 343], who was originally a man of the Western Regions. In the early years of the Eastern Jin Dynasty he arrived in Jianye, where Wang Dao [267–330],[18] Zhou Boren [269–322)][19] and Yu Liang

[289–340] all revered him. He had a skilled grasp of incantation arts[20] (*shanchi zhoushu*)—wherever he directed them there were many proofs of their efficacy (*yan*). At that time, the region east of the Yangzi did not yet have spell methods (*zhoufa*). Śrīmitra translated the Peacock King Spell.[21] This was the beginning of spell methods.

During the Northern Wei (386–534) there was then Bodhiruci of Song-shan (Putiliuzhi, d. 527), whose well-enchanting branch was power-fully effective.[22] During the Tang Dynasty there was the Dharma Master Zhitong (seventh century) who was exceedingly refined in his cultivation of esoteric spells (*jinzhou*).[23]

Next, [during the Tang] there was the Master of the Three Treasur-ies, Amoghavajra, a monk of the imperially sponsored Great Xingshan Monastery (Da xingshan si) in the capital, who broadly translated the dhāraṇī teachings (*zongchi jiao*) and constructed many maṇḍalas. No one could comprehend his spiritual arts (*shenshu*). The use of consecration altar rites (*guanding tanfa*) began with Bukong. During the Yongtai years (765–766) of the Emperor Daizong's reign, the emperor decreed that a consecration sanctuary (*guanding daochang chu*) be built. Fourteen people were chosen to long chant the spell of the Buddha's crown (*Foding zhou*) for the sake of the nation. The emperor exempted people from corvée duty and from taxes.[24]

During the period at the end of the [Later] Liang (907–923) and into the Later Tang Dynasty (923–936), the ācārya Daoxian (Daoxian sheli) traveled in a dream one night to the five regions of India (*Wutianzhu*). In the dream the Buddha pointed out the various countries and regions. At dawn, Daoxian suddenly understood the languages of the five regions of India (*Wu Yin yanyin*) without even the slightest error.[25] Today, the tradi-tion of powder altars (*fentan fa*) takes him as its master. He is none other than the ācārya of Fengxiang, whose Way the Qingtai Emperor of the Later Tang especially honored.[26] Later he followed the imperial procession into Luoyang, where he died. Today, his stūpa is in Longmen, south of the Eastern Capital [of Luoyang].

Great masters of Japan often discourse on the Mystic Store for kings, aristocrats, and great men. Their disciples teem even today. Those who transmit this practice (*ye*) are called Masters of the Three Treasuries. They equally preach scriptures, the monastic rule, and discourses, thus they are called transmitters of the manifest and hidden treasuries (xianmi zang; J. kenmitsu zō).[27]

Closely read, this text gives a revealing (which is to say, particularly slanted) picture of the history of Buddhist spells as it was understood by a prominent chronicler of the "great men," the "eminent monks" (*gaoseng*), of medieval Chinese Buddhism and partisan for the importance of their tradition within the high culture of China. Zanning's text, as noted, was a brief section within his *Historical Digest of the History of the Buddhist Order*. This work, one of the last Zanning composed, was an integral part of his larger project to convince the early Song court and literati classes of the important place of Buddhism within "This Culture" (*siwen*), the ancient literary and philosophical tradition with roots in the earliest classics that had for centuries been defined, at least in part, as fundamentally opposed to the foreign import of Buddhism.[28] As is well known, the literary/civil (*wen*) aspects of Chinese tradition, opposed in one of the central tropes of Chinese civilization to those aspects deemed martial (*wu*), were sharply on the rise in early Song China as the imperial court worked to strengthen the civil branches of government, in part in an attempt to weaken the regional military leaders whose power had become entrenched during the long decades of weak central control that began in the latter half of the Tang. Charles Orzech has explored further contexts of Zanning's writings, as well, especially the fact that the Song emperor Taizong had set up a new imperial translation academy in 980. This academy featured three Indian monks, Dharmapāla (Fahu, 963–1058), Tianxizai (*Devaśāntika?, d. 1000), and Dānapāla (Shihu, fl. 970s), who are especially relevant to our discussion because they were chiefly involved in translating works featuring, among other elements, incantations in various forms.[29] Indeed, the early Song saw another great age of the importation of texts featuring dhāraṇīs, one, like the high Tang, characterized especially by texts shaped by the tropes, frames, and social needs of Indian Esoteric Buddhism.[30] But the new Tantras were not the only incantation texts imported through the efforts of these monks. More importantly, as this chapter will show, Zanning clearly differentiated among closely related streams of these ritual traditions. Orzech has recently made clear that Zanning differentiated between Esoteric Buddhist subtraditions represented on the one hand by Vajrabodhi and Amoghavajra and on the other by Śubhakarasiṃha. He made further distinctions as well: between the high Esoteric traditions he called "the Wheel of Instruction and Command" and the more modest and ancient incantatory tradition he named the transmission of the "Mystic Store," two exemplars of which (the practical traditions surrounding the incantations of *Wish-Fulfillment* and *Glory*) have been explored in earlier chapters of this book.[31]

Zanning's larger project of demonstrating Buddhism's kinship with high literati culture is relevant to our reading of the "Transmission" mainly because it helps to explain his emphasis on those monks—and those incantations— that were important within aristocratic and imperial cultures in Chinese history. In a text as brief as this one every sentence counts for a great deal. Out of the vast number of historical figures he had studied in compiling his biographical and historical works, a great many of whom were said to have employed dhāraṇīs and other incantations as prominent parts of their Buddhist practice, Zanning mentions only five monks by name and alludes to only two specific incantations. He devotes space to three different moments when spells or spell casters interacted importantly with the Chinese aristocracy or the person of the emperor himself. The first is Śrīmitra's relationships with Wang Dao, Zhou Boren, and Yu Liang, three of the most prominent officials of the Jin Dynasty (265–420), men who seem to have valued him highly. The next was the Tang emperor Daizong's (Li Yu, r. 762–779) decree that the monks in the official monasteries of the realm chant a certain "Spell of the Buddha's Crown." Though Zanning appears to have gotten the date wrong, the event he describes here involved the *Incantation of Glory*, the Chinese version of the Uṣṇīṣavijaya dhāraṇī (*Foding zunsheng tuoluoni*), an event discussed briefly in chapter 3.[32] As far as the sources show, this is the only time an emperor of the medieval period deigned to take official interest of such dramatic kind in a dhāraṇī. The third instance involves Daoxian, the "*ācārya* of Fengxiang, whose Way the Qingtai emperor of the Later Tang especially honored." Daoxian, according to the *Song Biographies*, played an important oracular role in the life and death of Li Congke (885–936, r. 935–936) an ill-starred sovereign at the end of his brief dynasty. Zanning's account of Daoxian's oracular role, we will see, casts light on some of the occult elements—involving, among other things, dream journeys, revelations, and the interpretation of omens—that appear to have been important in tenth-century Chinese Buddhist incantation practice.

There is a fourth example of the importance of spells to rulers and high culture in the text, though it does not involve the Chinese official world. "Great masters of Japan," Zanning asserts, "often discourse on the Mystic Store for kings, aristocrats and great men." Zanning's suggestion of continuity between tenth-century Chinese and Japanese dhāraṇī traditions is fascinating, particularly for early twenty-first-century historians of Esoteric Buddhism, who work at a time when this relationship is still poorly understood. His elliptical accounts of Daoxian and these Japanese masters suggest that the tenth century may hold an important key to understanding a great deal

of what still eludes scholarly understanding. I but scratch the surface of this crucial period here. We should not, clearly, take the "Transmission" as fully encapsulating Zanning's understanding of the history of dhāraṇī practice in China, even less so the self-understandings of practitioners of this tradition themselves. The text is aimed at other targets. Properly framed, however, it remains very useful to an investigation of late medieval understandings of the nature of dhāraṇīs and their practical traditions. Close reading of the figural language he employs, moreover, opens several important avenues of inquiry.

The "Transmission" is organized into two main sections. The first is a brief discussion of the basic meanings of, and the proper language in which to understand, the concept of the Mystic Store. It makes two principal sets of claims about its subject. First, that the Store consists of methods— dhāraṇīs and the modes of their actualization—that are "mystic," "sublime," and "secret" (mimi), withheld from (it would seem) and beyond the spiritual capacities of adherents of the "two vehicles," those of the Disciples (shengwen; śrāvakas) and the "Solitary Buddhas" (dujue; pratyekabuddhas), the two standard foils of the Mahāyāna tradition. "Store," in these two sentences, is analogous to the other generic divisions of Buddhist texts called by the same name, zang (treasury, storehouse, canon) in Chinese, or piṭaka (basket, etc.) in Sanskrit. The genre of spells (and the rituals of their enactment) is here analogous to scriptures, monastic rules, and discourses, the usual three "baskets" of Buddhist literature. Indeed, accounts indicate the existence of a dhāraṇī-piṭaka ("Basket of Spells"), or vidyādhara-piṭaka ("Wizards' Basket"), consisting of collections of incantations and prescriptions for their enactment that is said in Chinese accounts to have been popular in Indian Buddhism. This "basket" is mentioned in biographies of Chinese monks who traveled to Southern and Inner Asia, but though several mammoth collections of incantation arts circulated in the China of the medieval period they never attained the status of an official division of the canon there. As an emblem of Buddhist incantation practice, however, the Wizards' Basket did attain a certain prominence, a phenomenon I will explore later.

The second basic claim of the first section is that the Mystic Store is a deep characteristic of buddhas and bodhisattvas, one that seems to define the character of their being in the world.[33] This latter understanding of the Mizang is further elaborated by Zanning's claim that the usual translation of dhāraṇī, "grasp" or "hold" (chi), has been superseded by the new translation of "nature." Zanning, in this text, does not simply repeat the traditional idea of the dhāraṇī-piṭaka as it was reported to exist in India; he reimagines it in line

with social and philosophical elements of tenth-century China, Buddhist and otherwise. In his hands, drawing on earlier conceptions, it becomes not simply a store of incantations and methods but the emblem of a tradition extending from India to Japan—and, as well, of the essence of reality itself.

Zanning's historical account, the second section of the text, begins with an allusion to Zhi Qian's third-century "Record of the Combined Scriptures of the Subtle and Sublime Grasp" (He weimichi jing ji), the preface to a long-lost compendium of dhāraṇī texts, whose only extant member is Zhi Qian's own translation of the Anantamukha dhāraṇī sūtra, the Scripture Spoken by the Buddha of the Infinite Gate of the Subtle and Sublime Grasp (Foshuo wuliangmen weimi chi jing).[34] Zanning's account then proceeds, via the wizardly and liturgical innovations of the monks Śrīmitra, Bodhiruci, Zhitong, Amoghavajra, and Daoxian, all the way to medieval Japan where, he indicates, the rubric of manifestness and hiddenness (or exoteric and esoteric) had found institutional purchase within Buddhism.[35]

ZANNING'S HISTORY OF DHĀRAṆĪ PRACTICE

Zanning's account of the Mystic Store's transmission begins with an allusion to Zhi Qian's translation idiom (though he does not mention Zhi Qian or his text by name)—specifically to his use of "subtle and sublime grasp" (weimi chi) as way to render the Sanskrit word dhāraṇī into Chinese. Like many of Zhi Qian's renderings, this term had only minimal influence upon later translators. It is rarely encountered outside of his rendering of the Anantamukha, a difficult text notable for being one of the very first translations of a dhāraṇī scripture into Chinese.[36] The importance of the Anantamukha is indicated by the fact that no fewer than nine translations of the text survive, dating from the third to the eighth centuries, by some of the most important monks of Chinese history, including (in addition to Zhi Qian himself), Buddhabhadra (Fotuobatuoluo, early fifth c.), Guṇabhadra (Qiunabatuoluo, 394–468), and Bukong.[37] The fact that the historical portion of the text begins with an allusion to the early version of the Anantamukha underscores the great range in the forms of dhāraṇī practice encompassed here within the rubric of the Mystic Store—and by the term dhāraṇī itself. As noted in the introduction, the dhāraṇī and the modes of its practice described in Zhi Qian's text bear much closer resemblance to the contemplative practices of the Bodhisattvabhūmi than they do with the wizardly exploits associated with the figures Zanning explicitly names in his history. The dhāraṇī in Zhi Qian's text is translated, not transliterated; what

brings the wondrous benefits advertised within the text is not the puissance of the syllables themselves but the meditative and ethical contemplation of their meanings. Over the history of the *Anantamukha's* translations—and reimaginings—the nature of the spell and its practices changed profoundly, coming into line with the incantatory practices that would become standard in dhāraṇī scriptures. The long history of the *Anantamukha's* translations and transformations presents a map, in fact, of the larger transformations in dhāraṇī practice over the course of the middle period.

Zanning begins his thumbnail history proper with tales, drawn from the genre of great man hagiography to which he himself was a central contributor, of Śrīmitra, the monk who by Zanning's day was widely considered the progenitor of Buddhist spell arts in China. Many medieval texts invoke Śrīmitra as the founder of the tradition. John Kieschnick, in his treatment of spells and spell casters told of within the *Biographies of Eminent Monks*, calls attention to the Song Dynasty monk Zuxiu, for example, who in his *Longxing biannian tonglun* put the matter starkly: "since the arrival of Śrīmitra in the Jin, any number of charlatan bhikṣus have come from foreign countries, equipped with arts with which they startle the ignorant."[38] Yet Śrīmitra was not, in fact, the first monk to bring spells to China, or even the first one to inspire a record in our elite sources. The logics of legend, like those of polemic and grand-scale historiography, are not those of the details of life as they happen. The longevity of Śrīmitra's iconic status was a result, in part, of the social power of the genre of the *Biographies of Eminent Monks* and its logics: Huijiao (497–554), the author of the first major collection, himself attributes the origins of spell craft to Śrīmitra; Zanning was no doubt simply quoting Huijiao's work. Yet, as Kieschnick also points out, Śrīmitra was preceded by other wizard-monks, including Heluojie (third c.) and Zhu Fakuang (fourth c.).[39] Little is known of Śrīmitra's involvement with Buddhist incantation arts, in fact, beyond these few lines that Zanning drew from Huijiao's *Biographies*, a text completed in 519.[40] Turning to that source, we may add a small but interesting detail about the nature of Śrīmitra's incantation technique. Huijiao describes the high pitch and impassive mien employed in his style of chanting, which, after he had taught it to his disciple Mili (d.u.),[41] is said to have gone on to be influential all the way down to Sengyou and Huijiao's own day (though perhaps not Zanning's much later era, given the fact that he left this detail out of his own account): " . . . his voice was high and loud yet his face was impassive. . . . He taught his disciple Mili the technique of high-pitched [or, perhaps simply "loud"] Brahmanic chanting. It has been transmitted and remains influential down to the present day."[42]

Aside from his exploits in the tale Zanning alluded to, Bodhiruci (Putili-uzhi, d. 527), the next figure mentioned, is not known to have had much to do with dhāraṇīs. Of the thirty-nine translations that the seventh-century monk Jingmai (fl. 645–666) attributed to Bodhiruci, only one appears to be a dhāraṇī text, the Dhāraṇī Scripture Spoken by the Buddha for the Protection of Children (Fos-huo hu zhu tongzi tuoluoni jing).[43] Zanning's mention of Bodhiruci's efficacious well-enchanting branch (zhoujing shu) is a reference to one of his signature legends. Once, Bodhiruci was sitting beside a well and saw that the wash bucket was empty. There being no disciples around to do the heavy work of drawing water up for him, he waved his willow branch—his "tooth-cleaning stick," Kieschnick reminds us—around at the mouth of the well and chanted a spell several times. The spring water came bubbling up to the top of the well and he used his bowl to wash himself with it. A monk who witnessed this, his mind boggling at the master's spiritual power, praised Bodhiruci as a great saint. But Bodhiruci would have none of it. Criticizing the monk for being igno-rantly overawed, he claimed that mere "techniques" (shufa) such as the monk witnessed were common abroad, though they were not cultivated in China. It was only due to the monk's ignorance that he thought it was a "saintly" power. From that moment on, the account relates, fearing to ensnare the Chinese in a web of delight in worldly powers, Bodhiruci kept these practices secret and did not teach them.[44]

Zhitong, Zanning's next transmitter of the Mystic Store, was a pivotal figure both within seventh-century Buddhism and within the history of dhāraṇī incantations in China more broadly. This fact has only rarely been noted, however, even in surviving medieval sources. His canonical biography focuses on his activities during the first half of the seventh century, in the closing decades of the Sui Dynasty and the first decades of the Tang. Accord-ing to that source, his younger days were characterized by devotion to the Vinaya and immersion in textual studies of both scriptures and treatises. He seems to have had singular talent for the latter path. His biographers tell that his wanderlust and desire to deepen his studies took him from Chang'an to Luoyang, where he entered the imperial translation academy and added the study of Sanskrit, both written and spoken, to his already broad erudition—the biography emphasizes his utter command of both Sanskrit and liter-ary Chinese. Four translations of dhāraṇī books relating to the Bodhisattva Guanyin are credited to him.[45] Modern scholarship confirms Zanning's wis-dom in including this little-known figure among the five monks he uses as emblems of a history spanning over six centuries, a fact that reinforces the

importance of Zanning's text for our understanding of the transmission of dhāraṇī practices over the course of the medieval period. Strickmann noted that "the texts translated . . . [by] Zhitong mark a clear progression within Esotericism."[46] It is in one of his works, for example, that we first encounter in a Chinese work the word maṇḍala as a term for a ritual area within which incantations are performed.[47]

As the "Transmission" moves forward in time closer to Zanning's own day the details he provides, not surprisingly, grow thicker. From this point on he relies not on the generalized boilerplate tropes of hagiography but gives somewhat more detailed pictures that include dates and the details of political history. It seems accurate, furthermore, to take his use of "next" (ci) before the shift to Amoghavajra strongly, as marking a qualitative shift in his work not only in its depth of detail but also in the kind of dhāraṇī practice it describes. We note a shift in terminology as well, from "incantation arts" to "the Dhāraṇī Teachings." This change reinforces the sense of a larger shift at this point within the text and the tradition it describes. The addition of the language of formal ritual—maṇḍala, altar, and daochang—within this section is also striking, and similarly suggestive. By Zanning's day they seem to have become emblems of a new, and newly coherent, ritual regime: the "mature synthesis" of the newly arrived Esoteric tradition. Among the resonant details Zanning offers in the final section of this piece is the fact that Amoghavajra is said to be the originator of the technique of consecration altars (guanding tanfa). Further innovations, "powder altars" (fentan) and the association of the term acārya (asheli), are associated with the monk Daoxian. Since Amoghavajra has become familiar in recent scholarship, I will focus on Daoxian here.[48] Zanning's picture of this little-known figure is, I think, especially revealing.

According to Buddhist tradition—though not, it would seem, to official court historians—Daoxian played an important role in the final years of the Later Tang Dynasty (923–936) of the Five Dynasties period.[49] As Li Congke, soon to become the last emperor of the Later Tang, plotted his seizure of the throne, he is said to have consulted Daoxian about the likelihood of his success. Daoxian recommended that he summon one Dou Balang (d.u.), a shadowy figure said to possess keen oracular powers. Zanning describes Dou elsewhere as a man of apparent contradictions, a rich man who "carried his own congee bowl," spoke weirdly, and (in behaviors associated with Chinese incantatory arts) went about with his hair unbound and his robes open. His true spiritual nature was revealed after his death when a golden butterfly, it is said, arose from his corpse on the funeral pyre. When Dou arrives,

he approaches Li Congke's horse wearing armor and carrying a spear and promptly takes up a pose of battle-readiness. After next dancing about wildly he undoes his armor, throws down his spear, and flees. Daoxian interprets this as a sign that Li's enemies will be defeated. "In the end," Zanning reports in the *Song Biographies*, "it was just as he said." When Li takes the capital of Luoyang and announces his new reign title of *Qingtai* ("clear and majestic/peaceful"), however, Daoxian makes another prediction. "This reign title is not good. Why? Because when water is clear then stones appear." This too turns out to be prophetic: a "stone" does indeed appear. Shi Jingtang (892–942), whose surname means "stone," is secretly in league with the Khitan and rebels against Li. He overturns the Later Tang and establishes the Later Jin Dynasty (936–947, r. 936–942). Li, distraught, commits suicide by self-immolation.[50] Daoxian himself dies shortly thereafter as the Later Jin forces move on Luoyang, where, as Zanning reports in the "Transmission," Daoxian's funerary stūpa was in later years still to be found.[51]

Zanning's account of Daoxian, though brief, is suggestive of his larger understanding of the nature of the practices associated with the Mystic Store in the tenth century. We see in it evidence of both continuity with older traditions and more recent innovations, particularly in terms of ritual form. The association of spell casting with other occult arts, such as prophecy and the interpretations of omens, had a long history in Chinese Buddhism already by Zanning's day, going back at least to the famous fourth-century wizard-monk Fotudeng (d. 348) who aided his disciple Guo Heilue (d. after 337), a commander in Shi Le's (274–333) army, by revealing to him in advance the outcomes of battles during Shi's campaign to establish the Later Zhao Dynasty (319–351). In Arthur Wright's translation of the *Gaoseng zhuan* passage:

[When] on a punitive expedition under Le, Lue always knew beforehand whether [an engagement] would result in victory or a defeat. Le marveled at this and asked him, "I was not aware that you had such extraordinary discernment, yet you know every time whether a military expedition will be a success or a failure. How is this?" Lue replied, "General, your naturally extraordinary military prowess is being aided by supernatural influences. There is a certain śramaṇa whose knowledge of devices is exceptional. He said that you, my general, should conquer China and that he should be your teacher. All the things I have told you on various occasions have been his words."[52]

Such interventions into the transmissions of orthodoxies—"from the margins" as Bernard Faure, drawing on the work of Victor Turner and Claude Lévi-Strauss, has characterized it—were common in Buddhist accounts of its place in the world. Between the eras of Fotudeng and Daoxian, the tradition tells of many other monks whose occult powers were seen as crucial to moments of dynastic legitimation (and as a result to the success of Buddhism in China), Baozhi's (d. 514) revelations to Emperor Wu of the Liang Dynasty and Shenxiu's (d. 706) prophecies to the future Tang Emperor Xuanzong being only the two most famous.[53] That Faure's work concentrates on the place of "thaumaturgy" in the Chan tradition and elsewhere makes clear the ubiquity of such powers in legends of Buddhist monks of all traditions, not only those of Buddhist Tantra or other forms centering on incantatory art.[54] Reports of wizardly monks, both those said to roam the margins of religious orthodoxy and imperial power and those who, like Daoxian and Amoghavajra, were their very pillars, reached deep into the foundations of Chinese Buddhism.

The sources that treat Daoxian are unanimous on the subject of his greatest contribution to the Buddhist tradition: "powder altars." His association with this element of the broader ritual tradition seems in fact to have strengthened as the Song Dynasty wore on. The thirteenth-century Buddhist chronicler Zhipan (fl. 1258–1269) reports in his *Complete Record of Buddhist Patriarchs* (*Fozu tongji*) that the method of "powder altars" was in his own day commonly known as the "method of the Fengxiang acārya."[55] However, though Zanning and Zhipan strongly associate powder altars with Daoxian—thereby implying a key creative role for him within this element of the developing occult ritual tradition—powder had been used to limn and adorn ritual spaces in China since at least the middle years of the fifth century, and in India long before that.[56] More generally, as well, the use of powder (and related substances like sand and soil) had long and various uses in Buddhist incantation practice. Mixed with water into a paste it could be enchanted and either directly applied to the body or smeared on objects to be worn as amulets (see chapters 3 and 2, respectively, for these varying uses). Dry and spread on the ground of the ritual space it not only limned the contours of that space but also effectively determined the character of its interior area, bearing the imprints of seals, whether of vajras or other potent objects.[57] Ritual manuals are thick with detail about the uses of powder in incantation rites, which would clearly have required a high degree of skill and training to carry out effectively. Practitioners of Buddhist ritual traditions would have had, by the end of the tenth century, more than a few centuries of accumulated technical

know-how on which to draw. We might speculate that Daoxian was well regarded especially for his technical skill and for his innovations within this subtradition of practice.

In the *Song Biographies*, after recounting Daoxian's prophetic interventions in some of the great events of history, Zanning draws more concrete connections between Daoxian's practices and those of wider Buddhist traditions. As with his final invocation, in the "Transmission," of the esoteric dispensation of the Japanese masters, in this earlier text he explicitly connects the Mystic Store with the early Song Esoteric transmission. "Today [that is, circa 1000], those who transmit the Great Teachings in the two capitals are all Dharma descendants [of Daoxian] and are even more profound [than he was]."[58] The term *Great Teachings* can simply mean the Buddhist religion in general, or the Mahāyāna teachings more specifically. However, by the tenth century the term, often combined with the tag *yoga*, was used to indicate the teachings of Buddhist Tantra (at times specifically the tradition of Mahāyoga). It is in that sense that I understand its use here.[59] That Zanning featured Amoghavajra and Daoxian in both the new Esoteric Buddhist dispensation and as key figures in the *longue durée* of occult practice, which he otherwise kept distinct, attests to the inherently perspectival natures of these two traditions. Their "memberships" were less features of self-conscious institutions than historiographical pictures of a complex heritage.

THE WIZARDS' BASKET, THE ADAMANTINE SEAT, AND OTHER LOST ORIGINS

The language of *mizang*, the "Mystic Store," drew on the idea of the "Wizards' Basket," the *Vidyādhara-piṭaka*, the legendary trove of incantations and their lore mentioned occasionally in accounts of India that became, like *mi* itself, a prominent emblem of Buddhist incantation arts. In China, the Wizards' Basket seems to have been largely new to the Buddhist discourse of the Tang period, where it was featured in a range of dhāraṇī traditions, including that of the *Incantation of Glory*.[60] The earliest surviving Chinese references to the existence of a canon of spells in India are in Jizang's (549–623) *Sanlun xuanyi, Profound Meaning of the Three Treatises*[61] and in Xuanzang's (602–664) account of his journey to the Western Regions, *Da Tang Xiyu ji, The Great Tang Record of the Western Regions*.[62] They list not the well-known "three treasuries" (*sanzang; tripiṭaka*), the canons of scripture, monastic rules, and treatises, but slightly different groups of five canons. In Jizang's text, the canon of spells is listed as

number four out of five, the fifth being the "*bodhisattva piṭaka*" (*pusa zang*).[63] In Xuanzang's slightly later text the five include a canon of "miscellaneous collections" (*zaji zang*) and one of "secret incantations" (*jinzhou zang*).[64]

The most extended Chinese account of the nature of the *Vidyādhara-piṭaka* as it was supposed to have existed in India during the early centuries of the Common Era—though again as portrayed in a late seventh-century text—is the brief description within the biography of the monk Daolin (fl. seventh c.) included in Yijing's (635–713) *Da Tang xiyu qiufa gaoseng zhuan, Great Tang Biographies of Eminent Monks Who Sought the Dharma in the Western Regions.*[65] Daolin, according to Yijing's account, developed a passion for the "Canon of Incantations" (*zhouzang*), which he explored along with the monastic code, meditation, and wisdom (a version of the classic "three trainings," one basic map of Buddhist practice). The technical name for spells given in this account is *vidyā* (*mingzhou*, literally, in Chinese, "illuminating [or "wisdom" or "power"] spells"). Yijing quotes an unnamed treatise: "As for 'illuminating spells,' in the Sanskrit language this is 'Vidyādhara-piṭaka' (*pidituoluo bidejia*). 'Vidyā' translated is 'illuminating spell.' 'Dhara' is 'to grasp or to wield.' 'Piṭaka' is 'store.'" Yijing comments that the full term "should be translated as 'the Store of the Spell Wielders.' However, the received version is 'Store of Spells.' In Sanskrit texts it consists of a hundred thousand verses, which if translated into the Tang language would make 300 scrolls. Today, searching for it, [one finds that] much has been lost and there are but few complete collections."

Yijing claims that the collection originated with a little-known student of the famed Buddhist monk Nāgārjuna (second century CE) named Nanda (*Nantuo*, d.u.), a man of "keen intelligence and broad mind who had a deep interest in the texts [of the spell caster's basket]."[66] The account of Nanda's wizardly and editorial practice that Yijing gives next, when taken along with his much briefer account of Daolin's own spell practice (consisting almost entirely of the statement "he erected numinous altars (*lingtan*) and devoted himself to the study of spells"),[67] gives a picture already familiar from Zanning's "Transmission."

[Nanda] spent 12 years in western India. Focusing his mind on understanding and wielding spells he often experienced their wondrous effects (*ganying*). At every mealtime food would come down from the sky. Also, once when he chanted spells seeking after a wish-fulfilling bottle he soon attained one. Within the bottle he found scriptures. In his delight [at his good fortune] he neglected to secure (*jie*) it with

incantations, and the bottle disappeared. After this, Dharma Master Nanda feared that knowledge of spells (*zhouming*) would itself be scattered and lost. He proceeded to gather about twelve thousand verses [of spell texts], putting them together into one body of literature (*yijia zhi yan*). He made editorial insertions within each verse of the texts of the spell-seals [or, "spells and mudrās," *zhouyin*]:[68] For although the words often appeared the same and indeed the characters *were* the same, in reality the meanings were different and the usages were different. If one has not had the orally transmitted teachings there is no basis for true understanding of these matters.[69]

The Wizards' Store, as the mythical elements of Yijing's account suggest, was understood to be more than simply a collection of texts. It was, or it became, an emblem of something much more profound and important within the Buddhist imagination. Surviving Chinese accounts of the existence of the Wizards' Store, though the collection itself is said to have originated in the early centuries CE, all date from the seventh century or later. The invocations of the Store most relevant to an understanding of Chinese dhāraṇī literature, and the traditions in which that literature was composed, begin to appear toward the end of that century in a cultural milieu characterized by, among other things, one of the greatest flourishings of dhāraṇī-sutra translation in Chinese history—a project to which Yijing himself made important contributions. The *Vidyādhara-piṭaka*, along with a mysterious *Jin'gang daochang jing*, or *Scripture of the Adamantine Seat of Awakening*, was at times said to have been the source of the dhāraṇīs and their scriptures. Though evidence such as the accounts of Jizang, Xuanzang, and Yijing suggest that at one time there may indeed have existed an at least semi-canonical collection of incantation rites in India, in Tang China the "Wizards' Store" had by the seventh century taken on a mythic cast, become, with its associated *Scripture*, two in a larger set of tropes of the inaccessible, inconceivable, and utterly vast true form of the Buddhist teachings (and later, by extension, of the true nature of reality itself). This set included images of other scriptures' inaccessible mystic sites of origin, such as the iron stūpa of the *Adamantine Pinnacle*, one of the principal texts of East Asian Esoteric Buddhism, and the dragon's palace of the *Flower Garland*, the namesake of the Huayan tradition, as well as the very idea of the "decline of the Dharma" (*mofa*) itself. In fact, it is tempting to read these new images as being a later development of the *mofa* ideology that had so captivated earlier ages of Chinese Buddhists. Dhāraṇī texts were, in this

way, framed by the implication that Buddhists in the Tang had access to but a small fraction of a vast lost whole.

The image of this loss was taken, along with the details of dhāraṇī ritual practice, into the Esoteric tradition where it became a common backstory for the transmission of the Tantras and served to justify esoteric lines of transmission and to heighten the mystique of their adepts.[70] Amoghavajra, for example, famously proclaimed the great size of the original text of the *Vajraśekhara Sūtra*, the *Adamantine Pinnacle* (*Jin'gang ding jing*), also known as the *Symposium of Truth of All the Tathāgatas* (*Sarvatathāgatatattvasaṃgraha*)—"as broad and long as a bed, four or five feet thick [and composed of] countless verses." This astounding text was inaccessible to humans of the world because it was kept behind the iron doors of an iron stūpa secured with iron locks that no one had been able to open in the centuries since the death of the Buddha, at least until Vajrabodhi gains entry through his yogic mastery and the grace of Vairocana Buddha (though Vajrabodhi then proceeds, perhaps predictably, to lose the text in his ocean crossing).[71] Yixing, as well, in his commentary on the *Mahāvairocana-sūtra*, the other primary text of East Asian Esoteric Buddhism, explained in similar terms that the one hundred thousand cantos of the lost original of that text were too vast for the human intellect. "Thus, the sages who transmitted its teachings took but a pinch of its essentials, about three thousand verses," from which they composed the text known in the Tang.[72] In China, notably, these images of lost origins worked at times side by side with others suggesting a very different situation: sometimes the Indian monks who took their fragments of the riches of the Wizards' Store to China went there because China was the home of Mañjuśrī, last lord of the ancient days of Buddhist truth still said to dwell in this world.

Atikūṭa's (Adijuduo, fl. 654) 654 translation, the *Foshuo tuoluoni jijing, Collection of Dhāraṇī Scriptures Spoken by the Buddha*, a massive compendium of occult lore consisting of twelve scrolls that span over one hundred pages in the modern critical edition of Buddhist Scriptures, proclaims itself to be but a small portion of the "Great Store of Incantations" (*Da mingzhou zang*), itself simply a section within *The Scripture of the Great Adamantine Seat of Awakening*.[73] This legendary text, as we will see, was often described as the *fons et origo* of Tang Buddhist occult tradition.[74] Atikūṭa's is the only text I am aware of that explicitly associates the "Store" with the *Scripture*. However, when all the Tang references to both are put together, the implicit association is clear, and seems to have been a central feature of the imagination of dhāraṇīs in this period.

The *Scripture*'s emblem, the "Adamantine Seat of Awakening" (*jin'gang daochang*), was already ancient by the time it was adopted within dhāraṇī literature. An early use of the term is found within the *Guangzan jing*, the *Scripture of Radiant Verse*, Dharmarakṣa's (Zhu Fahu, d. 316) late third-century translation of an early version of the *Pañcaviṃśati-sāhasrikā-prajñāpāramitā*, the *Perfection of Wisdom Sūtra in Twenty-five Thousand Lines*. Here it is the name for a grade of meditative absorption, the "Samādhi of the Adamantine Seat of Awakening" (*jin'gang daochang sanmei*), which the text defines, drawing on the language of the concept of dhāraṇī, as being the state wherein "one abides in meditative concentration and absorption and fully encompasses (*zongchi*) all the seats of meditative concentration (*dingyi daochang*)."[75] Approximately a century later, another usage draws explicitly on the most important association in Buddhism of the term "seat of awakening" (*daochang, bodhimaṇḍa*): the place where the Buddha achieved his awakening seated beneath a tree. In Dharmakṣema's (Tanwuchen, 385–433) translation of the *Karuṇā-puṇḍarīka-sūtra*, the *Scripture of the Compassionate [Lotus] Blossom* (*Beihua jing*), a distinction is drawn between the physical site of the Buddha's awakening (and by extension, any site of Buddhist practice) and its true spiritual form. "If a being gives rise to doubt at the Seat of Awakening (*puti chang*), when he hears the Buddha preach the Law he will immediately attain to understanding of the Adamantine Seat of Awakening."[76] This second usage of the term helps to clarify something of what is going on in later Tang usages, where the image of the Adamantine Seat suggests a mystical notion of the hidden true nature of the site considered to have been the genesis of the Buddhist tradition as a whole, and of dhāraṇīs in particular. These images find their most famous version in the tale of the true spiritual site of the Buddha's awakening—remote from worldly space and time—found in Esoteric scriptures such as the *Mahāvairocana Sūtra*.

The earliest surviving invocations of the *Scripture* and the *Store* as textual sources appear in works translated in the Northern Zhou (557–581) and Sui Dynasties. The *Foshuo shiyi mian Guanshiyin shenzhou jing*, the *Scripture of the Spirit Incantations of the Eleven-Faced Guanshiyin*, by Yaśogupta (Yeshejueduo, sixth c.), a monk said to have been active during the reign of the Northern Zhou Dynasty emperor Wudi (561–578), gives a now-familiar account of its provenance. "[The full] name of this scripture is the *Scripture of the Spirit Incantations of the Adamantine Great Seat of Awakening*. Ten thousand verses make up one of its sections. [The present text] is but an abbreviated edition of the chapter on the

Eleven-Faced Guanshiyin."[77] The gist of the image—the impossibly large original represented in China only by a fragment of a section—was already clear here in its first instance. In a somewhat simpler vein, Jñānagupta's (Shenajueduo; 523–600) early Sui translation of the *Da weide tuoluoni jing*, the *Scripture of the Dhāraṇī of Majestic Virtue*, claims that its incantation was drawn from the "Mystic Store" (*mizang*), described within the text in mythical terms as the storehouse wherein this dhāraṇī, written on golden leaves and kept within a treasure cabinet, was housed.[78]

Though it took different forms, the mythical cast of the Store's descriptions remained its central feature in following centuries. Surviving canonical sources dating from the 650s contain at least two texts relevant here. The first we have already seen, Atikūṭa's *Collection of Dhāraṇī Scriptures*. The second was Zhitong's—a monk featured in Zanning's "Transmission"—translation of the *Scripture of the Dhāraṇī Incantations of the Thousand-Eyed and Thousand-Armed Bodhisattva Guanshiyin*. The relevant passage in this work refers not to textual origins but to ritual action and the inherent nature of a dhāraṇī. It features as well a familiar homology between the mystic origins of awakening, here the Adamantine Seat, and the ritual enactment of an incantation. Zanning's own deft figure of this connection will be the subject of the final section of this chapter. Zhitong's text states: "Know that these [incantation] rites inconceivably contain vast spiritual efficacy. In chanting them one enters the three maṇḍalas of the Great Capital Assembly's Adamantine Seat of Awakening. There is no need to create the maṇḍalas. One only need make the seal [mudrā] and chant the spell. No prayer will fail; you will quickly attain Buddhahood."[79]

Such associations occur elsewhere in surviving texts, but these few suffice, I think, to reveal the depths of what terms such as the Wizards' Store, the Incantation Store, the Dhāraṇī Teachings—and, indeed, "dhāraṇī" itself—implied by the early Tang. In the eighth century these emblems gained in stature, moving from the colophons to the main titles and subheadings of the works that featured them. Rather than being invoked merely at the beginnings or ends of texts as resonant images of their origins, citations of the legendary works were absorbed in a more systematic fashion within the coalescing textual tradition of Esoteric Buddhism. The "Real Word Store" (*zhenyan zang*) of mantras, for example, appears as early as the translation of the *Mahāvairocana Sūtra*, completed around 724, in the chapter title "The Universal Real Word Store" (*Putong zhenyan zang pin*).[80] In early Song Dynasty translations of Tantric

works the phrase "Teachings of the Wizards' Store" appears frequently as a component of scripture titles.

The emblems were employed as well in Tang discussions of the practices of those who translated and enacted these texts and rituals. Indeed, and as we would expect from reading their scriptures, "incantations"—both actual spells and the broader rubrics associated with them, in forms such as "Dhāraṇī-Teachings" and "Yogic Dhāraṇī-Teachings" (*Yuqie zongchi jiaomen*)—were themselves among the principal guiding emblems of the practical traditions of Chinese Esoteric Buddhism.[81] We have already seen (in the introduction), for example, how Śubhakarasiṃha, one of the three central masters of eighth-century Chinese Esoteric Buddhism, is said to have declared dhāraṇīs to be the "quick vehicle to *bodhi*," in that they "utterly encompass" the entirety of Buddhist doctrine and practice in their brief extents and ritual enactments. Dhāraṇī traditions offered powerful resources for the nascent tradition of formal Esoteric Buddhism, both in India, where the "mature synthesis" of the mid- and late seventh century drew heavily on dhāraṇī practices, but in China as well, where by the early eighth century, when the products of this synthesis arrived there, dhāraṇī traditions had been developing as a local heritage quite separate from its Indic sources for nearly five hundred years.

The association between the dhāraṇī-piṭaka, in the Chinese guise of either the "Incantation Store" (*zhouzang*, etc.) or the "Wizards' Store" (*chiming zang*), and these "occult" ranges of Buddhist practice was clearly standard by Zanning's time. It had wide enough currency in the early ninth century, at least, that Huilin (d. 820), himself a former student of Bukong's, in his linguistic, historical, and practical guide to the "sound and sense of the scriptures" employed it without explanation in his discussion of the use, within Xuanzang's (600–664) translation of the massive *Mahā Prajñāpāramitā Sūtra* (*Da bore boluomiduo jing*),[82] of the word *jiafu*, the technical term for the cross-legged postures employed during seated meditation. He first describes the version of the posture associated with the "Chan lineages" (*chanzong*; clearly here a tradition of practical instruction): first right foot on left thigh, then left foot on right thigh; right hand nested within the left. This was called the "Demon Defeating Seat" (*xiangmo zuo*). The next posture he describes is called the "Auspicious Seat" (*jixiang zuo*). It is, in part, the opposite of the "Demon Defeating Seat": First left foot on right thigh and then right on left (hands as above, right within left). The tradition within which this posture is recommended he names the "Dharma Gate of Yoga [within] the Teachings of the Wizards' Store" (*chimingzangjiao yuqie famen*).[83]

THE SECRET AND SUBLIME NATURE

So far in this chapter I have mainly ignored three of the "Transmission's" most provocative statements. The details of its historical account and their resonances in Buddhist tradition are only part of what makes Zanning's mini-essay such a powerful text for an understanding of the medieval Chinese dhāraṇī heritage: its philosophical content is just as important.[84] Careful consideration of these three sentences both deepens our understanding of the ritual imagery explored in the previous section and broadens our exploration into the wider world of Tang and early Song Buddhist philosophy.

> [The Mystic Store] is what enables all buddhas and bodhisattvas to roam [among] and encompass [all beings]. The old translation [of dhāraṇī] was "to grasp"; the new translation is "nature." [The treasury's] root is the subtle and marvelous nature of dharmas; formed into speech it is the mother of dhāraṇīs.

These lines in general terms are rather familiar. The introduction's overview of the meanings of "dhāraṇī" within the *Treatise on the Great Perfection of Wisdom* and the *Stages of the Bodhisattva Path* helps to understand much of what is going on in them: "dhāraṇī" as a name for an aspect of the nature of buddhas and bodhisattvas. Yet, the worlds of the *Treatise* and the *Stages* were not Zanning's world, wholly; he expands the concept in new directions. In addition to reminding the reader of the ongoing importance of ancient philosophical senses of "dhāraṇī," he asserts an alignment at the deepest level of both Buddhist and native Chinese models of personal cultivation.

In the brief compass of his brief text's opening lines, Zanning makes clear that for him the Mystic Store was not a simple referent. *Mizang*—the word as a whole as well as both its component syllables—had semantic resonance as complex and broad ranging as did "dhāraṇī." Indeed, as we have now seen, *zang* did not only refer to literary genres and *mi* did not only indicate a special category of the Buddhist teachings. Broadening the scope of analysis to take account of larger discursive contexts provides a clearer and more widely resonant understanding of what Zanning achieved in the opening of this miniature and elliptical history.

We can notice first the way that Zanning, in part drawing on ideas of the Wizards' Store and the *Scripture of the Adamantine Seat*, associates the Mystic Store with the fundamental nature of reality. Given the rest of his text it is clear that

he mainly has dhāraṇīs as incantations in mind, and not (for example) deep characteristics of the bodhisattva. But here at the beginning of his text he connects the two. He first mentions the spells and the methods of their enactment and then cites the fact that the Mystic Store, in the sense of dhāraṇī as comprehensive spiritual grasp encountered in texts such as the Bodhisattvabhūmi, is one of the defining characteristics of great beings. It is what "enables all buddhas and bodhisattvas to roam among and encompass all beings." Here Zanning gives his own explicit (if still enigmatically brief) account of the unity of dhāraṇī as grasp of reality and as spell. The Mystic Store's "root," he states, "is the subtle and marvelous nature of dharmas; formed into speech it is the mother of dhāraṇīs." On the way to this revelation, Zanning reports that the "old" standard translation of dhāraṇī, "to hold, grasp, wield" (chi) has been superseded, perhaps due to the very ascendance of the term mizang itself, by the "new" translation, "nature" (xing), explicitly identified in the next line with the dharma-nature, or reality as such.[85] In terms of his project to justify Buddhism to his aristocratic audience, this assertion of the primacy of xing as the new translation—not as far as I know attested elsewhere in tenth-century sources—was a brilliant stroke: xing, in the sense of intrinsic human nature, was one of the concepts most fundamental to the Chinese philosophical tradition. To some extent parallel with Buddhist scholastic explorations of dhāraṇī as the name for a feature of the spiritual adept, discussions of xing from Chinese philosophy emphasized the connection of the human person with the cosmos, with tian ("heaven"), ziran (that which is spontaneously so by itself), and by association with the ancient traditions of self-cultivation central to Ruist ("Confucian") discourse.[86] Though no direct responses to Zanning's move survive, it is clear that this "new translation" would have done much to make the philosophical stakes of his text vivid to his literati audience.

Beyond the associations of the relatively narrow scope of the ritual texts explored earlier, connections between zang—in various compounds—and ideas of the true nature of reality were common in the scholastic literature of Tang Buddhism. The influential ninth-century exegete Zongmi (780–841) equated the use of zang in the Scripture of Perfect Enlightenment with the "storehouse of the dharma-realm" and the "true suchness of mind" found in other scriptural texts. Indeed, in an association on which Zanning certainly drew, Zongmi explicitly equated this zang with the "nature of things" (faxing).[87] Here we are deeply within the discourse associated most importantly with the "Storehouse (or 'Womb') of the Thus-Come One," or Tathāgatagarbha (rulai zang), the notion of the "matrix" or "font" of buddhahood, a concept ascendant in Chinese Buddhist doctrine of

the eighth and ninth centuries.[88] The qualifier *mi*, or "hidden" (etc.), was sometimes inserted into the middle of this word, which then became *rulai mizang*, suggesting the intimate connection between ideas of *mizang* and *rulai zang* for at least some Buddhist writers.[89] The hidden nature of the "storehouse" is suggested, in fact, by many of the metaphors for the *Tathāgatagarbha* given in the famous *Scripture on the Storehouse of the Thus-Come*, the *Tathāgatagarbha-sūtra*, which include a golden statue of the Buddha hidden in the mud.[90] As Zongmi's writings—which contain treatments of a wide range of late Tang Buddhist doctrinal works—make clear, however, *mi*'s particular sense of "hidden" was not simply "hidden from view" or "secret." The implications of mystic hiddenness, of a reality beyond the ken of normal consciousness and language, in formulations such as those just surveyed, are made explicit in Zongmi's famous preface to his history of the Chan lineage, where, in discussing the term *miyi* ("hidden [or sublime, etc.] meaning"), he defines *mi*: "The meaning is not formed within language and is thus called '*mi*'."[91] Mi and *zang* in such writings seem to have been practical synonyms, or at the very least to exhibit intimate semantic relations.[92]

Another term, as Zanning himself notes one of the first used in translating "dhāraṇī," further deepens this well of associations. This is *weimi*, "subtle and sublime." Zanning mentions it in passing at the start of his historical narrative as part of one of the terms for dhāraṇī, *weimichi*, which he equates with "spirit incantations" (*shenzhou*). This term, sometimes treated as a synonym for *mimi*, "occult," "secret," or "mystic," was yet another modifier employed within the *Tathāgatagarbha* literature, particularly in the *Nirvāṇa Sūtra*.[93] As its usage in texts as disparate as the *Treatise on the Great Perfection of Wisdom* and the *Mahāvairocana Sūtra* make clear, *weimi* (like *mimi*) simply deepens the sense of *mi* as "inconceivable," "beyond the ken of normal beings," a by definition unconceptualizable concept of the sort we have seen commonly employed in dhāraṇī-talk (and central to much Buddhist thought more generally).[94] The early use of *weimi* as a modifier of *chi* (the basic translation of "dhāraṇī" in Chinese) helps clarify, as well, the sense of "encompassing" (*zong*) when that term is used as the chief modifier of *chi* in translations of "dhāraṇī"—and to the extent that *chi* ("hold") and *zang* ("a hold") are often functionally the same image, this semantic chain of associations brings us yet closer to a full picture of what the *Mizang* was understood to be.

More to the point in my exegesis of Zanning's lines, however, these associations—and we should include the image of the "Treasure Store" (*baozang*) as found in the famous *Treasure-Store Treatise* (*Baozang lun*), a text that would have been well known to Zanning[95]—clarify some of what the "new" translation

of dhāraṇī as "nature" implies about late tenth-century understandings of dhāraṇīs. These associations give a very different picture of the Mystic Store than the one offered in the first sentence of the passage, which states simply that the Store consists of the methods of dhāraṇī." That sentence inspired the bibliographical and historical exploration I engaged in above; these elaborations of the sentence, as we have seen, deepen the sense of the term considerably. They refine the picture of dhāraṇīs as being profound spiritual forms of synecdoche, as being the sublime and ineffable essence of the Buddha's teachings, and thereby help us further understand the connections between the various pictures of "dhāraṇī" I have presented thus far in this book. Dhāraṇī incantations, it turns out here, are simply vocal forms of the dhāraṇī storehouse, the essential nature (or "root") of which is the essential nature of reality itself.

This understanding of dhāraṇīs, which as we saw was central to the development of "Dhāraṇī" and "Esoteric" traditions, is echoed as well in the statement found in the *Great Perfection of Wisdom* literature that "the encompassing grasp ["dhāraṇī"] is without words and letters; words and letters manifest the encompassing grasp," a claim that, among other things, shows the near omnipresence of the trope of hidden versus revealed in Buddhist writings, even here *within* the imaginings of dhāraṇīs.[96] Zhiyi (or perhaps his amanuensis, Guanding) cites this line in the *Great Calming and Contemplation*.[97] He explains that the image indicates that worldly transactional truth (that is, not the absolute truth of emptiness, etc., but the truth of things as they appear and as they exist in human practices) can be spoken of (*ci zhi sudi keshuo*), implying that absolute truths about the nature of reality—or of awakening itself—are ineffable.[98] The implicit connection made here between, on the one hand, the category of dhāraṇī as such—the quality of being—and ineffable ultimate truth, and, on the other, that between the words and letters of specific incantations and contingent and describable worldly truth, closely parallels Zanning's formulation. The complex of associations figured in these two passages looks something like this:

Basic nature / absoluteness / the root of dhāraṇī
in contrast to
Actual incantations / contingency / dhāraṇīs as expressions of the ultimate.

Beyond such philosophically technical formulations of the relationship between Buddhist incantations and the hidden nature of reality, however, the

phrase "Mystic Store" was often deployed simply as an evocative name for the essential (and in that sense "esoteric") form of the religion and of reality itself. We see this usage in many canonical texts. In the preface to Śikṣānanda's (652–710) translation of the *Flower Garland Scripture* attributed to Empress Wu, that scripture is said to be the "secret treasury of the Buddhas, the nature-ocean of the Thus-Come Ones" (*rulai zhi xinghai*).[99] "Nature-ocean of the Thus-Come Ones" is of course a precise echo of the Tathāgatagarbha doctrine, suggesting once again the wider currency of the associations between *mizang* and what is often called the "Buddha Nature." In far less mystical terms, we can see another example of the praise function of the term in the biography of Zhanran (711–782), the famous prelate associated with the Tiantai lineage, who is described in the *Song Biographies* as "carrying the Mystic Treasury as he went alone into the Southeast." It seems likely that *mizang* here simply refers to the texts of his lineage—his "precious and sublime texts," as it were—which were not, perhaps, available to all.[100]

Some Buddhists, however, resisted the implication of words like *secret* or *esoteric* that there existed elite forms of the teachings not available to all. A passage in the *Nirvāṇa Sūtra* categorically denying "secret" treasuries of the teachings was often cited:

At that time, Kāśyapa said to the Buddha, "World-honored One, if a buddha were to say that all buddhas and world-honored ones have secret treasuries [of the teachings] (*mimi zang*), this would be incorrect. Why? Because though buddhas have secret [hidden/mystic/essential] words (*miyu*) they do not have secret treasuries (*zang*) [of teachings]. Take the example of a magician animating a wooden man—people see his stretchings and bendings, his lowerings and risings up, but they do not know how he is made to do these things. The Buddhadharma is not like this: all beings can know it—how could it be said that buddhas and world-honored ones have secret treasuries?" The Buddha praised Kāśyapa. "Excellent! Excellent! Good son, it is as you say. The thus-come ones truly have no secret treasuries of teachings. Why? Like a full moon in autumn that is clear in the sky, that is pure and clean and can be seen by all people—the words of the thus-come ones are also like this. They are open and manifest, pure and without taint. Foolish people do not understand this and say there are secret treasuries. Those who know understand and do not name them treasuries."[101]

The distinction between secret words, which the text finds unobjection-able, and secret treasuries, is important. I take the text to be denying the existence of hidden, or esoteric knowledge in the tradition, but not of difficult concepts that require explication or deep study. What seems obscure, or esoteric, the Buddha explains, is simply misunderstood.[102] Though *miyu* can also be a word for spells, in Mahāyāna scriptures it often simply means the "profound words" of the Buddha.[103] The authors of this passage would seem to have been playing with the complex semantic range of the term *mi* (with which we are now familiar), contrasting *mi* as "secret" with its sense as "profound" to make a point about the nature of the Buddha's speech.

In other instances, the term *mizang* indicates neither an acme of the teachings nor the hiddenness of certain of them but simply the religion itself. In Zanning's biography of Huilin (d. 820), for example, Huilin's dual dedication to Buddhist and Ruist traditions is described using the term: "Inwardly he held to the Mystic Store, outwardly he studied the traditions of the Ru" (*nei chi mizang, wai jiu ruliu*).[104] Given the parallel with Ruism, it is clear that the Store here is simply Buddhism. It is possible, as well, that in the passage from Zhan-ran's biography mentioned above, *mizang* simply means "Buddhist texts," which he carried into the south, away from the social chaos and violence that characterized life in the north after the terrible rebellion of An Lushan (703–757) and Shi Siming (d. 761). We are getting rather far away from spells here, but I hope the point of this short excursus is clear: the rich life across a range of texts and traditions of the metaphor of the Mystic Store. Its use as a name for spell arts drew on a deep fund of imagery and ideas that would have created a vivid set of associations in the mind of the educated reader or practitioner. At the very least, these associations and resonances should belie any reductive understandings of *mizang* as something flatly "esoteric" or "secret." There is far more, clearly, in the store transmitted by the men in Zanning's narrative than is told of in our traditional pictures of the "esoteric."

CONCLUSION

As I have read it, Zanning's "Transmission of the Mystic Store" helps clarify important features of medieval Chinese dhāraṇī practice. Zanning's nutshell history of elite incantation masters and ritualists, whom he describes as having been parts of a loose tradition distinct from, but from certain perspectives intertwined with, the institutions of high esotericism he knew as "The Wheel of Instruction and Command," sheds light on what has become, in large part

due to the ascendancy in East Asia of that high tradition, a hidden history of practice and understanding. The usual picture of these more diffuse incantatory traditions takes their connections with the Esoteric lineages to have been their most salient characteristic. Yet Zanning, writing nearly two hundred years after the Indian esoteric syntheses had been brought into China, still found the older rites and their proponents, from Zhi Qian in the fourth century to Daoxian in the tenth, to constitute a coherent "transmission" in their own right. His text provides elements for a historical frame in which to understand the "un-synthesized" dhāraṇī traditions of practice and thought I have explored in previous chapters. The signature practices and images of the incantations of Wish Fulfillment and Glory—centering on amulets and incantation pillars, respectively—were not products of the high Esoteric tradition. When the long history of Chinese Buddhist incantation practice is viewed from the vantages offered by these two dhāraṇī traditions, the picture given in Zanning's "Transmission" makes perfect sense. Conversely, and confirming the findings of recent scholarship, the frameworks for this material provided by the relatively late-arriving Esoteric tradition (whether "proto-" or mere "Action-" Tantra) are clearly procrustean beds of little analytic utility for a history of the older and abiding heritage of medieval Chinese dhāraṇī practice.

Zanning's assertion of profound connection between dhāraṇī incantations and the philosophical and spiritual import of the concept of the dhāraṇī storehouse, figured as the mystic source of being, also helps to bring this book to a close, by connecting the doctrinal explorations of the introduction with the studies of material incantations that followed it. It further clarifies the ways that philosophical and material practices were part of a continuum in Buddhism. Zanning's "Transmission" echoes the early ideas, explored in the introduction, of "dhāraṇī" as the name for a deep characteristic of the spiritual adept, as a "grasp" or "hold" both in the sense of a personal capacity and a feature of the highly cultivated mind. His text, however, drawing not only on particular traditions of Buddhist ritual shaped (in part) by dhāraṇī practice but, as well, by the conventions of tenth-century Chinese Buddhist thought more generally, presents those older ideas in terms consonant with his own age, as the "nature." The dhāraṇī "hold" or "storehouse," the feature of bodhisattvas, is said here to be rooted in the "marvelous nature of dharmas." Most revealingly, this marvelous essence—the "nature" of things—is explicitly connected with the incantations that share their name. Similar associations had long been at work in the Buddhist imagination. They resulted in and were in turn deepened by ideas, found in images and objects such as the Dharma

Body and text relics, of the equivalence of reality with Buddhist images and accounts of it (along with the physical media of those images and accounts). Perhaps especially, statements like those of Śubhakarasiṃha and Yixing in their commentary to the *Mahāvairocana sūtra* that Buddhist incantations were the very speech of "suchness" itself, were powerful and widely cited claims.[105] Deepening this identification in the present case was the fact that in China *zang* ("store") had become the standard translation both of *piṭaka*, the bibliographical division, and of *garbha*, the philosophical image. In such associations text and reality were yet more deeply wed.

The associations also reveal the profound continuity down the centuries of Buddhist thought across a wide range of sources, from elite doctrinal treatises to accounts of the history of incantation practice—even, as I have shown, within bodily and communal practices otherwise considered merely "popular." The conceptual rooting of dhāraṇīs within images of a hidden essence of things had become by Zanning's time a prominent feature of the Buddhist incantatory imagination. This hidden source, as we have seen, was figured in mythical terms as an inaccessible and incomprehensibly vast original text with origins in the mystic Adamantine Seat of Awakening, the site understood in a range of texts to be the true source of the Buddha's wisdom and power. Related but simpler images of an impossibly large original text, located in lands far to the west or lost in the ocean, whose overwhelming cantos were but partially available in redacted form, hint as well at other and vaster inaccessibilities made present in the incanted phones and inscribed signs of dhāraṇīs.

CODA: MATERIAL INCANTATIONS AND THE
STUDY OF MEDIEVAL CHINESE BUDDHISM

> Yet behind each of the early texts was of course the oral tradition, the tradition
> of practice—of which even the best of our texts is but an imperfect reflection.
> —MICHEL STRICKMANN, *Chinese Magical Medicine*

This book is an attempt to revise our understanding of the nature of dhāraṇīs
and other Buddhist spells as they were practiced and made (by hand, often)
in late medieval China. I have tried to show that material incantations and
their bodily engagements were natural and integral to Buddhist incantation
practice, not strange or secondary developments parasitic upon a tradition
centered on oral performance, and to show that dhāraṇī practice in medieval
China, taken in the *longue durée*, displays its own logics and coherences, quite
apart from the narrower history of Esoteric Buddhism to which it has often
been reduced. The profoundly embodied Buddhist practices central to enact-
ments of material incantations have deep roots within the wider Buddhist
tradition and are not understandable apart from that wider context. Espe-
cially, Buddhist incantatory inscriptions are not understandable apart from
the material, visual, textual, and ritual cultures in which they were enacted
and made. This book will have succeeded, then, at least in part, if it has dem-
onstrated that one must consider the manuscripts, epigraphy, stones, metal
cases, images, and physical behaviors that gave life to dhāraṇīs as closely as
one does the texts collected in the scriptural canons—and more importantly,
if it has made a case for their mutual inclusion in the complete language not
only of Buddhist spell craft, but of medieval Chinese Buddhism as a whole.[1]

Rather than fully recapping the book's arguments, I would like to briefly
consider a few issues in the study of Buddhism in Tang and tenth-century
China, and of the religious practice there somewhat more generally, upon
which the previous chapters have, I hope, shed light. These include the place
of late medieval Chinese religious cultures within larger trans-Asian Buddhist
histories, as well as the variety of situations in which (and levels at which)
Chinese of the period encountered and transformed incantation techniques
and objects. How should we imagine the nature of Buddhist practice in late

medieval China, and how should we go about studying it so that its complete language is clearly in view?

Robert Sharf's essay, "Prolegomenon to the Study of Medieval Chinese Buddhist Literature," offers a valuable starting point.[2] The essay critiques the metaphors of encounter and dialog between civilizations that have shaped our understanding of the history of Buddhism in China. Models of encounter and dialog, Sharf argues, do not fully match the picture we have of medieval Chinese Buddhist history: transmitted records suggest that relatively few Chinese monks of this period, for example, traveled to India or other Buddhist lands to the west of China, or (as far as we know) learned foreign languages to any great degree; similarly, few foreign monks seem to have made it to China or had much influence there. Moreover, the influence of those Indians and Central Asians who are remembered in China for their teachings and translations would have been decisively mediated and shaped by the Chinese monks and literati who worked with them, translating, reworking, and polishing their words to fit local styles of knowledge. Sharf reminds us that the works of the most successful Buddhist translator in Chinese history, Kumārajīva (Jiumoluoshi, 344–413), were successful not because of their fidelity to Indic originals but because they read well according to the conventions of literary Chinese prose. The translations of Xuanzang (602–664), in contrast, famed for their rigorous doctrinal accuracy and faithfulness to the conceptual styles of Indic thought and Sanskrit prose, had relatively scant impact on later East Asian Buddhist writers and thinkers. Sharf makes the well-taken Gadamerian point that, in the great majority of cases, the alterity of the imported tradition was, ironically, recognized most when it appeared in familiar guise within the horizons of local styles.[3]

In many ways the explorations of this book confirm this picture. Styles and instruments of Buddhist material incantation, when they appeared in Tang China, were quickly absorbed and transformed according to local styles and became, in their own ways, "accomplices in the Chinese domestication" of the tradition they embodied.[4] The Indic ritual figure of direct bodily enchantment was, as we saw in chapter 3, refigured in China as the metaphor of infusion or soaking, zhan, an image with deep roots in Chinese philosophical and literary traditions. Visual forms of the inscribed *Incantation of Wish Fulfillment*, as discussed in chapter 2, were rather quickly transformed according to local conventions, losing their Indic character as active incantations as they were remade into printed icons of the sort then popular in China. Conceptual

translations such as these, wrought within medieval Chinese horizons, are emblematic of the character of Buddhism as it shifts across cultures.

But, by encouraging an overly hermetic picture of the Chinese reception of Indic and Central Asian Buddhist practices and concepts, the dismissal of metaphors of encounter and dialog can do mischief to our understanding of medieval Chinese Buddhist history. Something closer to the kind of recognition and dialog that Sharf finds missing in canonical texts was in operation in the bodily practices of the amulets, and perhaps in the oral practical and craft traditions in which they were transmitted. While his observations about the character of the discursive reception of Buddhism in medieval China (and modern America) largely stand—particularly in terms of conceptual translations—we must be careful not to miss areas of openness and truer contact, evidence for which may be found at times beyond the translation halls of the monasteries, in less-censored manuscripts and in the extra-canonical wilds of material (and visual) culture.[5] As I have tried to show in this book, when one widens one's gaze beyond only the translations and the other highly edited texts of the transmitted canons and looks also to the material instruments of practice, a broader arena of encounter (and perhaps at times a modest but true form of dialog) comes into view. When one broadens one's view in this way, the world of medieval Chinese Buddhism—and the religious culture of the period more generally—appears more open and porous, at more levels, than can otherwise be seen. This complexity is visible in the contrast between how the wearing of incantation amulets is described in the Chinese translations of the scripture of the Mahāpratisarā incantation and the ways in which they were actually worn in China. Were one to limit one's inquiry to the texts of the Chinese translations alone, one would conclude that the enactments of "The Great Amulet" in China were wholly Sinitic in character, that they had been refigured in line with ancient native practices of wearing seals, fu-talismans, and other potent objects and substances.[6] Indeed, scholars have in many (even most) cases taken the imperatives to wear the spell given in its translated scripture as Chinese additions to it. Study of the translations and other transmitted texts alone results in a skewed picture of the history of Buddhist practice in medieval China and its relationship with the Buddhist cultures of South and Central Asia. Scriptural and other normative accounts, no matter how skillfully or honestly made, can only caricature the behaviors of those who put them into practice, or who provided the means for others to do so.

The archeological record helps to rectify our understanding. As I discussed in chapter 2, few if any instruments for the wearing of the spell yet discovered conform to the Chinese styles one would expect from a reading of the figurative language employed in the Chinese version of its scripture.[7] Instead, in line both with longstanding Indic practices and with the meaning of the Sanskrit word *pratisara* ("circle," "bracelet," etc.), translated by the Chinese *suiqiu* ("wish fulfillment," "talisman"), itself, *Mahāpratisarā* amulets in China usually took the form of armlets or necklaces—forms that were not specifically described in the Chinese translations of the *Scripture* or in any other known text from medieval China. There seem to have been at least two parallel traditions of amulet cases in late medieval China: the scriptural, which was strongly shaped by native epistemic forces; and the material, which was not. The Chinese linguistic idioms employed by the translators of the tales of the spell contrast sharply in this way with the Indic material idioms evidenced in the armlets and pendants made to carry the spell. The styles of the latter, in fact, suggest the existence of Chinese craft traditions with active links to artisans to the west, relationships made possible by the ancient trade routes now known as the "Silk Roads."[8]

In this regard, historians of Tang Buddhist religious practice might heed recent studies of Tang military culture, particularly of the place of normative texts within it and its own place within a wider military culture stretching into Inner Asia. As Jonathan Karam Skaff has argued, Tang military practice was shaped in key ways by interactions with the skilled nomadic warriors of Inner Asia, by the "operational experience of a multi-ethnic array of officials, officers, and soldiers in the northern borderlands." Indeed, Skaff argues that this experience was, even more than the classical military writings and theories Tang soldiers inherited, of the "greatest practical importance" to the development of Tang practices.[9] Contrary to the picture one gets from studies claiming the centrality to traditional Chinese military culture of the various military classics, or *bingfa*, etc., such works appear to have had little impact on actual tactics or practices in the Tang. David Graff, similarly, has shown that in the early Tang there was "no clear correlation between the prescriptions of military manuals and practices on the battlefield, even in the case of the presumed minority of educated officers who had read the military classics."[10] Now, clearly, military and Buddhist cultures in the Tang were not perfectly parallel, either in regard to the places of classical texts within them or in regard to their places in larger trans-Asian cultures, but these findings provide fascinating points of comparison for the student of late medieval Chinese Buddhism

(and for students of the wider history in which it was practiced). Canonical texts were not fully normative for the practices of either military men or monastics in the late medieval period. Both sets of practitioners lived within and learned from largely oral practical cultures that were constantly remade, among other ways, through contact with the practical cultures of skilled foreigners—and, in the case of the Buddhists this book is largely about, with skilled proponents of other religious traditions and styles, foreign and native.

Archeological sources, as this book has shown, also disclose histories of practice—and styles of practice—*within* Chinese Buddhism that are otherwise difficult, even impossible, to see. Often this near invisibility is caused, on the one hand, by the too-broad application of analytical categories such as "Esoteric Buddhism," and on the other by the centering of the pictures of practice, and of Buddhism as a trans-Asian phenomenon, contained in transmitted texts. While ignorance of continuities between medieval Chinese Buddhist material practices and those to their west, such as those I explored in chapter 2, skews our understanding in one way, overemphasis of trans-Asian doctrinal or institutional continuities does the same in another. In particular, when we center canonical pictures of Chinese Buddhism as downstream of the Indic source, the images and objects of particular Chinese sites can be (and all too often are) taken simply as locally variant illustrations of the ideas and practices enshrined in those canons; that is, in the present case, as simply variant forms of "Esoteric Buddhism" or "the Mahāyāna"—phenomena we imagine we already understand. The religious imaginations and traditions of the people who were buried wearing dhāraṇī amulets, or who joined together in life to pool their resources to have a pillar carved with incantations and placed in their village, are in this way written over with doctrines and stories of which in many cases they likely never dreamed.

Eagle's-eye views of Buddhism as a trans-Asian religion are naturally important, and it is one job of scholarship to produce them. In the case of the material explored in this book, scholars at times speak of forms of the religion called "Esoteric" or "Mahāyāna" (or "Esoteric Mahāyāna") and map their spread with only passing reference to local understandings, which on this kind of view are secondary to history as viewed from the privileged high vantage of the modern Buddhologist. In this book, even as I have investigated practices and objects that clearly traveled across large parts of Asia, I have chosen not to focus on the world historical in the form of categories like Esoteric or Mahāyāna. The original Indian social meanings of these concepts were, I think, weakened and essentially transformed as they were employed

in medieval China, where in a sense they were brands attached to imported objects and practices rather than names for living social movements whose realities were real for any to see. I have often thought that keeping concepts such as these in the foreground in studies of Chinese Buddhism has gotten in the way of understanding its nature and history. At times it has amounted to trying to tell an Indian story of China.

The close (yet admittedly incomplete) attention to the particular logics, placements, and visual characters of dhāraṇī amulets and stones that I have given in this book has instead revealed in great detail a medieval Chinese world of practice that included men and women of nearly all social strata and levels of religious commitment and affiliation, a world that was itself part of an open and extremely wide-ranging Buddhist technical culture, only a relatively small part of which was guided by normative doctrinal and institutional frames such as those labeled "Esoteric." This culture developed and spread across China, both inside and outside temples, according to its own logics and contingencies for centuries, quite apart from the practices of the socially elite and doctrinally super-literate monks of the great monasteries of the Tang and early Song, who trained their chosen few disciples in the later-arrived and more complex traditions of philosophy, incantation, and ritual imagination they named Esotericism, Yoga, and the Vajrayāna.[11] Though the high tradition has received the lion's share of scholarly attention, it is the humbler history of amulets, incantation pillars, and cultic sites that is by far the most widely and vividly evidenced in the Chinese material and visual records. At Dunhuang, for example, in evidence stretching through the tenth century, the high lineages of the Chinese traditions and their scriptures are barely in evidence at all, while traces of the broader landscape of cults and techniques are, quite literally, everywhere.[12]

APPENDIX 1

SUIQIU AMULETS DISCOVERED IN CHINA

KEY: Name / Alternate name. 1. Medium. 2. Size. 3. Hand done, printed, or both. 4. Date. 5. Central image. 6. Description of inscribed incantation. 7. Colophon. 8. Case. 9. Archeological and other reports.

MANUSCRIPTS

1. Madame Wei / Yale Art Gallery. 1. Silk. 2. 21.5 × 21.5 cm. 3. Handwritten and painted, ink and pigments. 4. Mid-eighth century? 5. Vajradhara empowering Wei, with name and description in flanking text. 6. Spell in Indic script with names inserted. 7. No colophon. 8. Round case. 9. No report, but see Ma, "Da suiqiu tuoluoni mantuluo," 529–531.

2. Jiao Tietou / Fenghao Rd 西郊灃滈路. 1. Silk. 2. 26.5 × 26.5 cm. 3. Handwritten and painted, ink and pigments. 4. Late eighth century? 5. Eight-armed bodhisattva with Jiao kneeling in prayer to side. 6. Spell in Indic script with names inserted. 7. No colophon. 8. Armlet of gold-enameled bronze, 1 cm in width, with copper box riveted to it, 4.5 × 2.4 cm. 9. Archeological report: *Wenwu* 1984.7: 50–52; see also Ma, "Da suiqiu tuoluoni mantuluo," 528–529; Cheng, *Xi'an beilin*, 152.

3. Mother and Son / EO 1182. 1. Silk. 2. 40 × 37.6 cm. 3. Handwritten and painted in ink and pigments. 4. Eighth century? 5. Vajrakumāra (?) and mother and son. 6. Spell in Chinese script without names. 7. No colophon. 8. No case. 9. No reports.

4. Stein Painting 18 / Ch.xxii.0015. 1. Silk. 2. 58.5 × 56.3 cm. 3. Handwritten and painted, ink and pigments. 4. Eighth century? 5. Vajradhara empowering man in hat. 6. Spell in Indic script without names. 7. No colophon. 8. No case. 9. No reports.

5. Xi'an West Suburbs Fragment. 1. Paper. 2. Fragmentary. 3. Handwritten and painted in ink and pigments. 4. Mid-eighth century? 5. Unknown. 6. Spell in Chinese script, fragmentary. 7. No colophon. 8. Armlet with enlarged section to hold amulet sheet; dimensions and material unknown. 9. No archeological report, but see Zhou, *Xunmi sanluo*, 131, 146–147; and Ma, "Da suiqiu tuoluoni mantuluo," 531–532.

6. Chen Chouding / Pelliot Chinois 3679. 1. Paper. 2. 23.6 × 24.6 cm. 3. Handwritten and painted in black and red ink. 4. Tenth century? (acc. Bibliothèque Nationale). 5. An 唵 ("Oṃ") within lotus flower. 6. Spell in Chinese script with name once within it (name inscribed to four sides of sheet). 7. No colophon. 8. No case, but folds and holes that contain possible traces of thread, as if sheet had been folded and sewn into clothing. 9. No archeological report, but see Bibliothèque Nationale 4: 165.

7. Xingsi / Pelliot Chinois 3982. 1. Paper: two sheets mounted together on what the Bibliothèque Nationale identifies as the fine muslin-like fabric known as mousseline. 2. 44.5 × 44.3 cm. 3. Handwritten and painted in ink and pigments. 4. Tenth century? (acc. Bibliothèque Nationale). 5. Architectural central image. 6. Spell in Chinese script with names inserted. 7. No colophon. 8. No case. 9. No archeological report, but see Bibliothèque Nationale 4: 454.

8. Turfan 72TAM188: 5. 1. Paper. 2. Fragmentary. 3. Handwritten and painted in ink and pigments. 4. Early mid-eighth century? 5. Unknown. 6. Spell in Indic Script. 7. No colophon. 8. No case: found along with next sheet covering corpse. 9. See Ma, "Da suiqiu tuoluoni mantuluo," 532–533.

9. Turfan 72TAM189: 13. 1. Paper. 2. Fragmentary. 3. Handwritten and painted in ink and pigments. 4. Early mid-eighth century? 5. Unknown. 6. Spell in Indic script. 7. No colophon. 8. No case: found along with previous sheet covering corpse. 9. See Ma, "Da suiqiu tuoluoni mantuluo," 533–535.

HALF-MANUSCRIPT HALF-PRINTED

10. Wu De__ / Diesel machine factory 柴油機械 (Xi'an area). 1. Paper? 2. 27 × 26 cm. 3. Printed with handwritten and drawn elements. 4. Ninth or tenth century? 5. No central image (blank space), with name (+ *fu* 福 ("blessings")

written to side. 6. Spell in Indic script without names. 7. No colophon. 8. Arc-shaped copper pendant, 4.5 × 4.2 cm. 9. Han 1987, 404–410; Su 1999, 7–11, 125; Ma, "Da suiqiu tuoluoni mantuluo," 535–536.

11. Metallurgy Works (*yejin jixie* 冶金機械, Xi'an area). 1. Paper. 2. 35 × 35 cm. 3. Printed and hand drawn. 4. Ninth or tenth century? 5. Empowerment of donor (nature of deity unclear), hand drawn. 6. Spell in Chinese script, blanks left for names between "meme" and "xie." 7. No colophon. 8. Copper box, 5–6 cm long. 9. Han, "Shijie zuizao de yinshua pin," 404–410; Su, *Tang Song shiqi de diaoban yinshua*, 7–11, 127; Ma, "Da suiqiu tuoluoni mantuluo," 536–537.

12. Jing Sitai / Fengxi 灃西 (Xi'an area). 1. Paper. 2. 32.3–32.7 cm × 28.1–28.3. 3. Printed and hand drawn. 4. Mid/late eighth century? 5. Vajradhara empow-ering male figure with headscarf. 6. Spell in Indic script with names; name to side of sheet as well. 7. No colophon. 8. Copper tube, 4 × 1 cm. 9. Archeo-logical report, An and Feng, "Xi'an Fengxi chutu"; Ma, "Da suiqiu tuoluoni mantuluo," 537–539.

PRINTS

13. Sichuan University / Jin River, Chengdu. 1. Paper. 2. 31 × 34 cm. 3. Block print. 4. Late ninth (post 841) or very early tenth century. 5. Eight-armed bodhisattva. 6. Spell in Indic script without names. 7. Fragmentary: "成都," " 龍池坊," "印賣咒本," etc. 8. Silver armlet. 9. Archeological report, Feng, "Ji Tang yinben tuoluoni"; see also Ma, "Da suiqiu tuoluoni mantuluo," 539–541.

14. Monk Shaozhen / Chengdu Bao'en si 報恩寺 / Xi'an Sanqiao 三橋. 1. Paper. 2. 30 × 31 cm. 3. Block print, with handwritten name in center: Biqiuseng Xiaozhen 比丘僧少貞. 4. Late ninth century, as no. 13, above. 5. Eight-armed bodhisattva, with name to side. 6. Spell in Indic script without names. 7. 成都 府浣花溪報恩寺XX生敬造此印施, etc. 8. Copper armlet, 9 cm in diameter, 1 cm in width. 9. Zhou, *Xunmi sanluo*, 130, 146–147; Ma, "Da suiqiu tuoluoni mantuluo," 541–542.

15. Bodhi-nature / Shanghai auction. 1. Paper w/rust stains (suggesting it was found in a metallic container). 2. Dimensions unknown. 3. Block print. 4. Ninth or tenth century? 5. Eight-armed bodhisattva. 6. Spell in Indic script. 7. No colophon. 8. Unknown. 9. See Jiang, *Zhongguo paimai*, "Autumn,

2000, item no. 10" (2000年秋10號拍品); Ma, "Da suiqiu tuoluoni mantuluo," 542–544.

16. A-Luo / Chang'an county. 1. Paper. 2. 23.5 × 24.5 cm. 3. Block print with names handwritten. 4. Ninth or tenth century? 5. Vajradhara empowering male figure wearing headscarf. 6. Spell in Indic script with names inserted (and once to side). 7. No colophon. 8. Case unknown, but sheet has fold marks, suggesting that it was carried in something. 9. No report, but see Cheng, *Xi'an beilin*,153.

17. Xu Yin / Luoyang, Shijiawan 史家灣. 1. Paper. 2. 38 × 28.5 cm. 3. Block print. 4. 927. 5. Eight-armed bodhisattva. 6. Spell in Indic script without names. 7. Printed colophon drawn from sūtra, with date of carving, 926, name of donor, Seng Zhiyi 僧知益, and block carver, Shi Hongzhan 石弘展, with handwritten date of printing, 927, and name of recipient, Xu Yin 徐殷: 報恩寺僧知益發願印施布衣石弘展雕字天成二年正月八日徐殷弟子依佛記. 8. Small tube (dimensions and material unknown) found near ear of corpse. 9. Archeological report: Cheng, "Luoyang chutu"; see also Ma, "Da suiqiu tuoluoni mantuluo," 544–545; Drège, "Les Premières Impressions," 31–32; Tsiang, "Buddhist Printed Images," 222–223.

18. Xi'an city. 1. Paper. 2. Dimensions unknown. 3. Block print. 4. Tang Dynasty? 5. Two-armed bodhisattva. 6. Spell in Chinese script. 7. No colophon. 8. Case unknown. 9. No report, but see Tsiang, "Buddhist Printed Images," 237–238.

19. Li Zhishun / S.P. 249. 1. Paper. 2. 43.2 × 31.8 cm. 3. Block print. 4. 980. 5. Eight-armed bodhisattva. 6. Spell in Indic script without names. 7. Printed colophon draws on sūtra, dated 980; names of donor, Li Zhishun 李知順, and block carver, Wang Wenzhao 王文沼, included with their images in middle of sheet. 8. No case. 9. Stein, *Serindia*, v. 2: pl. 25; Whitfield, *Art of Central Asia*, v. 2, fig. 151; Matsumoto, *Tonkōga*, 604–609; Ma, "Da suiqiu tuoluoni mantuluo," 550–552, Fraser, *Performing the Visual*, 155–158, and Tsiang, "Buddhist Printed Images," 218–219. (Two other copies of this amulet [of lesser quality] are Pelliot Sanskrit 2 and EO 3639.)

20. Jixiang / MG 17688. 1. Paper. 2. 37 × 29.7 cm. 3. Block print. 4. Late tenth century? 5. Mahāvairocana Buddha. 6. Spell in Indic script without names.

7. Printed colophon draws on sūtra, identifies donor as *Foding Asheli Jixiang* 佛
頂阿闍黎吉祥. 8. No case. 9. See Matsumoto, *Tonkōga*, 604–609; Ma, "Da
suiqiu tuoluoni mantuluo," 552–554.

21. Yang Fa / MG 17689. 1. Paper. 2. 45.2 × 33.7 cm. 3. Block print. 4. Late tenth
century? 5. Eight-armed bodhisattva. 6. Spell in Indic script without names.
7. Printed colophon draws on sūtra, seems to name donor and possibly block
carver, but difficult to read, the (partial?) name Yang Fa 楊法 is visible. 8. No
case. 9. See Matsumoto, *Tonkōga*, 604–609.

22. Ruiguangsi Chinese. 1. Paper. 2. 44 × 36.1 cm. 3. Block print. 4. 1001. 5.
Mahāvairocana. 6. Spell in Chinese script without names; begins with ritual
invocation also found at Dunhuang. 7. Printed colophon contains title of spell
(Amoghavajra version), date, and long list of donor's names. 8. Found in small
pillar inside stūpa. 9. Suzhou shi wenguan hui, "Suzhou shi Ruiguangsi."

23. Ruiguangsi Indic. 1. Paper. 2. 25 × 21.2 cm. 3. Block print. 4. 1005. 5. Tejaprabha
Buddha. 6. Spell in Indic script without names. 7. Printed colophon mentions
monk Xiuzhang 沙門秀璋, who had the sheet made for his parents; also
mentions putting the sheet into pillars. 8. Found in small pillar inside stūpa.
9. Suzhou shi wenguan hui, "Suzhou shi Ruiguangsi."

APPENDIX 2

STEIN NO. 4690: FOUR SPELLS

灌頂印呪: 唵 一 阿蜜㗚 二合 多伐隷二合 嚩囉嚩囉 三 鉢囉鉢囉 四 毗羅毗羅輪提 五 唅唅 六 泮座泮座 七 莎呵.

結界呪: 唵 一 阿蜜㗚 二合多毗盧羯你 二 揭囉婆 重二合X[口*絡]剎尼 上三 阿羯 囉沙 二合 尼 上四 唅唅 五 泮吒泮吒 六 莎呵.

佛心呪: 唵 一 毗麼隷 二 闍耶伐底 丁里反三 阿蜜㗚帝 四 唅唅唅唅 五 泮吒泮吒 泮吒泮吒 六 莎呵 七.

心中心呪: 唵 一 跋 重 囉跋囉二 跋囉三 印地音涅㗚二合耶 四 毘輪達你 五 唅 唅 六 嚕嚧遮隷 七 莎呵.

NOTES

PREFACE: THE BODY INCANTATORY

1. On the importance of these four temples to Tang Esoteric Buddhism, see Chen, "Esoteric Buddhism and Monastic Institutions."
2. Kessler and Sheppard, eds. *Mystics*, vii.
3. There are, of course, scholars who have attended carefully and often brilliantly to the place of spells in medieval Chinese Buddhism. As later chapters of this book will make explicit, my work builds on theirs, especially that of Michel Strickmann, Liu Shufen, Ma Shichang, Li Xiaorong, Kuo Liying, John Kieschnick, and Richard McBride.
4. Wang, "Buddha Seal," 118. See also Copp, "Voice, Dust, Shadow, Stone," 255–270.
5. *Song gaoseng zhuan*, T no. 2061, 50: 714c.
6. Lear, *A Case for Irony*, 10. Lear, drawing here on the works of the philosophers Christine Korsgaard and Robert Brandom, is in the passage quoted describing the nature of "pretense" as discussed in the writings of Søren Kierkegaard.
7. I borrow the language of "domains" from the work of Richard Sennett, who—in a stimulating meditation on the "material consciousness" of the craftsman (an idea very helpful for understanding the nature of ritual practice, itself irreducibly material)—speaks of the nature of shifts among cognitive and bodily domains, an idea he traces originally to Claude Lévi-Strauss's assertion of an intimate connection between, for example, things being "good to eat" and "good to think." "[Lévi-Strauss] means this literally: cooking food begets the idea of heating for other purposes; people who share parts of a cooked deer begin to think they can share parts of a heated house; the abstraction 'he is a warm person' (in the sense of 'sociable') then becomes possible to think. These are domain shifts" (Sennett, *The Craftsman*, 129).
8. Powers, *Pattern and Person*, 3.

9. Ibid., 268 and 17.

10. Ibid., 4, quoting Keightley, "Archaeology and Mentality," 93. Just in passing, we might also consider in this light the famous statement of Marshal McLuhan's that "we shape our tools and afterwards our tools shape us," as well as more radical conceptions such as Adam Gopnik's counter that "contraptions don't change consciousness; contraptions are part of consciousness" ("The Information: How the Internet Gets Inside Us," *New Yorker*, Feb. 14, 2011; http://www.newyorker. com/arts/critics/atlarge/2011/02/14/110214crat_atlarge_gopnik, accessed Feb. 12, 2011).

11. See chapter 2 for an example of a scripture apparently revised in reaction to changes in material practice. I borrow the image of "bundling" from Webb Keane, who writes (for example) of the ways that an American flag's particular bundling of the material and the symbolic causes it to escape doctrinal control— the cotton chosen for the ways it allows a flag to lay smoothly flat also allows it to be burned dramatically. "No one would say that flags are made of cotton in order that they may be burned, but their wholly contingent flammability makes available a potent political symbol. Flammability is bundled together with all the other material characteristics of flags . . . Bundling gives to material things (including linguistic forms) an inherently open-ended character." Keane, "On the Materiality of Religion," 230; see also Keane "The Evidence of the Senses and the Materiality of Religion" for a more in-depth treatment of these ideas.

12. See Waley, *A Catalogue of Paintings Recovered from Tun-Huang*, xiii, for an early assertion of the importance of "Dhāraṇī Buddhism" in China.

13. The Five Dynasties Period is traditionally said to have stretched from 907 to 960 and the Song Dynasty from 960 to 1267.

14. Kieschnick, *The Impact of Buddhism on Chinese Material Culture*, 24–82, and throughout.

15. Ibid., 24; see also page 56, where he discusses all such objects as simply "repositories of sacred power."

16. Strong, *Relics of the Buddha*.

17. Ryūichi Abé has discussed such visions of the nature of words and bodies in Esoteric Buddhist practice using the evocative and helpful phrase, "the physiology of words" (Abé, "Word," 305).

18. *Qianshou qianyan Guanshiyin pusa guangda yuanman wu'ai dabeixin tuoluoni jing*, T no. 1060; vol. 20: 109a. See chapter 3 for a fuller discussion of this passage and its contexts.

19. For example, a dhāraṇī sutra translated by Baosiwei (d. 721), a key figure in the spread of material dhāraṇī practices in the late seventh century, reports that as the Buddha's worlds-illuminating radiance was returning into his body, it proclaimed

itself to be the "Wheel-Turning King One Syllable Mind-Spell of the Wisdom of all Tathāgatas." *Da tuoluoni mofazhong yizi xinzhou jing*, T no. 956, 19: 315c.

20. On this work, see Copp, "Anointing Phrases and Narrative Power."

INTRODUCTION

1. *Mantras* constitute the oldest class of spells in Indic cultures. They were taken into Buddhist practice, along with much else of traditional Indian religious culture, and often conflated with dhāranīs. *Parittas* are Buddhist words of power found in Southeast Asian traditions. *Hṛdaya* and *vidyā* are specialized, and more narrowly contextually based, terms for Buddhist spells in Mahāyāna Buddhism. On mantras, see Abé, *The Weaving of Mantra*, especially 5–6, 12–13, 262–264; Gonda, *History of Ancient Indian Religion*, 248–301; Kapstein, "Scholastic Buddhism and the Mantrayāna"; Padoux, "Mantras—What Are They?"; Staal, "Vedic Mantras"; Wayman, "The Significance of Mantras"; among others. On parittas, see Harvey, "The Dynamics of *Paritta* Chanting in Southern Buddhism"; McDaniel, "Paritta and Rakṣā Texts"; and Skilling, "The Rakṣā Literature of the Śrāvakayāna." On *hṛdaya* as a term for spells, see Lopez, *Elaborations on Emptiness*, 165–186.

2. See Tambiah, *Buddhist Saints of the Forest and the Cult of Amulets*, for a study of the place of amulets in a modern Buddhist culture.

3. This aversion to the "magical" is not limited to modern scholars of Buddhism—practitioners of what has been called "modernist Buddhism" have been similarly averse to spells and ritual. For surveys of the nature of "modern Buddhism," or "Buddhist modernism," see Lopez, *Buddhism and Science*, and McMahan, *The Making of Buddhist Modernism*.

4. Müller and Nanjio, *The Ancient Palm Leaves*, 31–32. John Gager, in his study of curse tablets and binding spells in the ancient world, notes that the tradition of scholarly disrespect for practices such as spells is best seen as stretching back to Lucian's "Lover of Lies" (*Philopsueda*, chapter 10). See Gager, *Curse Tablets and Binding Spells*, 9.

5. Suzuki, *The Lankavatara Sutra*, 223 n.1. To Müller's and Suzuki's characterizations, we might also add that of Charles Luk, who in the preface to his 1966 translation of the *Śūraṅgama Sūtra* explains why he omitted the text's incantation, though it is central to the nature of the text as a whole. "[The] average Western student of Buddhism seems to have little faith in mantras and rituals which should not be published lest they create unnecessary disbelief and confusion and so compromise the beauty of this profound sūtra" (Luk, tr., *The Śūraṅgama Sūtra*, xx).

6. Starn, "A Historian's Brief Guide to New Museum Studies," 84 (cited in Bynum, *Christian Materiality*, 280). See also Bynum, "Perspectives, Connections, and Objects," 78–80.

7. Examples of this trend in recent scholarship on East Asian Buddhism are far too numerous to fully mention here, but any listing must feature, for example, Foulk and Sharf, "On the Ritual Use of Ch'an Portraiture in Medieval China"; " Teiser, *The Scripture on the Ten Kings and Reinventing the Wheel*; Ruppert, *The Jewel in the Ashes*; Sharf, "Prolegomenon to the Study of Japanese Buddhist Icons"; Kieschnick, *The Impact of Buddhism*; Benn, *Burning for the Buddha*; Rambelli, *Buddhist Materiality*; Mollier, *Buddhism and Taoism Face to Face*; Robson, *Power of Place*; and, most broadly, the great tradition of French scholarship on Buddhism, which seems never to have conceived the radical split between doctrinal thought and material culture that has until recently characterized its Anglo-American cousin. See, for example, the works of Demiéville, Pelliot, Soymié, Durt, Drège, Trombert, and Mollier listed in the bibliography. Note that this listing also excludes the work of art historians, who have obviously focused on objects and their practices for much longer than have other scholars.

8. Benn, *Burning for the Buddha*, 202.

9. Gager notes a similar scholarly neglect of the "irrational" or "magical" among scholars of the classical West. "One reason for this persistent neglect stems surely from the potentially harmful character of these small metal tablets . . . the potential harm to the entrenched reputation of classical Greece and Rome, not to mention Judaism and Christianity, as bastions of pure philosophy and true religion" (Gager, *Curse Tablets and Binding Spells*, 3). Similar descriptions of the history of Buddhist Studies might not be far off the mark, as Robson ("Signs of Power") also notes in his discussion of this issue.

10. See Kieschnick, *The Eminent Monk* and McBride, "Dhāraṇī and Spells in Medieval Sinitic Buddhism."

11. See Li Xiaorong, *Dunhuang Mijiao wenxian lungao*, 295ff. for some vivid examples from the eighth century.

12. See chapter 3 for an exploration of this evidence.

13. Williams and Tribe, *Buddhist Thought*, 206.

14. Dhāraṇīs are traditionally said to be variations of Sanskrit words, as are the originals of the Buddhist scriptural texts translated into Chinese. Yet, one commonly encounters statements in Indian texts asserting that the spells are incomprehensible—the language of the "barbarians." Further, as recent research has shown, it is clear that many of the sūtras brought into China were actually in languages other than Sanskrit: probably the language of whatever monk or layman happened to have introduced the text to the Chinese. It seems best to assume, or at least consider the possibility, that the same held true for the dhāraṇīs contained within those texts. The case of spells is more complicated than that of sūtras,

however, as the specific *sounds* of any one spell—originally Sanskrit, at least in inspiration—were said to be of paramount importance and thus, in theory, would likely have been preserved in ways that the merely discursive language of the scriptural narratives were not. The language of origin thus seems an open question: though the theory is clear, prescription and practice are not always as tightly related as the prescribers might hope.

15. See Abé, *Weaving of Mantra*, 166–167 for a discussion of this shift in dhāraṇīs' place within sūtras that understands it to be a feature of a more general shift from "exoteric" to "esoteric" styles. See chapter 4 of this book, as well, for further discussion of these issues.

16. *Yiqie jing yinyi*, T no. 2128, vol. 54: 366c.

17. The characterization of the Chinese transliterations is drawn from Kroll, *Dharma Bell and Dhāraṇī Pillar*, 40.

18. "[By] forgetting to examine the implicit presuppositions behind the operation which consists in deciphering, in seeking the meaning of the words, the 'true' meaning of the words, philologists expose themselves to the risk of projecting into the words they study the philosophy of words which is implied by the very fact of studying words . . . You can see that if the philologist were to reflect on what being a philologist means, he would be obliged to wonder whether the use he makes of language coincides with the use made of it by those who produced it; and whether the gap between linguistic usages and interests does not risk introducing into interpretation an essential bias, one that is far more radical than mere anachronism or any other form of ethnocentric interpretation, since it stems from the activity of interpretation itself." (Bourdieu, *In Other Words*, 97–98; and, more generally, Bourdieu, *Outline of a Theory of Practice*.) See also Lamarre, *Uncovering Heian Japan*, 116–124 (and *passim*), who notes a related danger in unreflexive textual scholarship that seeks to collapse the various "figural registers" of writing into only the verbal.

19. See Yuyama, "An Uṣṇīṣa-Vijayā-Dhāraṇī Text from Nepal," 168, for a discussion of one such "corruption."

20. Padoux, "Mantras—What Are They?," 300.

21. See Benjamin, *Illuminations*, 69–82.

22. Malinowski, *Coral Gardens and Their Magic*, and Tambiah, "The Magical Power of Words," respectively.

23. Wittgenstein, "Remarks on Frazer's *Golden Bough*."

24. Staal, "Vedic Mantras."

25. See, for example, Ibid.; Padoux, "Mantras—What Are They?" and "L'énergie de la parole."

26. Lopez, *Elaborations on Emptiness*, 167.

27. Austin, *How to Do Things with Words*. But see also Bourdieu, *Language and Symbolic Power*, 107–136, for an important critique of Austin for insufficiently emphasizing the role of institutional and other social contexts in his analysis of how words do things.

28. We can also note, again merely in passing, the work of recent philosophers who have taken issue with what they see as the prioritizing of the spoken over the written word in Western cultures, of whom the most famous exemplar is, of course, Derrida, *Grammatology*.

29. The fraught relationship between these terms in the history of scholarship (to say nothing of that between "magic" and "science") is familiar. Another side effect of my use of the words *spell* and *incantation* is that it might seem to imply that this relationship is at work in the history of Chinese religious spell craft. It is not. The presence invoked by these terms is illusory. As noted before, I use the words *incantation* and *spell* because they are good translations of the Chinese word *zhou*, which is one of the terms most commonly used by Chinese to translate the Sanskrit words *dhāraṇī* and *mantra*.

30. For an earlier version of the following discussion, see Copp, "Notes on the Term 'Dhāraṇī.'" See also Davidson, "Studies in Dhāraṇī Literature I," and McBride, "Dhāraṇī and Spells," for detailed discussions of the nature of dhāraṇīs and the term *dhāraṇī*.

31. Though *zhenyan* and *miyan* are often said to have been a translation of *mantra*, it is clear that the terms referred to dhāraṇīs in medieval China as often as they did mantras.

32. A point that will be especially clear in chapter 4.

33. For Chinese Buddhist traditions of spell craft, see Strickmann, *Chinese Magical Medicine*, 89–122; Kieschnick, *The Eminent Monk*, 67–111; and McBride, "Dhāraṇī and Spells."

34. For an early example of *dhāraṇī* as memory we can take the discussion of the "four adornments" of the bodhisattva listed in Dharamarakṣa's (Zhu Fahu; d. 316) translation of the *Great Compassion Sūtra* (*Da ai jing*), the fourth of which is called "the adornment of dhāraṇī (*zongchi zhuangyan*), whereby what is heard is never forgotten" (*suowen buwang*). T no. 398, 13: 416a. Scholarly explorations of mnemonic conceptions of dhāraṇī include those of Braarvig, "Dhāraṇī and Pratibhāna," Gyatso, "Letter Magic," Kapstein, "Scholastic Buddhism and the Mantrayāna," and Nattier, *A Few Good Men*," 291–292, n. 549. For discussions of dhāraṇīs as spells and incantations, see McBride, "Dhāraṇī and Spells," as well as the following chapters of this book.

35. The word usually used here, *chi*, itself often simply means "dhāraṇī" (including in these very contexts) as I will discuss later.

36. Bakhtin, *The Dialogic Imagination*, 64.

37. Nattier, *A Few Good Men*, 291–292, n. 549.

38. Braarvig, "Dhāraṇī and Pratibhāna," 19.

39. Strickmann, *Chinese Magical Medicine*, 103.

40. Kapstein, "Scholastic Buddhism and the Mantrayāna," 237.

41. For a recent extensive study of related matters, see Overbey, "Memory, Rhetoric, and Education in the *Great Lamp of the Dharma Dharani Scripture*."

42. Braarvig, "Dhāraṇī and Pratibhāna," 18.

43. The place of the Bodhisattvabhūmi in medieval Chinese Buddhism has not yet inspired a high level of interest among scholars, though it was clearly among the most often-cited treatises in Chinese exegetical and doctrinal works, and its fourfold rubric for classifying dhāraṇīs was extremely influential in East Asia. The text exists as one section of the *Yogacārabhūmi*, though it circulated independently of that larger work and was so translated into Chinese twice in the fifth century, once (*Pusa dichi jing*; T no. 1581) by Dharmakṣema (Tanwuchen; 385–433), and once (*Pusa shanjie jing*; T no. 1582) by Guṇavarman (Qiunabamo; 367–431). See McBride, "Dhāraṇī and Spells," for a concise discussion of Dharmakṣema's fame as a spell caster, his translation of the *Bodhisattvabhūmi*, as well as the development of that text's fourfold dhāraṇī rubric by Jingying Huiyuan (523–592). For a much longer study of Dharmakṣema, including information about the dating of his translations, see Chen, "The Indian Buddhist Missionary Dharmakṣema," especially p. 258.

44. There are several treatments of these passages in the scholarly literature. Among them, Ryūichi Abé's succinct discussion in his *The Weaving of Mantra* is especially clear (p. 166). His treatment, however, though in many ways excellent, does not sufficiently distinguish among ideas of dhāraṇīs as spells—such as those found in the *Lotus Sūtra*—as "mnemonic device," and as forms of spiritual capacity.

45. Braarvig, "Dhāraṇī and Pratibhāna," 18.

46. *Pusa dichi lun* (T no. 1581, 30: 934a). Braarvig, who translates from a Sanskrit version of the text, has a somewhat different rendering (Ibid., 20).

47. P. 2141; T no. 2803; 85: 951c.

48. Braarvig, "Dhāraṇī and Pratibhāna," 20. We should keep in mind, as Kapstein notes, that in its Sanskrit original this is a difficult passage, and that "not all aspects of its interpretation are entirely secure" (Kapstein, "Scholastic Buddhism and the Mantrayāna," 238). The Chinese version is, however, rather clear.

49. *Pusa dichi lun*, T no. 1581, 30: 934a. Xuanzang's translation of the *Yogacarabhūmi*, *Yuqieshi dilun*, in a parallel passage, has *zhou zhangju*, which amounts to the same thing (T no. 1579, 30: 543a).

50. *Pusa dichi lun*, T no. 1581, vol. 30: 934a.

51. P. 2141; T no. 2803, 85: 952a.

52. P. 2141; T vol. 85: 952c. The connection between dhāraṇīs and this particular form of kṣānti, the patient acceptance of the emptiness of all phenomena, is found in dhāraṇī sūtras as well, though the relationship is not often so explicitly accounted for. For a convenient example, we may take the *Great Vaipulya Dhāraṇī Sūtra* (to use Paul Swanson's translation of the title), the *Da fangdeng tuoluoni jing*, translated by Fazhong (fl. 401–413) very early in the fifth century. In the beginning of the scripture's narrative, as a result of hearing the Buddha speak the names of nineteen dhāraṇīs, the bodhisattvas in the audience come to abide in the "patience [of tolerating the knowledge] that dharmas do not arise"—that is, that they are empty. The lesser beings in attendance achieve accordingly lesser spiritual states upon hearing the names (Swanson, "Dandala, Dhāraṇī, and Denarii," 206–207). Though the bodhisattvas here are not said to engage in the sort of practice described in the *Bodhisattvabhūmi* (though it is possible that "hearing the names" here might have been understood in something like the contemplative sense described in the *Bodhisattvabhūmi*), the two texts create the same parallel relationships between textual dhāraṇīs and this most profound form of kṣānti (though, as will become clear in later chapters, the sūtra is closer in spirit to the later understandings of dhāraṇīs as powerful utterances in that simply hearing the words seems to induce the state described).

53. *Foshuo wuliangmen weimichi jing*, T no. 1011, 19: 681b. The translations of the syllables are highly tentative.

54. Gyatso, "Letter Magic," 191, also provides an especially clear and concise discussion of this issue.

55. *Qing Guanyin jing shu chanyi chao*, T no.1801, 39: 998b. The quotation from the Mahā-Prajñāpāramitā-sūtra is from Kumarajiva's translation (*Mohe bore boluomi jing*, T no. 223, 8: 421b). For another, roughly contemporary, statement, see Zixuan's (965–1038) commentary to the Lengyan jing, the so-called "Pseudo-Śūraṃgama" (on which see more below). "The mystic words of the buddhas [that is, dhāraṇīs], occult teachings that only buddhas and buddhas understand—they are not something that other [lesser] saints are able to penetrate" (*Shoulengyan yishu zhujing*, T no. 1799, 39: 919c).

56. P. 2197 verso.

57. *Da piluzhena chengfo jingshu*, T no. 1796, 39: 579b.

58. *Sūryagarbha vaipulya sūtra* (*Rizang fen*, collected within the larger *Da fangdeng da jijing*), T no. 397, 13: 254b.

59. *Xianjie jing*, T no. 425, 14: 4c-5a. Both the *Anantamukha* and *Bhadrakalpika* scriptures provide examples of the ways dhāraṇī practices, and the ways dhāraṇīs were construed within them, changed over time. In both texts dhāraṇīs begin as simple runs of syllables to be contemplated in the ways discussed in this chapter. In later versions of the texts, in both Chinese and Tibetan translations, the syllables are replaced by dhāraṇīs of the later incantation variety and the nature of their ritual engagements change correspondingly. See Skilling, "An Arapacana Syllabary in the *Bhadrakalpika-Sutra*," for a brief discussion of later Tibetan versions of the *Bhadrakalpika Sūtra*, where the translated syllables of the Dharmarakṣa translation are replaced by the standard arapacana syllabary. The *Anantamukhadhāraṇī Sūtra*, which was translated into Chinese several times over the centuries, provides especially stark examples of this transformation.

60. For works that understand dhāraṇīs as codes of various kinds, see, for example, Buswell, *Cultivating Original Enlightenment*, 271ff; McBride, "Dhāraṇī and Spells," 97, and Davidson, "Studies in Dhāraṇī Literature I"—though Davidson's use of the term seems quite different from Buswell's or McBride's.

61. See below for a discussion of the *Treatise on the Great Perfection of Wisdom*.

62. *Dazhidu lun*, T no. 1509, 25: 408a-b.

63. *Mohe bore boluomi jing*, T no. 223, 8: 256a; *Dazhidu lun*, T no. 1509, 25: 407c.

64. *Dazhidu lun*, T no. 1509, 25: 408b.

65. *Dazhidu lun*, T no. 1509, 25: 408a. As an aside, it seems likely that we should add this passage to those that Matthew Kapstein has highlighted as having "smoothed the way for and presaged the development of" later Mantrayāna, or even "full-blown Vajrayāna," conceptions, in that we seem to have here, in these assertions about the ultimate meaningfulness of the syllable "a," something very close to those later notions of the inconceivable and inconceivably pregnant sounds and sigils that make up mantras and dhāraṇīs. See Kapstein, "Scholastic Buddhism and the Mantrayāna."

66. Or, as Chou Po-kan has recently argued, by Sengrui, his editor and student (Chou, "The Problem of the Authorship of the *Mahāprajñāpāramito-padeśa*").

67. The canonical status of his work has more recently been affirmed in Michel Strickmann's own deeply learned study, *Mantras et mandarins: le bouddhisme tantrique en chine*, which relies heavily on Lamotte's discussion in its own introduction of the nature of dhāraṇīs.

68. *Dazhidu lun*, T no. 1509, 25: 95c. Cf. Lamotte, tr., *Le Traité de la grande vertu du sagesse* 1:317. In the translation that follows I have consulted Lamotte's translation, especially in the case of difficult passages, but the translation is my own.

69. Translation adapted from Lamotte: "*Elle est contenue dans un élément (dhātu), une base de la connaisance (āyatana), et un agrégat (skandha).*"

70. *Dazhidu lun*, T no. 1509, 25: 95c.

71. The Song, Yuan, and Ming versions of the text do not have this line, which has *tuolinni* for "dhāraṇī."

72. The distinction here seems to be between bodhisattvas and bodhisattva-mahāsattvas, who are characterized by dhāraṇī, samādhi, and kṣānti. The former have not yet attained these powers.

73. I follow Lamotte's lead on where to end the quotation.

74. Lamotte (321), no doubt wisely, does not translate the names of these dhāraṇī. My translations are highly provisional.

75. Lamotte (321) omits the character "revolutions" (*xuan*).

76. *Dazhidu lun*, T no. 1509, 25: 95c–96c.

77. Ṛṣi, in the Sanskrit.

78. *Dazhidu lun*, T no. 1509, 25: 97c.

79. On chi as term indicating the "wielding" of texts, see Gimello, "Icon and Incantation," 225–256.

80. For a succinct discussion of this term, see Teiser, *The Scripture on the Ten Kings*, 140–141, including note 6.

81. P. 2807, collected in XB vol. 17, p. 11571. For a recent study that at least in part carries forward the work begun here (and makes explicit reference to its earlier version in Copp, "Notes on the Term 'Dhāraṇī'"), see Eubanks, *Miracles of Book and Body*, 50 (and *passim*).

82. *Song Gaoseng zhuan*, T no. 2061, 50: 714c.

83. See, for example, the text on the Dunhuang manuscript P. 2094, *Chisong Jin'gang jing lingyan gongde ji*, which, in praising the power of the popular incantation "a-ra-pa-ca-na," proclaims: "when someone chants these real words with a perfect mind it is as if he had chanted all the scriptures stored in the world one time." T no. 2743, 85: 160a.

84. *Boreboluomiduo xinjing*, T no. 251, 8: 848.

85. For a discussion of terms such as "one mind" and "mind ground" in Tang Buddhism, see Gregory, *Tsung-Mi and the Sinification of Buddhism*.

86. T no. 251, 8: 848c.

87. Davidson, "Studies in Dhāraṇī Literature I"—the state-of-the-art study of dhāraṇīs in Indic Buddhist literature—comes to a conclusion about the nature of dhāraṇīs similar to the one I have given here (and in Copp, "Notes on the Term 'Dhāraṇī'"), though one expressed in the language of "codes," specifically the kind represented by the nearly infinitely capacious DNA encodings of life. I find this a provocative and in many ways powerfully apt analogy, though simply as a

matter of method I prefer to try to account for traditional Chinese-language discussions of dhāraṇīs and their practice as much as possible in their own terms; thus my use of the imagery of "grasp" and "hold" (and to a lesser extent the rhetorical figure of synecdoche), which I take to be a literal translation of *chi*, the basic linguistic image employed in this literature.

I. SCRIPTURE, RELIC, TALISMAN, SPELL

1. Lopez, *Elaborations on Emptiness*, 167.

2. As well as a range of historical contingencies that are now largely irrecoverable. I do not mean to discount the role of "extra-religious" history in the history of material incantation practice (and the reader will find some attention to it in the following chapters), but this is at its heart a study of ritual logic and I will keep my attention focused there.

3. Their original Indic versions likely date to the sixth century, as Gergely Hidas argues was the case for the early version of the *Scripture of the Incantation of Wish Fulfillment*, the *Mahāpratisarā Mahāvidyārājñī* (see Hidas, "Mahāpratisarā-Mahāvidyārājñī, The Great Amulet, Great Queen of Spells," 17).

4. That is, it seems likely that the full-blown versions of ideas and practices exemplified in such texts reflect a relatively late stage in their development. Ritual improvisations, conversations, lost drafts of scriptures, and the other milieu of their earlier forms would no doubt have existed for some time before a sūtra was composed.

5. Ma Shichang has proposed a different set of rubrics in which to understand this range of practices—recitation, wearing, and devotion (Ma, "Da suiqiu tuoluoni mantuluo tuxiang de chubu kaocha," 556).

6. As noted in the introduction, the early third-century translation of the *Anantamukha dhāraṇī sūtra* calls for the writing of syllables as part of a contemplative dhāraṇī practice that, as I see it, bears little relation to what I construe here to be the writing down of spells. I do not count such practices here.

7. *Qifo bapusa suoshuo da tuoluoni shenzhou jing*, T no. 1332; vol. 21: 536b–561b.

8. A possible exception is the final occurrence in the text, in a moment within a ritual enchanting of water—a singularly strange rite even within dhāraṇī literature—where one is enjoined to "enchant the water seven times and write [the spell?] in the opening [of the water bottle?]," as part of the ritual setup (T 21: 560b).

9. For the origins of this now-long-pervasive notion see Schopen, "The Phrase 'sa pṛthivīpradeśaś caityabhūto bhavet' in the Vajracchedikā."

10. Conze, *The Perfection of Wisdom in Eight Thousand Lines and its Verse Summary*, 104–106.

11. *Qifo bapusa suoshuo da tuoluoni shenzhou jing*, T 21: 538b. The "evil paths" are those that lead to birth as an animal, a hungry ghost, or a dweller in a Buddhist hell.

12. See, for example, T 21: 540a.

13. *Beihua jing*, T no. 157, vol. 3: 167–233.

14. *Henghe sha*. That is, the Ganges.

15. "Supreme, correct, awakening," a standard term for the perfect awakening of a buddha, here in its usual Chinese transliteration.

16. Harrison, "Is the *Dharma-kāya* the Real 'Phantom Body' of the Buddha?" 76.

17. *Pratyutpanna Sūtra* (*Banzhou sanmei jing*); T no. 418, vol. 13: 911b; translated in Harrison, tr. *The Pratyutpanna Samādhi Sutra*.

18. A notable exception to this fact, though one probably unique in its particulars, is the 1117 burial of nearly the entire Chinese Buddhist canon inscribed on stone tablets beneath a stupa. Though the immediate reason for this act was not "religious" but simply the fear that the stones would be lost in the chaos attending the imminent fall of the Liao Dynasty, the inclusion of the stupa makes it at least an outlying example of text relic. On this event and its aftermath see Ledderose, "Carving Sutras into Stone Before the Catastrophe."

19. It is important to note that the texts seem to have been called relics only after they were placed inside the stūpa—the basic architectural marker of the Buddha's body.

20. *Da Tang Xiyu ji* (T no. 2087, vol. 51: 920a). See *Fahua chuanji* (T no. 2068, vol. 51: 92a-b) for another brief account of the use of dharma relics in the "western lands."

21. Translation from Boucher, "The *Pratītyasamutpādagāthā*," 11.

22. Ibid., 6.

23. Skilling, "Traces of the Dharma."

24. Liebenthal, "Sanskrit Inscriptions from Yunnan I," 2. Liebenthal describes bricks from the inside of a Yunnan stūpa inscribed (in Brāhmī, a script he states was normally reserved for dhāraṇīs) with both the *ye dharmā* and dhāraṇīs (Ibid., 31–34, 36).

25. Schopen 1997b, 120–121 (original article published in 1987).

26. Bentor, "On the Indian Origins of the Tibetan Practice of Depositing Relics and Dhāraṇīs in Stūpas and Images," 252ff. This article provides a convenient overview of these issues in Tibetan and South Asian contexts. Curiously, given the popularity of this practice, it seems that spells were only rarely referred to as dharma relics in other ritual contexts. The only example I have found is from Cixian's (Liao Dynasty, 907–1125) version of the *Miaojixiang pingdeng guanmen dajiaowang jing lüe chu humo yi*, which states that one should "recite with a focused mind this dharma relic mantra (*zhenyan*) while burning objects" on the *homa* pyre (T no. 1194, vol. 20: 935c). The nature of the practice determines the nature of its objects, it would seem.

27. The use of dhāraṇīs did not entirely replace the "Verse on Dependent Origination," at least within later scriptural accounts known in China. Both the "Sūtra Preached by the Buddha on the Merits of Constructing Stūpas" (*Foshuo zaota gongde jing*, T no. 699), translated in 680, and the "Sūtra on the Merits of Bathing the Buddha" (*Yufo gongde jing*, T no. 698), translated by Yijing early in the eighth century, contain the injunction to employ this verse.

28. T no. 967, vol. 19: 351b.

29. T no 967, vol. 19: 351b. For an extensive and excellent discussion of the ideas and practices of "complete body relics," as well as of reliquary practices in premodern Chinese and Korean Buddhism in general, see Seunghye Lee, "Arts of Enshrining."

30. For the new identification of cave 217, see Shimono, *Tonko Bakukōkutsu dai niyakujūnana kutsu minamiheki kyōhen no shin kaishaku*. Wang Huimin, building on her work, has pushed the identification farther and extended it to other caves, including no. 33.

31. See below for a discussion of the metaphor of seals in dhāraṇī practice.

32. *Putichang zhuangyan tuoluoni jing*, T no. 1008, vol. 19: 672c.

33. Barrett, "Stūpa, Sūtra, and Sarīra in China," 51–58, and Chen Jinhua, "Śarīra and Scepter," 103–116.

34. Barrett, "Stūpa, Sūtra, and Sarīra in China," 51–58; Antonino Forte, as cited in Chen, "Śarīra and Scepter," 115.

35. Campany, "Notes on the Devotional Uses and Symbolic Function of Sūtra Texts."

36. Ibid., 44.

37. Here again it is important to emphasize the ideal-typical nature of the analyses of practical logics I present in this book. Relics can be (and were and are) sometimes worn as amulets in Buddhist Asia, as well, following modes of practice other than those I explore here. For a vivid example, see Stein Painting no. 247 (figure 2.19) an incantation amulet that names its spell *śarīra-gāthā* (*sheli zhi qieta*): "reliquary verses." In addition, the specific material placement of a spell in a stupa must be carefully attended: the work of Seunghye Lee, for example, makes clear that not every dhāraṇī in a stupa or pagoda functioned simply as a relic; incantations were at times sited in positions clearly ancillary to the relics, some of which were also in the forms of spells. (See Lee, "Arts of Enshrining"). The ideal types laid out in the first half of this chapter provide analytical tools, not rigid practical rules.

38. For a later example of the earlier material styles, see for example, the *Qianshou qianyan Guanshiyin pusa guangda yuanman wu'ai da beixin tuoluoni jing*, T no. 1060, vol. 20:109a. See also next.

254 I. SCRIPTURE, RELIC, TALISMAN, SPELL

39. On *fu*, see Seidel, "Imperial Treasures and Taoist Sacraments"; Despeux, "Talismans and Diagrams"; Liu Xiaoming, *Zhongguo fuzhou wenhua daguan*; Mollier, "Talismans"; and Wang Yucheng, *Tang Song Daojiao mi zuanwen shili*; among many others. On Buddhist *fu*, see Mollier, *Buddhism and Taoism* and Robson, "Signs of Power."

40. Mollier, *Buddhism and Taoism*.

41. On which see Ibid. and Robson, "Signs of Power."

42. Brown, *The Cult of the Saints*, 13–22, especially 17ff. Brown credits David Hume for the original insight. For a discussion of the question of "popular religion" in China, as well as a useful overview of the problematic in the study of European history, see Bell, "Religion and Chinese Culture." Teiser, "Popular Religion," offers a critical analysis of both the rubric itself and its recent history in the field of the study of Chinese religions. But see also Lancaster, "Elite and Folk," especially 88, who defends the model.

43. Sørensen, "Michel Strickmann on Magical Medicine in Medieval China and Elsewhere." I am grateful to Dr. Sørensen for his comments on this section (and others in the book) and for encouraging me to keep it in the chapter. This section is also intended as a response to an early anonymous reviewer of the book for the press who voiced concerns related to those raised in Sørensen's essay.

44. Ibid., 323.

45. Ibid., 323.

46. As Robert Sharf has argued, "Our identification of a text, doctrine, image, or rite as Indian or Chinese, Buddhist or Taoist, Tantric or Ch'an orients our approach to the material, predisposing us to one set of readings while foreclosing others. It behooves us to reflect on the premises and entailments of such identifications" (Sharf, *Coming to Terms with Chinese Buddhism*, 21; and see the entire discussion, 21–25).

47. For extensive explorations of the ways Buddhists and Daoists used the same tales, see Mollier, *Buddhism and Taoism*, and Robson, *Power of Place*.

48. As we have seen, other much less descriptive (and evocative) terms also appear, such as "to secure" (*an*) and "to tie" (*xi*).

49. *Liji* 13: 563.

50. *Shishuo xinyu* 2. Translation by Richard Mather, from Liu Yiqing, 30–31.

51. Ibid., 31.

52. *Hanyu dacidian* 1:1341, citing lines from the works of the Tang poets Wang Wei and Wei Zhuang.

53. See Seidel, "Imperial Treasures and Taoist Sacraments," on this subject.

54. Liu Zhaorui, *Kaogu faxian yu zaoqi Daojiao yanjiu*, 135–138. See also the seminal work of Michel Strickmann on religious seals in China contained in Strickmann, *Chinese Magical Medicine*.

55. In addition to Liu Zhaorui's and Michel Strickmann's works noted earlier, see Wang Yucheng, *Daojiao fayin lingpai tan'ao*; Li Yuanguo, *Daojiao fayin mizang*; and various works of Xiao Dengfu, including *Daojia Daojiao yingxiangxia de Fojiao jingji*. I am, further, preparing a separate study of the pervasive and structuring place of seals in Chinese Buddhism that focuses on archeological and tale evidence.

56. For works that take the amulets in one form or another to have been Chinese additions, see Ma, *Da suiqiu tuoluoni mantuluo tuxiang de chubu kaocha*, 530; Xiao, *Daojia Daojiao yingxiangxia de Fojiao jingji*, 773; and Xiao, *Daojiao shuyi yu mijiao dianji*, 194–195.

57. *Yiqie jing yinyi*, T no. 2128, vol. 54: 553b.

58. *Zhenyuan xinding shijiao mulu*, T no. 2157, vol. 55: 1010a.

59. *Yiqie jing yinyi*, T no. 2128, vol. 54: 404a.

60. Harper, *Early Chinese Medical Literature*, 167. Such techniques were not limited to amuletic practices—Harper (Ibid., 166ff) surveys a wide range of other practices. See also Sivin, "Ailment and Cure in Traditional China," 36ff. and Yu, *Shendao renxin*, 330–332.

61. Birrell, *The Classic of Mountains and Seas*, 3.

62. See Campany, *To Live as Long as Heaven and Earth*, 27, on *zhi* in Chinese religious writings. Campany makes clear that the term refers not to fungi (as is often assumed), but, "redolent of the numinous," it is more basically a "generic word for protrusions or emanations from rocks, trees, herbs, fleshy animals, or fungi."

63. *Baopuzi neipian jiaoshi* 11: 199.

64. *Baopuzi neipian jiaoshi* 17: 304.

65. Schafer, "Orpiment and Realgar in Chinese Technology and Tradition," 80–85, and Obringer, *L'Aconit et L'Orpiment*, 65–90.

66. For a color plate of the object, see Shōsōin Jimusho, *Shōsōin hōmotsu*, 16 (see also pp. 104 and 215 of that work).

67. Schafer, "Orpiment and Realgar," 84.

68. *Ishinpō* 26: 610b. The text refers to Sun's text simply as the "Qianjin fang." On this passage, see Sivin, "Ailment and Cure," 37.

69. Pregadio, *Great Clarity*, 129. In a related matter, Yu Xin, in his study of "livelihood religions" (*minsheng zongjiao*) in Tang-Song Dunhuang, notes evidence for the wearing, or carrying, of sticks of peach wood in almanacs discovered at Mogao, a practice he relates to the ancient belief that arrows of peach wood were effective weapons against certain demons. Yu speculates, in fact, that the carrying of

peach wood mentioned in his text (p. 2661) indicates the carrying of such arrows in case they are needed, not the treating of the wood as itself effective (Yu, *Shendao renxin*, 332). Though Yu's suggestion here is not fully convincing—for example, the use of demonifugal peach wood idols is found from the early period (Harper, *Early Chinese Medical Literature*, 169–170)—the caution in reading the texts he urges is well taken.

70. *Guanzizai pusa suixin zhou jing*, T no. 1103a, vol. 20: 462a. On Zhitong, see chapter four. Given that the phrase *suixin* is parallel with other phrases used to translate Indic words for amulets or other talismanic objects—*ruyi* rendering *maṇi* and *suiqiu* translating (as we will see in the next chapter) *pratisara*—it seems very likely that it also translated a word for amulets, a possibility of course made more likely given the contents of the text.

71. *Guangda bao louge shanzhu mimi tuoluoni jing*, T no. 1006, vol. 19: 641b.

72. *Guanshiyin pusa mimizang ruyilun tuoluoni shenzhou jing*, T no. 1082, vol. 20: 198c. See, as well, the Jñānagupta, Xuanzang, and Bodhiruci versions of the *Amoghapaśa Dhāraṇī Sūtra*, which contain similar recommendations (taking the first as representative, see T no. 1093, vol. 20: 401c). In keeping with the caution urged by Yu Xin in his study of the carrying of peach wood effective (Yu, *Shendao renxin*, 332), it is important to point out here that not every instance of the prescribed carrying of potent substances in Buddhist texts describes an amuletic practice. The *Tuoluoni jijing*, for example, recommends that such drugs be carried on the person not as periapts, but so that they will be ready to hand if needed (T no. 901, vol. 18: 858a-b). As well, the *Dharmaguptaka Vinaya* allows that if a monk is sick he is permitted to fit a container ("of bone, ivory, horn, iron, copper, wax, lead, or wood") filled with smoking herbal preparations into a small sack to be worn from his arm. The Buddha makes clear, however, that such a rig is only allowed if the monk is too weak to hold the container in his hands (*Sifen lü*, T no. 1428, vol. 20: 877a).

73. *Baopuzi neipian jiaoshi* 19: 336. Translation Pregadio, *Great Clarity*, 126–127.

74. *Foshuo guanding qiwan erqian shenwang hu biqiu zhoujing*; T no. 1331, vol. 21: 501a.

75. T 21: 501b.

76. As Sivin has noted, "The secret names of gods themselves served as charms, as in the *Divine Treasure Canon*, *Ling-pao ching*; so could a list of drugs" (Sivin, "Ailment and Cure," 31). He cites Kaltenmark 1960 and Schipper 1965. Another apparently related practice was the simple holding of certain words in the palm of one's hand as talismans. See Yu Xin, *Shendao renxin*, 335.

77. T 21: 502b. A version of this passage is quoted in *Fayuan zhulin*; T no. 2122, vol. 53: 925b.

78. *Bukong juansuo shenbian zhenyan jing*; T no. 1092, vol. 20: 232a. On earlier translations of this scripture and their importance in the development of the use of incantation cords, see above.

79. *Guangda bao louge shanzhu mimi tuoluoni jing*; T no. 1006, 19: 639a. The earlier, sixth-century translation of the text, the *Moli mantuoluo zhou jing*, contains one of the earliest injunctions to "hold the spell on your body or your clothes"; see T no. 1007, vol. 19: 658b. As so often with these texts, there is also a later and more elaborate version by Bukong; see T no. 1005.

80. *Yizi foding lunwang jing*; T no. 951, vol. 19: 226b. See also Bodhiruci's translation of the *Wu foding sanmei tuoluoni jing*; T no. 952, vol. 19: 264b.

81. *Wugou jin'guang da tuoluoni jing*; T no. 1024, vol. 19: 721a.

82. The practice of wearing images is much less well attested. In fact, the only clear account I have found so far is a brief tale of the great Song literatus Su Shi (1037–1101) included in the Ming collection *Collected [Accounts] of Departed Births* (*Wangsheng ji*), an anthology of Pure Land devotional tales compiled by Zhuhong (1535–1615). Since the anecdote dates from around the turn of the seventeenth century, it can hardly be taken to reflect Su Shi's actual practice, to say nothing of those of earlier centuries, but its resemblance to spell wearing makes it at least worth mentioning here. Su Shi, in the days of his exile in the south, painted an image of Maitreya and wore it when he walked about. When people would ask him about it he replied that it was an offering in honor of his deceased mother. He said he'd had her jewelry made into a "foreign-style monk's staff" (*huxi*) and painted the image to generate merit for her rebirth in a pure land (*yi jian wangsheng*). (See *Wangsheng ji*, T no. 2072, vol. 51: 141a.) No reason is given for why he chose to wear the image, but it seems reasonable to think about the tale within the context of the wearing of spells, seals, and talismans. Other instances mainly come from early collections of "miracle tales," including tales of people wearing small metallic images of Guanyin in their long hair (*dai jingfa zhong*) apparently as markers of their Buddhist faith (though in one case the main event of the tale comes when the statuette turns an executioner's blade). See *Guanshiyin yingyan ji*, 85, 105, et al. An especially interesting example exists as a fragment of the lost *Xuanyan ji* quoted in Falin's (572–640) *Bianzheng lun*, tells of a man named Fofo, said to have been "a buddha among men," who wore an image of the Buddha on his back, which forced monks to worship at his back. The man was struck down by lightning while traveling. After he was buried, his coffin was struck by lightning as well and his corpse tumbled out. On his back were the words "vicious and without the Dao" (*xiongnüe wudao*). T no. 2110, vol. 52: 540a.

83. Contained in Sengyou's (445–518) *Hongming ji*, T no. 2102, vol. 52: 48c–49a.

84. *Hongming ji*, T no. 2102, vol. 52: 48c.

85. For this characterization of the text, see Lai, "The Earliest Folk Buddhist Religion in China." The foundational study of the scripture remains Makita, *Gikyō kenkyū*, 148–211, who based his work on the Dunhuang fragments, P. 3732 and S. 2051. For another discussion of this passage and its relevance for an understanding of Buddhist talismans, see Robson, "Signs of Power," 140, who notes that this particular passage from the sūtra is only evidenced by Zhiyi's quotation of it. The fact that Zhiyi's quotations in the two texts do not seem to match each other suggest that he may have exercised an active editorial hand in his use of the work.

86. On the "teachings of men and gods" in the context of Huayan doctrines, see Gregory, "The Teaching of Men and Gods."

87. *Miaofa lianhua jing xuanyi*, T no. 1716, vol. 33: 804a.

88. T 33: 806b.

89. *Jin guangming jing wenju*, T no. 1785: 50c15

90. *Miaofa lianhua jing xuanyi*, T no. 1716, vol. 33: 804a.

91. *Longshu wuming lun*, T no. 1420, vol. 21: 957b-958b. The text is not mentioned in any medieval catalog and is evidenced only by a single manuscript copy held in the Ishiyama-dera in Japan (which was copied into T). Strickmann's treatment of the text (Strickmann, *Chinese Magical Medicine*, 170–178) appears in part to have been based on Osabe, *Tō Sō Mikkyō shi ronkō*, 234–247. For more recent studies, see Robson, "Signs of Power," 147–149, and Young, "Conceiving the Indian Patriarchs in China," 287–292. Young suggests convincingly that at least in its present form the text was likely a product of the seventh century (though Strickmann places it in the sixth).

92. On this idea, see also Sivin, "Ailment and Cure," 31; and Pregadio, *Great Clarity*, 129.

93. For studies of *fu* in Chinese Buddhism, see Robson, "Signs of Power," and Mollier, *Buddhism and Taoism*.

94. The best study of this manuscript is now Yu Xin, "Personal Fate and the Planets," but see also Stein, *Serindia*, 2:1080; Waley, *A Catalogue of Paintings Recovered from Tun-Huang*, 164; Whitfield and Farrer, *Caves of the Thousand Buddhas*, 83; Mollier, "Talismans," 409; and Robson, "Signs of Power," 155–158.

95. On this point I am in agreement with Mollier ("Talismans," 409) and Robson ("Signs of Power," 158).

96. For the identification of the first figure as Mercury, rather than the Pole Star (as has become common in scholarship on the talisman), see Yu Xin, "Personal Fate and the Planets."

97. For another talisman explicitly drawing on dhāraṇī lore—here one to be inscribed on a seal and worn—see the eighth seal model included among the set on p. 3874,

and Wang Yucheng's transcription and discussion of it (Wang, *Daojiao fayin lingpai tan'ao*, 46–53).

98. See, for example, Sørensen, "Michel Strickmann on Magical Medicine" (though note that he does not question the "Chineseness" of such practices).

99. Mollier, *Buddhism and Taoism*, 209.

100. See Sharf, *Coming to Terms with Chinese Buddhism*, 2.

2. AMULETS OF THE INCANTATION OF WISH FULFILLMENT

1. I follow Katherine Tsiang in taking *fang* to have indicated, most probably, an artisanal workshop rather than a section of the city (Tsiang, "Buddhist Printed Images and Texts of the Eight–Tenth Centuries").

2. Feng, "Ji Tang yinben tuoluoni jingzhou de faxian," 50. The last phrase is not legible in the photograph provided in the archeological report; I follow Feng's description. Existing photographs of the amulet are unclear, but one can consult the example reproduced as plate 7c in Su, *Tang Song shiqi de diaoban yin shua*.

3. Feng, "Ji Tang yinben tuoluoni," 50.

4. This xylograph is by far the most studied and published example of a *Mahāpratisarā* amulet. See, for example, Whitfield, *The Art of Central Asia*, v. 2, fig. 151; Matsumoto, *Tonkōga no kenkyū*, 604–609; Ma, "Da suiqiu tuoluoni mantuluo," 550–552; Fraser, *Performing the Visual*, 155–158; and Tsiang, "Buddhist Printed Images and Texts," 218–219.

5. *Shouchi*. On this term see the introduction.

6. The text paraphrased is the Baosiwei translation, *Foshuo suiqiu jide dazizai tuoluoni shenzhou jing*, T no. 1154, on which see below. See chapter 1 and below for discussions of the relevant features of amulet culture in China and elsewhere in Asia.

7. *Monier-Williams Sanskrit-English Dictionary*. See also Hidas, "Mahāpratisarā-Mahāvidyārājñī, The Great Amulet, Great Queen of Spells," 18ff.

8. Bühnemann, "Buddhist Deities and Mantras in the Hindu Tantras II," 34.

9. See Hidas, "Mahāpratisarā-Mahāvidyārājñī, The Great Amulet, Great Queen of Spells," for the translation of *Mahāpratisarā* as "the Great Amulet."

10. Note that the drawing of the pelvis seems to indicate that the wearer was male, though since the drawing was made long after the discovery of the tomb, we should be cautious in interpreting its details.

11. *Foshuo suiqiu jide dazizai tuoluoni shenzhou jing* (*Mahāpratisarā-dhāraṇī-sūtra*), T no. 1154. Though, following Hidas, "Mahāpratisarā-Mahāvidyārājñī," and following the basic meaning of "*pratisara*" itself, I take seriously the fact that "*suiqiu*" in part referred specifically to amulets and not more generally to "wish fulfillment." Indeed, we find structurally similar translations—*ruyi* most prominently—as

renderings for amulets or talismans, *maṇi* in the case given. However, given that *suiqiu* was, in the present case, a shortened form of the phrase "*suiqiu jide*," "what is wished for is immediately achieved," I translate it in general as "wish fulfillment" and not as "amulet."

12. On Maṇicintana, see Forte, "The Activities in China of the Tantric Master Manicintana."

13. On the importance of her reign in the history of dhāraṇī practice, see the following chapter, and especially Barrett, *The Woman Who Discovered Printing*.

14. *Dafangguang pusazang jing zhong Wenshushili genben yizi tuoluoni jing*, T no. 1181. See Forte, "The Activities in China of the Tantric Master Manicintana," for a discussion of the translations of these texts. On incantation cords and their relationship to the amulets, see below.

15. In addition to Amoghavajra's text, Vajrabodhi is said to have made his own translation because he found the Maṇicintana version lacking. See *Song gaoseng zhuan*, 712a; *Kaiyuan shijiao lu*, 571c; and *Yiqie jing yinyi*, 553a. The latter text glosses two terms in Vajrabodhi's work. Since neither appears in the received edition of Amoghavajra's text, Vajrabodhi's would indeed seem to have been a third version. See Hidas, ""Mahāpratisarā-Mahāvidyārājñī," for a translation of a Sanskrit version that seems close to Amoghavajra's. More generally, comparison of the Chinese versions with Hidas's work makes clear the great extent to which different versions of the scripture differed from one another, and were perhaps local improvisations around a core of amuletic instructions and tales—though this last possibility awaits a broader systematic study of all extant versions.

16. For an overview of the nature of dhāraṇī scriptures, see Copp, "Dhāraṇī Scriptures."

17. Reflecting the conventions of Esoteric scriptures, the Amoghavajra translation situates its opening scene at "the summit of Great Vajra-Sumeru (*da Jin'gang xumilu feng*, T no. 1153, vol. 20: 616a), a fact reflected in the later Sanskrit version studied by Hidas, which situates the Buddha at the peak of "Mt. Vajrameru" (Hidas, "Mahāpratisarā-Mahāvidyārājñī," 184).

18. T 20: 637b.

19. See Skilling, "The Rakṣā Literature of the Śrāvakayāna," which makes clear, as well, that protection and reassurance was one of the main concerns of Buddhist iconography from its earliest stage. See also Granoff, "Maitreya's Jewelled World," for a discussion of the central place of the "concern for protecting its believers" (p. 181) in Buddhist (and Hindu and Jain) traditions and the ways that demonic predators were transformed into guardians of Buddhism and its adherents, a

feature important in the *Scripture of the Incantation of Wish Fulfillment* and in dhāraṇī traditions in general.

20. In terms of dhāraṇī books and their Daoist counterparts during this period, Michel Strickmann's work is most helpful. Nearly his entire corpus bears on the subject, but see especially Strickmann, *Mantras et mandarins* and *Chinese Magical Medicine*. For Fangshan, see the forthcoming study by Lothar Ledderose, a taste of which is available in Ledderose's aptly titled "Carving Sutras into Stone before the Catastrophe." It is important to note, however, that *mofa* belief in China was not limited to the early medieval period—it made a strong return in the Liao Dynasty (907–1125), for example.

21. For the early Indian history of anti-demonic magic as seen in the Atharva-veda, see N. P. Ahuja, "Changing Gods, Enduring Rituals." For the early Chinese situation, see Harper, *Early Chinese Medical Literature* and "Warring States Natural Philosophy and Occult Thought," and Seidel, "Imperial Treasures and Taoist Sacraments," as well as the discussion in chapter 1 of this book.

22. Hidas, "Mahāpratisarā-Mahāvidyārājñī," 18. Pratapaditya Pal, in a discussion of the amulet cords and boxes represented on Gandhāran bodhisattva statues (which he believes would have carried dhāraṇīs) notes that, in addition to the *Atharva-Veda*, the use of the Sanskrit word *pratisarā* (or the Prakrit *paḍisarā*) for amulets is found in the play *Pratijñā-Yaugandharāyaṇa*, by the probably early fourth-century poet Bhāsa (Pal, "Reflections on the Gandhāra Bodhisattva Images," 101–102, 113 n. 7).

23. Material traces of the other sorts of amulet practices prescribed in the text have not survived, at least as clearly, a situation due in part simply to the fact that tombs preserve their contents, and provide contexts for them, in ways that little else that remains from the medieval period does. We cannot, thus, assume that non-mortuary practices of the *Incantation of Wish Fulfillment* were less popular based only on those amulets that have survived.

24. As noted above, in this section I will sample a few of the most important passages in the sutra, with only minimal commentary, in order to present some of the discursive background for the study of the amulets the text prescribes that will follow.

25. T 20: 637b-c.

26. On this point, as on others, the Maṇicintana and Amoghavajra texts diverge. The Amoghavajra text does, in fact, start off with recitation. This feature of the text, like many others in scriptural translations attributed to Amoghavajra, seems an aspect of the increasing absorption of dhāraṇī practice into the conventions of

the Esoteric Buddhist programs he propounded, in large part those associated with the *Sarvatathāgatatattvasaṃgraha*.

27. T 20:.

28. The word used here, *shi*, can also refer to the penis. Thus, given that the spell confers the power to create only (or mostly) males, "masculine power" might be a more fitting translation here. But since the passage also emphasizes the powers of persuasion and personal security (for her and for her fetus) conferred by the spell, I give its more usual sense.

29. T 20: 637c-638a.

30. Possibly referring to one of the forms of Maheśvara.

31. T 20: 641a-b.

32. This would seem to be a function of the fact that, as I will explore below, the amulet itself is an altar of the iconic variety.

33. For the purposes of this chapter, I will split my presentation of the sutra into two parts, the first outlining its descriptions of how to wear the spell and the other, given later in the chapter, its accounts of how to write it and draw its accompanying imagery.

34. T 20: 640b-c.

35. T 20: 638a.

36. *Miaofa lianhua jing*, T no. 262, vol. 9: 2a.

37. T 20: 640b.

38. T 20: 641b-c.

39. T 20: 640b. The king's martial practice finds a striking parallel in the Chinese historical record. As J. J. M. De Groot mentioned in an 1891 article, the emperor Xiaowu (510–535, r. 532–535), the final ruler of the Northern Wei Dynasty, is reported to have had within his retinue the monk Huizhen (d.u.) who, it was said, "bore a seal on his back (*fuxi*) and wielded a thousand-ox blade (*qianniu dao*)." See De Groot, "Militant Spirit of the Buddhist Clergy in China," 128. My translation follows the passage contained in juan 156 of the *Zizhi tongjian*, which appears to be the earliest extant version of the anecdote. De Groot cites juan 29 of the seventeenth-century *Rizhi lu* by Gu Yanwu (1613–1682). A *thousand-ox blade* was a term for a sharp blade wielded with consummate skill. It originated in the *Zhuangzi* story of Cook Ding, who employed his knife with such skill that though he carved thousands of oxen it never grew dull. It is, short of further information, impossible to determine if the seal noted in the anecdote was simply a display of allegiance to his sovereign—*xi* typically referring to imperial seals—or a religious practice in line with that of the *Incantation of Wish Fulfillment*.

40. T 20: 640b. See below for the important implications of the likening of dhāraṇīs to seals.

41. Hidas notes that the later Sanskrit version of the *Mahāpratisarā* scripture often mentions cognitive engagement with the spell (Hidas, "Mahāpratisarā-Mahāvidyārājñī").

42. That is, a lay donor to the monastic community.

43. The editors of T identify this as Puṣkalāvatī, a city in the Peshawar region of Gandhara (in modern Pakistan), a common stopping point for Chinese pilgrims of the medieval period. The Chinese name "Fulfilment City" (*manzu cheng*) seems only to be attested within translations of this scripture.

44. T 20: 640c.

45. T no. 2084, vol. 51: 842a-b. The version runs: "Once there was a *bhikṣu* who, [though] his mind embraced pure faith, went against the controlling precepts of the Thus Come One. Without writing out [the proper forms? (*Buxie*)] he seized for his own uses numerous objects from the common property of the resident saṃgha. Later, he became severely ill and suffered greatly. At this time, there being no cure for the monk, he cried out in a loud voice. Nearby there was a Brahmin who, hearing his great cry, hurried to the monk's side. Great compassion arising within him, [the Brahmin] immediately wrote out this *Great Incantatory King Dhāraṇī of Wish Fulfillment* and fastened it to [the monk's] neck, whose torments all ceased. The monk's life thereupon immediately came to an end, and he was born into the Hell of No Interval [that is, Avīci Hell]. Because this dhāraṇī was borne on the corpse of the bhikṣu, entombed in its pagoda, as soon as he entered hell all the torments of the sinners there all came to an end. Everyone there, without exception, attained security and joy. All the conflagrations of Avīci Hell, because of the awesome virtuous might of this dhāraṇī, were completely extinguished"

46. See appendix 1 for a survey of the 23 *Suiqiu* amulets considered in this chapter. Su Bai has made clear that others have been discovered but not yet reported or published (Su, *Tang Song shiqi de diaoban yinshua*, 7–9).

47. Ma, "Da suiqiu tuoluoni mantuluo," 529–530.

48. At the time of this writing I have not found any photographs of the tubes, boxes, or pendants. Indeed, it is often frustrating that the archeological reports often do not include images of the cases at all.

49. For a photograph of the Jiao Tietou armlet, see Li and Guan, "Xi'an xijiao chutu."

50. See the previous chapter or a survey of relevant Chinese practices.

51. Zysk, "Religious Healing in the Veda," 174; Bolling, "The Cantikalpa of the Atharva Veda," 120; Hidas, "Mahāpratisarā-Mahāvidyārājñī," 18. See also Bühnemann, "Buddhist Deities and Mantras," 34.

52. Note that "knotted 'protection cords'" are still in use in contemporary Tibetan Buddhism, at least in Nepal, as Matthew Kapstein has noted (Kapstein, Tibetan Buddhism: A Very Short Introduction, 2).

53. Ślączka, *Temple Consecration Rituals in Ancient India*, 68–69, 175.

54. *Jingchu suishi ji*, comp. Zong Lin (fl. 550s), I am grateful to Ian Chapman for alerting me to the existence of these cords in Chinese amuletic practice. The translation of Zong Lin's description is his.

55. *Wuming luocha ji*; T no. 720, vol. 16: 851a-b. For a convenient summary of the contents of this little-studied text, see *Busshō kaisetsu dajiten* 10: 420. Kings required the protection of such cords not only on the battlefield, it seems. Alexis Sanderson describes an instance where a king was adorned with a "protective wrist thread" (*pratisaraḥ*) as he prepared for his first foray onto the wedding bed (Sanderson, "Religion and the State," 250).

56. *Rulai fangbian shanqiao zhoujing* (perhaps, as the editors of H propose, reading back from a later Tibetan version, the *Saptabuddhakasūtra* [H, p. 116]); T no. 1334, vol. 21: 565c. It is unclear if (here and in the next accounts) the details that the cords to be used were often "five colored" were additions of the Chinese translations, as seems possible, or were present in earlier Indic versions.

57. T 21: 567b.

58. The precise identity of these "mountain stakes" is unclear. They would seem to be a special version—perhaps one occurring naturally in the mountains?—of the stakes commonly used to nail down the corners of ritual spaces, sometimes called "vajra stakes" (*jin'gang jue*; *vajrakīla*). On the use of similar stakes, at times painted with human images and used in exorcistic rites, see Mollier, *Buddhism and Taoism*, 85; Whitfield and Farrer, *Caves of the Thousand Buddhas*, 174–175; and Liu Zhaorui 2007, *Kaogu faxian yu zaoqi Daojiao yanjiu*, 356–357.

59. *Bukong juansuo shenzhou xinjing*; T no. 1094, vol. 20: 405.

60. Thus we see, once again, the essential identity of amuletic practices (including the logics of their descriptions) with those known in Chinese as *zhaifa*, which secure the safety of physical spaces. For an excellent discussion of these techniques in late medieval Dunhuang, see Yu Xin, *Shendao renxin*.

61. The *Susiddhikara* (on which see below) and its ancillary ritual manuals typically call for the armlet to be strung with "living children" (*huo erzi*), a term for the seeds of the "Bodhi Tree" (*putishu*), under which, legends tell us, Siddhartha Gautama achieved the awakening of a Buddha.

62. For example, see *Suxidijieluo jing*, T no. 893, vol. 18: 628c.

63. *Tuoluoni ji jing*, T no. 901, vol. 18: 838a.

64. *Putichang suoshuo yizi lunwang jing*, T no. 950, vol. 19: 222a.

65. See the helpful brief discussion of *samaya* in Rolf Giebel's discussion of the Susid-dhikara (Giebel, *Two Esoteric Sutras*, 11).

66. Powers, *Pattern and Person*, 61.

67. Shengjing, T no. 154, vol. 3: 101a.

68. In this regard, a (perhaps unique) event in the history of the Tang imperial house takes on added interest: "[The] emperor [Tang Suzong (711–762; r. 756–762)] arranged for a . . . religious drama to be enacted in the newly completed chapel in the Lin-te Hall of the Ta-ming Palace. His ministers were summoned to render homage to palace attendants who were dressed as Buddhas and bodhisattvas, while army officers portrayed the guardian spirits of Buddhism (*jin'gang shenwang*)" (Weinstein, *Buddhism Under the T'ang*, 59). See below for more on this emperor and his involvement with dhāraṇī practice. For a study of some similar portrayals, see Li Yuhang's study of women's devotion to Guanyin in the late imperial period, especially her chapter on the Empress Dowager Cixi's practice of dressing up as the bodhisattva and having her portrait painted or photographed (Li, "Gendered Materialization").

69. Tuoluoni ji jing, T no. 901, vol. 18: 796b.

70. Cheng, *Luoyang chutu Hou Tang diaoyin jingzhou*; and Ma Shichang, *Da suiqiu tuoluoni mantuluo*. See below for a discussion of the amulet sheet.

71. Han, *Shijie zuizao de yinshua pin*, 404–410; Ma, *Da suiqiu tuoluoni mantuluo*, 535. See below for a discussion of this amulet sheet.

72. Kotansky, "Incantations and Prayers for Salvation on Inscribed Greek Amulets," 114 and *passim*.

73. For fascinating studies of medieval Arabic block-printed amulets, see Schaefer, *Enigmatic Charms*; and Elverskog, *Buddhism and Islam on the Silk Road*, 104–116. Elverskog's work, which was published after the present book was sent to the press and which I only discovered just before it was to be printed, is especially important for the connections it draws between Buddhist and Arabic printed amulets.

74. Skemer, *Binding Words*, 26–29 and *passim*. See also Skemer's extensive and very helpful bibliography for a list of relevant studies. The study of amulets in the ancient and medieval worlds constitutes, naturally, a vast topic. The connections of this material with Central and East Asian traditions fairly cry out for serious study. A very helpful contribution to this study is Elverskog, *Buddhism and Islam on the Silk Road*, 104–116 (see previous note and the coda to the present volume).

75. On the *ye dharmā* and its central place in text relic practices, see the previous chapter.

76. Salomon, *Ancient Buddhist Scrolls from Gandhāra*, 86, 59–60.

77. Ibid., 86, quoting Bühler, *Detailed Report of a Tour in Search of Sanskrit Mss.*, 29 n. 4.

78. See von Hinüber, *Die Palola Sahis*, 16–17; von Hinüber, "Namen in Schutzzaubern aus Gilgit," *passim*; and Hidas, "Mahāpratisarā-Mahāvidyārājñī, 17, 25–26.

79. Skjærvø, *Khotanese Manuscripts*, 231, where the text is identified as IOL Khot 28/5 and Kha. i 182a1.

80. Ibid., 193, labeled as IOL Khot 16/4 and Kha. i 53.

81. Ibid., 585, and Emmerick, "Some Khotanese Inscriptions," 142–143, and pl. II. For the images figured on it see Aurel Stein, *Serindia*, v. IV: XCI.

82. Emmerick, "Some Khotanese Inscriptions," 142.

83. Skjærvø, *Khotanese Manuscripts*, 585.

84. T no. 1154, vol. 20: 641c.

85. I have added the numbers and the paragraphing for ease of reference.

86. See below for an example of an amulet apparently following this prescription.

87. T no. 1154, vol. 20: 641c–642a.

88. Strickmann, *Chinese Magical Medicine*, 184. The connection with bile in medieval China seems to have been especially close. Edward Schafer noted that while traditionally "bezoar" referred to a "concretion found in the fourth stomach of many ruminants, notably the bezoar goat . . . [the] 'bezoars' of medieval China, called 'ox yellow' there, did not always match this classic definition. Some, if not most, were biliary calculi, taken from the gall bladders of oxen" (Schafer, *The Golden Peaches of Samarkand*, 191).

89. It is especially important in the early Tantric *Susiddhikara*, as well as in earlier texts of dhāraṇī tradition, such as the *Tuoluoni jijing* and the *Amoghapāśa*.

90. Strickmann, *Chinese Magical Medicine*, 188.

91. Schafer, *The Golden Peaches of Samarkand*, 191.

92. Strickmann, *Chinese Magical Medicine*, 185.

93. Schafer, *The Golden Peaches of Samarkand*, 191.

94. See, for example, *Yizi foding lunwang jing*, T no. 951, 19: 226b; and *Wu foding sanmei tuoluoni jing*, T no. 952, vol. 19: 264b. See also chapter 1 of this book.

95. Strickmann, *Chinese Magical Medicine*, 185.

96. Chaves, "The Legacy of Ts'ang Chieh," 210–211. The power attributed to the ink could, as well, have been due to its physical connection with a Buddhist temple, for reasons that will be become clear in the next chapter.

97. Ma, "Da suiqiu tuoluoni mantuoluo."

98. T no. 1153, vol. 20: 623c–624a.

99. Taking *sanji* as an abbreviated form of *sanchaji*, "trident" (Skt. Triśūla).

100. Thus connecting the amulet's image with canonical accounts of the realms of buddhas, which nearly always feature such "treasure pools" (*baochi*). See, for

one example among a great many, Prajña's eighth-century translation of the
Gaṇḍavyūha Sūtra (Dafangguang fo huayan jing), T no. 293, vol. 20: 718c.

101. T 20: 624a-b.

102. That the diagrams seem to have been used in constructing actual ritual images (or
perhaps actual physical spaces) is suggested, as Sarah Fraser has pointed out, by
the corrections written on to Stein Painting 172, evidently by the diagram maker's
"supervisor" (Fraser, Performing the Visual, 153). These corrections, for example,
"put the deity in the center and move the mudra to the left," in Fraser's translation
(153), likely are traces of a dialog between the artists and a ritual master.

103. Fraser also draws close connections between diagrams such as Stein Painting
172 and the amulets, particularly Stein Painting 249, and notes the talismanic
function of the latter set. She sees a "high/low" distinction in the cultures of the
two types, with the handwritten altar diagrams part of highly individualized and
sophisticated monastic practices of contemplation, and the amulets, particularly
their printed variety, as "popular expressions of prayers" (drawing a link between
the printed amulets and other printed icons, on which see below) that were mass-
produced and important in the economic life of the monasteries (Fraser, Perform-
ing the Visual, 157–158).

104. See, for example, Yizi foding lunwang jing, T 951, vol. 19: 226b; and Wu foding sanmei
tuoluoni jing, T 952, vol. 19: 264b.

105. Fraser, Performing the Visual, 153.

106. See, for example, Da fangguang pusazang Wenshuhili genben yigui jing, T no. 1191,
vol. 20: 876c–877b; Foshuo shengbaozang shen yigui jing, T no. 1284, vol. 21: 350b and
351c; and Yuqie dajiao wang jing, T no. 890, vol. 18: 560a-b.

107. See Da Song sengshi lüe, T no. 2126, vol. 54:240b-c, and chapter 4 below.

108. Interestingly, two of these amulets seem to date from transitional moments in
the history of the production of the amulets. The first, made for "Iron-head" Jiao,
was handwritten and painted, yet its central image is an iconic representation of
the Bodhisattva Mahāpratisara (see below for the significance of these images).
The second was made for a certain "A-luo." Like late amulets, it is a woodblock
print, yet like early amulets, its central image is of the donor receiving divine
blessings, and the name of the donor has been written in to the text of the spell.
Both amulets are contained in the collection of the Xi'an Forest of Stone Tablets
Museum. See Cheng, Xi'an Beilin Bowuguan, 152–153.

109. Ma Shichang, Da suiqiu tuoluoni mantuoluo, 530. For related claims for the Chinese
origins of amuletic practices involving dhāraṇīs, see Xiao Dengfu, Daojia Daojiao,
773, and Daojiao shuyi, 194–195, as well as Li, Dunhuang Mijiao wenxian, 295.

110. Strikingly, Hidas, in his study of Indic versions of the *Mahāpratisarā* dhāraṇī and scripture, notes that though many extant versions of the spell from Gilgit and elsewhere in the Indic world contain names inserted within it, the Sanskrit version of the scripture he studies contains "no definite instruction" to insert names within it. Instructions within the Chinese versions are included as interlinear notes, a fact suggestive of the culture of practice evidenced everywhere surrounding this incantation, including in translations of its scripture.

111. The character/syllable *xie* (to write, copy, etc.) might initially be taken simply as part of the transliteration of the spell (and, indeed, I took it that way for some time), but three facts strongly suggest that it was taken as a Chinese word: it recurs at each point the name is indicated, regardless of the incantatory words that follow; it bears no relation to the next words in the dhāraṇī; and, finally, the Chen Chouding amulet substitutes "receives and keeps" for "writes," and makes clear that the syllable *xie* was taken as a Chinese word (at least in that one instance).

112. *Dazuigu darani kanchū*, T no. 2242, vol. 61: 747a-b.

113. See the next chapter for further discussion of this phenomenon. For an extended study of such glosses and what they reveal about dhāraṇī practice in medieval China and Japan, see Copp, "Anointing Phrases and Narrative Power."

114. Bibliothèque Nationale, *Catalogue des Manuscrits Chinois*, 165.

115. See the next chapter for a discussion of this account.

116. Bibliothèque Nationale, *Catalogue des Manuscrits Chinois*, 454.

117. An and Feng, "Xi'an Fengxi chutu de Tang yinben," 89–90. An and Feng date the sheet largely based on three stylistic judgments: they note that the *vajradhara* figure resembles mid-eighth century forms at Dunhuang, that the headscarf of the kneeling figure matches "High Tang" images, and that the shortness of the clouds' "tails" marks them as either early or High Tang styles.

118. Ibid., 87.

119. See chapter 1 for a discussion of the relationship between seal practices, the *Baopuzi* and related works, and inscribed Buddhist incantations.

120. Ma, "Da suiqiu tuoluoni mantuoluo," 539.

121. See Drège, "Les Premières Impressions"; Su, *Tang Song shiqi de diaoban yin shua*; Barrett, "Stūpa, Sūtra, and Sarīra"; and Strickmann, *Chinese Magical Medicine*, 123–193.

122. Zwalf, *Buddhism: Art and Faith*, 70 (fig. 82), and the British Museum online collection notes.

123. See Schopen, *Figments and Fragments of Mahāyāna Buddhism*, 338, for the identification and 314–344 on this dhāraṇī in broader contexts. The stamp also bears the

text: "whosoever constructs a caitya after having written this dhāraṇī and thrown it inside, will gain the merit of having constructed 100,000 caityas."

124. *Daizong chaozeng sikong dabian zheng guangzhi sanzang heshang biaozhi ji*, T no. 2120, vol. 52: 829b. For more on this passage see chapter 3. The text notes, as well, that Amoghavajra used the *Incantation* in 761 to cure the emperor when he had fallen ill.

125. The word I have translated as "text" here, *ben*, was in fact often employed, in the compound *zhouben*, or "spell text," in naming single sheets of incantations, often those belonging to individual practitioners, including at least one example of a Mahāpratisarā amulet—the Chengdu xylograph with which this chapter opened (and to which I will return below). The term was also used as a general term for the texts of spells, particularly in catalogs. Most known examples of *zhouben* were found within the Dunhuang cache and consist not of elaborate pairings of spell and image but simpler manuscripts that more often than not took the forms of single sheets inscribed with the text of a transliterated dhāraṇī. The manuscript known as S. 165, "Changxin's spell text," apparently the personal spell sheet of a monk named Changxin (otherwise unknown), is a typical example.

126. *Foshuo suiqiu jide dazizai tuoluoni shenzhou jing*, T no. 1154, vol. 20: 637c.

127. For the image, see Su, *Tang Song shiqi de diaoban yinshua*, 4, 127; and Ma, "Da suiqiu tuoluoni mantuoluo," 536–537, 569. The printed edition of the spell on this sheet, incidentally, may be the earliest version of the transliterated spell yet known. As Ma notes, its Chinese transliterations differ from those of transmitted editions of the Baosiwei spell, whose title this sheet bears—a trait shared by the version of the spell found on S. 4690, as discussed below.

128. An and Feng, "Xi'an Fengxi chutu de Tang yinben," 88.

129. Ibid.

130. See T no. 1154, vol. 20: 642a.

131. Two versions of these spells are found at T no. 1154, vol. 20: 640a (the version found on the Koryŏ edition) and 644b (the one dating to the Ming edition). Close examination of the text of the spells inscribed on S. 4690 sheds some light on the discrepancies between the two versions. In general, it is closer to the Koryŏ version, but at several points it matches the Ming spell quite precisely. The two versions included in T seem to have been but two of many versions used in the history of Buddhist practice in China, and not necessarily "canonical" in anything but a rather contingent sense (i.e., they were enshrined in printed canons). Taking only the two received versions as evidence, one would be tempted to conclude that the much later Ming edition was in fact a text developed after the earlier Korean printing. But such a conclusion is complicated by the existence of the version on

this amulet model, which very likely predated both of them. The four spells on S. 4690, as best as I can transcribe them, are given in appendix 2.

132. The amulet can be viewed on the International Dunhuang Project website (http:// idp.bl.uk/) under the search value "EO 1182."

133. With, again, the exception of the "A-luo" sheet, which blurs my sharp ideal types, and which I take (provisionally) as the product of a transitional or perhaps backward-looking practice.

134. See the following chapter for a discussion of these objects.

135. Mair's analysis proceeds in terms of the distinction between "bianxiang" and "maṇḍala" (Mair, "Records of Transformation Tableaux," 3–4), while Teiser uses "narrative" and "icon" (Teiser, *Scripture on the Ten Kings*, 42–43). Teiser's analysis focuses on the hanging silk paintings that I will discuss below. Though I have tried in this section to apply the rubrics with care, and to adjust them to the material I consider here, Teiser's warning that "we must remember that the distinction is modern and arbitrary, and at times impedes an understanding of medieval culture" is well taken (Ibid., 43).

136. Wu Hung, *The Wu Liang Shrine*, 133.

137. Teiser, *Scripture on the Ten Kings*, 42–43.

138. Wu Hung, *The Wu Liang Shrine*, 133.

139. See chapter 1 for an exploration of this ritual logic.

140. Stein Painting no. 247.

141. *Bukong juansuo shenbian zhenyan jing*, T no. 1092, vol. 20: 299c.

142. But see the Ruiguangsi prints discussed below.

143. On the Dunhuang Mahāpratisarā invocations, see Chen Huaiyu, "Dunhuang P. 2058v wenshu." Note that, as mentioned earlier, the monk Xingsi's amulet (P. # 3982), which the compilers of the Pelliot Catalog date to the tenth century—contemporary with the manuscript versions of the ritual invocations—also contains an invocation (though a much simpler one) within the text of its spell.

144. See Suzhou bowuguan, *Suzhou bowuguan cang Huqiu Yunyansi ta*, Seunghye Lee, "Arts of Enshrining," and Eugene Wang, "Ritual Practice Without a Practitioner?"

145. At least none have yet been made public. The slow pace of the publication of archeological finds in China imposes the need for caution here. There is, however, later textual evidence suggesting that the Mahāpratisarā was used for amulets in later periods in Japan; Jōnen's (fl. 1154) collection of ritual modules, the *Gyōrinshō*, contains an account of how to make amulets that clearly drew on knowledge of Chinese examples (T no. 2409, 76:304b).

146. See chapter 4 for a discussion of this shift in regards to the material studied in this book.

147. The sole exception being the holes, and the possible traces of thread they still bear, within the Chen Chouding amulet.

148. See, now, the excellent discussion of this small pillar and its place in the Ruiguang si pagoda in Lee, "Arts of Enshrining."

149. Reading *wu neng sheng*.

150. I have used the transcription of the text found in Ma, "Da suiqiu tuoluoni mantuoluo," 546.

151. The image can be viewed on the International Dunhuang Project website (http://idp.bl.uk/) under the search value "EO 1232." For the ritual prescriptions, see, for example, the description of a rite in the Uṣṇīṣavijaya tradition that calls for, among other things, vajras at the frame of an icon and wheels at the corners: the manual attributed to Śubhākarasiṃha known as the *Zunsheng foding yuqie fa yigui* (T no. 973, vol. 19:375c); see also the later Japanese summary in the *Gyōrinshō* (T no. 2409, vol. 76: 78c).

152. It should be noted that the Tang Dynasty had fallen in 907.

153. For a fuller description and analysis of this painting, see Whitfield, *The Art of Central Asia*: Vol. 2, Plate 7. The image and Whitfield's analysis are also included in the website of the International Dunhuang Project (www.idp.bl.uk), under the search value "1919,0101,0.14." See also Waley, *A Catalogue of Paintings*: 26.

154. Teiser, *Scripture on the Ten Kings*, 42.

155. See Tsiang, "Buddhist Printed Images and Texts," for an overview of early Buddhist printed images.

156. It is crucial to emphasize the very different natures of icons such as Stein Painting 237 and dhāraṇī amulets such as those that are the subject of this chapter. Cf. Fraser, *Performing the Visual*, 155–158.

157. For a study of this print in the context of concepts of the "True Visage" and the cult of Mañjuśrī on Wutaishan, see Choi, "Quest For the True Visage."

158. Jiao's amulet, found on Fenghao Rd in Xi'an in the early 1980s (see Ma, "Da suiqiu tuoluoni mantuoluo," 528–529), confounds any simple picture of historical progression in the design and production of the amulets. It features an image of the eight-armed deity at its center, yet it is a handwritten and painted manuscript that includes Jiao's name within the text of the spell. Ma Shichang, because of its visual similarity with Madame Wei's amulet, deemed it to be roughly contemporary with that painting, dating it to the middle of the eighth century. Yet the presence of the multiarmed deity makes this unlikely. I think, instead, that it is most likely either an "archaized" product of the following century, created by someone who knew the older amulet traditions and sought to merge them with the new iconography, or a truly transitional piece whose makers adapted the new

iconography at a time (or place) where the new styles of xylograph icons had not yet taken hold.

159. See Liu Yongzeng, "Mogaoku di 148 ku nanbei kan tianjing tuxiang jieshuo," 524–526, for a discussion of this painting. See also Li Ling, "Dasuiqiu tuoluoni zhoujing de liuxing yu tuxiang," who claims to be able to read the entire inscription as "Suiqiu pusa."

160. Wong, "Divergent Paths."

161. Waley, "A Catalogue of Paintings."

162. As Liu Yongzeng notes, a nearly identical tableaux is found in the slightly later Cave 156.

163. Tsiang, "Buddhist Printed Images and Texts," 246–247.

164. Abé, *Weaving of Mantra*, 124–125. See 487–488 n. 60 for Abé's discussion of the nature of this work.

165. That is, literally, an "Indic case" (*fanqie*) in which a collection of inscribed leaves were kept.

166. Hizōki 2:12. See also Ishida, *Mandara no kenkyū*, 44–45, for a discussion of this form of the *Zuigu bosatsu* within the context of the Womb Mandala.

167. *Yōson dōjōkan*, T no. 2468, vol. 78: 50c.

168. *Betsugyō*, T no. 2476, vol. 78: 132c.

169. *Yuqie dajiao wang jing*, T no. 890, vol. 18: 568a-b. Though he does not mention this text, Mevissen has tracked these images to the eleventh- and twelfth-century iconographic manuals known as the *Sādhanamālā* and the *Niṣpannayogāvalī*, sources that, if Mevissen is correct about their dates, significantly postdate the Chinese translations. See Mevissen, "Studies in Pañcarakṣā Manuscript Painting," 362–363, and Mevissen, "Images of Mahapratisara in Bengal," 99, where he notes that the earliest actual statues exhibiting this form date only to the eleventh century at the earliest.

170. Mevissen, "Images of Mahapratisara," 99–108.

171. Ibid., 106.

172. Some of the Javanese examples seem to include objects, such as in several cases a jewel in place of a "jeweled banner" (Ibid., 116), not found elsewhere among these images.

173. The two similar pieces are numbers three and six in his account. Of the two, the most completely readable sculpture is the latter, a bronze image from Java now held in Paris's Musée Guimet (Ibid., 102–103). Its possible match is a metal sculpture held in the Bangladesh National Museum in Dhaka (Ibid., 100, 103). Neither piece is precisely datable.

174. Ibid., 116.

175. Ibid., 117.

176. See Chou, "Tantrism in China," 290 n. 29, on the identification of this land as Java.

177. *Da Tang gu dade sikong dabianzheng guangzhi Bukong sanzang xingzhuan*, T no. 2056, vol. 50: 292c. A slightly different version is collected in *Song gaoseng zhuan*, T no. 2061, vol. 50: 712b. See also Chou, "Tantrism in China," 290, for a translation of the latter work, which I sometimes followed.

178. This is, indeed, how Mevissen seems to have taken it (Mevissen, "Images of Mahapratisara," 117). It should be noted, however, that since no full Western language translation of the *Mahāpratisarā dhāraṇī sūtra* existed at the time of his research on the iconography, he may not have had access to the scriptural tales I discuss here.

179. This is either the timiṅ, a large fish mentioned in the *Vedas*, or (as the editors of T have it), the timiṅgila, the "eater of the timiṅ," an even greater beast. The authors of the *Fan fanyu* take timiṅgila to mean "fish of the gods" (tianyu); T no. 2130, vol. 54: 1024b.

180. Reading *xiao* for *suo*.

181. T no. 1153, vol. 20: 621b–622a.

3. DUST, SHADOW, AND THE INCANTATION OF GLORY

1. *Rulai fangbian shanqiao zhoujing* (perhaps, as the editors of H propose, reading back from a later Tibetan translation, the *Saptabuddhakasūtra* [H, p. 116]); T no. 1334, vol. 21: 565c.

2. *Bukong juansuo shenzhou xinjing*; T no. 1094, vol. 20: 405c.

3. *Foding zunsheng tuoluoni jing*; T no. 967, vol. 19: 351c.

4. I have followed the edition of this text in Li Xiaorong, *Dunhuang Mijiao wenxian lungao*, 59–60, which was based on the versions found on the manuscripts Sh.M. 48.6; S. 5598; and S. 5560.

5. Shimono, *Tonko Bakukōkutsu dai niyakujūnana kutsu*. Though I think Shimono is correct, her identification of this painting remains controversial. See, for example, Wang, *Shaping the Lotus Sutra*, for an alternative reading of some of the paintings at issue here.

6. Li Xiaorong, *Dunhuang Mijiao wenxian*, 64–65. In Japan, especially, another spell was most closely associated with these mortuary practices—the *Kōmyō shingon*, or *Mantra of Light*. For an in-depth discussion of this mantra and its practices—which bear a close resemblance to the much earlier Chinese techniques of the *Incantation of Glory*—especially as seen through the work of its earliest proponent, the thirteenth-century monk Myōe, see Unno, *Shingon Refractions*, and Tanabe, *Myōe the Dreamkeeper*, 137–152.

7. *Zongshi tuoluoni yi zan*, T no. 902, vol. 18: 898b.

8. "Dhāraṇī pillars" is the most common name for the structures in English. A better translation of their most common name in Chinese—*jingchuang*—is "scripture pillar." They were also labeled "treasure pillars" (*baochuang*) and "shadow pillars" (*yingchuang*), among other things (see Liu Shufen, *Miezui yu duwang*, 52).

9. Note that the text does *not* specify a *stone* banner or pillar.

10. The Buddha is addressing the god Indra.

11. The class of beings, sometimes called "titans" or "demigods" in English, which constitutes one of the possible "paths" of rebirth.

12. T no. 967, vol. 19: 351b. That is, unsurpassed and perfect awakening. The text gives the usual Chinese transliteration of the Sanskrit term given here.

13. *Longhua si ni Wei Qiyi zunsheng chuang ji*, in BQ 47: 12. See Liu, *Miezui yu duwang*, 10–11 and 134–5 for discussions of this inscription. For a discussion of the term *mizang*, see chapter 4.

14. Davidson, "Atiśa's *A Lamp for the Path of Awakening*," 290, discusses this "economy of basic forms" not only as a core feature of institutions but more narrowly as "one of the keys to understanding Buddhism during its final phases on Indian soil."

15. For more information on this pillar, see Liu Shufen, *Miezui yu duwang*, 62.

16. See, for example, Ibid., 46.

17. In such places the pillars often became new versions of older practices: in tombs they were like the tomb-securing (*zhenmu*) objects and texts of ancient Chinese practice; in homes and within cities they became forms of the "methods of the abode" (*zhaifa*) used to make them safe from perils, demonic or otherwise. For an exploration of such practices, see Yu, *Shendao renxin*.

18. Liu Shufen, *Miezui yu duwang*.

19. On this association, see Zhiru, *The Making of a Savior Bodhisattva*, 147–150, et al.

20. Howard, "The Dhāraṇī Pillar of Kunming."

21. Schopen, *Figments and Fragments of Mahāyāna Buddhism*, 350–370.

22. Liu, *Miezui yu duwang*, 131–139.

23. On this coffin, see Shen, "Praying for Eternity."

24. Frankfurter, "The Magic of Writing and the Writing of Magic." More recently, I encountered the work of Don C. Skemer, whose characterization of these modes of efficacy as "material magic" is in some ways closer to my own. In his discussion of Anglo-Saxon charms he notes that "there are a number of apotropaic texts that were supposed to be copied on writing supports that could then be applied directly to the body or used together with other remedies. . . . Material magic could take the form of inscribing a few sacred names, Christian symbols, and cryptic words on stones, wafers, plates and other objects, which could then be

worn from the neck or eaten or written directly on the body" (Skemer, *Binding Words*, 78–79).

25. These notions were not limited to the Chinese—there is much in them that is applicable to wider Buddhist practices and understandings. My relatively narrow focus on medieval China is not meant to deny or obscure this fact.

26. Frankfurter, "The Writing of Magic," 191. He notes that these distinctions were first put forth in the Cornell lectures of Marcel Détienne.

27. Ibid., 192. According to Frankfurter, the reasons why ancient Egyptians saw written spells as powerful have much to do with the nature of their hieroglyphic writing system—notably, its pictographic nature. The Chinese script, of course, is not primarily a pictographic system, save in a few, albeit prominent, cases. It is largely a phonetic script (there are several different kinds of characters, but the phonetic is the largest group). Frankfurter stresses the pictograph's ability to "reify their subjects as well as the things expressed," which he contrasts with Greek writing's close relationship with speech, as a partial explanation for the perceived potency of written Egyptian. The images of the script echoed the images of religious art and architecture, so that writing about a god captured something of that god. In addition, he describes the fact that the Egyptian script was the "indispensable and dynamic center of the Egyptian cultic-priestly world," and that it "was maintained by and for a priesthood with the intention of encoding or *fixing* ritual and cosmology in a timeless and ideal reality." He notes how the ritual and social status of the script lent instant authority, in the form of an "archaistic timelessness," to even the most ad hoc improvisations of priests. This was partly achieved by the fact of the script's "discontinuity with popular spoken Egyptian"—a feature, we may note, shared to some degree with literary Chinese (Ibid., 191–193). This is not the place for a full-scale comparison between Egyptian and Chinese talismanic writing, though such a project would doubtless be fascinating—not to mention provide balance to what to my mind is Sinology's overemphasis on Chinese-Greek parallels.

28. Ibid., 196.

29. For a convenient collection of these texts, see Huang and Wu, *Dunhuang yuanwen ji*.

30. Frankfurter, "The Writing of Magic," 196.

31. As opposed to the sense of the term *contagion* as employed by the mythographer James Frazer, whose writings yet remain interesting to a study of material incantations (Frazer, *The Golden Bough*, 43 et al.)

32. This image introduces further distinctions into the traditional Buddhist picture of how spiritual potency (of whatever vintage) is imbued into an object. For example, one might argue that the nearly physicalist account of incantatory potency

I advance here merely describes an epiphenomenon of the way the power of words is imagined in many forms of Buddhist practice, that the "charge" certain dhāraṇīs were thought to lend to the material they touched was simply the kind of merit generation common to many sorts of Buddhist ritual. This is certainly part of it; and as we saw before, the two modes were at times conflated. But such an objection might ignore the fact that, especially in the case of incantatory anointment, the substances so empowered were then themselves capable of empowering—that the dust and shadows described in the sūtra then have *the same qualities that the scriptural words have*. Seeing the empowered material as secondary to the *buddhavācana* itself, in these ritual contexts, misses something very important in the world the sūtra creates in its descriptions. It is also, perhaps, and particularly when we are interpreting materialized incantations such as amulets and pillars, a sign that scholars' love of words might blind them to the value of normally mute stuff. One might also counter that, in the case of the *Incantation of Glory*, I am inflating out of all proportion the importance of what is in the text a minor point, and one that the only Chinese commentary on its sūtra passes over almost totally in silence. (*Foding zunsheng tuoluoni jing jiaoji yiji*, Fachong (fl. eighth century), T no. 1803). Yet the pillars prescribed in that small portion of the scripture filled the landscape of medieval China, and images of their potent dust and shadows were key factors in this spread and key features of the Buddhism of the age.

33. See BQ 46: 6 for a pillar called a "shadow pillar." The imagination of shadows (or of the term *ying*, which can also mean "reflected image") in Buddhist writings deserves a study of its own. See, for example, the *Zanyang shengde duoluo pusa yibaiba ming jing*, translated by Tianxizai (*Devaśanti?; d. 1000), which states that a person's shadow can be made impervious to demonic harm (T no. 1106, vol. 20: 476a). See also the *Da weide tuoluoni jing*, translated by Jñanagupta (523–600), which names shadows as one possible vector of poison, in a list that includes the roots, stalk, branches, flowers, and fruit of a plant (T no. 1341, vol. 21: 834b-c).

34. Tanabe, *Myōe the Dreamkeeper*, 9. For a meditation on the nature of fantasy in Buddhism, see pages 1–10 of Tanabe's book.

35. Sontag, *Illness as Metaphor*, 3.

36. The pillar is dated to 939. See *Longyou jinshi lu*, Tang section, 70–71. I am grateful to Kuo Liying for this information.

37. For the listing of copies of the *Scripture of the Incantation of Glory*, see Dunhuang yanjiu yuan, *Dunhuang yishu zongmu suoyin xinbian*, pp. 7 and 55 of the index section; for the list of the *Huayan jing* copies, see pp. 5–6; for those of the *Lengyan jing*, see pp. 7 and 107.

38. Forte, "The Preface to the So-Called Buddhapālita Chinese Version of the Buddhoṣṇīṇa Vijaya Dhāraṇī Sūtra," and Chen Jinhua, "Śarīra and Scepter," are exemplars here.

39. See Barrett, "Stūpa, Sūtra, and Sarīra."

40. Li Xiaorong, Dunhuang Mijiao wenxian, 42–73, and Lü, Mijiao lunkao, 77–108.

41. Liu Shufen, Miezui yu duwang.

42. Forte, "The Preface," 6.

43. The issue of how to render the name of this monk is a vexed one, due to conflicting reports of how his name was translated in Chinese: Juehu and Jue'ai. I follow Forte, who renders it Buddhapāli[ta], based on Zhisheng's translation of Juehu. Forte notes that he does so not out of any clear sense that Zhisheng was correct but "to avoid confusion among readers" (see Forte [n.d.], 23–24, n. 115 for a discussion of these matters). I follow him in this.

44. My translation draws on Forte's (in "The Preface") and Lamotte's (in "Mañjuśrī"), and differs from theirs largely on stylistic grounds, except as noted.

45. The phrase here is qianling, literally "submerged their spirits" [or perhaps "souls," or "powers"].

46. The conditions that prevent one from meeting a buddha: life as a hell dweller, a hungry ghost, an animal, life in the heavens, in Uttaru-kuru (where all is pleasurable), being deaf, blind, or dumb, being a non-Buddhist philosopher, and living in an age between appearances of a buddha (see, for example, the Sifen lü, T no. 1428, vol. 22:567a).

47. My reading follows Forte. But note that the text can also simply be read, "coming from out of the mountains." However, as we will see, that the bodhisattva (and later Buddhapālita himself) resides inside a mountain is a key feature of these legends.

48. I follow Forte's suggestion that this date is not the year of Buddhapālita's return to China but of the completion of the version of the scripture attributed to him and Shunzhen. "This procedure was very familiar to the compilers of historical records when relating different events: the date of the central and final event following a series of related events is stated at the beginning" (Forte, "The Preface," 8 n. 39).

49. The text reads "dadi." As Forte points out, this is an abbreviation of the Gaozong Emperor's posthumous title, "tianhuang dadi," "Heavenly August Grand Emperor." The title was conferred soon after his death. See Forte, "The Preface," n. 41.

50. Foding zunsheng tuoluoni jing xu, T no. 967, vol. 19: 349b. For a translation and analysis of this preface and its historical context, see Forte (n.d.).

51. Chen, "Śarīra and Scepter," 107.

52. *Kaiyuan shijiao lu*, T no. 2154.

53. Chen, "Śarīra and Scepter," 111.

54. Ibid., 109. The matter rests on the portrayal of a monk named Buddhapālita found in the *Xiuchan yaojue*, XZJ 110: 834a. For a discussion of this text as a source for Tang history, see Forte, "The Preface," 26–28.

55. Barrett, "Stūpa, Sūtra, and Sarīra," 28. Though, as Barrett himself has noted, her engagement with Daoist practice, and her attempts to use it as another ground for her imperium, were significant.

56. On the connections between Wu, Wenshui, and Wutaishan, see Ibid., 18 (especially n. 38, where Barrett credits the observation to the scholar Du Doucheng), and Chen, "Śarīra and Scepter," 109.

57. Barrett, "Stūpa, Sūtra, and Sarīra," 18, citing *Fayuan zhulin*, T no. 2122, vol. 52: 393a and 596a.

58. Barrett "Stūpa, Sūtra, and Sarīra," 20–22. Barrett has done much to demonstrate the tight connections between the Empress's legitimation projects, permutations of the relic cult, and the rise of block printing. See Barrett, "The Rise and Spread of Printing," and *The Woman Who Discovered Printing*, for very helpful summaries of this work. Chen, "Śarīra and Scepter," also speaks to these matters.

59. Birnbaum, "The Manifestations of a Monastery," 120. For the alternate characterization of Fazhao's *wuhui nianfo*, see Weinstein, *Buddhism Under the T'ang*, 73, 175 n. 28. For further discussions of Fazhao, see Sasaki, *Jōen Hōshō no jiseki ni tsuite*, Tsukamoto, *Nangaku Shōen den*, and Robson, *Power of Place*, 301–302.

60. Birnbaum, "The Manifestations of a Monastery," 120. For further discussions of the caves of Wutaishan, see Birnbaum, "Secret Halls of the Mountain Lords."

61. *Song gaoseng zhuan*, T no. 2061, vol. 50: 717c.

62. Weinstein, *Buddhism Under the T'ang*, 81.

63. *Daizong chaozeng sikong da bianzheng guangzhi sanzang heshang biaozhi ji*. Yuanzhao (d. 778). T no. 2120, vol. 52: 837c–838a. Amoghavajra also requested that an image of the Bodhisattva Samantabhadra (Puxian pusa) be erected, and that the people be exempted from both their corvee and tax duties.

64. See chapter 4 for a discussion of Zanning's account.

65. Weinstein, *Buddhism Under the T'ang*, 82.

66. Forte, "The Preface," 1, quoting Chou, *Tantrism in China*, 322. The memorial is located in *Daizong chaozeng sikong da bianzheng guangzhi sanzang heshang biaozhi ji*, T no. 2120, vol. 52: 852c–853a.

67. *Jiaju lingyan foding zunsheng tuoluoni jing*, T no. 974c.

68. Chen Jinhua notes that Wu Che was a "fourth generation grandson of Wu Shi-rang, one of Empress Wu's uncles" (Chen, "Śarīra and Scepter," 110 n. 199).

69. *Jiaju lingyan foding zunsheng tuoluoni jing*, T no. 974c, vol. 19: 386a.

70. *Foding zunsheng tuoluoni jing*, T no. 967, vol. 19: 350a.

71. Anathapindika, whose name means "almsgiver to those without protection." His given name was Sudatta (see the *Sudatta Sutta* and the *Cullavaga* 6.). The Jeta Grove was the monastery provided by him for the Buddha.

72. *Foding zunsheng tuoluoni jing*, T no. 967, vol. 19: 349c–352a.

73. Forte, "The Preface."

74. *Foding zunsheng tuoluoni jing*, T no. 967, vol. 19: 350a. All citations of the sūtra, regardless of the specific translation, refer to the versions of the text found in volume 19 of T.

75. Snellgrove, *Indo-Tibetan Buddhism*, 52.

76. For this picture, see Sawada, *Jigokuhen*, and Teiser, *The Scripture on the Ten Kings* and *Reinventing the Wheel*.

77. This text, undated though probably from the ninth or tenth century, seems to be the archival script of a lecture given to the participants and audience of a confession and precepts ritual, though as with most works of its kind we have precious little contextual information with which to make a judgment. Modern scholars have entitled the text "A Piece on the Preaching of the Three Refuges and the Five Precepts" (*Shuo sangui wujie wen*); it is on the manuscript known today as S. 6551. I have also consulted the edition of the text found in Zhou, *Dunhuang bianwen*, 2: 1010–1032.

78. Zhou, *Dunhuang bianwen*, 1013, amends this to "is made to ache," (*quan suan*). But this seems unnecessary.

79. That is, a Buddhist teacher. The term is derived from the Sanskrit kalyānamitra.

80. Here the text interpolates "call out the [names of?] the Buddha's sons" (*cheng fozi*). Perhaps at this point the names of those about to confess were ritually spoken. Such interpolations (and interpellations) are also found in the texts of dhāraṇīs, including all versions of the incantations of *Glory* and *Wish Fulfillment* (see chapter 2 and below).

81. That is, an instant. Emending *ban* to *na*, following Zhou, *Dunhuang bianwen*.

82. The original is in verse, with lines of seven syllables. I have not tried to reproduce any of its prosodic features in my translation.

83. Zhou, *Dunhuang bianwen*, 2: 1015.

84. Kroll, *Dharma Bell and Dhāranī Pillar*, 46 n. 41.

85. Ibid., 46 n.42, quoting *Shiji jing* section of the *Chang ahan jing* 20, T no. 1, vol. 1: 133c. We might also note that according to the Chinese translation of the *Lokasthāna* (*Daloutan jing*), produced by Fali in the third century, males and females of this

heaven "perform the matters of yin and yang by employing winds" (T no. 23, vol. 1: 297b). See also Baochang's *Jinglü yixiang* 1, T vol. 53: 1, for a similar account, drawn from the *Sanfa dujing*, a text that is possibly Chinese in its provenance. Note that this source also states that "in enacting their desires they are like humans" (*xing yu ru ren*), a statement that would seem to weaken the grounds for any assertion that pleasure and intimacy at a distance are so very unlike their more physical versions, at least as understood by Chinese audiences.

86. Wu, "On Rubbings," 34.

87. Lamarre, *Uncovering Heian Japan*, 116. See the introduction for further discussion of these issues.

88. Liu Shufen, *Miezui yu duwang*, 46.

89. Zeitlin, "Disappearing Verses," 76.

90. XB 760, v. 13: 8981. A somewhat different version of this text, not attributed to Lü Shou, is found in JSCB 66: 45, where it is called *Tian Pu deng jingchuang*.

91. We should be clear that they do not always employ such precise imagery. At times they simply state that the shadow or the dust touches one.

92. According to the *Hanyu da cidian*, zhan (1) has the wider range in modern usage, including the negative usages of "contagiousness" and "taint."

93. *Wenxuan* 9.

94. *Wenxuan* 28. Ruan Ji (210–263) quotes this image in the *Wenxuan* version of the fifth of his "Song of My Cares" (*Yonghuai*), where he writes that "Clear dew covers the poolside lilacs; chill frost condenses on the wild grass" (*ningshuang zhan yecao; Wenxuan* 23). We might note in passing the juxtaposition here of "covering" and "infusing" (here rendered as "condensing"). This is the most common basic pairing in inscriptions related to the *Incantation of Glory*, signaling, perhaps, a deeper rhetorical or tropical structure in Chinese writings in general.

95. T no. 968, vol. 19: 354b.

96. T no. 970.

97. See also the previous chapter, where I argue that the latest translation of the *Mahāpratisarā dhāraṇī sūtra* also reflected then-current practices and conceptions.

98. *Fo mimi xin*. I take xin here in the sense of "heart/essence," rather than "mind," because of the former's close association with spells, as in the term hṛdaya.

99. *Tihuang wanhui*. The meaning of this phrase is not entirely clear to me. *Tihuang* means, literally, "stairs and boats," and often is an image of journeying, over land and sea. I read it as indicating that the words of the spell offer access to all regions, along both vertical (stairs) and horizontal (boats) axes.

100. XB v. 20: 13587. Like Lü Shou's composition, this lyrical evocation of the beauty and power of stone engraved with the "phrases of the Buddha's Crown" is not a

simple example of the picture I have presented so far. The complications it offers are salutary, however; attention to them helps to show the almost ironic position these accounts of the magic of the embodied spell had within other more-established patterns of Buddhist discourse. Composers of texts such as the one at hand were keenly aware of these ironies and the rhetorical conflicts they engendered are detectable in phrases such as those translated above. The practice and theory of dhāraṇīs fit for the most part within a larger discourse founded in rather strict ideas of purity and impurity. In many cases, and certainly in the scriptures of the spell, this discourse employs the figures of earthly filth versus the light of the Buddhas and their pure lands. "Dust" is one of the chief images of delusion and the impurities that hinder one's advancement among the paths of rebirth. For the Chinese context, one need only invoke the famous dust that occludes the mind's otherwise bright mirror in Shenxiu's verse in the Platform Sūtra (leaving aside Huineng's equally famous dust-denying reply, which would take us into discursive realms quite distant from both dhāraṇī practice and traditional karma talk). More broadly in the Chinese language as well, and in a precise echo of our terminology, the term dust drenched (zhanchen) can denote the state of being stained, or defiled. Yet here on the pillars dust is one of the two principal vectors of purification itself. Hence, perhaps, its ambivalent position in our inscription: whoever is lucky enough to be infused by the dust is thereby lightened of his load of dust—or, not quite—this isn't homeopathy, after all. In the line in which the latter image occurs, it is not the dust that infuses but the wind that (elsewhere) bears it. The anonymous writer of these lines was careful to keep his discourses neat. We see the same tactic in other inscriptions as well, such as one from the Tang that proclaims that "the mightiest of dhāraṇīs is the Buddha's Crown. Inscribe it on a pillar: "The flying dust [of delusion that causes] karmic-actions to amass: when the shadow turns, [these] calamities vanish" [XB v. 20: 13535]. Such small moments in the accounts of the dhāraṇī suggest that the tropes of the Incantation of Glory did not fit cleanly into the places made for them in the literate Buddhism of the Tang. In this the spell was not alone; the growth of a religious tradition does not only require rearrangements on the grand scale.

101. Reading 附近 for 俯近.

102. Baqiong 81: 24.

103. XB 19: 13545.

104. Za ahan jing, T no. 99, vol. 2: 304b.

105. Dasheng bensheng xindi guanjing, T no. 159, vol. 3: 304.

106. From Jingde chuandeng lu, The Jingde Record of the Transmission of the Flame, T no. 2076, vol. 51: 208.

107. From *Fayuan zhulin*, T no. 2122, vol. 53: 569b.

108. XB 19: 13532. During the Kaiyuan period (713–741) of the Tang. Also XB 19: 13546–13547, from 869 (*Xiantong* 10).

109. XB 19: 13533. (n.d.)

110. XB 19: 13531–13532. This pillar was originally constructed in 731, then rebuilt in 855, then rebuilt again in the *Qianyou* period (951–954) of the short-lived Northern Han Dynasty (951–979), whence this phrase.

111. *Jiaju lingyan foding zunsheng tuoluoni ji*, T no. 974c, vol. 19: 386.

112. *Dasheng yujia jin'gang xinghai Manshushili qianbei qian*, T no. 1177a.

113. That is, monasteries.

114. "Forest," and by extension a secluded, quiet, abode for monastics.

115. *Dasheng yujia jin'gang xinghai Manshushili qianbei qian*, T no. 1177a, vol. 20: 726c.

116. *Qianshou qianyan Guanshiyin pusa guangda yuanman wu'ai dabeixin tuoluoni jing*, T no. 1060.

117. That is, three of the four possible forms of birth described in Buddhist cosmology.

118. *Qianshou qianyan Guanshiyin pusa guangda yuanman wu'ai dabeixin tuoluoni jing*, T no. 1060, vol. 20: 109a.

119. A fact that provides further evidence that this text was steeped in the Buddhist tale literature of its age.

120. *Da fangguang fo huayan jing ganying zhuan*, T no. 2074, vol. 51: 175a.

121. The latter work claims the tale is taken from an otherwise unknown text called the *Jing tianji youji* (*Sanbao ganying yaolüe lu*, T no. 2084, vol. 51: 837b), the former simply from a "record of the Western Regions" (*Da fangguang fo huayan jing ganying zhuan*, T no. 2074, vol. 51: 175a). Fazang's work simply states that the tale was "transmitted from western countries" (*xiguo xiangchuan*).

122. *Huayan jing chuanji*, T no. 2073, vol. 51: 169c.

123. It should be noted that this is true even though the tale here functions mainly as the setup for a claim for the true way to enact the spell as prescribed in this text: verbally.

124. The term here is *chi*. See the introduction for a discussion of its meanings and centrality in the discourse of incantation practice.

125. The terms used here closely parallel those used in the tales. For example, this text reads (*yi shui guan zhang*), while Fazang's and Feizhuo's texts both read (*yishui guan zhang*). The words for "wash" here are homophones. Similarly, the texts all use the term *zhansa* to describe the drenching of the ant, a binome that occurs rather rarely in canonical Buddhist texts (eleven times, according to an electronic search). While this is certainly faint evidence for a connection, the possibility that the Divākara text was influenced by Fazang's seems worth thinking about, and is

made more likely by the fact that Divākara and Fazang worked together as translators. See, for example, Fazang's *Huayan jing tanxuan ji*, T no. 1733, vol. 35: 111c.

126. *Zuisheng foding tuoluoni jingchu yezhang zhoujing*, T no. 970, vol. 19: 360b.

127. Comparison with worlds far removed in time and place from the one under examination is probably rarely a helpful move in a strictly historical study, but here one might be forgiven for wanting to remind the reader of a modern work, if only for the pleasure it gives. William Butler Yeats's "Sailing to Byzantium" might echo something here: " . . . Consume my heart away; sick with desire/And fastened to a dying animal/It knows not what it is; and gather me/Into the artifice of eternity.// Once out of nature I shall never take/My bodily form from any natural thing,/But such a form as Grecian goldsmiths make/Of hammered gold and gold enameling. . . ." In considering any parallels here, however, one would do well to keep in mind that Yeats himself reportedly sought enhanced life not through perfect artificial substance but through the grafting of a monkey's thyroid gland onto his body.

128. T no. 970, vol. 10: 361a.

129. ibid., 350a.

130. For an extended meditation on this and related themes, see Cole, *Mothers and Sons in Chinese Buddhism*.

131. See the discussion of this text in the introduction.

132. Zhou, *Dunhuang bianwen* 1: 273–333.

133. For an illuminating discussion of this exegetical tactic in the context of the Chandogya Upaniṣad, see Lincoln, "How to Read a Religious Text," 130ff.

134. As will soon be apparent, these quotations from the text often differ from the received edition of the *Da zhidu lun*. The differences seem sometimes to be simply scribal errors, while at others they reflect substantive variations.

135. The corresponding passage in the received edition of the *Treatise* reads, "Contemplate the five impure marks of the body/person," T 25: 198c.

136. The text presents the five impurities in an order different from that of the received text, in which the first impurity is "the impurity of the birth location." "The impurity of the seed" is the second in that text.

137. Or, *karma* and *kleśa*.

138. The line in the corresponding received text reads, perhaps, "it is not a remnant of a marvelous treasure." T vol. 25: 199a.

139. The received text reads here, "it is not from pure whiteness born, but issues from the urinary tract" (p. 199a). We might also note in passing that the fact that, according to legend, the Buddha was born out of his mother's side when he "descended to birth." See S. 2440 (Zhou, *Dunhuang bianwen*, 1056).

140. The received version reads "birth location" (p. 198c).

141. The received version reads, "This body is reeking and filthy, it was not born amid blossoms" (p. 198c).

142. The *Yiqie jing yinyi* describes the Campaka tree as follows: "it is tall with large and exceedingly fragrant flowers whose aroma travels far on the wind" (T no. 2128, 54: 363b). There are many different baoshans spoken of in Buddhist texts; it is unclear if one specific mountain (or range) is intended here. The Taisho edition reads, "Indeed not from Zhampu, nor from a Jewel Mountain" (p. 199a).

143. Morris and Hardy, eds., The Aṅguttara Nikāya, 4: 377; discussed in Wilson, *Charming Cadavers*, 50–51.

144. T vol. 19: 353b.

145. T vol. 19: 350a.

146. *Miaofa lianhua jing*, T no. 262, vol. 9: 53b.

147. Benn, *Burning for the Buddha*.

148. Quoted (with permission) from the draft version of his paper "Self-cultivation and self-immolation: preparing the body for auto-cremation in Chinese Buddhism."

149. The text is unclear on this point. But while the prose sections are simply commentary on the *Lotus Sūtra* text, the portions in verse seem to be directed toward the audience in more personal ways.

150. That is, *chang*.

151. Zhou, *Dunhuang bianwen*, 231–232.

152. Most notably in the *Song gaoseng zhuan* (p. 871c) and the *Da fangguang fo Huayanjing ganying zhuan* (p. 176c), on which see below.

153. *Huayan jing chuanji*, T no. 2073, vol. 51: 167a.

154. Mrozick says that the only extant Sanskrit manuscript of the text, however, is dated to the thirteenth or fourteenth century. According to Hōbōgirin, the Chinese translation (*Dasheng ji pusa xuelun*; T no. 1636) dates to the early eleventh century.

155. Mrozick, "The Relationship Between Morality and the Body," 179. I have removed her parenthetical notations of the Sanskrit for the terms of this sentence, as well as the one quoted below.

156. Ibid., 179–180. The *Compendium* is here quoting the *Tathāgataguhya sūtra*.

157. Ibid.

158. Campany, *To Live as Long as Heaven and Earth*, 21–22.

159. The difficulties of translating this term are well known and I think at this point moot, given its wide acceptance in contemporary usage. Campany, though he seems to mostly agree with this position, follows Bokenkamp's usage in mainly translating it as "pnuema," a term that echoes qi's primary sense of "breath." His

capsule description of the term is helpful: "for religious thought and practice, the significance of qi is that all things are made of it, exist in it, and share it; heaven and earth, gods, humans, lesser spirits, animals, plants, minerals—all are consubstantial, despite the great range of qualities exhibited by qi in these various forms, and this consubstantiality provides a kind of ladder connecting all levels of being, a ladder that could be climbed by systematically working on and transforming the qi constituting oneself" (Ibid., 18–19).

160. Ibid., 21–22.

161. Ibid., 19.

162. T no. 2074, vol. 51: 174b-c. In another version, the boy takes the dirt from under his fingernails and gives it to the monk to take as medicine (T no. 2073, vol. 51: 165c).

163. T no. 967, vol. 19: 351a-b.

164. Owen, "A Monologue of the Senses," 245.

165. T no. 1803, vol. 39: 1028a–1033c. It appears in Shūei's (in China, 862–866) catalog, Shinshosha shōraihōmon tō mokuroku, Newly Copied Buddhist Texts Requested and Brought [From China]; T no 2174a, vol. 55: 1110b), where it is called simply Foding zunsheng tuoluoni jing shu, Commentary on the Scripture of the Glorious Dhāraṇī of the Buddha's Crown, an alternate title that appears in the body of the received version of Fachong's text. The oldest extant manuscript of Shūei's work dates from the Kamakura period (1185–1333), but elements from it were cited in texts discovered at Dunhuang. For a fuller exploration of this text, see Copp, "Anointing Phrases and Narrative Power: A Tang Buddhist Poetics of Efficacy."

166. At least three glossaries of the words that make up the Incantation of Glory remain among our sources. Two were apparently produced within Amoghavajra's (Bukong 705–774) Esoteric Buddhist circle in the eighth century; an anonymously produced third is contained in the Beijing collection of Dunhuang manuscripts (B. 7323 [Shuang 13], in DHBZ 105: 466a–471b). The two glossaries from Amoghavajra's circle appear in works whose existence in late medieval China is evidenced mainly by their presence in ninth-century Japanese catalogs of works brought back to Japan from China: Annen's (fl. 884) Sho ajari shingon mikkyō burui sōroku, Comprehensive Catalog of the Shingon [i.e., "real word"] Esoteric Teachings of All the Ācāryas, T no. 2176, vol. 55., and Shūei's (in China, 862–866) Shinshosha shōraihōmon tō mokuroku, Newly Copied Buddhist Texts Requested and Brought [From China]. The first set of glosses, which circulated independently, was called Foding zunsheng tuoluoni zhuyi, Commentary on the Meaning of the Glorious Dhāraṇī of the Buddha's Crown; T no. 974d. Its authorship is attributed to Amoghavajra. The second, which I will focus on here, is much larger and offers more details for analysis. Other glosses on other spells also exist, two of which I will discuss below.

167. On the status of the Qianfusi among its peers, see Xiong, *Sui-Tang Chang'an*, 265.

168. On the Amoghavajra version of the *Renwang jing* (T no. 246) see *Daizong chaozeng sikong da bianzheng guangzhi sanzang heshang biaozhi ji*, T no. 2120, vol. 52: 831b; Weinstein, *Buddhism Under the T'ang*, 78; and Orzech, *Politics and Transcendent Wisdom*. On his version of the *Da xukong pusa suowen jing* (T no. 404) see *Zhenyuan xinding shijiao mulu*, T no. 2157, vol. 55: 888a.

169. *Daizong chaozeng sikong da bianzheng guangzhi sanzang heshang biaozhi ji*, T no. 2120, vol. 52: 834c.

170. It is important to note that, though the spell is treated the way it is in this text at least in part because it is a dhāraṇī in a sūtra, a part of a narrative, the glosses were appended to versions of the spell that circulated free of the sutra as well. The meaningfulness of the spell was thus not simply a result of its enclosure in a narrative.

171. Most of these categories seem to be of Fachong's own coinage, though a few of them occur elsewhere. "Clearing away the bad trajectories," for example, is an explanatory rubric in Bodhiruci's translation of the "Assembly of Bodhisattvas of Inexhaustible Wisdom," collected within the *Ratnakūṭa sūtra*, though it is unclear what, if any, connections might obtain between these two texts (*Da baoji jing*, T no. 310, vol. 11: 648c). It occurs as the fifth in a series of ten elements that constitute the bodhisattva's perfection of ethics, or śīla (jie).

172. I have inserted the numbers of the explanatory headings for reference and treated the text within each heading as if it were a sentence. At times Fachong provides alternate glosses on a term; I have included them in brackets. In addition, I have included the Sanskrit of those translated terms, such as oṃ, or abhiṣeka, I deem especially common in Buddhological usage.

173. It should be emphasized that, though, as I have presented it here, this text might appear to be a performance script, a prayer or invocation, this appearance is an illusion. It was not intended for performance; indeed, the shape I have given it is artificial. The "text" is the product of Fachong's interpretive analysis of the dhāraṇī—the actual performance piece. Monks did not chant this translation, in other words, but would have read it (or heard it expounded) for the understanding it provided of the dhāraṇī and its practices. This is a crucial, if obvious, distinction to keep in mind, and one that Fachong himself is at pains to make in his text.

174. See Tanabe, *Myōe the Dreamkeeper*, 138ff, for a discussion of the thirteenth-century Japanese monk Myōe's use of this imagery in his explanation of the power of the kōmyō shingon, a spell whose practice in medieval Japan (as noted earlier) bore striking resemblances to the much earlier enactments of the *Incantation of Glory*. Myōe described the workings of the mantra's power through analogy with a scene

in the *Huayan jing* where "all the buddhas . . . spoke into their right hands and rubbed Samantabhadra's [the figure who, empowered in this way, speaks for the Buddha in the text] head, thus transferring to him their virtue through their hand-held words" (138).

175. See, for example, Kapstein, "Scholastic Buddhism and the Mantrayāna."

176. T vol. 39: 1029b.

177. According to Yixing in his commentary on the *Mahāvairocana sūtra, xiang* in this phrase does not denote cognitive activity but "that which is distinguished [from something else]," i.e., in a process homologous to the productions of thought. He goes on to explain the term by noting that all the different mantras (or real words) derive from one single syllable (*a*), which is to make a distinction between the undifferentiated (the one "one-syllable mantra") and the differentiated (the countless multisyllabic spells). *Da piluzhena chengfo jingshu,* T no. 1796, vol. 39: 775b–776a. The phrase seems to derive from the *Mahāvairocana sūtra.*

178. It is unclear if "held" (*zhi*) simply means "made by the hands," or if it refers to ritual stamps that one holds in ones hands. The verb is employed to describe both activities in Buddhist texts.

179. T vol. 39: 1030a. The passage goes on to detail practices involving the four directions.

180. That is, the affective and cognitive hindrances to awakening; on which see canonical discussions in the *Yogācārabhūmmi* (T no. 1579, vol. 30: 327a and 345b) and the *Cheng weishi lun* (T no. 1585, vol. 31: 1a).

181. T vol. 39: 1029c. Note the close association here between the empowering luminosity of the spell and the practice of anointing the dead with enchanted dirt, discussed early in this chapter.

182. *Shaiji* also at times renders the Sanskrit "*sukha,*" or "joy."

183. My translation of this line is tentative. It reads *zhiqian jiekong.* I take the first two characters to be shorthand for phrases such as "*pozhi qianmi,*" as found (for example) in the *Mohe zhiguan* (T no. 1911, vol. 46: 68b).

184. References to "sweet" or "refreshing" rains have an ancient lineage in Chinese literature, stretching at least back to the *Shijing.* The poem "Futian" from the Xiao Ya section reads "in offering to the ancestor of the fields, in praying for refreshing rains." The *Chunqiu zhengyi* clarifies the meaning of "refreshing rains" in this poem: "The *Shijing* states: 'In praying for refreshing rains.' Here [the text] mentions 'distressing [literally, 'bitter'] rains.' There is only one kind of rain, and there is no difference between them in terms of tasting 'bitter' or 'sweet.' If it nurtures [the myriad things], it is 'refreshing'; if it harms [the myriad things], it is 'distressing.'" (*Chunqiu Zuo zhuan zheng yi* 42.1379). My thanks to Alexei Ditter for

providing these references. The translations here are his (Ditter, "Genre and the Transformation of Writing in Tang Dynasty China," 168 n51).

185. T vol. 39: 1030b.

186. That is, the "wisdom that is like a great spherical mirror" (*da yuanjing zhi*), the "wisdom [that sees] all things as equal in nature" (*pingdeng [xingzhi]*), the "wisdom of subtle observation" (*miao guan [cha zhi]*), and the "wisdom of the completion of deeds" (*cheng suozuo zhi*). See *Cheng weishi lun*, T no. 1585, vol. 31: 56a.

187. T vol. 39: 1033a.

188. See chapter 1 for an exploration of the ritual relationships seen to obtain between seals and spells.

189. T vol. 39: 1030c.

190. As I explore in a separate article on these glosses ("Anointing Phrases and Narrative Power"), the complications it lends what seems on the surface a rather simple text are not limited to narrative structure. Fachong presents a split-screen picture of the action of the spell, describing on the one hand the ways that any speaking of it universally transforms (almost) all beings of the cosmos and, on the other, reiterating a particular practice of the spell. This turns out to be characteristic of his method. His text is simultaneously a narrative of the spell's unfolding, a guide to the ritual implementation and practices of the spell, and a study book of its philosophical nuances.

191. Or (see below), "*momo*." Both appear to be transliterations of the Sanskrit enclitic *me*, which acts as a first person pronoun.

192. Each of the canonical versions of the sūtra contains a version of this instruction. In the Buddhapālita version it is contained in both versions of the spell, the first is located at T no. 967, vol. 19: 350c, where it reads simply "call out a name" (*cheng ming*); the second is at T no. 967, vol. 19: 352b. It reads "the one who receives and keeps should himself chant his name at this point." The instructions occur twice in the Du Xingyi version. In both instances the text reads "*meme* is to say: so and so, the one who receives and keeps [the spell], should at this point chant out his name" (T no. 968, vol. 19: 353c). The first Divākara version reads simply "call out your own name" (T no. 969, vol. 19: 356b), while the second seems to be the locus classicus for the many manuscripts and inscriptions that have *momo* instead of meme. Its explanatory note reads, "call out a name instead of these characters [that is, *momo*]" (T no. 970, vol. 19: 359b). The Yijing version, finally, reads, "Chant your name yourself: 'I so and so'" (T no. 971, vol. 19: 362c). Similar instructions are fairly common in dhāraṇīs from at least the seventh century, though not all spells have this component. See, for example, the eleventh "great spell of the horse-headed bodhisattva Guanshiyin" (*Matou Guanshiyin pusa dazhou*), collected in the

Foshuo tuoluoni jing (T no. 901, vol. 18: 835b), compiled by Atikūṭa (var. Atigupta; Adijuduo) (fl. 653–4); and the second "shouted seal" (*huanyin*, a genre of spells that seems to have been limited to Bodhiruci's translations), the "Yiqie dinglun-wang tongqing huanyin," contained in the *Yizi foding lunwang jing* (T no. 951, vol. 19: 257a), compiled by Bodhiruci (Putiliuzhi), active in China, 693–727; d. 727).

193. DHBZ, vol. 105: 480a. This is close to a formulation found in the Du Xingyi version of the sūtra. The fact that this formulation is common among the Dunhuang manuscripts is suggestive: once again, though the Buddhapālita version of the text was thought to be the most influential, the Du Xingyi version seems to have been important as well. See also, for example, B. 7371 (Sheng 7) and S. 165.

194. Individual scriptures in the Song edition of the canon did have colophons detailing their specific donors, however.

195. Harrist and Fong, *The Embodied Image*, 103.

196. T no. 1803, vol. 39: 1032a-b.

197. As noted earlier, the reader interested in dhāraṇī pillars should consult Liu Shufen, *Miezui yu duwang*, and the in-process study of the pillars by Kuo Liying (an early report of which is available in Kuo, "Bucchōsonshōdarani no dempa to gishiki"), which promises to greatly deepen our knowledge of these important objects.

4. MYSTIC STORE AND WIZARDS' BASKET

1. Davidson, *Indian Esoteric Buddhism*. See Hidas, "Mahāpratisarā-Mahāvidyārājñī, The Great Amulet, Great Queen of Spells," 17 (drawing in part on Williams and Tribe 2000, 271), for example, which notes in particular that the early version of the *Mahāpratisarā* scripture was part of this body of practice. For *Vidyādhara-piṭaka* as a term for dhāraṇī practice, see below.

2. I take the term *esoteric synthesis* from Davidson *Indian Esoteric Buddhism*, on which see below.

3. Waley, *A Catalogue of Paintings*, viii.

4. See, especially, the excellent "Thaumaturgy" chapter in Kiechnick, *The Eminent Monk*, and chapter 4 of Reis-Habito, *Die Dhāranī des grossen Erbarmens des Bodhisattva Avalokiteśvara mit tausend Händen und Augen*; as well as Gentetsu, "Kōsōden no ju"; Sharf, *Coming to Terms with Chinese Buddhism*, 263–278; and McBride, "Dhāranī and Spells."

5. For critiques of this model see Abé, *Weaving of Mantra*, 152–154; and Sharf, *Coming to Terms*, 263–278. The term zōmitsu ("mixed" or "diffuse" esotericism) seems to have been first used by the monk Ekō (1666–1734; Sharf, *Coming to Terms*, 267). More recent Japanese scholarship has largely moved beyond this model, often

calling the earlier material "ancient Esoteric Buddhism" (komikkyō). See, for example, Nara Kokuritsu Hakubutsukan, Komikkyō: Nihon Mikkyō no Taidō, who gave their book—an excellent catalog of images, objects, and manuscripts of, in many cases (in my view), pre-Esoteric dhāraṇī practices—the subtitle "the incipient stages of Japanese Esoteric Buddhism" (the translation is their own). Such understandings clearly maintain the basic assumption that earlier dhāraṇī rites and iconographies were simply early and relatively crude forms of the later high tradition, and not (as I see the parallel Chinese material) as a wide family of practices with their own logics and trajectories separate from those of the later synthesized high tradition that had (in India) grown from it. See also Abé, Weaving of Mantra, 152–167, who, even as he demolishes the usefulness of the old jun/zō model, still speaks of the "invisibility" of the esoteric as a category in the earlier Japanese traditions, rather than simply of its absence.

6. For the most influential use of the concept "proto-Tantra," see Strickmann, Mantras et mandarins. For critiques of Strickmann's position, see Sharf, Coming to Terms, 265ff, and McBride, "Dhāraṇī and Spells." Sharf and McBride take a rather extreme view in these works—and one that is effectively the opposite of the one taken by Abé, as described in the previous note—rejecting altogether the rubric of "esotericism" in their treatments of dhāraṇī practices and related material. For an argument that they may have gone too far in their conclusions, see Gimello, "Manifest Mysteries." For an extensive assessment of these issues and sources, see also Orzech, "The 'Great Teaching of Yoga'."

7. The literature on invented traditions is now vast. For representative works, see the essays collected in Hobsbawn and Ranger, The Invention of Tradition. For an especially insightful study of an East Asian example, see LaMarre, Uncovering Heian Japan.

8. See, again, Abé, Weaving of Mantra, 152–154; and Sharf, Coming to Terms, 263–278 (for example).

9. Davidson, Indian Esoteric Buddhism, passim, and especially 116–118.

10. Ibid., 117. Charles Orzech, responding to Richard McBride's somewhat different view (McBride, "Dhāraṇī and Spells"), draws a similar analogy to the use of "Chan" as the emblem for a new Buddhist way (Orzech, "The 'Great Teachings of Yoga'").

11. As well as in later dhāraṇī collections such as Shouhu guo jie zhu tuoluoni, the Sūtra of Dhāraṇīs for Safeguarding the Nation, the Realm, and the Chief of State, T no. 997. Translated by Prajña (Bore) [744–810] and Muniśrī (Mounishili) [d. 806]), translated in 790. I am grateful to Ronald Davidson for alerting me to this text's importance in this regard.

12. Da Song sengshi lüe (Zanning, 919–1001). T no. 2126.

13. T no. 2126, vol. 54: 240a-b.

14. The question of the proper translation of *mizang* is worth a brief consideration (though this chapter as a whole is in part an explication of its wider meanings as Zanning's work implies them). Zanning's use of the compound suggests connections among a great range of East Asian Buddhist traditions and bodies of literature, including most obviously those of Esoteric, or Tantric, Buddhism. *Mizang* might also profitably be translated as the "secret-," "esoteric-," "occult-," "hidden-," "essential-," "transcendent-," or "sublime-store." Though some will surely object that the word is burdened with too many unhelpful associations, "mystic," I think, is the right word here: it suggests the latter three senses of *mi* listed in the previous sentence while avoiding the sociological implications of "esoteric." Social practices of enforced secrecy were not always a feature of dhāraṇī traditions, as earlier chapters of this book have made clear (though it is important to note at the outset that Zanning himself begins his essay invoking a separatist notion of *mi*). The images of hiddenness implicit in terms such as *mizang* were most basically figures of incomprehensible spiritual essence rather than of the protected secrets of a lineage or school. We see this understanding of *mi* perhaps most clearly in the preface on the translation of the *Tuoluoni jijing*, which employs, in part, the Laozi-derived vocabulary of Tang elite "Buddho-Daoist" thought: "The methods of dhāraṇīs, seals [i.e., mudrās], and altars are the heart and marrow of all the scriptures and guide the myriad practices. Their principle is profoundly mystic (*zong shen mimi*) and cannot be understood by shallow minds; their meaning extends deep into mystery (*chongxuan*) and is not something thought can penetrate. The mystic essence within the mystic essence (*mizhong geng mi*), it cannot be named" (*Foshuo tuoluoni jijing fanyi xu*, T no. 901, vol. 18: 785a). Though it would surely be naïve to imagine that figures of mystic hiddenness were employed in ways innocent of elitist or separatist social formations, often indeed as their very emblems, neither do I think would it be true to these images to foreground such formations in every instance. As a matter of method, I will attempt to reserve "esoteric" for those discursive and social contexts where social secrecy is clearly implied—such as the esoteric dispensations controlled by Bukong and his disciples in the eighth century—and "mystic" for those contexts where a more generally spiritual image seems to me in play. Charles Orzech, particularly in his recent work, has made the clearest arguments about this understanding of Bukong's lineage. My use of the term *dispensation* is drawn from Orzech, "The 'Great Teachings of Yoga'."

15. *Song gaoseng zhuan*. Zanning (919–1001). T no. 2061, vol. 50:717c. See chapter 3 for a discussion of this account.

16. On "grasp" as a translation of *chi* in this context, see the introduction.

17. This statement is an adaptation of a line in the *He weimi chi jing ji* by Zhi Qian (a.k.a. Zhi Gongming; third c.), as quoted in *Chu sanzang jiji*, T no. 2145, vol. 45: 51c. The passage in the received text does not make a statement about the nature of "spirit spells," however. Instead, it equates "encompassing grasps" with "secret and sublime grasps."

18. For Wang Dao's official Jinshu account, see *Jinshu* 65.35. For his place within the Buddhist tradition, see, for example, *Gaoseng zhuan* (T no. 2059, vol. 50: 327c), *Chu sanzang jiji* (T no. 2145, vol. 55: 98c), *Fozu tongji* (T no. 2035, vol. 49: 339b and 345a), and *Shenzhou sanbao gantong lu* (T no. 2106, vol. 52: 405a).

19. For Zhou's (a.k.a. Zhou Yi) official *Jinshu* account, see *Jinshu* 69.39. For accounts of him within Buddhist texts, see *Gaoseng zhuan* (T no. 2059, vol. 50: 327c and 367b), *Chu sanzang jiji* (T no. 2145, vol. 55: 98c), *Bianzheng lun* (T no. 2110, vol. 52: 505b), and *Hongming ji* (T no. 2102, vol. 52: 69a), among many others.

20. Or, simply, "was skilled at wielding incantations." I translate *zhoushu* as "incantations arts" here in order to preserve its parallel with "incantation methods" (*zhoufa*) below. Both terms seem to simply mean "incantations."

21. The *Mahāmayūri-dhāraṇī*. Note here that *mi* refers not to the nature of his translation (that is, "secret") but to Śrīmitra himself—*mi* is a component of his transliterated name. This is clearer in the *Gaoseng zhuan* account Zanning drew upon (on which see below) than it is here.

22. As I discuss later, the words I read as "well-enchanting branch" might also be read "enchanting of wells and trees."

23. As Sharf points out (Sharf, "Coming to Terms," 342, n. 42), this little-known monk is credited with "the translation of four dhāraṇī works preserved in the Taishō canon (T. 1035, T. 1038, T. 1057, and T. 1103)." See also Yoritomi, *Chūgoku mikkyō no kenkyū*, 121.

24. Though Zanning appears to have gotten the date wrong, this is the *Incantation of Glory*. This account is drawn from one dated 770 in *Daizong chazeng sikong da bianzheng guangzhi sanzang heshang biaozhi ji*, T no. 2120, vol. 52: 837c–838a. See chapter 3 for a brief discussion of this event. Note also that another spell called the *Incantation of the Buddha's Crown* achieved prominence in the reign of Tang Daizong. According to *Daizong chazengi sikong da bianzheng guangzhi sanzang heshang biaozhi ji*, Bukong presented a sandalwood image of Marīci (Molizhi) and an Indic language edition of the *Da foding tuoluoni* to the emperor Daizong on the thirteenth day of the tenth month of 762 (baoying 1) (T no. 2120, vol. 52: 830a). *Zhenyuan xinding shijiao mulu* states that this occurred on the tenth day of the seventh month of 763 (baoying 2) (T no. 2157, vol. 55: 884a). Weinstein, citing both these accounts

follows the 762 date (Weinstein, *Buddhism Under the T'ang*, 77). Zanning may have partly conflated these two spells.

25. For Zanning's fuller account of this dream in the *Song gaoseng zhuan*, see T no. 2061, vol. 50: 870c. For more on dreams in Buddhism see, for example, Laufer, "Inspirational Dreams in Eastern Asia," Strickmann, "Dreamwork of Psycho-Sinologists," and Strickmann, *Mantras et mandarins*, 291–336.

26. Li Congke, r. 935–936.

27. *Da Song sengshi lüe*, T no. 2126, vol. 54: 240b-c.

28. See Welter, "A Buddhist Response to the Confucian Revival."

29. See Sen, "The Revival and Failure of Buddhist Translations," and Orzech, "The 'Great Teachings of Yoga'," 36–40.

30. On the nature and history of medieval Indian Esoteric Buddhism, see Davidson, *Indian Esoteric Buddhism*.

31. See Orzech, "The 'Great Teachings of Yoga'," for a discussion of Zanning's differentiation of the two traditions.

32. *Daizong chaozeng sikong da bianzheng guangzhi sanzang heshang biaozhi ji*, T no. 2120, vol. 52: 837c–838a.

33. I emphasize "seems" because the proper reading of the line is not wholly clear. Zanning might mean that buddhas and bodhisattvas are able to roam and encompass the occult treasury, that is, that its contents are among the things that these beings have mastered.

34. T no. 1011, vol. 19.

35. A brief note on my use of the term *wizardly* might be in order here, given that *thaumaturgical* has become the standard term in English language discussions of Buddhist spell casters. I prefer *wizard* because its etymological roots connect it with the words *wise* and *wisdom*. This, particularly when the arts the "wizard-monks" under discussion employ are *dhāraṇīs*, a term that itself connects etymologically with Buddhist terms such as *Dharma*, seems truer to the spirit of the case than the alternative. "Wizard" seems even more apt when translating (as below) the term *vidyādhara* (Ch. *chiming*), often translated as "sorcerer" (a term that, unhelpfully here, connects etymologically with words for divination practice), given that *vidyā* (Ch. *ming*), meaning in these uses "incantation" or "magical power," in other contexts means "illumination," "understanding," and by extension "wisdom," in Buddhist usage. *Thaumaturge*, with its roots in terms meaning "marvel" and "work," seems more in line, perhaps ironically given the explicit discussions of Zanning himself on this matter, with Buddhist polemical characterizations of non-Buddhist techniques. See Faure, *The Rhetoric of Immediacy*, 103, for a helpful discussion of Zanning's stance on these issues.

36. Zhiqian translated at least three other spell texts in addition to this one: T nos. 1300, 1351, and 1356.

37. *Chusheng wuliangmen chi jing*, tr. Buddhabhadra (Fotuobatuoluo, fl. early fifth c.), T no. 1012, vol. 19: 682–685. *Anantuomuqieni helituo jing*, tr. Guṇabhadra (394–468), T no. 1015, vol. 19: 692–695. *Chusheng wubianmen tuoluoni*, tr. Bukong (705–774), T no. 1009, vol. 19: 675–679.

38. Kieschnick, *The Eminent Monk*, 94.

39. Ibid., 84. Śrīmitra's status as canonically established forefather of Buddhist spell arts made him an attractive figure to anchor, in turn, the canonical status of an "apocryphal" text. Michel Strickmann notes the fact that the text most closely associated with Śrīmitra, the *Guanding jing*, or *Consecration Sūtra*, a large collection of occult lore, was actually composed over a century after he died. His connection with the work was not asserted until considerably later (Strickmann, "The Consecration Sutra," 79–80). Śrīmitra's link with the *Scripture of the Peacock King*—the *Mahāmayūrī dhāraṇī sūtra*, one of the most widely practiced Buddhist spell texts—may have been due to a similar process of virtue by association. Aside from Huijiao's and Zanning's texts, there is no evidence that Śrīmitra translated this work; none of the surviving medieval bibliographical works mention such a version, at least.

40. The same account is included in Sengyou's *Chu sanzang jiji*, a text upon which Zanning had already drawn, and which had been completed seven years earlier than Huijiao's work, in 512 (a fact that suggests it was probably the source for Huijiao's text, at least in this case). Perhaps Zanning found Huijiao's work a more prestigious, or reliable, source, or perhaps his own involvement in carrying forward Huijiao's project made him more sympathetic to the later work. (*Gaoseng zhuan*, T no. 2059, vol. 50: 328a. *Chu sanzang jiji*, T no. 2145, vol. 55: 99a). The latter text transliterates the mi in Śrīmitra's name as mi 1, while the former text uses mi 2, strongly suggesting that Zanning did indeed follow Huijiao's text.

41. Mili was credited by Sengyou as being the transmitter of the *Da biqiuni jie, Great Bhikṣuṇī Precepts*, a text already however lost by Sengyou's day (*Chu sanzang jiji*, T 55c). See also the entry in the *Kaiyuan shijiao lu*, which (following the *Zhongjing mulu*, but unlike Sengyou's account) notes that Mili was Śrīmitra's disciple (*Kaiyuan shijiao lu* 18, T no. 2154, vol. 55: 673c).

42. T vol. 50: 328a and T vol. 55: 99a.

43. *Foshuo hu zhu tongzi tuoluoni jing*, tr. Bodhiruci (Putiliuzhi, d. 527), T no. 1028. This reckoning of his spell texts does not count the dhāraṇīs included in the Mahāyāna scriptures he translated. Jingmai's account is found in his *Gujin yijing tuji, Illustrated Record of Translated Scriptures of the Past and Present* (T no. 2151).

44. *Xu gaoseng zhuan*, T no. 2060, vol. 50: 428c–429a. A slightly different rendering of this tale may be found in Kieschnick, *The Eminent Monk*, 87. The tale was widely reported. See, for example, in addition to Huijiao's and Zanning's texts, Zhisheng's *Kaiyuan shijiao lu*, T no. 2154, vol. 55: 542a; Yuan Zhao's *Zhenyuan xinding shijiao mulu*, T no. 2157, vol. 55: 840b; Jingmai's *Gujin yijing tuji*, T no. 2151, vol. 55: 364a; Huibao's (ninth c.) commentary to Shenqing's (766–820?) *Beishan lu*, T no. 2113, vol. 52: 612a; and Huixiang's *Hongzan fahua zhuan*, T no. 2067, vol. 51: 17b-c (the latter three texts do not contain the detail about Bodhiruci refusing to teach his occult arts). As an aside on Bodhiruci's well enchantments, Daoshi's (d. 683) *Fayuan zhulin* contains a spell used to enchant the water of wells, pools, rivers, and springs, transforming it into a universally efficacious medicine. Notably, the incantation is attributed to the version of the "Dhāraṇī for the Protection of Children" found in the *Tuoluoni zaji, Dhāraṇī Miscellany*, though it is not included in the received editions of either the latter text or the freestanding version of the dhāraṇī scripture attributed to Bodhiruci (*Fayuan zhulin*, T no. 2122, vol. 53: 743b).

45. *Qianyan qianbei Guanshiyin pusa tuoluoni shenzhou jing*, T no. 1057a; *Qianzhuan tuoluoni Guanshiyin pusa zhou jing*, T no. 1035; *Guanzizai pusa suixin zhou jing*, T no. 1103; *Qingjing Guanshiyin Puxian tuoluoni jing*, T no. 1038.

46. Strickmann, *Mantras et mandarins*, 144. Note, however, that Strickmann mistakenly says the texts were translated between 627 and 649. According to the *Song gaoseng zhuan*, this is the period during which the Indic original of the text of *Guanyin of a Thousand Arms and Eyes* was presented to the court by an unnamed north Indian monk and when Emperor Taizong consented to its translation by Zhitong. Zhitong's actual translation of this sūtra, according to the *Song gaoseng zhuan*, occurred in 653 (T no. 2061, vol. 50: 719c). The text in question, *Qianyan qianbei Guanshiyin pusa tuoluoni shenzhou jing*, the *Scripture of the Dhāraṇī Spirit Spell of the Bodhisattva Guanshiyin of a Thousand Eyes and a Thousand Arms*, is of historical importance not only for its content. The preface to the edition of Zhitong's translation that was included in the Korean canon, composed at some point after 697, contains an anecdote that bears a rather close resemblance to a slightly later and more famous incident—one, like this one, central to the arrival and translation of a major dhāraṇī scripture—and hence takes on an almost paradigmatic cast. The preface relates that when the text and its attendant images and rites were first introduced to the imperial court, during the reign of Emperor Gaozu (r. 618–626), they met with the emperor's disfavor. The central Indian monk who brought them, named Juduotipo is otherwise unattested in surviving sources. When the next emperor, Taizong, was presented the text, this time by an unnamed monk from northern India, he had it and its ancillary mudras and rites translated. These

incidents echo, though in simpler form, the story of the treatment received at court by the *Uṣṇīṣavijaya dhāraṇī-sūtra* not long before the present preface was composed. As Timothy Barrett and others have noted, this latter tale seems to have been part of the legitimation campaigns of the newly crowned Empress Wu (Barrett, "Stūpa, Sūtra, and Sarīra in China," Forte, "The Preface to the So-Called Buddhapālita Chinese Version Of the *Buddhoṣṇīṇa Vijaya Dhāraṇī Sūtra*," and Chen, "Śarīra and Scepter: Empress Wu's Political Use of Buddhist Relics," et al.). The tale of the imperial snubbing of the dhāraṇī of Guanshiyin of a Thousand Eyes and Arms may have been created within the same milieu.

47. Strickmann, *Mantras et mandarins*, 144. For discussions of Zhitong as a figure of Esoteric Buddhist tradition, see *Song gaoseng zhuan*, T no. 2061, vol. 50: 719c–721a; Strickmann, *Mantras et mandarins*, 144–146; Ōmura, *Mikkyō hattatsushi*, 179–192, and Yoritomi, *Chūgoku mikkyō no kenkyū*, 121.

48. The most extensive study of Amoghavajra in a Western language remains that found in Orzech, *Politics and Transcendent Wisdom*.

49. See *Song gaoseng zhuan*, T no. 2061, vol. 50: 870c–871a; *Fozu tongji*, T no. 2035, vol. 49: 391a–b; and *Xinxiu kefen liuxue sengzhuan*, XZ 2B: 6: 489b–c. As far as I can determine, Daoxian is mentioned only once in the *Wudai shi*, in the biography of Li Congchang (d.u.), the second son of Li Maozhen (856—924), once King of Qi and later Prince of Qin under Li Cunxu (885–926, r. 923–926), the first emperor of the Later Tang. Li Congchang, who served as a general under Li Congke, is said to have been a disciple of Daoxian's. Daoxian is not mentioned by name, but the "acārya who understood the languages of the five regions of India and was followed by men of the *shi* class (*shiren*)" would seem to be him. See *Jiu Wudai shi* 132.1.

50. See Benn, *Burning for the Buddha*, for an extensive and important study of self-immolation in Chinese Buddhism.

51. *Song Gaoseng zhuan*, T 50: 870c–871a.

52. *Gaoseng zhuan*, T no. 2059, vol. 50: 383b-c. Translation, Wright, "Fo-t'u-teng: A Biography," 339.

53. Faure, *The Rhetoric of Immediacy*, 97–98.

54. For his full discussion of the place of "thaumaturgy" in the Chan tradition, see Faure, *The Rhetoric of Immediacy*, 96–131.

55. *Fozu tongji*, T no. 2035, 49: 39b.

56. Unlike most of the ritual modes prescribed in dhāraṇī sūtras and esoteric texts, we have extra-scriptural evidence of the use of powder altars in the early Song. Zhipan reports that ritual spaces drawn with powder were part of the physical set up of the space in which at least some early Song translations of tantras and sūtras were made. Translation, as one of the most central and revered Buddhist

practices during the medieval period—Zanning himself awards translators pride of place in his *Biographies*—was not primarily an affair of the scholar's study. Zhipan makes clear that the production of translations was a ritual act enacted within carefully prepared sacramental spaces. In the case he describes, powder altars were a key part of those spaces: "On the western side of the Eastern Hall, powder is used to arrange a sacred altar (constructing an altar by means of powder is attested in canonical texts). Indian monks are installed at each of the four open gates [of the altar, where they] chant secret incantations for seven days and nights. In addition, a wooden altar is constructed, composed of a syllable wheel [*zilun*] arranged with the names of saints and worthies. (The shape of this altar is perfectly round. Arrayed in relief upon it at their appropriate station are the names of buddhas, bodhisattvas, gods, and spirits. Its form is like that of a cart-wheel.)" (*Fozu tongji*, T no. 2035, vol. 49: 398b and *Song Huiyao* 200: 7891b. The sentences in parentheses are the commentary on the passage included in the text. For other translations and discussions of this passage, see Sen, "The Revival and Failure of Buddhist Translations," 35ff.; Bowring, "Brief Note: Buddhist Translations During the Northern Sung," 91; and Jan, "Ch'uan-fa yuan: The Imperial Institute for Transmission of Buddhadharma," 84.) One of the most detailed descriptions of a powder altar is included in a ritual text translated by Tianxizai (Devaśāntika) toward the end of the tenth century. The Buddha is offering teachings:

Now, I will speak of powder altar-maṇḍalas. [In terms of size,] they can be of two *zhou*, four *zhou*, or eight *zhou*, but they may not exceed this. As in the previous rites, search for an appropriate riverbank, mountaintop, or other peerlessly clean and pure site. Arrange an altar in square form with four open gates. The four corners and four sides should be square and precise. Construct it with powders of five different colors, or with mixed five-colored powder. Adorn each form [on the altar] subtly and marvelously. Those working together on this must concentrate with care on the minutest details, their minds free of defilements and their behavior without sin. According to the rite, those skilled in doing so should continuously chant [incantations].

The text goes on to describe variations on the basic form of the altar tailored for specific goals, such as the "elimination of disasters and increase in benefits." (*Da fangguang pusazang Wenshuhili genben yigui jing*, T no. 1191, vol. 20: 876c–877b. See also the *Foshuo shengbaozang shen yigui jing*, T no. 1284, vol. 21: 350b and 351c; *Foshuo yuqie dajiao wang jing*, T no. 890, vol. 18: 560a-b.).

57. See, for example, the "Enchanting Black Powder" (*zhou heifen*) section of the *Tuolu-oniji jing*, T no. 901, vol. 18: 865b.

58. *Song gaoseng zhuan*, T no. 2061, vol. 50: 870c-871a, and *Xinxiu kefen liuxue sengzhuan*, Z 2B: 6: 489b-c.

59. See Orzech, "The 'Great Teachings of Yoga'," 23ff. Note as well that the same term appears in Yijing's biography of Daolin, discussed below.

60. In his commentary on the *Incantation of Glory*, Fachong says the spell had origi-nated within the Dhāraṇī-piṭaka (T no. 1803, 39: 1027c).

61. *Sanlun xuanyi*, comp. Jizang's, T no. 1852.

62. *Da Tang Xiyu ji*, comp. Xuanzang, T no. 2087.

63. *Sanlun xuanyi*, T no. 1852, vol. 45: 9c. See also the *Yibu zonglun lunshu ji*, comp. Guiji (632–682), XZJ no. 844, 1: 83: 220, which has a similar set of five. For a study of the Bodhisattva-piṭaka, see Pagel, *The Bodhisattvapiṭaka*.

64. *Da Tang Xiyu ji*, T vol. 51: 923a.

65. *Da Tang xiyu qiufa gaoseng zhuan*, comp. Yijing, T no. 2066, vol. 51: 6c-7a.

66. T vol. 51: 6c. On Nāgārjuna as a Tantric adept, see Wedemeyer, *Aryadeva's Lamp that Integrates the Practices*, 7ff, and Young, "Conceiving the Indian Patriarchs in China."

67. T vol. 51: 6c.

68. The line might also be read "incantations and mudrās."

69. T vol. 51: 6c-7a.

70. See Lehnert, "Myth and Secrecy in Tang-Period Esoteric Buddhism," 84ff. for a discussion of this function of the tales.

71. *Jin'gang ding jing da yuqie mimi xindi famen yijue*, T no. 1798, vol. 39: 808a-b. On the many polemical uses of this passage see Lehnert, "Myth and Secrecy in Tang-Period Esoteric Buddhism," 84ff., and "Tantric Threads Between India and China," 258–259.

72. *Da piluzhena chengfo jingshu*, T no. 1796, vol. 39: 579c.

73. *Tuoluoni jijing*, T no. 901, vol. 18: 785b.

74. Including in the Lengyan jing, the so-called "Psuedo-Śuraṃgama"—a text with strong Chan associations. See *Da foding rulai miyin xiucheng liaoyi zhu pusa wanxing shoulengyan jing*, T no. 945, vol. 19: 133a.

75. *Guangzan jing*, T no. 222, vol. 8: 191a.

76. *Beihua jing*, T no.157, vol. 3: 209c.

77. *Foshuo shiyi mian Guanshiyin shenzhou jing*, T no. 1070, vol. 20: 152a.

78. *Da weide tuoluoni jing*, T no. 1341, 821c-822a. This usage was reflected as well in the description of the scriptural storehouse within the "Adamantine Grotto" on Wutaishan, mentioned earlier and in more detail in chapter 3.

79. *Qianyan qianbei Guanshiyin pusa tuoluoni shenzhou jing*, T no. 1057a, vol. 20: 87a.

80. *Da piluzhena chengfo shenbian jiachi jing*, T no. 848, vol. 18: 14a.

81. See, e.g., Amoghavajra's student Yuanzhao's usage of the term in his *Zhenyuan xinding Shijiao mulu* (T no. 2157, vol. 55: 943a), as well as the opening invocation of the *Shou puti xinjie yi* (T no. 915, vol. 18: 940b), traditionally attributed to Amoghavajra.

82. T no. 220.

83. The translation of this name is provisional, awaiting a deeper study of the terms of Tang Esoteric Buddhism than is yet available. For the moment we can note that the phrase "Dharma Gate of Yoga" within the longer title—in precisely the opposite syntactic structure to the one noted above—seems to indicate a subsection of the larger tradition named here the "Teachings of the Wizards' Store" (that is, the *Vidyādhara-piṭaka*). This is another suggestion that spells constituted the heart of this tradition, which later in the same brief discussion Huilin calls the rites of the "esoteric yoga" (*mimi yuqie*). A full exploration of the relationship between these Buddhist spell traditions and the early forms of Tantric Buddhism requires its own study beyond the much narrower purview of this book.

84. My exploration of "mizang," particularly in the following section, draws on and was in part inspired by Robert Sharf's work on the term *baozang* ("treasure-store," in his rendering), particularly his discussion of the "the complex interplay of often countervailing voices" at work in the term's usage (Sharf, *Coming to Terms*, 143).

85. Similar "new translations" feature in other prominent discussions of the nature of Buddhist incantations. The most influential is no doubt the parallel shift from "incantation" (*zhou*) to "Real Word" (*zhenyan*) as proper designations for mantra prescribed in Yixing's commentary on the *Mahāvairocana Sūtra*, said to have been based on the oral teachings of Śubhakarasiṃha (T no. 1796, vol. 39: 579b).

86. See the *RoutledgeCurzon Encyclopedia of Confucianism*, edited by Xinzhong Yao, 695–697 for an concise overview of the term *xing* in the Confucian tradition, as well as Bol, *This Culture of Ours*, 99–102 for a relevant brief discussion of *xing* in the Tang, and Csikszentmihalyi, *Material Virtue*, 101–250, for an extended exploration of related issues in the classical tradition.

87. T no. 1795, vol. 39: 529b.

88. On Zongmi's formulation, see Sharf, *Coming to Terms*, 144. On the *rulai zang*, and on Zongmi more generally, see especially Gregory, *Tsung-mi and the Sinification of Buddhism*.

89. This formulation is especially prevalent in the *Nirvaṇa Sūtra*. See T no. 374, vol. 12: 406c, et al.

90. *Dafangdeng rulaizang jing*, T no. 666.

91. *Chanyuan zhu quan ji du xu*, T no. 2015, vol. 48: 404a.

92. I suspect this set of terms should be widened to include *zhen*, "real/true," and *dun*, "sudden/immediate," among others, a fact that should help to further deepen our understanding of discursive connections not only among traditions of Chinese Buddhism but among the religions and philosophical traditions of China more generally.

93. *Daban niepan jing*, T no. 375, vol. 12: 649b, et al.

94. For the usages in the texts indicated, see *Da zhidu lun* 30, T no. 1509, vol. 25: 284a, and *Da piluzhena chengfo shenbian jiachi jing*, T no. 848, vol. 18: 40c.

95. For an in-depth study of this text, see Sharf, *Coming to Terms*.

96. See the *Great Prajñā-Pāramitā Scripture* (*Da bore boluomiduo jing*, T no. 220, vol. 7: 957a), for example. The lines are the first half of a paired couplet, the remainder of which reads "Based on *prajñā* and great compassion, one transcends words by using words to speak" (*you bore dabei, liyan yi yanshuo*).

97. But not the second couplet.

98. *Mohe zhiguan*, T no. 1911, vol. 46:3a. The anonymous preface to the Song Dynasty work, *Mizhou yuanyin wangsheng ji*, contains a similar formulation (T no. 1956, vol. 46: 1007a).

99. *Da fangguang fo huayan jing*, T no. 279, vol. 10:1a. One of the collections of miracle tales associated with the *Flower Garland Scripture* also names this text the "secret/sublime treasury," though here the term used is *mizang* (T no. 2074, vol. 51: 175a).

100. Cf. Penkower, "Tien-T'ai During the T'ang Dynasty," 74. For related discussions of some of the issues raised here, see Sharf, *Coming to Terms with Chinese Buddhism*, 263-278; and McBride, "Is There Really 'Esoteric' Buddhism?"

101. T no. 374, vol. 12: 390b. For one of the many instances in which this passage is quoted in canonical literature, see the biography of Zongmi in the *Jingde Chuandeng lu*, T no. 2076, vol. 51: 307a.

102. As an aside, at least one premodern writer, the Yuan Dynasty monk Nianchang (d. 1341), seems to have found this distinction itself obscure. His *Fozu lidai tongzai*, *Complete Records of the Generations of Buddhas and Patriarchs*, gives not "secret words" in its quotation of this passage but "clear words" (*luyu*); T no. 2036, vol. 49: 645c.

103. See *Miaofa lianhua jing wenju*, T no. 1718, vol. 34: 146c, et al.

104. T no. 2061, vol. 50: 738a.

105. *Da piluzhena chengfo jing shu*, T no. 1796, vol. 39: 579b.

CODA: MATERIAL INCANTATIONS AND THE STUDY OF MEDIEVAL
CHINESE BUDDHISM

1. Though the sense in which I use the phrase "complete language" here is not precisely Wittgenstein's as he employed it in his critique of Frazer's *Golden Bough* (in sentences that are one of the epigraphs to this book), his appeal in that work for a fulsome accounting of the nature of the "fantasies" of religious practice was one of the inspirations for my methods as a scholar. For dhāraṇī practices as "fantasies," see chapter 3.

2. The essay serves as the introduction to Sharf, *Coming to Terms with Chinese Buddhism*, 1–27.

3. Summarizing Sharf, *Coming to Terms*, 1–25.

4. Ibid., 24.

5. Indeed, in a very recent study that confirms (at least in general terms) the picture I argue for in this book, Sam van Schaik and Imre Galambos argue that manuscript and archeological evidence make clear that East-West interactions, at least in the tenth century, appears to have thrived (van Schaik and Galambos, *Manuscripts and Travellers*, 35–59).

6. See chapters 1 and 2 for, in the former, explorations of these ritual figures and, in the latter, of the amulets and their traditions.

7. The round case in which Madame Wei's amulet was discovered, as discussed in chapter 3, may be the exception to the rule.

8. As this book was going to press I discovered the work of Johan Elverskog on later "blockprinted Arabic amulets that seem to have a Buddhist origin." These amulets, which Elverskog rightly connects with some of the Chinese printed amulets also studied in this book, provide powerful evidence for the histories of religious and craft exchange I point to here. See Elverskog, *Buddhism and Islam on the Silk Road*, 104ff.

9. Skaff, "Tang Military Culture and Its Inner Asian Influences," 167.

10. Ibid., 170, citing Graff, "Early T'ang Generalship and the Textual Tradition," 553–554.

11. Investigations of these high traditions and their relationships with the broader practical landscape are extremely important, of course; I explored them briefly in chapter 4. Recently—for the most part too late for me to take full account of in this book—a number of brief, incisive explorations have been published together in Orzech, Payne, and Sørensen, *Esoteric Buddhism and the Tantras in East Asia*. I cannot note all relevant examples here, but the introductory essay by the three editors seems to me an especially clear exposition of some of the issues I raise,

particularly in the section "History, Context, Usage" (10–13). As well, though I think my comments in this coda make clear that I disagree with it in many respects, Sørensen's essay "On Esoteric Buddhism in China: A Working Definition" (155–175) is an important contribution. Along with the volume as a whole, it is a milestone in the study of Esoteric Buddhism and the Tantras in East Asia.

12. I emphasize "Chinese traditions" (*Hanchuan mijiao*, etc.) because Tibetan materials were also in abundance at Dunhuang, and their connections with Chinese materials (which in some periods appear to have been extremely close) are not yet well understood, and are thus not treated in this book (but see Dalton, "The Development of Perfection" and "A Crisis of Doxography," Van Schaik and Dalton, "Where Chan and Tantra Meet," Kapstein and Van Schaik, *Esoteric Buddhism at Dunhuang*, and Van Schaik and Galambos, *Manuscripts*, for example).

GLOSSARY

a 阿

Adijuduo 阿地瞿多 (Skt. Atikūṭa) fl. 653–654

ai 愛

aizeng 愛憎

A-luo 阿洛

amiliduobishaiji 阿蜜栗多鼻曬闍

an 安

an 唵

An Lushan 安禄山 703–757

Annen 安然 fl. 884

anoubotuo 阿耨波陀 (Skt. anutpāda)

anzi jiachi yi 唵字加持已

asheli 阿闍梨 (Skt. acārya)

Bai Juyi 白居易 772–846

bailu 白露

ban 般

Baochang 寶唱 d. 516

baochi 寶池

baochuang 寶幢

baoshan 寶山

Baosiwei 寶思維 d. 721

baoying 寶應

baozang 寶藏

Baozang lun 寶藏論

Baozhi 寶誌 d. 514

bazheluo 跋折囉

bei 悲

Beihan 北漢

Beishan lu 北山錄

Bei Wei 北魏 386–534

ben 本

Betsugyō 別行

Bianhuo lun 辯惑論

Bianzheng lun 辯正論

bichuan 臂釧

Biliulecha 毗留勒叉

bingfa 兵法

Bore 般若 (Skt. Prajña) 744–ca. 810

Bore Miqiebo 般若彌伽薄 n.d.

Boshilimiduoluo 帛尸梨密多羅, (Skt. Śrīmitra) d. ca. 343

bu de 不得

bu jian shishi 不見實事

bukede 不可得

bukesiyi 不可思議

Bukong 不空 (Skt. Amoghavajra) 705–774

Bukong juansuo 不空絹索 (Skt. Amoghapāśa)

busi di 不死地

busi ju 不死句

busi zhi yao 不死之藥

buxie 不寫

buyin xin zhisuo li 不因心之所立

bu you jingbai sheng dan cong niaodao chu 不由淨白生但從尿道出

buzhu 部主

buzun 部尊

chanding 禪定

chang 唱

changsheng zhi fu 長生之符

changshou 長壽

changxin 常信

changyang fu 長楊賦

Chanyuan zhu quan ji du xu 禪源諸詮集都序

chanzong 禪宗

chao 抄

Chen Chouding 陳丑定

cheng fozi 稱佛子

chengjiu neipan men 成就涅槃門

cheng ming 稱名

cheng ming ti cizi 稱名替此字

cheng suozuo zhi 成所作智

Cheng Yongjian 程永建

chi 持

chi 尺

chi changle zhi yin 持長樂之印

chiming 持明

chiming zang 持明藏

chimingzangjiao yuqie famen 持明藏教瑜伽法門

chongxuan 冲玄

Chuan changuan fa 傳禪觀法

chuang 幢

chuangcha 幢刹

Chuan'guang 傳光 d.u.

Chuan mizang 傳密藏

chui ren shaozhan shenfen 吹人少露身分

chuizhao shenzhe 吹著身者

Chunqiu zhengyi 春秋正義

ci 次

Cixian 慈賢 (Skt. Maitribhadra) 907–1125

ci zhi sudi keshuo 此指俗諦可說

cuzhong shen 麁重身

Da ai jing 大哀經

Da baoji jing 大寶積經

Da biqiuni jie 大比丘尼戒

dadi 大帝

Da foding tuoluoni 大佛頂陀羅尼

daheitian 大黑天

dai 帶

daijin peizi 帶金佩紫

dai jingfa zhong 帶頸髮中

Daizong's 代宗 (Li Yu 李豫, 726–779) r. 762–779

da jing 大鯨

Da Jin'gang xumilu feng 大金剛須彌盧峰

Da kongque wang 大孔雀王 (Skt. Mahāmayūrī)

Dali 大曆

Daloutan jing 大樓炭經

Da mingzhou zang 大明咒藏

Daolin 道琳 fl. seventh c.

daochang 道場

Daoshi 道世 d. 683

Daoxian sheli 道賢闍梨 fl. 930s

daoyi 道義

dapin 大品

dashi 大士

da shixiang gu yanwei zongchi dabian 達實相故言為總持大辯

Da Song sengshi lüe 大宋僧史略

Dasuiqiu tuoluoni 大隨求陀羅尼 (Skt. Mahāpratisarā dhāraṇī)

Da xingshan si 大興善寺

da yuanjing zhi 大圓鏡智

dechajia 德叉迦

de pusa ren tuoluoni 得菩薩忍陀羅尼

de pusa ren zhoushu 得菩薩忍咒術

dimi yu 低彌魚

ding 定

dinghui xiangying men 定慧相應門

dingyi daochang 定意道場

diyu 地獄

dizi Chen Chouding yixin shouchi 弟子陳丑
定一心受持

dizi Xingsi 弟子幸思

Dou Balang 竇八郎 d.u.

du 度

du 讀

dujue 獨覺 (Skt. pratyekabuddha)

dusong 讀誦

Du Xingyi 杜行顗 fl. mid-seventh c.

Ekō 慧光 1666–1734

Fachong 法崇 fl. 760s–770s

Fahu 法護 (Skt. Dharmapāla) 963–1058

Fali 法立 third c.

Falin 法琳 572–640

Fan fanyu 翻梵語

fanqie 梵篋

fanshi 梵施

Fanshu Dasuiqiu tuoluoni yiben 梵書大隨求
陀羅尼一本

Fatian 法天 (a.k.a. Faxian 法賢) d. 1001

Faxian 法賢 d. 1001

faxing 法性

Fazhao 法照 fl. 766–774

Fazhong 法眾 fl. 401–413

fei yumiao baowu 非餘妙寶物

Feizhuo 非濁 d. 1063

fen 粉

fenbie zhongsheng tuoluoni 分別眾生陀
羅尼

Feng Hanji 馮漢驥

fentan 粉壇

fentan fa 粉壇法

focha 佛刹

Foding zhou 佛頂咒

Foding zunsheng tuoluoni 佛頂尊勝陀羅尼
(Skt. Uṣṇīṣavijayā dhāraṇī; often called
by its abbreviated name, the Zunsheng
zhou 尊勝咒)

Fofo 佛佛

Fo mimi xin 佛秘密心

Foshuo tuoluoni jijing fanyi xu 佛説陀羅尼
集經翻譯序

Fotudeng 佛圖澄 232–348

Fotuobatuoluo 佛陀跋陀羅 (Skt.
Buddhabhadra) early fifth c.

Fotuoboli 佛陀波利 (Skt. Buddhapālita)

fozi 佛子

fu 符 talisman

fu 覆 to cover

futian 甫田

fuxi 負璽

Fuxian si 福先寺

ganlu 甘露

ganlu guanding 甘露灌頂

ganying 感應

gaoseng 高僧

Gaozong 高宗 (a.k.a. Li Zhi 李治)
628–683, r. 650–683

Ge Hong 葛洪 283–343

gou 垢

guan 觀

guanding 灌頂

Guanding 灌頂 561–632

guanding daochang chu 灌頂道場處

guanding guang 灌頂光

Guanding jing 灌頂經

guanding tanfa 灌頂壇法

Guanding zhou 灌頂咒

Guangchengzi 廣成子

guangming guanding 光明灌頂

Guangzan jing 光讚經

Guiji 窺基 632–682

guijing zunde men 歸敬尊德門

guiming jiuhu bushe tuoluoni 歸命救護不捨陀羅尼

Guiyijun 歸義軍

Gujin yijing tuji 古今譯經圖紀

Guo Heilue 郭黑略 d. after 337

Gushi shijiu shou 古詩十九首

Gu Yanwu 顧炎武 1613–1682

Gyōrinshō 行林抄

Hanchuan mijiao 漢傳密教

hanling 含靈

Heling 訶陵

Heluojie 訶羅竭 third c.

henghe sha 恆何沙

Hou Zhao 後趙 319–351

hua 畫

huaman 花鬘

Huangdi 黃帝

huanyin 喚印

huazuo yi 畫作一

hui 慧 wisdom

hui 悔 to regret, repent

Huibao 慧寶 ninth c.

Huijiao 慧皎 497–554

Huilin 慧琳 d. 820

Huixiang 惠詳 fl. 706

Huiyi si 慧義寺

Huizhen 惠臻 d.u.

hui zizai 慧自在

Huizhong 慧忠 eighth c.

huo erzi 活兒子

hushen 護身

hushen zhi wu 護身之物

huxi 胡錫

ji 記 record

ji 跡 trace

jia 夾 [= qie 篋]

jiachi 加持

jiafu 跏趺

Jianye 建業

jianzhi 繭紙

jiao 教

Jiao Tietou 焦鐵頭

jiaotou guanding 澆頭灌頂

jie 戒 precept, ethics

jie 結 to tie, to secure

jie 界 realm, ritual area

jiejie 結界

Jigong 際公

Jin 晉

jing 經

jin'gang 金剛

jin'gang bore si 金剛般若寺

jin'gang chu 金剛杵

jin'gang daochang 金剛道場

jin'gang daochang jing 金剛道場經

jin'gang daochang sanmei 金剛道場三昧

Jin'gang ding jing 金剛頂經

jin'gang gongyang men 金剛供養門

jin'gang jue 金剛橛

jin'gang ku 金剛窟

jin'gang shen 金剛神

jin'gang shou 金剛手 (Skt. Vajrapāṇi)

Jin'gang tongzi 金剛童子

Jin'gangzhi 金剛智 (Skt. Vajrabodhi) 671–741

jingchuang 經幢

jingchu equ men 淨除惡趣門

jingjue 驚覺

Jingmai 靖邁 fl. 645–666

jingshi 精士

Jing Sitai 荊思泰

jingtu 淨土

Jingying Huiyuan 淨影慧遠 523–592

Jinshu 晉書

jinzhou 禁咒

jinzhou zang 禁咒藏

jinzuo yi 盡作一

Jiumoluoshi 鳩摩羅什 (Skt. Kumārajīva) 344–413

jixiang zuo 吉祥坐

Jizang 吉藏 549–623

Jōnen 靜然 fl. 1154

Juduotipo 瞿多提婆 (Skt. *Gupta[or Kuta-]deva?) d.u.

Jue'ai 覺愛 (Skt. Buddhapālita?)

Juehu 覺護 (Skt. Buddhapālita?)

Jumoluo tian 俱摩羅天

Junnyū 淳祐 890–953

juyi guanding 句義灌頂

komikkyō 古密教

Kōmyō shingon 光明真言

Kūkai 空海 774–835

Kunwu tie 崑吳鐵

Lengyan jing 楞嚴經

li 力

liao xindi 了心地

Li Congchang 李從昶 d.u.

Li Congke 李從珂 885–936, r. 935–936

Li Cunxu 李存勗 885–926, r. 923–926

Liji 禮記

Li Maozhen 李茂貞 856–924

ling 靈

lingtan 靈壇

lingyan 靈驗

Liu Yiqing 劉義慶 403–444

longchi fang 龍池坊

Longmen 龍門

lü 律

lun 論

luo 羅 (Skt. ra or rā)

luoshe 羅闍 (Skt. rāga)

Lü Shou 呂受 d.u

luyu 露語

Manzu cheng 滿足城

Ma Shichang 馬世長

Matou Guanshiyin pusa dazhou 馬頭觀世音菩薩大咒

Mei Yaochen 梅堯臣 1002–1060

meme 麼麼

Meme (moujia) xie 麼麼 (某甲) 寫

meme yun moujia shouchizhe yuci zicheng ming 麼麼云某甲受持者於此自稱名

men 門

mi 1 蜜

mi 2 密

miao guan [cha zhi] 妙觀[察智]

mie 滅

Mili 覓歷 d.u

mimi 祕密

mimi yuqie 祕密瑜伽

mimi zang 祕密藏

min 敏

ming 明

mingzhou 明咒

minsheng zongjiao 民生宗教

miyan 密言

miyi 密意

miyu 密語

mizang 密藏

mizhong geng mi 密中更密

mofa 末法

Molizhi 摩利支 (Skt. Marīci)

momo 摩摩

moshi 末世

moujia 某甲

moujia shouchizhe zicheng ming 某甲受持者自稱名

Mounishili 牟尼室利 (Skt. Muniśrī)
d. 806

mu weixi zhi 木威喜芝

muzhi 木芝

Myōkaku's 明覺 b. 1056

na 那

Nalientiyeshe 那連提耶舍 (Skt.
Narendrayaśas) 517–582

nantuo 難陀 (Skt. Nanda) d.u

nanwu deng 難无燈

nanwu hua 難无花

nanwu xiang 難无香

nanwu xiangshui 難无香水

Nanyue 南嶽雲峰寺

nei chi mizang, wai jiu ruliu 內持密藏,
外究儒流

nengchi 能持

nengzhe 能遮

Nianchang 念常 d. 1341

nian jian er dai zhi 念緘而帶之

ningshuang zhan yecao 凝霜霑野草

niuhuang 牛黃

pei 佩

peidai zai shen 佩帶在身

Pei Qiangou 裴虔搆

peiyin 佩印

peiyu 佩玉

pidituoluo bidejia 毘睇陀羅必梼鐌家 (Skt.
Vidyādhara-piṭaka)

pingdeng 平等

pingdeng [xingzhi] 平等 [性智]

pozhi qianmi 破執遣迷

pubian zhaoyao 普遍照曜

Pulguksa 佛國寺

pusa zang 菩薩藏

puti chang 菩提場

Putidamo 菩提達磨 (Skt. Bodhidharma)
sixth c?

Putiliuzhi 菩提流志 active in China,
693–727; d. 727

Putiliuzhi 菩提流支 (Skt. Bodhiruci) d.
527

putishu 菩提樹

puti suji zhi lun 菩提速疾之輪

Putong zhenyan zang pin 普通真言藏品

Puxian pusa 普賢菩薩 (Skt.
Samantabhadra)

puzheng qingjing men 普證清淨門

qi 氣 energy, pnuema

qi 棄 abandon, discard

Qi 岐

Qianfu si 千福寺

qianling 潛靈

qianniu dao 千牛刀

Qianyou 乾佑

Qianyuan 乾元

qie 篋

Qin 秦

qingjing 清淨

Qingtai 清泰

qiqingwen 啟請文

Qiunabamo 求那跋摩 (Skt.
Guṇavarman) 367–431

Qiunabatuoluo 求那跋陀羅 (Skt.
Guṇabhadra) 394–468

quan 悛

ren 忍

rentian jiao 人天教

Renwang jing 仁王經

ren zhan er en qia 仁霑而恩洽

Rizang fen 日藏分

Rizhao 日照 (Skt. Divākara) seventh c.

Ruan Ji 阮籍 210–263

ru bazi yi 入八字義

rulai mizang 如來密藏

rulai zang 如來藏 (Skt. Tathāgatagarbha)

rulai zhi xinghai 如來之性海

run 閏

Runan 汝南

ruo seng daizhe yu zhouxin jin zuo yi jin'gang shen 若僧帶者於呪心中盡作一金剛神

ruyi 如意

ruyibao kai 如意寶鎧

Ruyilun 如意輪 (Skt. Cintāmaṇicakra)

ru zhenyan men 入真言門

sanchaji 三叉戟

Sanfa dujing 三法度經

Sanhuang wen 三皇文

sanji 三戟

sanluan 散亂

sanmeiye 三昧耶

sanmi 三密

san qi wangzhe renshen gu zhi ti 散其亡者人身骨之體

sanye 三業

sanzang 三藏

seng 僧

seng dai 僧帶

Sengrui 僧叡 fl. early fifth c.

Sengyou 僧祐 445–518

shagui 殺鬼

Shaiji 曬罽

shanchi zhoushu 善持咒術

shanjie 善解

shanjue 山橛

shanming guanding men 善明灌頂門

Shanwuwei 善無畏 (Skt. Śubhākarasimha) 637–735

Shanzhu 善住

sheli zhi qieta 舍利之伽他 (Skt. śarīra-gāthā)

Shenajueduo 闍那崛多 (Skt. Jñānagupta) 523–600

Sheng 生

shengchu 生處

Shengjing 生經

shengming 聲明

shengwen 聲聞 (Skt. śrāvaka)

shengyu ci men 生於此門

shenli jiachi men 神力加持門

Shenqing 神清 766–820?

shenshu 神術

shentong 神通

shenxian 神線

Shenxiu 神秀 d. 706

shenzhou 神咒

shenzhou zhe 神咒者

Shihu 施護 (Skt. Dānapāla) fl. 970s

Shiji 史記

Shijiawan 史家灣

Shiji jing 世記經

Shijing 詩經

Shi Jingtang 石敬瑭 892–942

Shi Le 石勒 274–333

shiren 士人

Shi Siming 史思明 d. 761

Shi zhenyan yi 釋真言義

shouchi 受持

shouchizhe 受持者

shouchizhe yuci zicheng ming 受持者於此自稱名

shoudai 綬帶

shouming zengchang men 壽命增長門

Shu 蜀

Shuang 霜

shubian 舒遍

shubian zhe 舒遍者

Shūei 宗叡 in China 862–866

shufa 術法

Shunyi 順儀

shuxie 書寫

siwen 斯文

sizhi 四智

suan 酸

sui 隨

suiqiu 隨求 (Skt. pratisara)

Suiqiu pusa 隨求菩薩

suixin 隨心

suo 鎖

suowen buwang 所聞不忘

suozhi qiyin 所執契印

Su Shi 蘇軾 1037–1101

Suzong 肅宗 711–762; r. 756–762

tafang jingtu 他方淨土

tai 泰

taiji zhang 太極章

taizang jie 胎藏界

tan 壇

Tang Suzong 唐肅宗 r. 756–762

Tanwuchen 曇無讖 (Skt. Dharmakṣema) 385–433

tiandi shenshi 天帝神師

tiandi shi 天帝使

tianhuang dadi 天皇大帝

Tianpideng jingchuan 田伾等經幢

tianshi 天師

tianxian 天仙

Tianxizai 天息災 (Skt. *Devaśāntika?) d. 1000

tianyu 天魚

tiao 調

tibishi 題壁詩

Tihuang wanhui 梯航萬彙

Titoulaizhai 提頭賴吒

tong bi guiyi 同彼軌儀

tuolinni 陀鄰尼 (Skt. dhāraṇī)

tuoluoni 陀羅尼 (Skt. dhāraṇī)

tuoluoni guang 陀羅尼光

tuoluoni lun 陀羅尼輪

tuxiang 塗香

Wang Dao 王導 267–330

Wang Kaishi 王開士

Wang Wei 王維 699–759

wei 惟

Wei Daniang 魏大娘

Weigui daifu feifa zhi ji 畏鬼帶符非法之極

weimi 微密

weimiao seshen 微妙色身

weimichi 微密持

Wei Zhuang 韋莊 d. 910

wen 文

Wenshu 文殊 (Skt. Mañjuśrī)

Wenshushili tongzhen pusa wu zi zhenyan 文殊師利童真菩薩五字真言

Wenshui 文水

wo 我

wowen 我聞

wu 無 not, "non-being," no, without

wu 武 martial

Wu 吳

wu'ai tuoluoni 無礙陀羅尼

wuchanna 烏禪那

Wu Che 武徹 fl. late eighth c.

Wudai shi 五代史

Wugou jinguang tuoluoni 無垢金光陀羅尼

wuhui nianfo 五會念佛

Wuliangshou 無量壽

wuliang zongchi men 無量總持門

Wuming luocha ji 無明羅剎集

wu neng sheng 無能勝

wuqing yu wanhua 無情於萬化

Wushang biyao 無上祕要

Wutianzhu 五天竺

wuwei 無畏

Wuyin yanyin 五印言音

Wuyue zhenxing tu 五嶽真形圖

Wu Zetian 武則天 (a.k.a. Wu Zhao 武曌)
 625–705; r. 690–705
wuzhong bujing 五種不淨
xi 繫 to tie, to fasten
xi 璽 seal
xiang 想
xiangmo zuo 降魔坐
xiang za 相雜
Xianjie jing 賢劫經 (Skt.
 Bhadrakalpikasūtra)
xianmi zang; J. kenmitsu zō 顯密藏
Xiantong 咸通
xiao 消
Xiaowu 孝武 510–535, r. 532–535
Xiao Ya 小雅
xie 寫 to write, to copy
xie 謝 to thank, to apologize,
 to regret
xiguo xiangchuan 西國相傳
xing 性
Xingsi 幸思
xing yu ru ren 行欲如人
"Xin Nanshan" 信南山
xionghuang 雄黃
xiongnüe wudao 兇虐無道
xiuxing 修行
xu 序
xuan 旋
Xuanyan ji 宣驗記.
Xuanzang 玄奘 602–664
Xuanzong 玄宗 685–762; r. 712–756
Xu Yin 徐殷
yan 驗
Yang Xiong 楊雄 53 BCE–18 CE
Yang Yourun 楊有潤
ye 業
Yeshejueduo 耶舍崛多 (Skt. Yaśogupta)
 sixth c.

yi 已
yi jian wangsheng 以薦往生
yijia zhi yan 一家之言
Yijing 義淨 635–713
ying 影
yingchuang 影幢
yingzhan 影霑
yingzhan gongde 影霑功德
yinmai zhouben 印賣咒本
Yintuoluobore 因陀羅般若
Yiqie dinglunwang tongqing huanyin 一切頂
 輪王同請喚印
Yiqie foxin zhou 一切佛心咒
Yiqie jing yinyi 一切經音義
yi shui guan zhang 以水灌掌
yishui guan zhang 以水盥掌
Yixing 一行 684–727
yong 用
yongchang 永昌
yongchong gongyang 永充供養
Yonghuai 咏懷
Yongtai 永泰 765–766
you bore dabei, liyan yi yanshuo 由般若大
 悲, 離言以言說
youming 幽明
youming 幽冥
yuan 院
yuanqiu 圓丘
yuanwen 願文
Yuanzhao 圓照 d. 778
yuefu 鉞斧
yuelun 月輪
yufeng 餘風
Yu Liang 庚亮 289–340
yuqie zongchi jiaomen 瑜伽總持教門
zaji zang 雜集藏
zan 贊/讚
zang 藏

Zanning 贊寧 919–1001

Zhai 翟

zhaifa 宅法

zhaiwen 齋文

zhan 1 沾

zhan 2 霑

zhanchen 霑塵

zhan ci fu 霑此福

zhangbiao fashen men 章表法身門

Zhang Jue 張角 d. 184

zhanpu 瞻蔔

Zhanran 湛然 711–782

zhansa 霑灑

zhan yecao 沾野草

zhanzhao qi shen 霑著其身

zhao 著

Zhao Qian 趙遷 fl. 766–774

zheng 證

zheng Fanwen 證梵文

zhenjiao ru mimi men 真教入祕密門

zhenmu 鎮墓

zhenru ruyu 真語如語

zhenyan 真言

zhenyan xiang 真言想

zhenyan zang 真言藏

zhenyi 真儀

zhi 執

zhi 芝

Zhipan 志磐 fl. 1258–1269

Zhi Qian 支謙 (a.k.a. Zhi Gongming
 恭明) fl. 223–253

zhiqian jiekong 執遣界空

Zhisheng 智昇 669–740

zhisheng gaoxian 至聖高賢

Zhitong 智通 fl. 605–653

Zhiyi 智顗 538–598

zhiyin guanding 智印灌頂

Zhiyuan 智圓 976–1022

zhongzi guanding 種子灌頂

Zhou 周

zhou 咒

zhouben 咒本

Zhou Boren 周伯仁 (a.k.a. Zhou Yi 顗)
 269–322

zhoufa 咒法

zhou heifen 咒黑粉

zhoujing shu 咒井樹

zhoulun 咒輪

zhouming 咒明

zhoushu 咒術

zhousuo 咒索

zhouyin 咒印

zhouyuan 咒願

zhouzang 咒藏

zhou zhangju 咒章句

zhu 柱

zhuangyan 莊嚴

Zhu Fahu 竺法護 (Skt. Dharmarakṣa)
 d. 316

Zhu Fakuang 竺法曠 fourth c.

Zhuhong 袾宏 1535–1615

Zhulin si 竹林寺

zi 字

zicheng ming 自稱名

zicheng ming wo moujia 自稱名我某甲

zideng yudeng 字等語等

zi jieyuan 字界緣

zilun 字輪

zimen 字門

ziran 自然

Zixuan 子璿 965–1038

zong 總

zongchi 總持

zongchi gouzhang xiaochu, gonde manyuan
 總持垢障消除，功德圓滿

zongchi jiao 總持教

zongchi zhuangyan 總持莊嚴

Zongmi 宗密 780–841

zong shen mimi 宗深祕密

Zuigu bosatsu 隨求菩薩

Zunsheng zhou 尊勝咒 (Skt. Uṣṇīṣavijaya dhāraṇī. Abbreviated name of the Foding zunsheng tuoluoni 佛頂尊勝陀羅尼)

zuofa jiachi 作法加持

SOURCES

PRIMARY SOURCES

For Manuscript and Printed Amulets Consulted, see appendix 1.

TEXTS

Anantuomuqieni helituo jing 阿難陀目佉尼呵離陀經. Guṇabhadra 求那跋陀羅 (394–468). T no. 1015.

Apidamo pinlei zulun 阿毘達磨品類足論. Xuanzang 玄奘 (602–664). T no. 1542.

Bai Juyi Quanji 白居易全集. Shanghai: Shanghai guji, 1999.

Banzhou sanmei jing 般舟三昧經. Lokakṣema (Zhiloujiachan 支婁迦讖, 2nd c.) T no. 418.

Baopuzi Neipian jiaoshi 抱朴子內篇校釋. Ge Hong 葛洪 (283–343). Ed. Wang Ming 王明. Beijing: Zhonghua, 1985.

Beihua jing 悲華經. Dharmakṣema (Tanwuchen曇無讖, 385–433). T no. 157.

Beishan lu 北山錄. Shenqing 神清 (766–820?) and Huibao 慧寶 (9th c.). T no. 2113.

Betsugyō 別行. Kanjo 寬助 (1057–1125). T no. 2476.

Bianzheng lun 辯正論. Falin 法琳 (572–640). T no. 2110.

Boreboluomiduo xinjing 般若波羅蜜多心經. Xuanzang 玄奘 (602–664). T no. 251.

Bukong juansuo shenbian zhenyan jing 不空羂索神變眞言經. Bodhiruci (Putiliuzhi 菩提流志; d. 727). T no. 1092.

Bukong juansuo shenzhou xin jing 不空羂索神呪心經. Xuanzang 玄奘 (602–664). T no. 1094.

Chanyuan zhu quan ji du xu 禪源諸詮集都序. Zongmi 宗密 (780–841). T no. 2015.

Cheng weishi lun 成唯識論. Xuanzang 玄奘 (602–664). T no. 1585.

Chisong Jin'gang jing lingyan gongde ji 持誦金剛經靈驗功德記. T no. 2743; P. 2094.

Chunqiu Zuozhuan zhengyi 春秋左傳正義. Kong Yingda 孔穎達 (574–648), ed. Shanghai: Shanghai guji.

Chu sanzang jiji 出三藏記集. Sengyou 僧祐 (445–518). T no. 2145.

Chusheng wubian men tuoluoni 出生無邊門陀羅尼經. Amoghovajra (Bukong 不空, 705–774). T no. 1009.

Chusheng wuliang men chi jing 出生無量門持經 Amoghovajra (Bukong 不空, 705–774). T no. 1012.

Da ai jing 大哀經. Dharmarakṣa (Zhu Fahu 竺法護, d. 316). T no. 398.

Daban niepan jing 大般涅槃經. Dharmakṣema (Tanwuchen 曇無讖, 385–433). T no. 374.

Da boreboluomiduo jing 大般若波羅蜜多經. Xuanzang 玄奘 (602–664). T no. 220.

Da Han yuanling mizang jing 大漢原陵秘葬經, Zhang Jingwen, comp. In *Zangwai daoshu* 藏外道書, vol. 1. Chengdu: Bashu shushe, 1992.

Daizong chaozeng sikong da bianzheng guangzhi sanzang heshang biaozhi ji 代宗朝贈司空大辨正廣智三藏和上表制集. Yuanzhao 圓照 (d. 778). T no. 2120.

Da fangdeng da jijing 大方等大集經. Dharmakṣema (Tanwuchan 曇無讖, 385–433), et al. T no. 397.

Dafangdeng rulaizang jing 大方等如來藏經 Buddhabhadra 佛陀跋陀羅 (fl. 406–418). T no. 666.

Da fangdeng tuoluoni jing 大方等陀羅尼經. Fazhong 法眾 (fl. 401–411). T no. 1339.

Da fangguang fo huayan jing 大方廣佛華嚴經. Śikṣānanda (Shichanantuo 實叉難陀, 652–710). T no. 279.

Da fangguang fo huayan jing ganying zhuan 大方廣佛華嚴經感應傳. Huiying 慧英 (fl. 687) and Hu Youzhen 胡幽貞 (fl. 783). T no. 2074.

Dafangguang pusazang jing zhong Wenshushili genben yizi tuoluoni jing 大方廣菩薩藏經中文殊師利根本一字陀羅尼經. Baosiwei 寶思惟 (d. 721). T no. 1181.

Da fangguang pusazang Wenshuhili genben yigui jing 大方廣菩薩藏文殊師利根本儀軌經. Tianxizai 天息災 (fl. 980–1000). T no. 1191.

Da Foding rulai fangguang xidaduo bodaluo tuoluoni 佛頂如來放光悉怛多鉢怛囉陀羅尼, Amoghovajra (Bukong 不空, 705–774). T no. 944a.

Da foding rulai miyin xiuzheng liaoyi zhu pusa wanxing shoulengyan jing 大佛頂如來密因修證了義諸菩薩萬行首楞嚴經. T no. 945.

Daji da xukong zang pusa suowen jing 大集大虛空藏菩薩所問經. Amoghovajra (Bukong 不空, 705–774). T no. 404.

Da piluzhena cheng fo jingshu 大毘盧遮那成佛經疏. Yixing 一行 (683–727). T no. 1796.

Da piluzhena chenfo shenbian jiachi jing 大毘盧遮那成佛神變加持經. Śubhakārasimha (Shanwuwei 善無畏, d. 735). T no. 848.

Dasheng bensheng xindi guanjing 大乘本生心地觀經. Prajña 般若 (744–ca. 810). T no. 159.

Dasheng ji pusa xuelun 大乘集菩薩學論. Fahu 法護 (d. 1058) and Richeng 日稱, tr. T no. 1636.

Dasheng yujia jin'gang xinghai Manshushili qianbei qian 大乘瑜伽金剛性海曼殊室利千臂千鉢大教王經. Amoghavajra (Bukong 不空, 705–774). T no. 1177a.

Dasheng zaoxiang gongde jing 大乘造像功德經. Devaprajñā (Tiyunbore 提雲般若, fl. 689–691). T no. 694.

Da Song sengshi lüe 大宋僧史略. Zanning 贊寧 (919–1001). T no. 2126.

Da Tang gu dade sikong dabianzheng guangzhi Bukong sanzang xingzhuan 大唐故大德贈司空大辨正廣智不空三藏行狀. Zhao Qian 趙遷. T no. 2056.

Da Tang Xiyu ji 大唐西域記. Xuanzang 玄奘 (602–664). T no. 2087.

Da Tang xiyu qiufa gaoseng zhuan 大唐西域求法高僧傳. Yijing 義淨 (635–713). T no. 2066.

Da tuoluoni mofazhong yizi xinzhou jing 大陀羅尼末法中一字心咒經. Baosiwei 寶思惟 (d. 721). T no. 956.

Da weide tuoluoni jing 大威德陀羅尼經. Jñānagupta (Shenajueduo 闍那崛多 523–600). T no. 1341.

Da xukong pusa suowen jing 大虛空藏菩薩所問經. Amoghavajra (Bukong 不空, 705–774). T no. 404.

Dazhidu lun 大智度論. Kumarajiva (Jiumoluoshi 鳩摩羅什, 344–413). T no. 1509.

Dazuigu darani kanchū 大隨求陀羅尼勘註. Myōkaku 明覺 (b. 1056). T no. 2242.

Dichi yiji 地持義記. Anonymous. T no. 2803.

Dongpo quanji 東坡全集. Taipei: Taiwan shangwu, 1983.

Eun risshi shomokuroku 惠運律師書目錄. Eun 惠運 (798–869). T no. 2168b.

Fahua chuanji 法華傳記. Huixiang 慧祥 (fl. 667). T no. 2068.

Fanyi mingyi ji 翻譯名義集. Fayun 法雲 (1088–1158). T no. 2131.

Fayuan zhulin 法苑珠林. Daoshi 道世 (d. 683). T no. 2122.

Fo apitan jing 佛阿毘曇經. Paramārtha (Zhendi 眞諦; 499–569). T no. 1482.

Foding zunsheng tuoluoni biefa 佛頂尊勝陀羅尼別法. Ruona 若那 (*Jñāna?, fl. 838). T no. 974f.

Foding zunsheng tuoluoni jing 佛頂尊勝陀羅尼經. Buddhapālita (Fotuoboli 佛陀波利, fl. late 7th c.). T no. 967.

Foding zunsheng tuoluoni jing 佛頂尊勝陀羅尼經. 679. Du Xingyi 杜行顗 (fl. 679). T no. 968.

Foding zunsheng tuoluoni jing 佛頂尊勝陀羅尼經. Divākara (Dipoheluo 地婆訶羅, d. 688). T no. 969.

Foding zunsheng tuoluoni jing 佛頂尊勝陀羅尼經. Anon. (Japanese?). T no. 974b.

Foding zunsheng tuoluoni jingchu yezhang zhou jing 最勝佛頂陀羅尼淨除業障咒經. Divākara (Dipoheluo 地婆訶羅, d. 688). T no. 970.

Foding zunsheng tuoluoni jing jiaoji yiji 佛頂尊勝陀羅尼經教跡義記. By Fachong 法崇 (fl. 8th c.). T no. 1803.

Foding zunsheng tuoluoni niansong yigui fa 佛頂尊勝陀羅尼念誦儀軌法. Amoghovajra (Bukong 不空, 705–774). T no. 972.

Foding zunsheng tuoluoni zhenyan 佛頂尊勝陀羅尼真言. Anon. T no. 974e.

Foding zunsheng tuoluoni zhuyi 佛頂尊勝陀羅尼主義. Amoghovajra (Bukong 不空, 705–774). T no. 974d.

Foding zunsheng xin po diyu zhuan yezhang chu sanjie mimi sanshen Foguo sanzhong xidi Zhenyan yigui 佛頂尊勝心破地獄轉業障出三界祕密三身佛果三種悉地真言儀軌. Śubhakārasimha (Shanwuwei 善無畏, d. 735). T no. 906.

Foding zunsheng xin po diyu zhuan yezhang chu sanjie mimi Tuoluoni 佛頂尊勝心破地獄轉業障出三界祕密陀羅尼. Śubhakārasimha (Shanwuwei 善無畏, d. 735). T no. 907.

Fomu da jin kongque mingwang jing 佛母大金孔雀明王經. Amoghovajra (Bukong 不空, 705–774). T no. 982.

Foshuo foding zunsheng tuoluoni jing 佛說佛頂尊勝陀羅尼經, Yijing 義淨 (635–713). T no. 971.

Foshuo guanding fumo fengyin da shenzhou jing 佛說灌頂伏魔封印大神呪經. T no. 1331.

Foshuo guanxi foxingxiang jing 佛說灌洗佛形像經. Faju 法炬 (fl. 290–306). T no. 695.

Foshuo hu zhu tongzi tuoluoni jing 佛說護諸童子陀羅尼經. Bodhiruci (Putiliuzhi 菩提流支, d. 527). T no. 1028.

Foshuo shengbaozang shen yigui jing 佛說聖寶藏神儀軌經. Fatian 法天 (fl. late 10th c.), tr. T no. 1284.

Foshuo shiyi mian Guanshiyin shenzhou jing 佛說十一面觀世音神呪經, Yaśogupta (Yeshejueduo 耶舍崛多, fl. mid 6th c.). T no. 1070.

Foshuo suiqiu jide dazizai tuoluoni shenzhou jing 佛說隨求即得大自在陀羅尼神呪經. Baosiwei 寶思惟 (d. 721). T no. 1154.

Foshuo tuoluoni jijing 佛說陀羅尼集經. Atikūṭa (Adijuduo 阿地瞿多, fl. 651–654). T no. 901.

Foshuo Wenshushili fabaozang tuoluoni jing 佛說文殊師利法寶藏陀羅尼經. Bodhiruci (Putiliuzhi 菩提流志; d. 727). T no 1185A.

Foshuo wuliangmen weimichi jing 佛說無量門微密持經. Zhi Qian 支謙 (fl. 223–253). T no. 1011.

Foshuo wunengsheng fanwang rulai zhuangyan tuoluoni jing 佛說無能勝幡王如來莊嚴陀羅尼經. Shihu 施護 (fl. 982–1017). T no. 943, vol. 19.

Foshuo yiqie rulai wusenisha zuisheng zongchi jing 佛說一切如來烏瑟膩沙最勝總持經. Fatian 法天 (*Dharmadeva; arr. Chang'an 973, d. 1001). T no. 978.

Foshuo yuqie dajiao wang jing 佛說瑜伽大教王經. Faxian 法賢 (fl. late 10th c.), tr. T no. 890.

Foshuo yu xiang gongde jing 佛說浴像功德經. Baosiwei 寶思惟 (d. 721). T no. 697.

Foshuo zaota gongde jing 佛說造塔功德經. Divākara (地婆訶羅, 7th c.), tr. T no. 699.

Fozu lidai tongzai 佛祖歷代通載. Nianchang 念常 (d. 1341). T no. 2036.

Fozu tongji 佛祖統紀. Zhipan 志磐 (1220–1275). T no. 2035.

Gaosengzhuan 高僧傳. Huijiao 慧皎 (497–554). T no. 2059.

Guangda bao louge shanzhu mimi tuoluoni jing 廣大寶樓閣善住祕密陀羅尼經. Bodhiruci (Putiliuzhi 菩提流志; d. 727). T no. 1006.

Guang hongming ji 廣弘明集. Daoxuan 道宣 (596–667). T no. 2103.

Guangzan jing 光讚經, Dharmarakṣa (Zhu Fahu 竺法護, d. 316). T no. 222.

Guanshiyin pusa mimizang ruyilun tuoluoni shenzhou jing 觀世音菩薩祕密藏如意輪陀羅尼神咒經. Śikṣānanda (Shichanantuo 實叉難陀, 652–710). T no. 1082.

Guanshiyin yingyan ji 觀世音應驗記, Fu Liang 傅亮 (374–426). Beijing: Zhonghua ed.

Guanzizai pusa suixin zhou jing 觀自在菩薩隨心咒經. Zhitong 智通 (fl. 605–653). T no. 1103a.

Gujin yijing tuji 古今譯經圖紀. Jingmai (fl. 645–665). T no. 2151.

Gyōrinshō 行林抄. Jōnen 靜然 (fl. 1154). T no. 2409.

Hizōki 秘藏記. Kūkai 空海 (774–835). In *Kōbō daishi zenshū* 弘法大師全集.

Hongming ji 弘明集, Sengyou 僧祐 (445–518). T no. 2102.

Hongzan fahua zhuan 弘贊法華傳. Huixiang 惠詳 (fl. 706). T no. 2067.

Hou Han shu 後漢書. Fan Ye 范曄 (398–445). Beijing: Zhonghua shuju, 1965.

Huayan jing chuanji 華嚴經傳記. Fazang 法藏 (643–712). T no. 2073.

Huayan jing tanxuan ji 華嚴經探玄記. Fazang 法藏 (643–712). T no. 1733.

Ishinpō 醫心方. Tanba Yasayori 丹波康賴. Beijing: Renmin Weisheng, 1993.

Jiaju lingyan Foding zunsheng tuoluoni ji 加句靈驗佛頂尊勝陀羅尼記. Wu Che 武徹 (fl. 765). T no. 974c.

Jingde chuandeng lu 景德傳燈錄. Daoyuan 道原 (fl. 1004). T no. 2076.

Jin'gang ding jing da yuqie mimi xindi famen yijue 金剛頂經大瑜伽祕密心地法門義訣. Amoghovajra (Bukong 不空, 705–774). T no. 1798.

Jinglü yixiang 經律異相. Baochang 寶唱 d. 516. T no. 2121.

Jin guangming jing 金光明經. Dharmakṣema (Tanwuchan 曇無讖, 385–433). T no. 663.

Jin guangming jing wenju 金光明經文句. Zhiyi 智顗 (538–598). T no. 1785.

Jin'guangming zuisheng wang jingshu 金光明最勝王經疏. Huizhao 慧沼 (d. 714). T no. 1788.

Jinshu 晉書. Fang Xuanling 房玄齡 (578–648), et al. Beijing: Zhonghua Shuju, 1974.

Jiu Wudai shi 舊五代史. Xue Juzheng 薛居正 (912–981). Beijing: Zhonghua shuju.

Kaiyuan shijiao lu 開元釋教錄. Zhisheng 智昇. (669–740). T no. 2154.

Kōbō daishi zenshū 弘法大師全集. 6 volumes. Ed. Hase Hōshū. Tokyo, 1909–1911, 1966.

Longshu wuming lun 龍樹五明論. Anonymous. T no. 1420.

Longyou jinshi lu 隴右金石錄. Zhang Wei 張維. Taipei: Yiwen, 1967.

Lüshi chunqiu 呂氏春秋. Attr. Lü Buwei 呂不韋 (d. 235 BC). Beijing: Zhonghua shuju, 1991.

Miaofa lianhua jing 妙法蓮華經. Kumarajiva (Jiumoluoshi 鳩摩羅什, 344–413). T no. 262.

Miaofa lianhua jing xuanyi 妙法蓮華經玄. Zhiyi 智顗 (538–598). T no. 1716.

Miaofa lianhua jing xuanzan 妙法蓮華經玄贊. Kuiji 窺基 (632–682). T no. 1720.

Miaofa lianhua jing wenju 妙法蓮華經文句. Zhiyi 智顗 (538–598). T no. 1718.

Miaojixiang pingdeng guanmen dajiaowang jing lüe chu humo yi 妙吉祥平等觀門大教王經略出護摩儀. *Maitribhadra (Cixian 慈賢; Liao Dynasty, 907–1125). T no. 1194.

Mizhou yuanyin wangsheng ji 密咒圓因往生集. Zhiguang 智廣 (fl. 1200). T no. 1956.

Mohe bore boluomi jing 摩訶般若波羅蜜經. Kumarajiva (Jiumoluoshi 鳩摩羅什, 344–413). T no. 223.

Moli mantuoluo zhou jing 牟梨曼陀羅咒經. Anonymous, Liang 梁 Dynasty (502–557). T no. 1007.

Pubian guangming qingjing zhisheng ruyi baoyin xin wunengsheng damingwang dasuiqiu tuoluoni jing 普遍光明清淨熾盛如意寶印心無能勝大明王大隨求陀羅尼經. Tr. Amoghovajra (Bukong 不空, 705–774). T no. 1153.

Pusa dichi lun 菩薩地持論. Dharmakṣema (Tanwuchan 曇無讖, 385–433). T no. 1581.

Pusa shanjie jing 菩薩善戒經. Guṇavarman (Qiunabamo 求那跋摩; 367–431). T no. 1582.

Putichang suoshuo yizi lunwang jing 菩提場所說一字頂輪王經. Amoghovajra (Bukong 不空, 705–774). T no. 950.

Putichang zhuangyan tuoluoni jing 菩提場莊嚴陀羅尼經. Amoghovajra (Bukong 不空, 705–774). T no. 1008.

Qianjin yifang jiaozhu 千金異方校注. Sun Simiao 孫思邈 (trad. 581–682). Shanghai: Shanghai guji, 1999.

Qianshou qianbei Guanshiyin pusa tuoluoni shenzhou jing 臂觀世音菩薩陀羅尼神咒經. Zhitong 智通 (fl. 605–653). T no. 1057a.

Qianshou qianyan Guanshiyin pusa guangda yuanman wu'ai da beixin tuoluoni jing 千手千眼觀世音菩薩廣大圓滿無礙大悲心陀羅尼經. *Bhagavaddharma 伽梵達摩 (fl. 650–660). T no. 1060.

Qianyan qianbei Guanshiyin pusa tuoluoni shenzhou jing 千眼千臂觀世音菩薩陀羅尼神咒經. Zhitong 智通 (fl. 605–653). T no. 1057.

Qianzhuan tuoluoni Guanshiyin pusa zhou jing 千轉陀羅尼觀世音菩薩咒經. Zhitong 智通 (fl. 605–653). T no. 1035.

Qifo bapusa suoshuo da tuoluoni shenzhou jing 七佛八菩薩所說大陀羅尼神咒經. Anonymous, Jin 晉 Dynasty (265–420). T no. 1332.

Qing Guanyin jing shu chanyi chao 請觀音經疏闡義鈔. Zhiyuan 智圓 (976–1022). T no.1801.

Qingjing Guanshiyin puxian tuoluoni jing 清淨觀世音普賢陀羅尼經. Zhitong 智通 (fl. 605–653). T no. 1038.

Reiganji oshō shōraihōmon dōgutō mokuroku 靈巖寺和尚請來法門道具等目錄. Engyō 圓行 (799–852). T no. 2164.

Rizhi lu 日知錄. Gu Yanwu 顧炎武 (1613–1682). *Guoxue jiben congshu*, ed.

Ruan Ji ji 阮籍集. Ruan Ji 阮籍 (210–263). Ed. Li Zhijun 李志鈞. Shanghai: Shanghai guji, 1978.

Rulai fangbian shanqiao zhoujing 如來方便善巧咒經. Jñānagupta (Shenajueduo 闍那崛多 d. 600). T no. 1334.

Sanbao ganying yaolüe lu 三寶感應要略錄. Feizhuo 非濁 (d.u.). T no. 2084.

Sanlun xuanyi 三論玄義 Jizang 吉藏 (549–623). T no. 1852.

Shengjing 生經. Dharmarakṣa's (Zhu Fahu 竺法護, d. 316). T no. 154.

Shinshosha shōraihōmon tō mokuroku 新書寫請來法門等目錄. Anonymous. T no. 2174.

Sho ajari shingon mikkyō burui soroku 諸阿闍梨真言密教部類總錄. Annen 安然 (fl. 884). T no. 2176.

Shouhu guo jie zhu tuoluoni 守護國界主陀羅尼經. Prajña 般若 (Bore, 744–ca. 810) and Muniśrī (Mounishili 牟尼室利, d. 806), tr. T. no. 997.

Shoulengyan yishu zhujing 首楞嚴義疏注經. Zixuan. 子璿 (965–1038). T no. 1799.

Shou puti xinjie yi 受菩提心戒儀. Attr. Amoghovajra (Bukong 不空, 705–774). T no. 915.

Shinshosha shōraihōmon tō mokuroku 新書寫請來法門等目錄. Shūei's 宗叡 (809–884, in China, 862–866). T no. 2174A.

Shuo sangui wujie wen 說三歸五戒文 (Stein 6551). In Dunhuang bianwen, jiangjing wen, yinyuan jijiao 敦煌變文講經文因緣輯校, edited by Zhou Shaoliang 周紹良, 1010–1032. Nanjing: Jiangsu guji, 1998.

Sifen lü 四分律. Zhu Fonian 竺佛念 (fl. 365). T no. 1428.

Song gaoseng zhuan 宋高僧傳. Zanning 贊寧 (919–1001). T no. 2061.

Song huiyao jigao 宋會樂輯搞. Xu Song 徐松 (1781–1848), et al., comp. Beijing: Zhonghua.

Suxidijieluo jing 蘇悉地羯羅經. Śubhakārasimha 善無畏 (d.735). T no. 893.

Taiping guang ji 太平廣記. Li Fang 李昉 (925–996). Beijing: Zhonghua, 1961.

Tang huiyao 唐會要. Wang Pu 王溥 (922–982). Beijing: Zhonghua, 1955.

Tiwei boli jing 提謂波利經. Anonymous. Pelliot Chinois 3732 and Stein 2051, et al.

Tuoluoni jijing 陀羅尼集經. Atikūṭa (Adijuduo 阿地瞿多, fl. 651–654). T no. 901.

Tuoluoni zaji 陀羅尼雜集. Anonymous. T no. 1336.

Wangsheng ji 往生集. Zhu Hong 祩宏 (1535–1615). T no. 2072.

Wenshushili suosho mohe boreboluomi jing 文殊師利所說摩訶般若波羅蜜經. Mantuoluoxian 曼陀羅仙; fl. 503. T no. 232.

Wen Xuan 文選. Xiao Tong 蕭統 (501–532). Annotated by Li Shan 李善. Beijing: Zhonghua, 1974.

Wu foding sanmei tuoluoni jing 五佛頂三昧陀羅尼經. Bodhiruci (Putiliuzhi 菩提流志; d. 727). T no. 952.

Wugou jin'guang da tuoluoni jing 無垢淨光大陀羅尼經. Mitraśānta (Mituoshan 彌陀山; fl. 690–704). T no. 1024.

Xianjie jing 賢劫經. Dharmarakṣa's (Zhu Fahu 竺法護, d. 316). T no. 425.

Xiaopin mohe boreboluomi jing 小品般若波羅蜜經. Kumarajiva (Jiumoluoshi 鳩摩羅什; 344–413). T no. 227.

Xinxiu kefen liuxue sengzhuan 新修科分六學僧傳. XZ 2B: 6: 489b-c.

Xiuchan yaojue 修禪要訣. XZ 110:834a.

Xu gaoseng zhuan 續高僧傳. Daoxuan 道宣 (596–667). T no. 2060.

Yibu zonglun lunshu ji 異部宗輪論述記. Guiji 窺基 (632–682). XZJ no. 844, 1: 83: 220.

Yiqie jing yinyi 一切經音義. Huilin 慧琳 (d. 820). T no. 2128.

Yizi foding lunwang jing 一字佛頂輪王經. Bodhiruci (Putiliuzhi 菩提流志; d. 727). T no. 951.

Yōson dōjōkan 要尊道場觀. Shunnyū 淳祐 (890–953). T no. 2468.

Yufo gongde jing 浴佛功德經. Yijing 義淨 (635–713). T no. 698.

Yunnan beizheng zhi 雲南備徵志. Wang Song 王崧 (1752–1837). In *Zhongguo Fangzhi Congshu: Huanan difang* 中國方志叢書; 華南地方, v. 45, 1909.

Yuqie dajiao wang jing 瑜伽大教王經. Faxian 法賢 (d. 1001). T no. 890.

Yuqieshi dilun 瑜伽師地論 (*Yogacārabhūmi*). Xuanzang 玄奘 (602–664). T no. 1579.

Yusenisha bizuoye tuoluoni 于瑟捉沙毘左野陀囉尼. Zhikong 指控 (d. 1363). T no. 979.

Za ahan jing 雜阿含經. Guṇabhadra 求那跋陀羅 (394–468). T no. 99.

Zanyang shengde duoluo pusa yibaiba ming jing 讚揚聖德多羅菩薩一百八名經, Tianxizai 天息災 (d. 1000). T no. 1106.

Zhenyuan xinding shijiao mulu 貞元新定釋教目錄. Yuanzhao 圓照 (d. 778). T no. 2157.

Zhong ahan jing 中阿含經. Gautama Samghadeva (Jutan Sengqietipo 瞿曇僧伽提婆; fl. 383–398). T no. 26.

Zhongjing mulu 眾經目錄. Fajing 法經 (fl. 594). T no. 2146.

Zizhi tongjian 資治通鑑. Sima Guang 司馬光 (1019–1086). Beijing: Zhonghua, 1956.

Zongshi tuoluoni yi zan 總釋陀羅尼義讚. Attributed to Amoghovajra (Bukong 不空; 705–774). T no. 902.

Zuisheng tuoluoni jing 最勝陀羅尼經. Fatian 法天 (*Dharmadeva; arr. Chang'an 973, d. 1001). T no. 974.

Zunsheng Foding xiu yujia fa guiyi 尊勝佛頂脩瑜伽法軌儀. Śubhakārasimha 善無畏 (d.735). T no. 973.

Zuo foxingxiang jing 作佛形象經. Anon. Han Period. T no. 692.

SECONDARY SOURCES

Abe, Stanley. *Ordinary Images*. Chicago: University of Chicago Press, 2002.

Abé, Ryūichi. "Word." In *Critical Terms for the Study of Buddhism*, edited by Donald S. Lopez, Jr., 291–310. Chicago: University of Chicago Press, 2005.

——. *The Weaving of Mantra: Kūkai and the Construction of Esoteric Buddhist Discourse*. New York: Columbia University Press, 1999.

Ahuja, N. P. "Changing Gods, Enduring Rituals: Observations on Early Indian Religion as Seen in Terracotta Imagery c. 200 BC–AD 200." *South Asian Archaeology* 2 (2001): 345–354.

Allen, Graham. *Intertextuality*. London: Routledge, 2000.

Alper, Harvey P., ed. *Understanding Mantras*. Albany: State University of New York Press, 1989.

An, Jiayao 安家瑶 and Feng Xiaotang 冯孝堂. "Xi'an Fengxi chutu de Tang yinben Fanwen tuoluoni zhou" 西安沣西出土的唐印本梵文陀罗尼经咒. *Kaogu* 5 (1998): 86–92.

Appadurai, Arjun, ed. *The Social Life of Things: Commodities in Cultural Perspective*. Cambridge: Cambridge University Press, 1986.

Auslander, Leora, "Beyond Words." *The American Historical Review* 110.4 (2005): 1015–1045.

Austin, J. L. *How to Do Things with Words*. Cambridge: Harvard University Press, 1962.

Bakhtin, Mikhail. *The Dialogic Imagination*. Austin: University of Texas Press, 1981.

Barrett, T. H. *The Woman Who Discovered Printing*. New Haven: Yale University Press, 2008.

——. "The Rise and Spread of Printing: A New Account of Religious Factors." *SOAS Working Papers in the Study of Religions*. London: School of Oriental and African Studies, 2001.

——. "Stūpa, Sūtra, and Sarīra in China, c. 656–706 CE." *Buddhist Studies Review* 18.1 (2001): 1–64.

——. "Woodblock Dyeing and Printing Technology in China, c. 700 A.D.: The Innovations of Ms. Liu, and Other Evidence." *Bulletin of the School of Oriental and African Studies* 64.2 (2001): 240–247.

——. "Did I-Ching Go to India? Problems in Using I-Ching as a Source for South Asian Buddhism." *Buddhist Studies Review* 15.2 (1998): 142–156.

——. "Images of Printing in Seventh Century Chinese Religious Literature." *Chinese Science* 15 (1998): 81–93.

——. "The *Feng-tao k'o* and Printing on Paper in Seventh-Century China." *Bulletin of the School of Oriental and African Studies* 60.3 (1997): 538–540.

Bell, Catherine. *Ritual Theory, Ritual Practice.* New York: Oxford University Press, 1992.

——. "Religion and Chinese Culture: Toward an Assessment of 'Popular Religion'." *History of Religions* 37.4 (1989): 35–57.

Belting, Hans. *Likeness and Presence: A History of the Image Before the Era of Art.* Translated by Edmund Jephcott. Chicago: University of Chicago Press, 1994.

Benjamin, Walter. *Illuminations: Essays and Reflections.* New York: Schocken Books, 1969.

Benn, James A. *Burning for the Buddha: Self-Immolation in Chinese Buddhism.* Honolulu: University of Hawaii Press, 2007.

——. "Where Text Meets Flesh: Burning the Body as an Apocryphal Practice in Chinese Buddhism." *History of Religions* 37.4 (1998): 295–322.

Bentor, Yael. "On the Indian Origins of the Tibetan Practice of Depositing Relics and Dhāraṇīs in Stūpas and Images." *Journal of the American Oriental Society* 115.1 (1995): 1–27.

Bibliothèque Nationale, Département des manuscrits. *Catalogue des Manuscrits Chinois de Touen-Houang, Fonds Pelliot Chinois de la Bibliothèque Nationale. Volume IV, Nos. 3501–4000.* Paris: École Français d'Extrême-Orient, 1991.

Birnbaum, Raoul. "Secret Halls of the Mountain Lords: The Caves of Wu-t'ai shan." *Cahiers d'Extreme-Asie* 5 (1989): 115–140.

——. "Essays Honoring Rolf Stein." *History of Religions* 27.1 (1987): 94–97.

——. "The Manifestations of a Monastery: Shen-ying's Experiences on Mount Wu-t'ai in T'ang Context." *Journal of the American Oriental Society* 106:1 (1986): 119–137.

——. *Studies in the Mysteries of Mañjuśrī.* Society for the Study of Chinese Religion Monograph no. 2, 1983.

Birrell, Anne, tr. *The Classic of Mountains and Seas.* London: Penguin Books, 1999.

Bizot, Francois. "Notes Sur Les Yantra Bouddhiques D'Indochine." In *Tantric and Taoist Studies in Honor of R.A. Stein,* edited by Michel Strickmann, vol. 1: 155–191. Brussels: Institute Belge des Hautes Etudes Chinoises, 1981.

Bokenkamp, Stephen. *Early Daoist Scriptures.* Berkeley: University of California Press, 1997.

——. "Sources of the Ling-pao Scriptures." In *Tantric and Taoist Studies in Honor of R.A. Stein,* edited by Michel Strickmann, vol. 2: 434–486. Brussels: Institute Belge des Hautes Etudes Chinoises, 1983.

Bol, Peter. *This Culture of Ours: Intellectual Transitions in T'ang and Sung China.* Stanford: Stanford University Press, 1992.

Bolling, George Melville. "The Cantikalpa of the Atharva Veda." *Transactions and Proceedings of the American Philological Association*" 35 (1904): 77–127.

Boucher, Daniel. "The *Pratītyasamutpādagāthā* and Its Role in the Medieval Cult of the Relics." *Journal of the International Association of Buddhist Studies* 14.1 (1991): 1–27.

Bourdieu, Pierre. *Language and Symbolic Power*. Cambridge, MA: Harvard University Press, 1991.

——. *In Other Words: Essays Toward a Reflexive Sociology*. Stanford: Stanford University Press, 1990.

——. *Outline of a Theory of Practice*. Cambridge: Cambridge University Press, 1977.

Bowring, Richard. "Brief Note: Buddhist Translations During the Northern Sung." *Asia Major*, Third Series, 5.2 (1992): 79–93.

Braarvig, Jens. "Bhavya on Mantras: Apologetic Endeavors on Behalf of the Mahāyāna," in *Aspects of Buddhism: Proceedings of the International Seminar on Buddhist Studies*, edited by Agata Bareja-Starzyńska and Marek Mejor, 31–40. Warsaw: Oriental Institute, 1997.

——. "Dhāraṇī and Pratibhāna: Memory and Eloquence of the Bodhisattvas." *Journal of the International Association of Buddhist Studies* 8 (1985): 117–130.

Brough, John. "The 'Arapacana' Syllabary in the Old 'Lalita-vistara'." *Bulletin of the School of Oriental and African Studies* 40.1 (1977): 85–95.

Brown, Peter. "The Saint as Exemplar in Late Antiquity." *Representations* 2 (1983): 1–25.

——. *The Cult of the Saints: Its Rise and Function in Latin Christianity*. Chicago: University of Chicago Press, 1981.

Brunner, Hélène. "Maṇḍala et yantra dans le śivaïsme āgamique." In *Mantras et diagrammes rituels dans l'hindouisme*, edited by Andre Padoux, 11–35. Paris, 1986.

Bühler, G. "Detailed Report of a Tour in Search of Sanskrit Mss. Made in Kaśmir, Rajputana, and Central India." Extra number of *Journal of the Bombay Branch of the Royal Asiatic Society*, 1877.

Bühnemann, Gudrun. "Buddhist Deities and Mantras in the Hindu Tantras II: The *Śrīvidyārṇavatantra* and the *Tantrasāra*." *Indo-Iranian Journal* 43 (2000): 27–48.

Buswell, Robert E., Jr., tr. *Cultivating Original Enlightenment: Wŏnhyo's Exposition of the Vajrasamādhi-Sūtra (Kŭmgang Sammaegyŏng Non)*. Honolulu: University of Hawaii Press, 2007.

——. "Prolegomenon to the Study of Buddhist Apocryphal Scriptures." In *Chinese Buddhist Apocrypha*, edited by Robert E. Buswell, Jr., 1–30. Honolulu: University of Hawaii Press, 1990.

Bynum, Caroline Walker. *Christian Materiality: An Essay on Religion in Late Medieval Europe*. New York: Zone Books, 2011.

——. "Perspectives, Connections, and Objects: What's Happening in History Now?" *Daedalus* (Winter 2009), 71–86.

Campany, Robert F. *Making Transcendents: Ascetics and Social Memory in Early Medieval China*. Honolulu: University of Hawaii Press, 2009.

——. "On the Very Idea of Religions (in the Modern West and in Early Medieval China)." *History of Religions* 42.4 (2003): 287–319.

——. *To Live as Long as Heaven and Earth: A Translation and Study of Ge Hong's Traditions of Divine Transcendents*. Berkeley: University of California Press, 2002.

——. *Strange Writing: Anomaly Accounts in Medieval China*. Albany: State University of New York Press, 1996.

——. "The Real Presence." *History of Religions* 32 (1993): 233–272.

——. "Notes on the Devotional Uses and Symbolic Function of Sūtra Texts as Depicted in Early Chinese Buddhist Miracle Tales and Hagiographies." *Journal of the International Association of Buddhist Studies* 14.1 (1991): 28–69.

Certeau, Michel de. *The Writing of History*. New York: Columbia University Press, 1988.

——. *Heterologies: Discourse on the Other*. Minneapolis: University of Minnesota Press, 1986.

Chaudhuri, Saroj Kumar. "Siddham in China and Japan," *Sino-Platonic Papers* 88 (1998).

Chavannes, Edouard. *Mémoire composé à l'époque de la grande dynastie T'ang sur les religieux éminents qui allèrent chercher la loi dans les pays d'Occident*. Paris: E. Leroux, 1894.

Chaves, Jonathan. "The Legacy of Ts'ang Chieh: The Written Word as Magic." *Oriental Art* 23.2 (1977): 200–215.

Chen, Huaiyu. "Dunhuang P. 2058v wenshu zhong de jie dasuiqiu tan fayuan wen" 敦煌 P.2058v 文書中的結大隨求壇發願文. *Dunhuangxue* 27 (2008): 167–185.

Chen, Jinhua. "Esoteric Buddhism and Monastic Institutions." In *Esoteric Buddhism and and the Tantras in East Asia*, edited by Charles Orzech, Henrik H. Sørensen, Richard K. Payne, 286–293. Leiden: Brill, 2011.

——. "The Indian Buddhist Missionary Dharmakṣema (385–433): A New Dating of His Arrival in Guzang and of His Translations." *T'oung-Pao* XC (2004): 215–263.

——. "Śarīra and Scepter: Empress Wu's Political Use of Buddhist Relics." *Journal of the International Association of Buddhist Studies* 25 (2002):1–2, 33–150.

Cheng, Jianzheng 成建正. *Xi'an beilin bowuguan* 西安碑林博物館. Xi'an: Shaanxi Renmin, 2000.

Cheng, Yongjian 程永建. "Luoyang chutu hou Tang diaoyin jingzhou" 洛阳出土后唐雕印经咒. *Wenwu* 3 (1992): 96.

Chidester, David. "Word Against Light: Perception and Conflict of Symbols." *The Journal of Religion* 65.1 (1985): 46–62.

Choi, Sun-ah. "Quest For the True Visage: Sacred Images in Medieval Chinese Buddhist Art and the Concept of Zhen. Unpublished Ph.D. Dissertation, The University of Chicago, 2012.

Chou, I-liang. "Tantrism in China." *Harvard Journal of Asiatic Studies* 8 (1945): 241–332.

Chou, Po-kan. "The Problem of the Authorship of the Mahāprajñāpāramito-padeśa: A Re-examination." *Taida lishi xuebao* 臺大歷史學報 34 (2004): 281–327.

Cole, Alan. *Mothers and Sons in Chinese Buddhism*. Stanford: Stanford University Press, 1998.

Como, Michael. *Weaving and Binding: Immigrant Gods and Female Immortals in Ancient Japan*. Honolulu: University of Hawaii Press, 2009.

Conze, Edward. *The Perfection of Wisdom in Eight Thousand Lines and Its Verse Summary*. Bolinas: Four Seasons Foundation, 1973.

Copp, Paul. "Anointing Phrases and Narrative Power: A Tang Buddhist Poetics of Incantation." *History of Religions* 52.3 (2012): 142–172.

——. "Dhāraṇī Scriptures." In *Esoteric Buddhism and the Tantras in East Asia*, edited by Charles Orzech, Henrik H. Sørensen, Richard K. Payne, 176–180. Leiden: Brill, 2011.

——. "Manuscript Culture as Ritual Culture in Late Medieval Dunhuang: Buddhist Talisman-Seals and Their Manuals." *Cahiers d'Extrême-Asie* 20 (2011): 193–226.

——. "Altar, Amulet, Icon: Transformations in Dhāraṇī Amulet Culture, 740–980." *Cahiers d'Extrême-Asie* 17 (2008): 239–264.

——. "Notes on the Term 'Dhāraṇī' in Medieval Chinese Buddhist Thought." *Bulletin of the School of Oriental and African Studies* 71. 3 (2008): 493–508.

——. "Voice, Dust, Shadow, Stone: The Makings of Spells in Medieval Chinese Buddhism." Unpublished PhD Dissertation, Princeton University, 2005.

Csikszentmihalyi, Mark. *Material Virtue: Ethics and the Body in Early China*. Leiden, Brill, 2004.

Dalton, Jacob. "A Crisis of Doxography: How Tibetans Organized Tantra During the 8th–12th Centuries." *Journal of the International Association of Buddhist Studies* 28.1 (2005): 115–181.

——. "The Development of Perfection: The Interiorization of Buddhist Ritual in the Eighth and Ninth Centuries." *Journal of Indian Philosophy* 32 (2004): 1–30.

Davidson, Ronald. "Studies in Dhāraṇī Literature I: Revisiting the Meaning of the Term Dhāraṇī." *Journal of Indian Philosophy* 37.2 (2009): 97–147.

——. *Indian Esoteric Buddhism: A Social History of the Tantric Movement*. New York: Columbia University Press, 2002.

——. "Atiśa's *A Lamp for the Path of Awakening*." In *Buddhism in Practice*, edited by Donald S. Lopez. Princeton: Princeton University Press, 1995.

Davis, Edward L. *Society and the Supernatural in Song China*. Honolulu: University of Hawaii Press, 2001.

Derrida, Jacques. *The Truth in Painting*. Chicago: University of Chicago Press, 1987.

——. *Of Grammatology*. Baltimore: Johns Hopkins University Press, 1976.

De Groot, J. J. M. "Militant Spirit of the Buddhist Clergy in China." *T'oung Pao* 2.2 (1891): 127–139.

Despeux, Catherine. "Talismans and Diagrams." In *Daoism Handbook*, edited by Livia Kohn, 498–540. Leiden: Brill, 2000.

Ditter, Alexei Kamran. "Genre and the Transformation of Writing in Tang Dynasty China (618–907)." Unpublished PhD dissertation, Princeton University, 2009.

Donner, Neil and Daniel Stevenson, tr. *The Great Calming and Contemplation: A Study and Annotated Translation of the First Chapter of Chih-I's "Mo-ho Chih-kuan."* Honolulu: University of Hawaii Press, 1993.

Dudbridge, Glen. "Tang Sources for the Study of Religious Culture: Problems and Procedures." *Cahiers d'Extrême-Asie* 12 (2001):141–154.

——. "Buddhist Images in Action: Five Stories from the Tang." *Cahiers d'Extrême-Asie* 10 (1998): 377–391.

——. *Religious Experience and Lay Society in T'ang China: A Reading of Tai Fu's Kuang-i chi.* Cambridge: Cambridge University Press, 1995.

Dunhuang yanjiu yuan 敦煌研究院. *Dunhuang yishu zongmu suoyin xinbian* 敦煌遺書總目索引新編. Beijing: Zhonghua, 2000.

Drège, Jean-Pierre. "Les Premières Impressions des Dhāraṇī des Mahāpratisarā." *Cahiers d'Extrême-Asie* 11 (1999–2000): 25–44.

Elverskog, Johan. *Buddhism and Islam on the Silk Road*. Philadelphia: University of Pennsylvania Press, 2010.

Emmerick, R. E. "Some Khotanese Inscriptions on Objets D'Art." *Journal of the Royal Asiatic Society of Great Britain and Ireland* 3–4 (1968): 140–143.

Eubanks, Charlotte. *Miracles of Book and Body: Buddhist Textual Culture & Medieval Japan* Berkeley: University of California Press, 2011.

Faure, Bernard. *The Rhetoric of Immediacy: A Cultural Critique of the Chan/Zen Tradition*. Princeton: Princeton University Press, 1991.

Feng, Hanji 馮漢驥. "Ji Tang yinben tuoluoni jingzhou de faxian" 記唐印本陀羅尼經咒的發現. *Wenwu cankao ziliao* 文物參考資料 5 (1957): 48–51, 70.

Forte, Antonino. "The Preface to the So-Called Buddhapālita Chinese Version of the *Buddhoṣṇīṇa Vijaya Dhāraṇī Sūtra*. Unpublished Ms.

——. "The Activities in China of the Tantric Master Manicintana (Pao-ssu-wei 寶思惟: ?–721 A.D.) from Kashmir and of his Northern Indian Collaborators." *East and West*, New Series, (1984) 34:1–3, 301–357.

——. *Political Propaganda and Ideology in China at the End of the Seventh Century: Inquiry into the Nature, Authors and Function of the Tunhuang Document S. 6502 Followed by an Annotated Translation*. Naples: Istituto Universitario Orienatale, 1976.

Foulk, Griffith, and Robert H. Sharf. "On the Ritual Use of Ch'an Portraiture in Medieval China." *Cahiers d'Extrême-Asie* 7 (1993): 149–219.

Frankfurter, David. "Narrating Power: The Theory and Practice of the Magical Historiola in Ritual Spells." In *Ancient Magic and Ritual Power*, edited by Marvin Meyer and Paul Mirecki, 457–476. Leiden: Brill, 1995.

——. "The Magic of Writing and the Writing of Magic: The Power of the Word in Egyptian and Greek Traditions." *Helios* 21.2 (1994): 179–221.

Fraser, Sarah E. *Performing the Visual: The Practice of Buddhist Wall Painting in China and Central Asia, 618–960*. Stanford: Stanford University Press, 2004.

Frazer, J. G. *The Golden Bough: A Study in Magic and Religion, Part I, Vol. I, The Magic Art and the Evolution of Kings*. London: Macmillan, 1911.

Gager, John G. *Curse Tablets and Binding Spells from the Ancient World*. Oxford: Oxford University Press, 1992.

Gao, Guofan 高国藩. *Zhongguo wushu shi* 中国巫术史. Shanghai: Shanghai Sanlian, 1999.

——. *Zhongguo minsu tanwei: Dunhuang wushu yu wushu liubian* 中国民俗探微: 敦煌巫术与巫术流变. Nanjing: Hehai, 1993.

Gardner, D. S. "Performativity in Ritual: The Mianmin Case." *Man* 18 (1983): 346–360.

Gell, Alfred. *Art and Agency: An Anthropological Theory of Art*. Oxford: Oxford University Press, 1998.

Gentetsu, Naomi. *Kōsōden no ju* 高僧伝の呪. *Tōyō shien* 33 (1989): 32–48.

Gibson, Todd. "Inner Asian Contributions to the Vajrayāna." *Indo-Iranian Journal* 40: 37–57, 1997.

Giebel, Rolf, tr. *Two Esoteric Sutras*. Berkeley: Numata Center for Buddhist Translation and Research, 2001.

Gimello, Robert. "Manifest Mysteries: The Nature of the 'Exoteric/Esoteric' (Xian 顯/Mi 密) Distinction in Later Chinese Buddhism." Paper presented at the 2006 Conference of the American Academy of Religion, Washington, D.C., November 21, 2006.

——. "Icon and Incantation: The Goddess Zhunti and the Role of Images in the Occult Buddhism of China." In *Images in Asian Religions: Texts and Contexts*. Eds. Phyllis Granoff and Koichi Shinohara, 225–256. Vancouver: UBC Press, 2004.

Gokhale, Balkrishna Govind. "The Merchant in Ancient India." *Journal of the American Oriental Society* 97. 2 (1977): 125–130.

Gonda, Jan. *History of Ancient Indian Religion*. Leiden: Brill, 1975.

Graff, David. "Early T'ang Generalship and the Textual Tradition." Unpublished PhD Dissertation, Princeton University, 1995.

Granoff, Phyllis. "Maitreya's Jewelled World: Some Remarks on Gems and Visions in Buddhist Texts." *Journal of Indian Philosophy* 26 (1998): 347–371.

Gregory, Peter. *Tsung-Mi and the Sinification of Buddhism*. Princeton: Princeton University Press, 1991.

——. "The Teaching of Men and Gods: The Doctrinal and Social Basis of Lay Buddhist Practice in the Hua-yen." In *Studies in Ch'an and Hua-yen*, edited by Robert M. Gimello and Peter N. Gregory, 253–319. Honolulu: University of Hawaii Press, 1983.

Gulik, Robert H. van. *Siddham: An Essay on the History of Sanskrit Studies in China and Japan*. Nagpur, International Academy of Indian Culture, 1954.

Gyatso, Janet. "Letter Magic: A Peircean Perspective on the Semiotics of Rdon Grub-Chen's Dhāraṇī Memory." In *In the Mirror of Memory*, edited by Janet Gyatso, 173–213. Albany: SUNY Press, 1992.

Han Baoquan 韓保全. "Shijie zuizao de yinshua pin: Xi'an Tangmu chutu yinben tuoluoni jing" 世界最早的印刷品西安唐墓出土印本陀羅尼經. In *Zhongguo kaoguxue yanjiu lunji bianwei hui: jinian Xia Nai xiansheng kaoguxue wushi zhounian* 中國考古學研究論集: 紀念夏鼐先生考古學五十週年, edited by Zhongguo kaoguxue yanjiu lunji bianwei hui, 404–410. Xi'an: Sanqin, 1987.

Hao, Chunwen 郝春文. *Tang houqi Wudai Song chu Dunhuang sengni de shehui shenghuo* 唐后期五代宋初敦煌僧尼的社会生活. Beijing: Zhongguo shehui kexue chubanshe, 1998.

Harper, Donald. *Early Chinese Medical Literature: The Mawangdui Medical Manuscripts*. London: Kegan Paul International, 1998.

——. "Warring States Natural Philosophy and Occult Thought." In *The Cambridge History of Ancient China*, edited by Michael Loewe and Edward L. Shaughnesy, 813–883. Cambridge: Cambridge University Press, 1998.

——. "Wang Yen-shou's Nightmare Poem." *Harvard Journal of Asiatic Studies* 47.1 (1987): 239–283.

Harrison, Paul, tr. *The Pratyutpanna Samādhi Sutra*. Published with John McRae, tr., *The Śūraṅgama Samādhi Sutra*. BDK English Tripiṭaka 25-II, 25-III. Berkeley: Numata Center for Buddhist Translation and Research, 1998.

Harrison, Paul. "Is the Dharma-kāya the Real 'Phantom Body' of the Buddha?" *Journal of the International Association of Buddhist Studies* 15 (1992): 44–94.

Harrist, Robert E., Jr. and Wen C. Fong, eds. *The Embodied Image: Chinese Calligraphy from the John B. Elliot Collection*. Princeton: The Art Museum, Princeton University, 1999.

Harvey, Peter. "The Dynamics of *Paritta* Chanting in Southern Buddhism." In *Love Divine: Studies in Bhakti and Devotional Mysticism*, edited by Karel Werner, 53–85. Richmond Surrey: Curzon Press, 1993.

He, Mei 何梅. "Wutai shan gaoseng Fotuoboli yi 'Foding zunsheng tuoluoni jing' kaolue" 五台山高僧佛陀波利译《佛顶尊胜陀罗尼经》考略. *Wutai shan yanjiu* 3 (1977): 7–10.

Hickman, Brian. "A Note on the Hyakumanto Dharani." *Monumenta Nipponica* 30.1 (1975): 87–93.

Hidas, Gergely. "*Mahāpratisarāvidyāvidhi*: The Spell Manual of the Great Amulet." *Acta Orientalia Academiae Scientiarum Hung* 63.4 (2010): 473–484.

———. "*Mahāpratisarā-Mahāvidyārājñī*, The Great Amulet, Great Queen of Spells. Introduction and Annotated Translation." Unpublished DPhil Thesis, Balliol College, Oxford University, 2008.

Hikata, Ryūshō 干潟龍祥. "*Bucchōsonshō daranikyō shoden no kenkyū*" 佛頂尊勝陀羅尼経諸伝の研究. *Mikkyō kenkyū* 密教研究 68 (1938): 34–72.

Hinüber, Oskar von. *Die Palola Sahis, Ihre Steinischriften, inschriften auf bronzen, andscriftenkolophone und schutzzauber: Materialien zur Geschichte von Gilgit und Chilas.* Mainz: Verlag Philipp von Zabern, 2004.

———. "Namen in Schutzzaubern aus Gilgit." *Studien zur Indologie und Iranistik* 7 (1981): 163–171.

Hobsbawn, Eric and Terrance Ranger. *The Invention of Tradition.* Cambridge: Cambridge University Press, 1992.

Hodge, Stephen. *The Mahā-Vairocana-Abhisaṃbodhi Tantra with Buddhaguhya's Commentary.* London: RoutledgeCurzon, 2003.

Hou, Xudong 侯旭东. *Wu, liu shiji beifang minzhong fojiao xinyang: yi zaoxiangji wei zhongxin de kaocha* 五, 六世纪北方民众佛教信仰: 造像记为中心的考察. Beijing: Zhongguo shehui kexue chubanshe, 1998.

Howard, Angela F. *Summit of Treasures: Buddhist Cave Art of Dazu, China.* Trumbull, CT: Weatherhill, 2001.

———. "The Dhāraṇī Pillar of Kunming, Yunnan: A Legacy of Esoteric Buddhism and Burial Rites of the Bai People in the Kingdom of Dali (937–1253)." *Artibus Asiae* 57.1–2 (1997): 33–86.

Huang Zheng 黄徵 and Wu Wei 吳偉, eds. *Dunhuang yuanwen ji* 敦煌願文集. Changsha: Qiuli shushe, 1995.

Ishida, Hisatoyo 石田尚豊. *Mandara no kenkyū* 曼荼羅の研究. Tokyo: Tōkyō bijutsu, 1975.

Jan, Yün-hua. "*Ch'uan-fa yuan*: The Imperial Institute for Transmission of Buddhadharma in Sung China." In Buddha Prakash, ed., *Studies in Asian History and Culture.* Meerut: Meenakshi Prakashan, 1970.

Jay, Nancy. *Throughout Your Generations Forever: Sacrifice, Religion, and Paternity.* Chicago: University of Chicago Press, 1992.

Jiang Xun 姜尋, ed. *Zhongguo paimai guji wenxian mulu* 中國拍賣古籍文獻目錄, Shijie chuban jituan, Shanghai shudian chubanshe, 2001.

Jones, Andrea Sun-Mee. "What the Doing Does: Religious Practice and the Problem of Meaning." *Journal for Cultural and Religious Theory* 6.1 (2004): 86–107.

Kaltenmark, Max. "Ling-pao: Note sur un terme du Taoïsme religieux." *Mélanges de l'Institute des Hautes-Études Chinoises* 2 (1960): 559–588.

Kapstein, Matthew. 2014. *Tibetan Buddhism: A Very Short Introduction.* Oxford: Oxford University Press, 2014.

——. "Scholastic Buddhism and the Mantrayāna." In *Reason's Traces: Identity and Interpretation in Indian and Tibetan Buddhist Thought.* Boston: Wisdom Publications, 2001.

Kapstein, Matthew T. and Sam Van Schaik, eds. *Esoteric Buddhism at Dunhuang: Rites and Teachings for This Life and Beyond.* Leiden: Brill, 2010.

——. "The Evidence of the Senses and the Materiality of Religion." *Journal of the Royal Anthropological Institute* (N.S.) 14.1 (2008): 110–127.

Keane, Webb. "On the Materiality of Religion." *Material Religion* 4.2 (2008): 230–231.

——. "Language and Religion." In *A Companion to Linguistic Anthropology,* edited by Alessandro Duranti, 431–448. Malden, MA: Blackewell Publishing, 2004.

——. "Religious Language." *Annual Review of Anthropology* 26 (1997): 47–71.

Keightley, David. "Archaeology and Mentality: The Making of China." *Representations* 18 (1987): 91–128.

Kermode, Frank. *Pieces of My Mind: Essays and Criticism, 1958–2002.* New York: FSG, 2003.

Kessler, Michael and Christian Sheppard, eds. *Mystics: Presence and Aporia.* Chicago: University of Chicago Press, 2003.

Kieschnick, John. *The Impact of Buddhism on Chinese Material Culture.* Princeton: Princeton University Press, 2003.

——. *The Eminent Monk: Buddhist Ideals in Medieval Chinese Hagiography.* Honolulu: University of Hawaii Press, 1997.

Kinnard, Jacob N. "On Buddhist 'Bibliolaters': Representing and Worshipping the Book in Medieval Indian Buddhism." *Eastern Buddhist* 34.2 (2002): 94–116.

Kotansky, Roy. "Incantations and Prayers for Salvation on Inscribed Greek Amulets," in *Magica Hiera: Ancient Greek Magic and Religion,* edited by Christopher A. Faraone and Dirk Obbink, 107–137. Oxford: Oxford University Press, 1991.

Kroll, Paul. *Dharma Bell and Dhāraṇī Pillar: Li Po's Buddhist Inscriptions.* Kyoto: Scuola Italiana di studi sull'Asia Orientale, 2001.

Kuo, Li-ying. "Bucchōsonshōdarani no dempa to gishiki" 佛頂尊勝陀羅尼の伝播と儀式. *Tendai gakuhō* (October, 2007): 1–39.

——. *Confession et contrition dans le bouddhisme chinois du Ve au Xe Siècle.* Paris: École Française D'Extrême-Orient, 1994.

LaCapra, Dominick. *Rethinking Intellectual History: Texts, Contexts, Language.* Ithaca: Cornell University Press, 1983.

Lai, Whalen. "The Earliest Folk Buddhist Religion in China: Ti-wei Po-li ching and Its Historical Significance." In *Buddhist and Taoist Practice in Medieval Chinese Society,* edited by David Chappell, 11–35. Honolulu: University of Hawaii Press, 1987.

LaMarre, Thomas. *Uncovering Heian Japan: An Archaeology of Sensation and Inscription.* Durham and London: Duke University Press, 2000.

Lamotte, Étienne. "Mañjuśrī." *T'oung Pao* XLVII (1960): 1–96.

——. *Le Traité de la grande vertu du sagesse,* vol. I. Louvain: l'Institut Orientaliste de Louvain, 1946.

Lancaster, Lewis. "Elite and Folk: Comments on the Two-Tiered Theory." In *Religion and the Family in East Asia,* edited by George DeVos and Takao Sofue, 87–95. Berkeley: University of California Press, 1986.

Laufer, Berthold. "Inspirational Dreams in Eastern Asia." *Journal of American Folk-Lore* 44.172 (1931): 208–216.

Lear, Jonathan. *A Case for Irony.* Cambridge: Harvard University Press, 2011.

Ledderose, Lothar. "Carving Sutras into Stone Before the Catastrophe: The Inscription of 1118 at Cloud Dwelling Monastery near Beijing." *Proceedings of the British Academy,* 125 (2004): 381–454.

——. *Ten Thousand Things: Module and Mass Production in Chinese Art.* Princeton: Princeton University Press, 2000.

Lee, Seunghye. "Arts of Enshrining: The Making of Relics and Bodies in Chinese and Korean Buddhist Art from the Tenth through the Fourteenth Centuries." Unpublished Ph.D. Dissertation, the University of Chicago, 2013.

Lehnert, Martin. "Tantric Threads Between India and China." In *The Spread of Buddhism,* edited by Ann Heirman and Stephen Peter Bumbacher. Leiden: Brill, 2007.

——. "Myth and Secrecy in Tang-Period Esoteric Buddhism." In *The Culture of Secrecy in Japanese Religions,* edited by Bernhard Scheid and Mark Teeuwen. New York: Routledge, 2006.

Li Ling 李翎. "Dasuiqiu tuoluoni zhoujing de liuxing yu tuxiang" 大随求陀罗尼咒经的流行与图像. In *Tangdai guojia yu diyu shehui yanjiu: Zhonguo Tangshi xuehui dishi jie nian hui lunwen ji* 唐代国家与地域社会研究：中国唐史学会第十届年会论文集, edited by Yan Yaozhong 嚴耀中, 349–385. Shanghai: Shanghai guji, 2008.

Li Xiaorong 李小荣. *Dunhuang Mijiao wenxian lungao* 敦煌密教文献论稿. Beijing: Renmin wenxue, 2003.

Li Yuanguo 李遠國. *Daojiao fayin mizang* 道教法印秘藏. Zhanghua: Lingbao chubanshe, 2002.

Li Yuhang. "Gendered Materialization: An Investigation of Women's Artistic and Literary Reproductions of Guanyin in Late Medieval China." Unpublished PhD Dissertation, University of Chicago, 2011.

Li Yuzheng 李域铮 and Guan Shuangxi 关双喜. "Xi'an xijiao chutu Tangdai shouxie Jingzhou juanhua" 西安西郊出土唐代手写经咒绢画. *Wenwu* 7 (1984): 50–52.

Liebenthal, Walter. "Sanskrit Inscriptions from Yunnan II." *Sino-Indian Studies* 5 (1955): 1–23.

——. "Sanskrit Inscriptions from Yunnan I (and the Dates of the Foundation of the Main Pagodas in that Province)." *Monumenta Serica* 12 (1947): 1–40.

Lincoln, Bruce. "How to Read a Religious Text: Reflections on Some Passages of the Chaṇdogya Upaniṣad." *History of Religions* 46.2 (2006): 127–139.

Linrothe, Rob. "Xia Renzong and the Patronage of Tangut Buddhist Art: The Stūpa and Ushnīshavijayā Cult." *Journal of Song-Yuan Studies* 28 (1998): 91–121.

——. "Ushnishavijayā and the Tangut Cult of the Stūpa at Yü-lin Cave 3." *National Palace Musuem Bulletin* XXXI. 4&5 (1996): 1–25.

Liu Hong 刘弘. "Liangshan Fojiao mizong shike de chubu yanjiu" 凉山佛教密宗石刻的初步研究. *Sichuan wenwu* 4 (1999): 39–45.

Liu Shufen 劉淑芬. Miezui yu duwang: Foding zunsheng tuoluoni jingchuang zhi yanjiu 滅罪與度亡佛頂尊勝陀羅尼經幢之研究. Shanghai: Shanghai guji, 2008.

——. "Art, Ritual, and Society: Buddhist Practice in Rural China During the Northern Dynasties." *Asia Major* 8.1 (1995), 19–49.

Liu, Xiaoming 刘晓明. Zhongguo fuzhou wenhua daguan 中国符咒文化大观. Nanchang: Baihua zhou wenyi, 1999.

Liu Yongzeng 刘永增. "Mogaoku di 148 ku nanbei kan tianjing tuxiang jieshuo" 莫高窟第148窟南北龛天井图像解说. In Dunhuang bihua yishu jicheng yu chuangxin guoji xueshu yantaohui lunwen ji 敦煌壁画艺术继承与创新国际学术研讨会论文集, edited by Dunhuang yanjiu yuan 敦煌研究院, 518–536. Shanghai: Shanghai shiji, 2008.

——. *Elaborations on Emptiness: Uses of the Heart Sūtra.* Princeton: Princeton University Press, 1996.

Liu, Yiqing 劉義慶. A New Account of Tales of the World, 2nd ed. Translated with introduction and notes by Richard Mather (403–444). Ann Arbor: Center for Chinese Studies, University of Michigan, 2002.

Liu Zhaorui 劉昭瑞. Kaogu faxian yu zaoqi Daojiao yanjiu 考古發現與早期道教研究. Beijing: Wenwu, 2007.

Lopez, Donald. *Buddhism and Science: A Guide for the Perplexed.* Chicago: University of Chicago Press, 2010.

Lü, Jianfu 呂建福. Mijiao lunkao 密教論考. Beijing: Zongjiao wenhua, 2008.

——. Zhongguo mijiao shi 中國密教史. Beijing: Zhongguo Shehui Kexue, 1995.

Luk, Charles (Upāsaka Lu K'uan Yu). The Śūraṅgama Sūtra (Leng Yen Ching): Chinese Rendering by Master Paramati of the Central North India at Chih Chih Monastery, Canton, China, AD 705, Commentary (abridged) by Ch'an Master Han Shan (1546–1623). New Delhi: Munshiram Mahoharlal Publishers, 2001.

Ma, De 马德. Dunhuang Mogaoku shi yanjiu 敦煌莫高窟史研究. Lanzhou: Gansu jiaoyu chubanshe, 1996.

Ma, Shichang 馬世長. "Da suiqiu tuoluoni mantuluo tuxiang de chubu kaocha" 大隨求陀羅尼曼茶羅圖像的初步考察. *Tang Yanjiu* 10 (2004): 527–581.

Mair, Victor. "Records of Transformation Tableaux ('pien-hsiang')." *T'oung-Pao* 72.2 (1986): 3–43.

Makita, Tairyō 牧田諦亮. *Gikyō kenkyū* 疑經研究. Kyoto: Kyoto daigaku, 1976.

Malinowski, Bronislaw. *Magic, Science, and Religion and Other Essays*. Long Grove, IL: Waveland Press, 1992.

———. *Coral Gardens and Their Magic, Volume II: The Language of Magic and Gardening*. Bloomington: Indiana University Press, 1965.

Matsumoto, Eiichi 松本栄一. *Tonkōga no kenkyū* 敦煌画の研究. 2 Volumes. Kyoto: Dōhōsha, 1937.

Mauss, Marcel. *A General Theory of Magic*. Translated by Robert Brain. London: Routledge, 2001.

McBride, Richard. "Dhāraṇī and Spells in Medieval Sinitic Buddhism." *Journal of the International Association of Buddhist Studies* 28.1 (2005): 85–114.

———. "Dhāraṇī." In *Encyclopedia of Buddhism*, edited by Robert Buswell, 217. New York: Macmillan), 2004.

———. "Mantra." In *Encyclopedia of Buddhism*, edited by Robert Buswell, 512. New York: Macmillan, 2004.

McDaniel, Justin. "Paritta and Rakṣā Texts." In *Encyclopedia of Buddhism*, edited by Robert Buswell, 634–635. New York: Macmillan, 2004.

McMahan, David L. *The Making of Buddhist Modernism*. New York: Oxford University Press, 2008.

McMullen, David. "Bureaucrats and Cosmology: The Ritual Code of T'ang China," in *Rituals of Royalty: Power and Ceremonial in Traditional Societies*, edited by David Cannadine and Simon Price, 181–236. Cambridge: Cambridge University Press, 1987.

Mevissen, Gerd J. R. "Images of Mahapratisara in Bengal: Their Iconographic Links with Javanese, Central Asian and East Asian Images." *Journal of Bengal Art* 4 (1999): 99–129.

———. "Studies in Pañcarakṣā Manuscript Painting." *Berliner Indologische Studien* 4/5 (1989): 339–374.

Misaki, Ryōshu 三崎良周. "Bucchōsonshō daranikyō to Shoseibo daranikyō no kenkyū" 佛頂尊勝陀羅尼経と諸星母陀羅尼経の研究. In *Tonkō to Chugoku Bukkyō* 敦煌と中国佛教, edited by Makita Tairyō 牧田諦亮 and Fukui Fumimasa 福井文雅. Tokyo: Daitō, 1984.

Mollier, Christine. *Buddhism and Taoism Face to Face: Scripture, Ritual, and Iconographic Exchange in Medieval China*. Honolulu: University of Hawaii Press, 2008.

———. "Talismans." In *Divination et société dans la Chine Médiévale: Étude de laBibliothèque nationale de France et de la British Library, sous a direction de Marc Kalinowski*. Paris: Bibliothèque Nationale de France, 2003.

Morgan, Carole. "Inscribed Stones: A Note on a Tang and Song Dynasty Burial Rite." *T'oung Pao* LXXXII (1996): 317–348.

Müller, Max and Nanjio Bunyiu, eds. *The Ancient Palm Leaves Containing the Pragñâ-Pâramitâ-Hridaya-Sûtra and the Ushnîsha-Vigaya-Dhârani.* Oxford: Clarendon Press, 1884.

Murata, Jirō. "A Brief History of Chinese Stone Pagodas." *Ars Buddhica* 93 (1993): 16–36.

Mrozik, Susanne. "The Relationship Between Morality and the Body in Monastic Training According to the 'Siksasamuccaya'." Unpublished PhD Dissertation, Harvard University, 1999.

Nara Kokuritsu Hakubutsukan 奈良国立博物館. *Komikkyō: Nihon Mikkyō no Taidō: Tokubetsuten* 古密教: 日本密教の胎動: 特別展. Nara: Nara Kokuritsu Hakubutsukan, 2005.

Nattier, Jan. *A Few Good Men: The Bodhisattva Path According to the Inquiry of Ugra (Ugraparipṛcchā).* Honolulu: University of Hawaii Press, 2003.

Obringer, Frédéric. *L'Aconit et L'Orpiment: Drogues et poisons en Chine anciennne et médiévale.* Paris: Fayard, 1997.

Ogiwara, Unrai 荻原雲来. *Sonshō darani no kenkyū* 尊勝陀羅尼の研究. In *Ogiwara Unrai bunshū* 荻原雲来文集, 809–834. Tokyo: Taishō daigaku, 1938.

Ōmura Seigai 大村西崖. *Mikkyō hattatsushi* 密教發達志. Tōkyō: Bussho, 1918.

Ono, Gemnyō 小野玄妙. *Bukkyō no bijutsu to rekishi* 佛教の美術と歷史. Tōkyō, Daizō Shuppan Kabushiki Gaisha, 1937.

Orlando, Raffaelo. "A Study of Chinese Documents Concerning the Life of the Tantric Buddhist Patriarch Amoghavajra (A.D. 705–774)." Doctoral Dissertation, Princeton University, 1981.

Orzech, Charles D. "The 'Great Teaching of Yoga': The Chinese Appropriation of the Tantras, and the Question of Esoteric Buddhism." *Journal of Chinese Religions* 34 (2006): 29–78.

——. *Politics and Transcendent Wisdom: The Scripture for Humane Kings in the Creation of Chinese Buddhism.* University Park, PA: Pennsylvania State University Press, 1998.

——. "Mandalas on the Move: Reflections from Chinese Esoteric Buddhism Circa 800 C.E." *Journal of the International Association of Buddhist Studies* 19.2 (1996): 209–243.

——. "Seeing Chen-yen Buddhism: Traditional Scholarship and the Vajrayana in China." *History of Religions* 29.2 (1989): 87–114.

Orzech, Charles D., Henrik H. Sørensen, and Richard K. Payne. "Introduction: Esoteric Buddhism and the Tantras in East Asia: Some Methodological Considerations." In *Esoteric Buddhism and the Tantras in East Asia*, edited by Charles Orzech, Henrik H. Sørensen, Richard K. Payne, 3–18. Leiden: Brill, 2011.

Orzech, Charles D., Henrik H. Sørensen, Richard K. Payne, eds. *Esoteric Buddhism and the Tantras in East Asia.* Leiden: Brill, 2011.

Osabe, Kazuo 長部和雄. *Tō Sō Mikkyō shi ronkō* 唐宋密教史論考. Kobe: Joshi Daigaku, 1982.

Overbey, Ryan Richard. "Memory, Rhetoric, and Education in the *Great Lamp of the Dharma Dharani Scripture*." Unpublished PhD Dissertation, Harvard University, 2010.

Owen, Stephen. "A Monologue of the Senses." *Yale French Studies* 61 (1981): 244–260.

Padoux, Andre. *Vāc: The Concept of the Word in Selected Hindu Tantras*. Albany: State University of New York Press, 1990.

———. "Mantras—What Are They?" In *Understanding Mantras*, edited by Harvey P. Alper, 295–318. Albany: State University of New York Press, 1989.

———. *L'énergie de la parole: cosmogonies de la parole tantrique*. Paris: Soleil Noir, 1980.

Pagel, Ulrich. *The Bodhisattvapiṭaka: Its Doctrines, Practices, and Their Place in Mahāyāna Buddhism*. Tring, UK: Institute of Buddhist Studies, 1995.

Pal, Pratapaditya. "Reflections on the Gandhāra Bodhisattva Images." *Bulletin of the Asia Institute* (New Series) 20 (2006): 101–115.

Pelliot, Paul. *L'inscription nestorienne de si-ngan-fou*, edited with supplements by Antonino Forte. Kyoto: Scuola di Studi sull'Asia Orientale, 2002.

Peng, Jinzhang 彭金章. *Mijiao huajuan* 密教畫卷. Hong Kong: Shangwu yinshuguan, 2003.

Penkower, Linda. "Tien-T'ai During the T'ang Dynasty: Chan-Jan and the Sinification of Buddhism." Unpublished Ph.D Dissertation, Columbia University, 1993.

Powers, Martin J. *Pattern and Person: Ornament, Society, and Self in Classical China*. Cambridge, MA: Harvard East Asia Center, 2006.

Pregadio, Fabrizio. *Great Clarity: Daoism and Alchemy in Early Medieval China*. Stanford: Stanford University Press, 2006.

Qian Zongxiu [Ch'ien, Tsung-hsiu] 簡宗修. "Bai Juyi ji zhong de beizong wenxian yu beizong chanshi" 白居易集中的北宗文獻與北宗禪師. *Foxue yanjiu zhongxin xuebao* 6 (2003): 213–242.

Raz, Gil. "Creation of Tradition: The Five Talismans of the Numinous Treasure and the Formation of Early Daoism." Unpublished PhD Dissertation, Indiana University, 2004.

Reischauer, Edwin O, tr. *Ennin's Diary: The Record of a Pilgrimage to China in Search of the Law*. New York: Ronald Press, 1955.

———. *Ennin's Travels in T'ang China*. New York: Ronald Press, 1955.

Reis-Habito, Maria. *Die Dhāranī des grossen Erbarmens des Bodhisattva Avalokiteśvara mit tausend Händen und Augen: übersetzung und Untersuchung ihrer textlichen Grundlage sowie Erforschung ihres Kultes in China*. Sankt Augustin: Institut Monumenta Serica, 1993.

Robson, James. *Power of Place: The Religious Landscape of the Southern Sacred Peak (Nanyue 南嶽) in Medieval China*. Cambridge: Harvard Asia Center, 2009.

———. "Signs of Power: Talismanic Writing in Chinese Buddhism." *History of Religions* 48.2 (2008): 130–169.

Rong, Xinjiang 榮新江. *Dunhuangxue shiba jiang* 敦煌学十八讲. Beijing: Beijing Daxue, 2001.

———. *Zhonggu Zhongguo yu wailai wenming* 中古中国与外来文明. Beijing: Sanlian, 2001.

——. *Guiyi jun shi yanjiu: Tang Song shidai Dunhuang lishi kaosuo.* 歸義軍時研究: 唐宋時代敦煌歷史考索. Shanghai: Shanghai guji, 1996.

Rubin, Jay. "The Art of the Flower of Mumbo Jumbo." *Harvard Journal of Asiatic Studies* 53.2 (1993): 513–541.

Ruegg, David Seyfort. "Allusiveness and Obliqueness in Buddhist Texts." In *Dialectes dans les littératures Indo-Aryennes*, edited by Colette Caillat, 295–328. Paris: College de France, Institut de Civilisation Indienne, 1989.

Ruppert, Brian. *Jewel in the Ashes: Buddha Relics and Power in Early Medieval Japan.* Cambridge: Harvard Asia Center, 2000.

Salomon, Richard. *Ancient Buddhist Scrolls from Gandhāra: The British Library Kharoṣṭhī Fragments.* Seattle: University of Washington Press, 1999.

——. "An Additional Note on Arapacana." *Journal of the American Oriental Society* 113.2 (1993): 275–276.

——. "New Evidence for a Gandhari Origin of the Arapacana Syllabary." *Journal of the American Oriental Society* 110.2 (1990): 255–273.

Sanderson, Alexis. "Religion and the State: Śaiva Officiants in the Territory of the King's Brahmanical Chaplain." *Indo-Iranian Journal* 47 (2004): 229–300.

Sasaki, Kōsei 佐々木成功. "Jōen Hōshō no jiseki ni tsuite" 承遠法照の事蹟について. *Ryūkoku daigaku ronsō* 265 (1925): 67–85.

Sawada, Mizuhō 澤田瑞穂. *Jigokuhen: Chugoku no meikaisetsu* 地獄変:中国の冥界説. Tokyo: Hirakawa, 1991.

——. *Chūgoku no juhō* 中国の呪法. Tokyo: Hirakawa, 1984.

Schaefer, Karl R. *Enigmatic Charms: Medieval Arabic Block Printed Amulets in American and European Libraries and Museums.* Leiden: Brill, 2006.

Schafer, Edward H. *The Vermillion Bird: T'ang Images of the South.* Berkeley: University of California Press, 1967.

——. *The Golden Peaches of Samarkand: A Study of T'ang Exotics.* Berkeley: University of California Press, 1963.

——. "Orpiment and Realgar in Chinese Technology and Tradition." *Journal of the American Oriental Society* 75.2 (1955): 73–89.

Scherrer-Schaub, Christina Anna. "Some Dhāraṇī Written on Paper Functioning as Dharmakāya Relics: A Tentative Approach to PT 350." In *Tibetan Studies: Proceedings of the 6th Seminar of the International Association for Tibetan Studies, Fagernes 1992*, 711–727. Oslo: Institute for Comparative Research in Human Culture, 1994.

Schneider, Richard. "Un moine indien au Wou-t'ai Chan: Relation d'un pèlerinage." *Cahiers d'Extrême-Asie* 3 (1987): 27–40.

Schopen, Gregory. *Figments and Fragments of Mahāyāna Buddhism: More Collected Papers.* Honolulu: University of Hawaii Press, 2005.

——. *Bones, Stones, and Buddhist Monks: Collected Papers on the Archeology, Epigraphy, and Texts of Monastic Buddhism in India*. Honolulu: University of Hawaii Press, 1997.

——. "The Phrase 'sa pṛthivīpradeśaś caityabhūto bhavet' in the Vajracchedikā: Notes on the Cult of the Book in the Mahāyāna." *Indo-Iranian Journal* 17 (1975): 147–187.

Seidel, Anna. "Traces of Han Religion in Funeral Texts Found in Tombs." In *Dōkyō to Shūkyō bunka* 道教と宗教文化, edited by Akizuki Kan'ei 秋月觀暎, 21–57. Tokyo: Hirakawa, 1987.

——. "Imperial Treasures and Taoist Sacraments: Taoist Roots in the Apocrypha." In *Tantric and Taoist Studies in Honour of R.A. Stein*, v. 2, edited by Michel Strickmann. *Mélanges Chinois et Bouddhiques* 21 (1983): 291–371.

Sen, Tansen. "The Revival and Failure of Buddhist Translations During the Song Dynasty." *T'oung Pao* LXXXVII (2002): 27–80.

——. "Astronomical Tomb Paintings from Xuanhua: Mandalas?" *Ars Orientalis* 29 (1999): 29–54.

Sennett, Richard. *The Craftsman*. New Haven: Yale University Press, 2008.

Sharf, Robert. "Thinking Through Shingon Ritual." *Journal of the International Association of Buddhist Studies* 26.1 (2003): 51–96.

——. *Coming to Terms with Chinese Buddhism: A Reading of the Treasure Store Treatise*. Honolulu: University of Hawaii Press, 2002.

——. "Prolegomenon to the Study of Japanese Buddhist Icons." In *Living Images: Japanese Buddhist Icons in Context*, edited by Robert Sharf and Elizabeth Horton Sharf, 1–18. Stanford: Stanford University Press, 2001.

Shen, Hsueh-man. "Praying for Eternity: Use of Buddhist Texts in Liao Buddhist and Funerary Practices." In *Gilded Splendor: Treasures of China's Liao Empire (907–1125)*, edited by Hsueh-man Shen. New York: Asia Society, 2006.

——. "Realizing the Buddha's Dharma Body During the *Mofa* Period: A Study of Liao Buddhist Relic Deposits." *Artibus Asiae* 61.2 (2001): 263–303.

Shimono, Akiko 下野玲子. "Tonko Bakukōkutsu dai niyakujūnana kutsu minamiheki kyōhen no shin kaishaku" 敦煌莫高窟第二一七窟南壁経変の新解釈. *Bijutsushi* 157 (2004): 96–115.

Shōsōin jimusho 正倉院事務所. *Shōsōin hōmotsu: Kunaichō zōhan* 正倉院寶物: 宮内庁蔵版. Tokyo: Mainichi Shinbunsha, 1994.

Sivin, Nathan. "Ailment and Cure in Traditional China." Second Annual East Asian History of Science Foundation Lecture, The Chinese University of Hong Kong. Unpublished MS, 1984.

Skaff, Jonathan Karam. "Tang Military Culture and Its Inner Asian Influences." In *Military Culture in Imperial China*, edited by Nicolas Di Cosimo. Cambridge: Harvard University Press, 2009.

Skemer, Don C. *Binding Words: Textual Amulets in the Middle Ages*. University Park: Penn State Press, 2006.

Skilling, Peter. "Traces of the Dharma: Preliminary Reports on Some Ye Dhammā and Ye Dharmā Inscriptions from Mainland South-East Asia." *Bulletin de la Ecole Français d'Extréme-Orient* 90–91 (2003–2004): 273–287.

———. "An Arapacana Syllabary in the Bhadrakalpika-Sutra." *Journal of the American Oriental Society* 116.3 (1996): 522–523.

———. "The Rakṣā Literature of the Śrāvakayāna." *Journal of the Pali Text Society* 16 (1992): 109–182.

Skilton, Andrew. "State or Statement? Samādhi in Some Early Mahāyāna Sūtras." *Eastern Buddhist* 34.2 (2002): 51–93.

Skjærvø, Prods Oktor. *Khotanese Manuscripts from Chinese Turkestan in the British Library: A Complete Catalogue with Texts and Translations*. London: British Library, 2002.

Skorupski, Tadeusz. *Tibetan Amulets*. Bangkok: Orchid Press, 1983.

Ślączka, Anna A. *Temple Consecration Rituals in Ancient India: Text and Archaeology*. Leiden: Brill, 2007.

Smith, Jonathan Z. *Imagining Religion from Babylon to Jonestown*. Chicago: University of Chicago Press, 1982.

Snellgrove, David L. *Indo-Tibetan Buddhism: Indian Buddhists and Their Tibetan Successors*. London: Serindia Publications, 1987.

Sontag, Susan. *Illness as Metaphor and Aids and Its Metaphors*. New York: Picador, 1990.

Sørensen, Henrik H. "On Esoteric Buddhism in China: A Working Definition." In *Esoteric Buddhism and the Tantras in East Asia*, edited by Charles Orzech, Henrik Sørensen, and Richard Payne, 155–175. Leiden: Brill, 2011.

———. "Michel Strickmann on Magical Medicine in Medieval China and Elsewhere." *History of Religions* 43.4 (2004): 319–332.

Staal, Fritz. "Vedic Mantras." In *Understanding Mantras*, edited by Harvey P. Alper, 48–95. Albany: State University of New York Press, 1989.

Starn, Randolph. "A Historian's Brief Guide to New Museum Studies." *American Historical Review* 110.1 (2005): 68–98.

Stein, Aurel. *Serindia: Detailed Report of Explorations in Central Asia and Westernmost China Carried Out and Described Under the Orders of H. M. Indian Government*. Oxford: Clarendon Press, 1921.

Stein, Rolf A. *The World in Miniature: Container Gardens and Dwellings in Far Eastern Religious Thought*, translated by Phyllis Brooks. Stanford: Stanford University Press, 1990.

———. *Grottes-matrices et lieux saints de la déesse en Asie orientale*. Paris: Ècole Française D'Extreme-Orient, 1988.

Strickmann, Michel. *Chinese Magical Medicine*. Stanford: Stanford University Press, 2002.

——. *Mantras et mandarins: le bouddhisme tantrique en Chine.* Paris: Editions Gallimard, 1996.

——. "The Consecration Sutra: A Buddhist Book of Spells." In *Chinese Buddhist Apocrypha,* edited by Robert E. Buswell, Jr., 75–118. Honolulu: University of Hawaii Press, 1990.

——. "Dreamwork of Psycho-Sinologists: Doctors, Taoists, Monks." In *Psycho-Sinology: The Universe of Dreams in Chinese Culture,* edited by Carolyn T. Brown, 25–46. Lanham: University Press of America, 1988.

Strong, John. *Relics of the Buddha.* Princeton: Princeton University Press, 2004.

Su, Bai 宿白. *Tang Song shiqi de diaoban yinshua* 唐宋时期的雕版印刷. Beijing: Wenwu, 1999.

Summers, David. *Real Spaces: World Art History and the Rise of Western Modernism.* London: Phaidon, 2003.

Suzhou bowuguan 苏州博物馆, ed. *Suzhou bowuguan cang Huqiu Yunyansi ta Ruiguangsi ta wenwu* 苏州博物馆藏虎丘云岩寺塔、瑞光寺塔文物. Beijing: Wenwu chubanshe, 2006.

Suzhou shi wenguan hui 蘇州市文官會 and Suzhou bowuguan 蘇州博物館. "Suzhou shi Ruiguangsi ta faxian yipi Wudai Bei Song wenwu" 蘇州市瑞光寺塔發現一批五代北宋文物. *Wenwu* 11 (1979): 21–31.

Suzuki, D.T, tr. *The Lankavatara Sutra: A Mahayana Text.* Taipei: SMC Pubishing, 1991.

Swanson, Paul. "Dandala, Dhāraṇī, and Denarii: A T'ien-t'ai Perspective on *The Great Vaipulya Dhāraṇī Sūtra.*" *Buddhist Literature* 2 (2000): 197–233.

Swearer, Donald. *Becoming the Buddha: The Ritual of Image Consecration in Thailand.* Princeton: Princeton University Press, 2004.

Tambiah, Stanley Jeyaraja. *Magic, Science, Religion, and the Scope of Rationality.* Cambridge: Cambridge University Press, 1990.

——. *Culture, Thought and Social Action.* Cambridge, MA: Harvard University Press, 1985.

——. *Buddhist Saints of the Forest and the Cult of Amulets: A Study in Charisma, Hagiography, Sectarianism, and Millennial Buddhism.* Cambridge: Cambridge University Press, 1984.

——. "The Magical Power of Words." *Man,* New Series, 3.2 (1968): 175–208.

Tanabe, George J., Jr. *Myōe the Dreamkeeper: Fantasy and Knowledge in Early Kamakura Buddhism.* Cambridge, MA: Council on East Asian Studies, Harvard University, 1992.

Tanaka, Kaiyō 田中海應. "Sonshōdarani shinkō shikan" 尊勝陀羅尼信仰史観. *Taishō daigaku gakuhō* 大正大学学報 15 (1933): 1–33.

Tanaka, Kimiaki 田中公明. *Tonkō mikkyō to bijutsu* 敦煌密教と美術. Kyoto: Hōzōkan, 2000.

Tang, Yongtong 湯用彤. *Sui Tang Fojiao shi gao* 隋唐佛教史稿. Beijing: Zhonghua, 1982.

——. *Han Wei liang Jin Nanbeichao Fojiao shi* 漢魏兩晉南北朝佛教史. Taipei: Taiwan Shangwu, 1968.

Teiser, Stephen F "Ornamenting the Departed: Notes on the Language of Chinese Buddhist Ritual Texts." *Asia Major* 22.1 (2009): 201–237.

———. *Reinventing the Wheel: Pictures of Rebirth in Medieval Buddhist Temples.* Seattle: University of Washington Press, 2007.

———. "Perspective on Readings of the *Heart Sūtra*: The Perfection of Wisdom and the Fear of Buddhism." In *Ways with Words: Writing About Reading Texts from Early China*, edited by Pauline Yu, Peter Bol, Stephen Owen, and Willard Peterson, 130–145. Berkeley: University of California Press, 2000.

———. "Popular Religion." *Journal of Asian Studies* 54.2 (1995): 378–395.

———. *The Scripture on the Ten Kings and the Makings of Purgatory in Medieval Chinese Buddhism.* Honolulu: University of Hawaii Press, 1994.

———. "Hymns for the Dead in the Age of the Manuscript." *Gest Library Journal* 5.1 (1992): 26–56.

———. *The Ghost Festival in Medieval China.* Princeton: Princeton University Press, 1988.

———. "T'ang Buddhist Encyclopedias: An Introduction to *Fa-yuan Chu-lin* and *Chu-ching Yao-chi*." *T'ang Studies* 3 (1985): 109–128.

Trombert, Éric. "Bière et bouddhisme: la consommation de boissons alcoolisées dans les monastères de Dunhuang aux VIIIe-Xe siècles." *Cahiers d'Extrême-Asie* 11 (1999): 129–181.

Tsiang, Katherine. "Buddhist Printed Images and Texts of the Eighth-Tenth Centuries: Typologies of Replication and Representation." In *Esoteric Buddhism at Dunhuang: Rites and Teachings for This Life and Beyond*, edited by Matthew T. Kapstein and Sam Van Schaik, 201–252. Leiden: Brill, 2010.

Tsukamoto, Zenryū 塚本善隆. *Tō chūki no Jodokyō* 唐中期の浄土教. Kyoto: Hozōkan, 1975.

———. "Nangaku Shōen den to sono jōdo kyō" 南嶽承遠伝とその浄土教. *Tohō gakuhō* 2 (1931): 186–249.

Tsukinowa, Kenryū 月輪賢隆. "Ushinisha-bijaya-darani ni tsuite" 邬瑟抳沙尾匿野陀羅尼に就て. *Rokujō gakuhō* 六条学報 133 (1912): 1–23.

Ujike, Kakushō 氏家覚勝. *Darani no sekai* 陀羅尼の世界. Osaka: Toho, 1984.

Unno, Mark. *Shingon Refractions: Myōe and the Mantra of Light.* Somerville, MA: Wisdom Publications, 2004.

———. *Darani shisō no kenkyū* 陀羅尼思想の研究. Osaka: Toho, 1987.

Van Schaik, Sam, and Jacob Dalton. "Where Chan and Tantra Meet: Tibtan Syncretism at Dunhuang." In *The Silk Road: Trade, Travel, War, and Faith*, edited by Susan Whitfield, 63–70. London: The British Museum, 2004.

Van Schaik, Sam and Imre Galambos. *Manuscripts and Travellers: The Sino-Tibetan Documents of a Tenth-Century Buddhist Pilgrim.* Berlin: Walter de Gruyter, 2012.

Waddel, L. A. "The Dhāraṇī Cult in Buddhism, Its Origin, Defied Literature, and Images." *Ostasiatische Zeitschrift* I, no. 2 (1912): 155–195.

Waley, Arthur. *A Catalogue of Paintings Recovered from Tun-Huang by Sir Aurel Stein, K. C. I. E., Preserved in the Sub-department of Oriental Prints and Drawings in the British Museum, and in the Museum of Central Asian Antiquities, Delhi.* London: Kegan Paul, 1931.

Wang, Eugene Y. "Ritual Practice Without a Practitioner? Early Eleventh Century Dhāraṇī Prints in the Ruiguangsi Pagoda." In *Tenth Century China and Beyond: Art and Visual Culture in a Multi-Centered Age*, edited by Wu Hung, 179-211. Chicago: Center for the Arts of East Asia, University of Chicago, 2012.

——. "Buddha Seal." In *Buddhist Sculpture from China: Selections from the Xi'an Beilin Museum, Fifth Through Ninth Centuries*, edited by Annette L. Juliano, 118–121. New York: China Institute Gallery, 2007.

——. *Shaping the Lotus Sutra: Buddhist Visual Culture in Medieval China.* Seattle: University of Washington Press, 2005.

Wang Huimin 王惠民. "Dunhuang foding zunsheng tuoluoni jingbian kaoshi" 敦煌佛頂尊勝陀羅尼經變考釋. *Dunhuang yanjiu* 1 (1991): 7–18.

Wang Sanqing 王三慶 and Wang Yayi 王雅儀. Dunhuang wenxian yinsha fo wen yanjiu de zhengli 頓煌文獻印沙佛文的整理研究. *Dunhuang xue* 26 (2005): 45–74.

Wang, Yucheng 王育成. *Daojiao fayin lingpai tan'ao* 道教法印令牌探奧. Beijing: Zongjiao wenhua, 2000.

——. "Tang Song Daojiao mi zuanwen shili" 唐宋道教秘篆文释例. *Zhongguo Lishi bowuguan guankan* 中国历史博物馆馆刊 15–16 (1991): 82–94.

Wayman, Alex. "The Significance of Mantras, from the Veda Down to Buddhist Tantric Practice." *Indologica Taurensia* 3–4 (1976): 483–497.

Wedemeyer, Christian K. *Making Sense of Tantric Buddhism: History, Semiology, and Transgression in the Indian Traditions.* New York: Columbia University Press, 2013.

——. *Aryadeva's Lamp That Integrates the Practices (Caryamelapakapradipa): The Gradual Path of Vajrayana Buddhism According to the Esoteric Community Noble Tradition.* New York: American Institute for Buddhist Studies, 2008.

Weidner, Marsha. *Latter Days of the Law: Images of Chinese Buddhism 850–1850.* Honolulu: University of Hawaii Press, 1994.

Weinstein, Stanley. *Buddhism Under the T'ang.* Cambridge: Cambridge University Press, 1987.

Welter, Albert. "A Buddhist Response to the Confucian Revivial: Tsan-ning and the Debate Over Wen in the Early Sung." In *Buddhism in the Sung*, edited by Peter N. Gregory and Daniel Getz, 21–61. Honolulu: University of Hawaii Press, 2000.

White, David Gordon. *The Alchemical Body.* Chicago: University of Chicago Press, 1996.

Whitfield, Roderick. *The Art of Central Asia: The Stein Collection in the British Museum.* 2 Volumes. Tokyo: Kodansha International, 1982.

Whitfield, Roderick and Anne Farrer. *Caves of the Thousand Buddhas: Chinese Art from the Silk Route.* London: British Museum Publications, 1990.

Williams, Paul with Anthony Tribe. *Buddhist Thought: A Complete Introduction to the Indian Tradition.* London: Routledge, 2000.

Wilson, Liz. *Charming Cadavers: Horrific Figurations of the Feminine in Indian Buddhist Hagiographic Literature.* Chicago: University of Chicago Press, 1996.

Wittgenstein, Ludwig. "Remarks on Frazer's *Golden Bough.*" In *Wittgenstein: Sources and Perspectives,* edited by C. G. Luckhardt, 61–81. Sussex, UK: Harvester, 1979.

Wong, Dorothy. "Divergent Paths: Early Representations of Amoghapāśa in East, South, and Southeast Asia." Unpublished manuscript.

Wright, Arthur Frederick. "Fo-t'u-teng: A Biography." *Harvard Journal of Asiatic Studies* 11.3/4 (1948): 321–371.

Wu, Hung. "On Rubbngs: Their Materiality and Historicity." In *Writing and Materiality: Essays in Honor of Patrick Hanan,* edited by Judith Zeitlin and Lydia Liu, 29–72. Cambridge, MA: Harvard East Asia Center, 2003.

——. "What is *Bianxiang*? On the Relationship Between Dunhuang Art and Literature." *Harvard Journal of Asiatic Studies* 52.1 (1992): 111–192.

——. *The Wu Liang Shrine: The Ideology of Early Chinese Pictorial Art.* Stanford: Stanford University Press, 1989.

——. "Buddhist Elements in Early Chinese Art (2nd and 3rd Centuries AD)." *Artibus Asiae* 47.3/4 (1986): 263–352.

Xiao Dengfu 蕭登福. *Daojia Daojiao yingxiangxia de Fojiao jingji* 道家道教影響下的佛教經籍. Taipei: Xinwenfeng, 2005.

——. *Daojiao shuyi yu mijiao dianji* 道教術儀與密教典籍. Taipei: Xinwenfeng, 1994.

——. *Daojiao yu Mizong* 道教與密宗. Taipei: Xinwenfeng chubanshe, 1993.

Xiao, Yu 肖雨. "Jinge si Fojiao jianshi" 金閣寺佛教簡史. *Wutai shan yanjiu* 3 (1997): 11–21.

Xiong, Victor Cunrui. *Sui-Tang Chang'an: A Study in the Urban History of Medieval China.* Ann Arbor: Center for Chinese Studies, University of Michigan, 2000.

Yan, Wenru 嚴文儒. "Shichuang" 石幢. *Wenwu* 8 (1958).

Yan, Yaozhong 严耀中. *Hanchuan mijiao* 汉传密教. Shanghai: Xuelin, 1999.

——. *Jiangnan Fojiao shi* 江南佛教史. Shanghai: Shanghai renmin, 2000.

Ye Changzhi 葉昌熾. *Yushi, Yushi yitongping* 語石, 語石異同評. Beijing: Zhonghua, 1994.

Yin, Guangming 殷光明. *Bei Liang shita yanjiu* 北涼石塔研究. Hsin-chu, Taiwan: Chueh Feng Buddhist Art & Culture Foundation, 2000.

Yiengpruksawan, Mimi Hall. "Illuminating the Illuminator: Notes on a Votive Transcription of the *Supreme Scripture of the Golden Light (Konkōmyō saishō ōkyō)*." *Versus* 83/84 (1999): 113–120.

Yoritomi, Motohiru 頼富本宏. *Chūgoku mikkyō no kenkyū* 中国密教の研究. Tokyo: Daito, 1979.

Young, Stuart H. "Conceiving the Indian Patriarchs in China." Unpublished PhD dissertation, Princeton University, 2008.

Yu, Xin 余欣. "Personal Fate and the Planets: A Documentary and Iconographical Study of Astrological Diviniation at Dunhuang, Focusing on the 'Dhāraṇī Talisman for Offerings to Ketu and Mercury, Planetary Deity of the North'." *Cahiers d'Extrême-Asie* 20 (2011).

——. *Shendao renxin: Tang Song zhi ji Dunhuang minsheng zongjiao shehuishi yanjiu* 神道人心: 唐宋之際敦煌民生宗教社會史研究. Beijing: Zhonghua, 2006.

Yuyama, Akira. "An Uṣṇīṣa-Vijayā-Dhāraṇī Text from Nepal." *Sōka Daigaku Kokusai Bukkyōgaku Kōtō Kenkyūjo nenpō* (1999): 165–175.

Zeitlin, Judith. "Disappearing Verses: Writing on Walls and Anxieties of Loss." In *Writing and Materiality: Essays in Honor of Patrick Hanan*, edited by Judith Zeitlin and Lydia H. Liu, 73–132. Cambridge, MA: Harvard East Asia Center, 2003.

Zhang, Nong 张侬 *Dunhuang shiku mifang yu jiujingtu* 敦煌石窟秘方与灸经图. Lanzhou: Gansu wenhua, 1995.

Zhang, Xiantang 张先堂. "Dunhuang ben Tangdai Jingtu wuhui zanwen yu fojiao wenxue" 敦煌本唐代净土五会赞文与佛教文学. *Dunhuang yanjiu* 4 (1996) 63–73.

Zhao, Shengliang 赵声良. "Mogaoku di 61 ku Wutaishan tu yanjiu" 莫高窟第61窟五台山图研究. *Dunhuang yanjiu* 4 (1993): 88–107.

Zhiru. *The Making of a Savior Bodhisattva: Dizang in Medieval China.* Honolulu: University of Hawaii Press, 2007.

Zhou Shaoliang 周绍良, ed. *Dunhuang bianwen, jiangjing wen, yinyuan jijiao* 敦煌變文講經文因緣輯校. Nanjing: Jiangsu guji, 1998.

Zhou Tianyou 周天游. *Xunmi sanluo de guibao: Shanxilishi bowuguan zhengji wenwu jingcui* 寻觅散落的瑰宝: 山西历史博物馆征集文物精粹. Xi'an: Sanqin, 2000.

Zhu, Qingzhi 朱慶之. *Fodian yu zhonggu hanyu cihui yanjiu* 佛典與中古漢語詞彙研. Taipei: Wenjin, 1992.

Zwalf, W. *Buddhism: Art and Faith.* London: British Museum Publications, 1985.

Zysk, Kenneth G. "Religious Healing in the Veda." *Transactions of the American Philosophical Society* 75.7 (1985): 1–311.

INDEX

Changyang fu. See "Fu on Tall Poplars Palace"
Charts of the Real Forms of the Five Peaks. See
 Wuyue zhenxing tu
Chaves, Jonathan, 94
Chen Chouding's amulet, 105–6, 106
chi (grasp/hold), 15, 18, 22–23; literal
 translation of, 250n87; medieval Chinese
 Buddhism and, 25–26; samādhi and, 16
children: amulet sheets for, 93; *Incantation of
 Wish Fulfillment* amulet instructions for, 69
China: amulets evolution in, 40; Buddhist
 incantations popularity in medieval,
 xiii; dhāraṇīs in later works from,
 25–28; dharma relics in stūpas in,
 36; incantation cords history in, 80;
 Indian wearing of dhāraṇīs compared
 to, 46; seals showing state power in,
 45; "Wizards' Basket" history in, 214;
 xylographs in, 75, 103, 118, 139; Zanning
 on dhāraṇī tradition of Japan and, 204–5.
 See also medieval Chinese Buddhism;
 medieval Chinese religion
Chinese Magical Medicine (Strickmann), 42,
 227, 266n88
Chinese religion. *See* medieval Chinese
 religion
Chou Yi-liang, 165
Chuan changuan fa. See "Transmission
 of the Methods of Meditation and
 Contemplation"
Chuan'guang, 175
Chuan mizang. See "Transmission of the
 Mystic Store"
Cixian, 252n26
cliff pillars, 150, 150–51, 151
*Collative Commentary on the Dhāraṇī of Wish
 Fulfillment*. See *Dazuigu darani kanchū*
*Collection of Dhāraṇī Scriptures Spoken by the
 Buddha*. See *Foshuo tuoluoni jijing*
Collection of the Ignorant Rākṣasa. See *Wuming
 luocha ji*
colophons, 118–19, 124, 126
"concrete efficacy," 154, 156. *See also*
 material efficacy

consecration, 190–92. *See also* anointment
Consecration Scripture, 65
Consecration Sūtra, 50–51, 294n39
contemplation. *See* syllable contemplation
*Contemplations of the Ritual Spheres of the
 Essential Deities*. See *Yōson dōjōkan*
corpses: adornment of statues compared
 to, 85–87; *Incantation of Glory* enchanting,
 143, 144; *Incantation of Wish Fulfillment*
 amulets adorning, 72–74. *See also*
 mortuary practices
cow's bezoar, 93–94, 266n88

dai ("to wear on the belt or sash"), 45, 47
Daizong, 159, 164–65, 204
Dali Kingdom, 151
Dānapāla, 203
Daoism: *Consecration Scripture* and, 65;
 medieval Chinese Buddhism compared
 to, 42–43; medieval Chinese Buddhism
 permeability with, 41; ox yellow use in,
 94; talismans worn in, 51
Daolin, 213
Daoxian, 202, 204, 209–12, 296n46
Dasheng bensheng xindi guanjing (*Great Vehicle
 Contemplation Scripture of the Mind Ground of
 [the Buddha's] Original Lives*), 176–77
Da Song sengshi lüe (*Historical Digest of the
 Buddhist Order*), 199–203
Dasuiqiu tuoluoni. See *Incantation of Wish
 Fulfillment*
Davidson, Ronald, 198–99
Da weide tuoluoni jing (*Scripture of the Dhāraṇī of
 Majestic Virtue*), 217
Da xukong pusa suowen jing (*Scripture of
 the Inquiries of the Bodhisattva of Great
 Emptiness*), 188–92
Dazhidu lun. See *Treatise on the Great Perfection
 of Wisdom*
Dazuigu darani kanchū (*Collative Commentary on
 the Dhāraṇī of Wish Fulfillment*), 104
De Groot, J. J. M., 262n39
deities: adornment of, 85; on armlets,
 84–85; icons of objects from, 125–26

BRIDWELL LIBRARY
SOUTHERN METHODIST UNIVERSITY
DALLAS, TEXAS 75275

CPSIA information can be obtained
at www.ICGtesting.com
Printed in the USA
LVHW01s1426230218
567702LV00002B/5/P

9180218

9 780231 162715

Southern Methodist Univ.

3 2177 02280 6713

DATE DUE

ILL 224765070	
	PRINTED IN U.S.A.